AFRICAN AMERICAN VISUAL ARTS

African American Visual Arts

From Slavery to the Present

CELESTE-MARIE BERNIER

The University of North Carolina Press
Chapel Hill

First published in the United Kingdom by Edinburgh University Press.

Typeset in Fournier by
Koinonia, Manchester, and
printed and bound in Great Britain by
MPG Books Ltd, Bodmin, Cornwall

The paper in this book meets the guidelines for permanence and durability
of the Committee on Production Guidelines for Book Longevity of the
Council on Library Resources.

The University of North Carolina Press has been a member of the Green Press
Initiative since 2003.

Library of Congress Cataloging-in-Publication Data
Bernier, Celeste-Marie.
 African American visual arts: from slavery to the present / Celeste-Marie Bernier.
 p. cm.
 Includes bibliographical references and index.
 ISBN 978-0-8078-3256-1 (cloth: alk. paper) — ISBN 978-0-8078-5933-9 (pbk.: alk.
 paper)
 1. African American art. I. Title.
 N6538.N5B47 2009
 700.89'96073—dc22

 2008012512

cloth 12 11 10 09 08 5 4 3 2 1
paper 12 11 10 09 08 5 4 3 2 1

Contents

Plates

Section 1

1 Aaron Douglas, *Into Bondage*, 1936. © Corcoran Gallery of Art, Washington, DC.

2 Archibald J. Motley, Jr, *Mending Socks*, 1924, oil on canvas, 58.1.2801. © 2003. Valerie Gerrard Browne.

3 Charles Alston, *Jazz*, c.1950, oil on canvas 40in x 30in, signed. Private Collection. © Estate of Charles Alston; Courtesy of Michael Rosenfeld Gallery, LLC, New York, NY.

4 William Edmondson, *Critter*, c.1940. © Collection of Cheekwood Museum of Art, Nashville, Tennessee.

5 Horace Pippin, *John Brown Going to His Hanging*, 1942, oil on canvas 24¹⁄₈in x 30¼in. © Courtesy of the Pennsylvania Academy of the Fine Arts, Philadelphia, John Lambert Fund.

6 Jacob Lawrence, *The Shoemaker*, 1945. The Metropolitan Museum of Art, George A. Hearn Fund, 1946 (46.73.2). Photograph © 1986. The Metropolitan Museum of Art.

7 Charles White, *The Contribution of the Negro to Democracy in America*, 1943. © Courtesy of Hampton University Archives.

8 Elizabeth Catlett, *Mother and Child*, 1972, bronze 21in x 7in x 9in, 99.7. Courtesy Lauren Rogers Museum of Art. © Elizabeth Catlett, Licensed by DACS, London/VAGA, New York 2006.

Section 2

9 Gordon Parks, *Harlem Neighbourhood*, 1948. © The Gordon Parks Foundtion. All Rights Reserved.

10 Hale Woodruff, *Ancestral Memory*, 1967. Mid-20th Century Founders Society Purchase, African Art Gallery Committee Fund. Photograph © 1978 The Detroit Institute of Arts. Courtesy of Michael Rosenfeld Gallery, LLC, New York, NY.

11 Norman Lewis, *Post Mortem*, 1964, oil on canvas. 64in H x 50in W.

Virginia Museum of Fine Arts, Richmond. Gift of the Fabergé Society of the Virginia Museum of Fine Arts. Photo: Katherine Wetzel © Virginia Museum of Fine Arts.

12 Romare Bearden, *The Street*, 1964, collage of various papers on cardboard, 127⅞in x 153⅜in. Milwaukee Art Museum, Purchase, Gift of Friends of Art and African American Art Acquisition Fund, M1996.52. © Romare Bearden Foundation/DACS, London/VAGA, New York 2006.

13 Betye Saar, *Sunnyland (On the Dark Side)*, 1998, mixed media on vintage washboard, 33½in x 16in x 2½in, signed. Collection of the Artist; Courtesy of Michael Rosenfeld Gallery, LLC, New York, NY.

14 David Hammons, *Injustice Case*, 1970, body print (margarine and powdered pigments) and American flag, 63in x 40½in. Los Angeles County Museum of Art, Museum Acquisition Fund. Photograph © 2006 Museum Associates/LACMA.

15 Howardena Pindell, *Autobiography: Water/Ancestors/Middle Passage/Family Ghosts*, 1988, acrylic, tempera, cattle markers, oil stick, paper, polymer photo transfer, vinyl type on sewn canvas, 118in x 71in. Wadsworth Atheneum Museum of Art, Hartford, CT. The Ella Gallup Sumner and Mary Catlin Sumner Collection Fund.

16 Kara Walker, *A Means to an End ... A Shadow Drama in Five Acts*, 1995, etching and aquatint on white Somerset Satin paper 35in x 24in. Photography by Milwaukee Art Museum, Landfall Press Archive, Gift of Jack Lemon, LP1996.11.1-5. © Image courtesy of the Artist and Sikkema Jenkins & Co.

Acknowledgements

This book would not have been possible without the wonderful generosity and assistance of the following individuals for granting permission to quote from these unmicrofilmed and microfilmed materials and interviews. Please note that the abbreviations used throughout this book are identified in brackets at the end of each citation.

Papers

Charles Henry Alston Papers, 1928–1980, Archives of American Art, Smithsonian Institution [Microfilm reel numbers 4222, 4223]. (*CAP*)

Correspondence in the Charles Henry Alston Papers, 1928–1980. Owned by Charles H. Alston [Microfilm reel number N70-23]. Cited by kind permission from Lawrence Randall, Randall Galleries, Ltd, the Charles Alston Estate.

Correspondence and unmicrofilmed material in the Romare Bearden Papers, 1937–1982. Archives of American Art, Smithsonian Institution. Cited by kind permission from Diedra Harris-Kelley, the Romare Bearden Foundation.

[Microfilm reel number N68-87]. Other material on microfilm reel number N68–87 was microfilmed by the Archives of American Art and is owned by Romare Bearden]. (*RBP*), (*URBP*)

Elizabeth Catlett Papers, 1957–1980, Archives of American Art, Smithsonian Institution. [Microfilm reel number: 2249]. (*ECP*)

Aaron Douglas Papers, 1921–1973. Owned by Fisk University, Franklin Library Special Collections. Microfilmed by Archives of American Art, Smithsonian Institution. [Microfilm reel numbers: 4520–4523. Cited by kind permission from Professor Beth Howse, Fisk University, Franklin Library Special Collections. (*ADP*)

William Johnson Papers, 1922–1968, Archives of American Art, Smithsonian Institution. [Unmicrofilmed portion and microfilm reel numbers: 2678, 3829]. (*WJP*)

Jacob Lawrence and Gwendolyn Knight Papers, 1945–1995, Archives of American Art, Smithsonian Institution. [Unmicrofilmed portion and microfilm reel numbers 4571–4573]. (*JLP*), (*UJLP*)

Archibald J. Motley Jr. Papers, 1925–1977, Archives of American Art, Smithsonian Institution. [Microfilm reel number: 3161]. (*AMP*)

Horace Pippin Papers, 1920–1943, Archives of American Art, Smithsonian Institution. [Microfilm reel numbers: 4018, 138]: http://www.aaa.si.edu/collections/collections_list.cfm/fuseaction/Items.BrowseImages/filter_type/Collection/filter_key/8586(*HPP*)

Henry Ossawa Tanner Papers, 1860s–1978, Archives of American Art, Smithsonian Institution. [Microfilm reel numbers: D306-D307, 107. (*HTP*)

Charles Wilbert White Papers, ca. 1930–1982, Archives of American Art, Smithsonian Institution. [Unmicrofilmed portion and microfilm reel numbers 2041, 3189–3195]. (*CWP*), (*UCWP*)

Hale Woodruff Papers, 1927–1977, Archives of American Art, Smithsonian Institution. [Microfilm reel numbers: N70-60, 4222]. (*HWP*)

Interviews

'Romare Bearden', interview conducted by Avis Berman, 31 July 1980, transcript, Archives of American Art, Smithsonian Institution. Cited by kind permission from Avis Berman, August 2007.

'Aaron Douglas', interview conducted by L. M. Collins, 16 July 1971, transcript, Fisk University, Franklin Library Special Collections. Cited by kind permission from Professor Beth Howse, Fisk University, Franklin Library Special Collections.

'Aaron Douglas', interview conducted by Ann Allen Shockley, 19. November 1973, transcript, Fisk University, Franklin Library Special Collections. Cited by kind permission from Professor Beth Howse, Fisk University, Franklin Library Special Collections.

'Jacob Lawrence', interview conducted by Avis Berman, 20 July 1982, transcript, Archives of American Art, Smithsonian Institution. Cited by kind permission from Avis Berman, August 2007.

'Betye Saar', *African-American Artists of Los Angeles Oral History Transcript, 1990–1991*. Transcript of oral history conducted during 1990–1 by Karen Ann Mason. Collection 300/457. Department of Special Collections, Young Research Library, University of California, Los Angeles c.1996. Cited with the kind permission from Aislinn Sotelo.

I would like to offer sincere thanks for the generosity of the following art gallery curators and experts: Bill Hodges, Corinne Jennings, June Kelly and Marylou Hultgren. Special thanks must extend to Joy Weiner at the Archives of American Art who has been exceptionally kind and impressively organised in dealing with my incessant queries and problems. I would like to thank Giorgio Mariani for permission to include a discussion of Elizabeth Catlett's prints and sculptures in this book, a topic which I had also explored in an essay written for his edited collection published in 2007. I would like to thank the University of Nottingham for a New Lecturer's Award (2005), a sabbatical and additional research leave which all made it possible to complete this project.

This book would not have been possible without the editorial assistance and expert advice of Carol Smith, Nicola Ramsey and James Dale. I would like to thank Carol especially for her unflagging support and invaluable advice – while the errors are all mine, this is a much better book as a result of her editorial suggestions. This project has been greatly improved as a result of conversations with Sara Wood, Richard King, Dave Murray, Sharon Monteith, Judie Newman, Graham Taylor, John Stauffer, Susan Castillo, Graham Thompson and Andy Green. Special thanks are due to Sara, Dave, Graham and Andy for their intellectual advice and encouragement given generously over endless cups of tea and biscuits. This book is also informed by discussions held during undergraduate and postgraduate classes on African American art. In particular, I would like to thank Camilla Cox, Siobhan Haugh, Rebecca Cobby and Hannah Curr for their contributions. A sincere debt of gratitude must extend to Richard Anderson, a dear and long suffering friend, whose tireless driving made it possible for me to see the majority of the artworks examined in this book.

On a more personal note, enormous thanks go to my best friends and my wild and weird family: Claire Roberts, Tash and Dillon Tetley, Stephanie Lewthwaite, Helen Oakley, Catherine Nash, Richard Anderson, Champa Patel, Maha Marouan, Luca Prono, Lisa Rull, Neil Roberts, Graham Thompson, Jean Darnbrough, Becca Lloyd, Susan Billingham, Ruth Maxey and Owen Butler. I couldn't have finished this book without your advice, encouragement and brilliant sense of humour – thank you for everything. Special thanks go to 'Captain' George, Tina and Zac Green for far too many cream teas and perhaps far too few healthy, long walks. I would also like to thank the Salzburg clan: Axel, Brenda and Riley Schäfer, Travis Jacobs and Marty Gecek. Let's have more ping-

pong, dancing and castle-filled adventures in the future. Grateful thanks go to the happy newly-weds, Alex Goodwin and Andy Grewcock, for 'Chris in the Morning', Fleischman and many doughnuts. I would like to thank Helen Taylor, Ann McQueen, Jacqui Clay and Stuart Wright for bailing me out of so many 'Frank Spencer' mishaps and for getting me into far more. Special thanks go to Simon Brown, Michael Walker, Marion Bussetti, Andrew Gibb and Heather Nelson for their exceptional kindness.

This book is written in loving memory of my mother, Maureen Bernier, and my father, Nicholas Louis Bernier, my grandmothers, Sadie McKeever and Cecilia Mary Bernier, my uncle, Lawrence Robert Bernier, and my great uncle, Frank Bussetti. Finally, this book is written for Andy Green.

In loving memory of Maureen Bernier (1950–2002)

For Andy Green

'Art has saved my life'
(Jacob Lawrence)

Introduction:
'From Here I Saw What Happened and I Cried'

I have written this book with the aim of breathing fresh life into African American art history by focusing upon the aesthetic issues and experimental practices of artists working across a long time frame and a diverse range of media. Emerging during slavery and surviving on down through to a post-civil rights era, black visual arts have taken many forms including mural, portrait, landscape and abstract painting; sculpture; daguerreotyping and photography; pottery, quilting and collage; assemblage, installation, street and performance art. Despite their many and important differences, it is possible to trace thematic and formal continuities across this vast body of works produced by African American artists living and working in the United States. Many artists have repeatedly pushed the boundaries of media and materials in the search for a visual language which would represent the difficult realities of African American struggles for existence. For so many early artists emerging during slavery in particular, the act of sculpting, painting or quilting in and of itself constituted a radical act of self-expression and resistance.

As contemporary black artist, David Hammons, admits, the visual arts remain the most '"problematic"' for African Americans because '"[y]ou have to sit down and physically make art"' whereas in '"music you could sing the songs while you were picking the cotton; it didn't matter how much hell you were catching"' (in Berger, 1993: 177). African American critic, Alain Locke, was similarly under no illusion that, '[s]tripped of all else, the Negro's own body became his prime and only artistic instrument' (Locke, 1936: 3). By investigating such a diverse range of artists, art movements and forms across a time span of more than two hundred years, this study supports bell hooks's view that the responsibility rests upon us as critics to 'imagine new ways to think and write about visual art', as we 'engage a process of cultural transformation

I

that will ultimately create a revolution in vision' (hooks, 1995: xvi). In this book, I hope to encourage viewers to read against the grain, not only of their own assumptions but also of much contemporary scholarship by examining artists' statements in conjunction with detailed analyses of their works.

From the mid-twentieth century onwards, there has been a concerted effort among literary critics to explore the psychological realities of slavery by delving into the six thousand or more slave narratives written by African and African American fugitives. At the same time, historians have turned to plantation records, legal documents, personal testimonies and much more to excavate the social, economic and political realities of slavery. And yet, if silences, omissions and absences caused by white attempts to control black narratives and distort official records have hindered the fight either to explore the history of slavery or the poems, autobiographies, novels and plays of enslaved writers, then the recovery of an African American arts tradition has faced even more difficulties. As Michele Wallace argues, 'If black writers had had to rely on the kind of people and developments that determine the value of art, if writing had to be accepted into rich white people's homes' as a 'prized art object', then 'none of us would have ever heard of Langston Hughes, Richard Wright [or] Zora Neale Hurston' (Wallace, 2004: 366–7).

Given that it was hard for slave narrators such as Harriet Jacobs to gain literacy and for slave revolt leaders, including *Amistad* freedom-fighter, Sengbe Pieh, to quench slavery by physical resistance, almost insurmountable barriers stood in the way of enslaved Africans determined to paint, sculpt, carve and quilt in the face of white attempts to erase black culture. But the fact that African and African American pottery, jewellery, sculptures, paintings, musical instruments, quilts and religious objects have survived proves that enslaved Africans produced art regardless of these odds. Their determination to create art objects constituted a powerful blow against legislation inscribing enslaved Africans into law as property to be bought and sold and, as such, incapable of an imaginative inner life. More specifically, works by these early artists countered the dominance of a historical reality which admitted of 'no position within or outside American visual culture from which one could conceptualize the African American as a subject' (Ibid.: 186). As viewers attempting to analyse these works, difficulties arise not only because they have suffered from critical neglect but also because so many have simply disappeared. In light of the proliferation of white racist contexts in which black bodies

have been displayed, objectified and appropriated, black artists' works have suffered a similar fate as they have been repeatedly destroyed or have just simply been lost to history.

My aim in this book is not to outline a generic overview of African American art history but to provide case studies of twenty painters, sculptors, potters, daguerreotypists, photographers, quilters, installation, performance, assemblage, and street artists working across the nineteenth, twentieth and twenty-first centuries. Readers interested in a thematic summary and intellectual overview are advised to consult texts by Freeman Henry Morris, James Porter, Alain Locke, Cedric Dover, bell hooks, Elsa Honig Fine, David Driskell, Samella Lewis, Richard Powell, Sharon Patton, and Elvan Zabunyan, all listed in the further reading. By starting with archaeological discoveries and the artefacts created by women and men, both enslaved and free, I map the beginnings of African American art history in the early period to show the ways in which black artists remained indebted to their forebears. By focusing on specific artists, this book has much more in common with Elton Fax's *Seventeen Black Artists* (1971), *A History of African-American Artists* (1993) by Romare Bearden and Harry Henderson, and bell hooks's *Art on My Mind: Visual Politics* (1995). In particular, I share Bearden and Henderson's determination to examine artists' thematic concerns and aesthetic issues in light of their personal statements and 'individual histories' (Bearden and Henderson, 1993: xiii).

My discussion of the twenty African American artists in this book draws heavily on their unpublished manuscripts, autobiographies, speeches, lectures, interviews and essays. Readers interested in undertaking further research are recommended to consult the sources for further reading in which I list useful archival collections. Just as this volume explores the lives and works of artists who have influenced the development of the African American visual arts tradition, nearly every chapter opens and closes with brief readings of works by additional artists. The rationale for including this extra material is twofold: first, to provide avenues for future research and, second, to situate these artists in a wider context. Furthermore, I supplement the material supplied in the sources and further reading by including appendices. Appendix A provides a list of additional artists recommended for further study, while Appendix B lists bibliographic information and internet addresses where readers can access images which I examine but have been unable to reproduce in this volume.

As Greg Tate argues, 'Black visual culture suffers less from a lack of developed artists than a need for popular criticism, academically supported scholarship, and more adventurous collecting and exhibiting' (Tate, 1992: 243). One of the aims of this introduction, then, is to discuss the controversies within African American art scholarship as well as the ongoing problems artists face in the white mainstream art world. I also provide a chapter-by-chapter breakdown to give readers some insights into the structure of this book. Finally, I examine contemporary photographer, Carrie Mae Weems's recent work, *From Here I Saw What Happened and I Cried* (1995–6). Beyond their self-reflexive and thought-provoking aspects, these photographic prints explore issues which appear again and again in works by African American artists.

Controversies and Debates within African American Art Criticism

The purpose of this book is to take to task what Romare Bearden and Harry Henderson identify as a 'great blind spot in American art history, one that is color-sensitive, not color-blind' (Bearden and Henderson, 1993: xiii). As James Smalls argues, the study of African American art suffers from a 'dearth of a viable and critical art historical and historiographical practice within the discipline' (Smalls, 1994: 3). In my view, far too many critics celebrate African American artists solely for their ability to survive political disfranchisement, racist brutality and cultural annihilation, rather than for the ground-breaking formal qualities and aesthetic properties of their art. Traditionally in African American art criticism, artistic issues have been discounted in favour of their sociological, biographical and historical implications. Similarly, attempts by scholars to define a black visual arts canon or a key set of aesthetic principles have led to over-generalised and reductive readings which eschew the complexities of the tradition.

As Smalls suggests, a 'major problem' has emerged within current scholarship because 'a chosen canon of artists and works are presented in primarily biographic form with general arguments of racial injustice and Black struggle as the underlying base' (Smalls, 1994: 6). Taking this into consideration, I have written this book to foreground aesthetic rather than 'biographic' issues by focussing upon the artistic complexities which typify works by African American artists. For far too many critics, it is much easier to define what African American art is not – monolithic, homogenous, uniform and fixed – than it is to define the rich

contrasts, conflicts and ambiguities of an established and longstanding tradition which defies straightforward categorisation or synthesis. As hooks asserts, we must get beyond 'descriptive rather than critically interpretative' approaches to examine the otherwise buried experimental practices of African American art and artists (hooks, 1995: xv).

Michele Wallace's view that 'vision, visuality, and visibility are part of a problematic in African American discourse' provides a springboard to many of the discussions related to the search for artistic agency in this book (Wallace, 2004: 186). Recognising the importance of what she describes as 'the problem of visuality' for African American artists, I focus upon their experimentation with form and content in the search for an alternative visual language (Ibid.: 191). For numerous artists working within an African American visual arts tradition, art continues to operate as a site of subversion and resistance as they develop new strategies to counter popular stereotyping within white mainstream iconography. Just as eighteenth- and nineteenth-century slave writers such as Phillis Wheatley and Frederick Douglass pushed the boundaries of literary genres to obtain an independent voice, African American artists have repeatedly experimented with aesthetic issues, materials and media. They rely on their works to counter what Henry Louis Gates, Jr has described as a tendency among white Americans to 'create a white fiction of blackness', by viewing African Americans through a 'filter of a web of racist images' (in Berger, 1994: 52). Across the centuries, African Americans have been bought and sold, sexually assaulted and physically abused as a result of slavery and segregation. They have also been subject to racist stereotyping in repeated appearances as minstrel performers, scientific specimens, lynched victims and garish caricatures in popular advertising campaigns. As this book shows, for the vast majority of African American artists, the fight against what Cornel West identifies as the *'relative lack of black power to represent themselves and others as complex human beings'* constitutes one of their main priorities (in Berger, 1994: 13, his emphasis). If there is one key characteristic of African American art from the early period until now, it can be defined as their determination *'to contest the bombardment of negative, degrading stereotypes put forward by white supremacist ideologies'* (Ibid.).

Throughout this book, I encourage readers to heed Floyd Coleman's recent statement that, 'African American art' is 'still a new frontier in American art history' (Coleman, 2003: 25). As such, we should pay attention to his warning: 'I do not wish to see careful, visual analysis of

the object, nor exploration of aesthetics excluded from the art historical narrative' (Ibid.). By providing a 'careful, visual analysis' of artworks, I share Coleman's sense that an 'exploration of aesthetics' is fundamental to any useful investigation of the African American 'art historical narrative'. As regards the limitations of existing arts scholarship, I also support Wallace's conviction that there 'has not been nearly the focus on reconceptualising aesthetic criteria that there has been on refuting scientific rationalisations of racism' (Wallace, 2004: 190). As she shows, 'what we've tried to do is tie down one of two fists (science and aesthetics) in a combination punch. It should come as no surprise that racism succeeds again and again in freeing the other fist' (Ibid.). In light of the ways in which racist perspectives overshadow artistic issues when it comes to works by black artists, we should endorse Wallace's call for a 'flexible, freewheeling, indeterminate and polyvocal' definition of aesthetics as offering the best way to extrapolate the key features of an African American visual arts tradition (Ibid.: 418). Given an overwhelming tendency towards prescriptive approaches which close down rather than open up interpretations, it is essential that we develop a flexible approach which will be more sensitive to the ambiguities and complexities of artists and their works.

Scholars of African American art repeatedly overlook how, for the majority of artists, the desire to represent issues related to a range of black experiences does not preclude formal experimentation. More often than not, their determination to push aesthetic boundaries while examining cultural, historical and political issues is not mutually exclusive. As hooks suggests, 'white artists and critics', in particular, experience the 'greatest difficulty accepting that one can be critically aware of visual politics – the way race, gender, and class shape art practices (who makes art, how it sells, who values it, who writes about it) – without abandoning a fierce commitment to aesthetics' (hooks, 1995: xii). By providing in-depth readings of specific artists, this book pays close attention to aesthetic considerations to examine continuities and divergences within a longstanding African American visual arts tradition. I follow on from Richard Powell's insistence that scholars of African American art must not only examine the 'art object itself' but also 'its multiple worlds of meaning, and its place in the social production of black identities' (Powell, 2002: 22).

Just as it would be nonsensical to examine formal experimentation in literary works by African American authors without analysing their social and political implications, this book argues for the necessity of analysing

art objects in relation to their formal, historical and thematic contexts. As critics, it is essential that we engage in 'more debate on how African American art history, criticism, and theory are constructed and delivered' so that we can begin to 'progress beyond the legitimation stage' (Smalls, 1994: 4). By examining the experimental practices of twenty artists from slavery to the post-civil rights era, this book exposes the discrepancies between the 'moribund state of African American art history' and the African American art tradition itself which is 'richly complex and multi-faceted in terms of subject matter, style, and significant meaning' (Ibid.: 3). One of the aims of this study is to further the search for a criticism of black visual arts which will rival the sophistication of current research into African American literature and music. While David Hammons is right to suggest that it was much easier for African Americans to make music, regardless of 'how much hell you were catching', the survival of works from the eighteenth century on down to the present day proves that an art tradition persisted, irrespective of white attempts to censor, persecute or marginalise black visual culture.

'A Closed Circuit': Collecting and Exhibiting African American Art

One of the major difficulties encountered by critics of African American art is not only short-sighted criticism but also the underfunding, margin-alisation and exclusion of artworks and artists from white mainstream galleries and museums. As contemporary African American artist, Howardena Pindell asserts, 'The artworld does not want artists of color to be full participants' (in Sims, 1997: ix). Similarly, Greg Tate insists that the 'world of the "serious" visual arts' is nothing less than 'a bastion of white supremacy, a sconce of the wealthy whose high-walled barri-cades are matched only by Wall Street and the White House and whose exclusionary practices are enforced 24-7-365' (Tate, 1992: 234). In the 1980s and then again in the 1990s, Pindell was so angered by these injus-tices that she undertook a monumental study of the racist practices of major public and private galleries in the United States. Her research immediately proved that the white mainstream art world represented a 'closed circuit' which denied access to 'artists of color's activities and achievements' (in Sims, 1997: 7). She found that 'the "mainstream" art world continues to exclude people of color ... They do not state it, they practice it. The public sector is even craftier and will state that they do not discriminate and will roll out the word "quality"' (Ibid.: 16).

One of the key ways in which African American artists have been excluded and erased from major art exhibitions has been by nefarious attempts to evoke seemingly universal standards of 'quality' which purport to be neutral but are, in fact, ideologically charged and racially circumscribed. By adopting narrow, problematic and ignorant approaches to African American art, numerous mainstream curators and gallery owners have repeatedly been responsible not only for the neglect of major artists but even for the dismissal, if not complete loss, of important artworks. David Driskell convincingly explains the inequalities facing black and white artists on the grounds that, 'when a white image is depicted by white artists, mainstream critics ... see it as a universal or genre image, but when a black image is depicted by blacks, it is thought to be ethnic or more threatening than universal' (Driskell, 1995: 11). Even more worryingly, in cases where African American artists are included, as Pindell notes, the 'artworld will focus on one or two tokens, for an instant, then pull back, feeling they have "done their duty"' (in Sims, 1997: 18). African American painter, Jacob Lawrence, is one of many artists to admit that 'none of us wants to be selected as "the one and only"' (in Bearden, 1969: 246). Worse still, many of those who have chosen to commission, fund and exhibit African American art have done so on the assumption that it is possible to recognise an artist's racial identity simply from his or her choice of subject matter or formal approach. As Maurice Berger writes, the 'idea that black artists can produce work that is not visibly black offers a great point of resistance for white historians, curators and critics' (Berger, 1994: 154).

This situation presents a major stumbling block for African American artists who push the boundaries of formal experimentation to create abstract works bereft of an instantly recognisable, explicitly racialised content. And yet, this is no less the case for those whose works may appear to present straightforward themes related to African American experiences but which, in fact, also signify on other, less obvious, levels. As Tate argues, 'It is easier for a rich white man to enter the kingdom of heaven than for a Black abstract and/or Conceptual artist to get a one-man shown in lower Manhattan' (Tate, 1992: 234). In the same way that black writers have had to fend off attempts by white editors and publishers to control the stories they wish to tell, for African American artists, the fight for the right to create artworks which do justice to their aesthetic imagination is far from over. For bell hooks, 'as more white producers and consumers traffic in the commodification of blackness',

there can be little doubt that 'issues of cultural appropriation, ownership, and authenticity come to the fore' (hooks, 1995: 12).

While African American artists suffer overwhelming neglect in major American art exhibitions and museums, underfunded curators of collections in Historically Black Colleges and Universities and privately owned galleries undertake Herculean labours to fund, preserve and exhibit their work. As a result of research visits to the United States, I soon realised that it was outstanding black-owned public institutions such as Hampton University, North Carolina Central University, Maryland University, Fisk University, Atlanta University, Howard University and the Studio Museum in Harlem, as well as private galleries including Kenkeleba House, the June Kelly Gallery and the Bill Hodges Gallery, which have single-handedly sustained an African American tradition of visual arts. It is hardly surprising that their economic survival is far more uncertain in comparison with the majority of white-owned organisations. As Pindell asks, '[W]hy are institutions that are run by people of color put in the position of lobbying year after year for dwindling funds and constantly scrutinised?' (in Sims, 1997: 16). These problems confirm the ongoing relevance of abstract African American painter Sam Gilliam's rallying cry of the 1960s that '[w]e need more black owned art galleries' (in Bearden, 1969: 254).

The difficulties African American artists face in the struggle to obtain freedom of expression and secure funding and exhibition space for their work reflect back on the unresolved problems within existing scholarship. Writing a little over a decade ago, Kobena Mercer asserts that the ways in which public access to African American art and artists is 'rationed by the effects of racism' guarantee that critics will 'be constantly reinventing the wheel when it comes to black arts criticism' (Mercer, 1994: 236). He shows how the 'intrinsic aesthetic qualities' of black art are soon discounted in favour of examining the 'curatorial principles' and 'extra artistic issues concerning race and racism' (Ibid.: 233–4). In this book, I take account of these issues by arguing for the necessity not only of examining artists' works in light of their aesthetic practices and thematic interests but also in relation to the output of other African American artists working across a range of movements and time frames. By exploring the range and depth of the African American visual arts tradition, I intend to guard against tendencies to over-aggrandise 'extra artistic issues' and 'curatorial principles' to the exclusion of a close examination of the works themselves.

Refusing to surrender to white mainstream racism, many artists share Pindell's view that they must 'organise and work together' to prove, once and for all, that the 'visual arts are not a "white neighbourhood!"' (in Sims, 1997: 19). In recent times, many contemporary and emerging artists have become even more disillusioned. Deciding to turn their backs on the traditional gallery space entirely, they favour internet sites, street installations and performance pieces which are not at the mercy of white patronage and funding. They work on the same basis as David Hammons who admits, 'I'm not aligned with the collectors or the dealers or the museums' because 'I see them all as frauds' (in Berger, 1993: 176).

Mapping the Tradition: Narrative, History and Experimental Aesthetics

For many critics, the terms 'African American art' and 'black art' generate anxieties by leaving writers and critics wide open to charges of essentialism and segregation as they attempt to map new critical approaches to works by black artists. As Powell insists, critics attempting 'to define "African-American art" offer an empty term' given that 'its use as a tool of visual segregation attests to its hollowness' (Powell, 1994: 228). Similarly, Driskell argues that, whatever term we use, the 'most crucial issue will always be the quality of the work and its relevance to the society in which it was created' (Driskell, 1976: 11). He voices the opinion of many African American artists when he asserts that art 'knows no racial boundaries. It is ultimately a universal language of form, a visual dialogue about man's cultural history' (Ibid.). These concerns are valid and the terms 'African American art' or 'black art' do run the risk of over-essentialising and artificially setting works apart according to racialised lines, particularly given that many artists are heavily influenced by and, in turn, had their own impact upon, mainstream white American and European art movements.

However, I would argue that a case can be made for focusing solely on African American artists on the grounds that black artists not only had a profound influence on one another but also that their works betray a shared commitment to the search for a new visual language within which to represent personal and public narratives and histories related to African American life. I share Judith Wilson's view that it is possible 'to find a U.S. black aesthetic or an African-American aesthetic' in works by black artists, given that these terms begin to move us away from biological essentialism to suggest 'geographical, historical, or political catego-

ries' instead (Wilson, 1990: 25). In my readings of works by specific artists, I support Gen Doy's claim that 'specific themes and issues' remain 'embodied in the works of black artists and black visual culture', including 'history, memory, belonging and identity' (Doy, 2000: 3). As contemporary photographer, Roy DeCarava asserts, 'the black artist looks at the same world in a different way than a Euro-American artist' because '[h]e has a different agenda' (in Miller, 1990: 847). DeCarava is only one of many artists to argue that the 'black aesthetic is something that grows from our culture, from our experience that makes us see differently, feel differently' (Ibid.: 857).

In the first chapter of this book, '"The Slave who Paints": Beginnings and the Visual Arts Tradition', I explore the origins of African American art in the pottery, daguerreotypes, quilts, marble sculptures and paintings of Dave the Potter, James P. Ball, Harriet Powers, Edmonia Lewis and Henry O. Tanner. Contrary to the majority of critics who focus exclusively on the twentieth- and twenty-first centuries, African American art history began in 1619 with the arrival of the first Africans into Virginia. These early artisans provided a potent legacy for later artists in their fight for the right to aesthetic experimentation and insistence on the 'power of creative will over forces of destruction' (Thompson, 1983: 58). By improvising out of necessity and as a result of preferred artistic design, works by early artisans such as Dave the Potter and Harriet Powers shed light on the experimental practices of later artists such as William Edmondson, Romare Bearden and Betye Saar who have since experimented with cast-off materials to produce collages and sculptures from fragmented scraps and discarded objects. Similarly, the murdered black bodies of James P. Ball's early daguerreotypes resonate with scenes of urban rioting which appear in later photographs by Gordon Parks. This is no less the case for Edmonia Lewis's sculptures and Henry O. Tanner's paintings which paved the way for later artists such as Hale Woodruff and Elizabeth Catlett in their exploration of a mythic Africa, a history of slavery and rural poverty.

The reawakening of black visual arts in the 1920s is the subject of Chapter 2, '"Establishing an Art Era" in the Harlem Renaissance', which focuses on works by Aaron Douglas, Archibald J. Motley, Jr and Charles Alston. In their murals, portraits and abstract canvases, these artists celebrate a romanticised Africa and represent African American blues and jazz musicians and performers. They explore themes of ancestry, memory, folklore and a history of slavery by experimenting with colour

and composition in the search for new forms. Aaron Douglas's geometric shapes, stylised figures and monumental visual narratives examine the effects of slavery, racism, poverty and labour. In his paintings, Archibald Motley experimented with portraiture to resist racist stereotyping, at the same time that he produced crowded night scenes revelling in black working-class life to protest against class biases within African American art. Finally, Charles Alston visualised the jazz and blues singers of Harlem alongside Civil Rights protesters and brutalised black bodies to reinforce the relationship between black aesthetic experimentation and political resistance in his canvases.

Chapter 3, 'Struggle, Survival and Early Abstraction', examines the ways in which self-taught artists William Edmondson, Horace Pippin and Jacob Lawrence complicated the tendencies towards exoticism and exaggeration in the paintings of earlier artists such as Douglas and Motley. All three artists relied on abstract experimentation to challenge audience assumptions and address contemporary struggles. An ex-slave, William Edmondson turned to art late in life as he became a sculptor of tombstones, animals and everyday community figures which he then sold to members of the black community. A World War I war veteran, Horace Pippin has not only left behind his handwritten memoirs but also large numbers of thickly textured oil paintings dramatising military conflict, black domestic life and heroes from slavery. Perhaps the most famous twentieth-century African American artist, Jacob Lawrence experimented in his epic narrative series with the relationship between text and image to examine issues surrounding slavery, heroism, migration, labour, segregation, civil rights, racism and representations of the black body.

Art which takes to the streets is the focus of Chapter 4, '"Images Are Weapons": History, Narrative and a People's Art'. In their drawings, prints, murals, photographs and sculptures, Charles White, Elizabeth Catlett and Gordon Parks debate the difficulties of reaching audiences across the African Diaspora and contributing to their 'aesthetic development'. While Charles White's drawings and murals indict contemporary injustices by returning to scenes from African American history, Gordon Parks's highly aestheticised and symbolically laden black-and-white photographs capture the terrors of southern share-cropping and the suffering of northern factory workers. Both White and Parks address themes of heroism and civil rights alongside taboo topics of unemployment, domestic violence, alcoholism, urban rioting and street gang culture. By comparison, Catlett's prints and sculptures have continued

to push aesthetic boundaries to fight for black 'women's liberation' by examining themes of black female survival through resistance, labour and creativity (in Lewis, 1984: 102). Her black marble, terracotta, bronze and cedar sculptures not only celebrate mother and child relationships but also provide groundbreaking explorations of the black female nude. Chapter 5, '"Art comes to have a life of its own": Aesthetics, Experimentation, and a New Visual Language', takes up where Chapter 4 left off. Norman Lewis, Romare Bearden and Betye Saar ripped up documentary photographs, recycled found objects and experimented with abstraction in their canvases, collages and assemblages. The ambiguous and elusive paintings of Norman Lewis reinforce his conviction that solutions to racist injustice emerge from aesthetic accomplishments rather than the expression of a radical social and political consciousness. Romare Bearden experimented with collaging techniques to create photomontage projections from fragments of cloth, photographs, paintings and torn papers. His inspiration came from nineteenth-century slave quilters by adopting a similar practice of working with found materials in an art of improvisation. Still working today, Betye Saar relies on found objects to create multimedia assemblages, accumulative sculptures, altars, boxes and installations which explore themes of family, romantic love, memory, history, autobiography, ancestry, racism and stereotyping. In their works, Lewis, Bearden and Saar experimented with paint, found objects, and photographic fragments to break free of existing traditions and stake their claim to formal experimentation.

Controversy and taboo are the most important concerns of the concluding chapter, '"Racist Pathology is the Muck": Towards a Transgressive Visual Poetics', which examines the installations, paintings and performance art of David Hammons, Howardena Pindell and Kara Walker. With his bottle trees, basketball totems, hair rocks and snowball sales, David Hammons is the only street artist I discuss in this book. In the 1970s, he made prints with a short shelf life by greasing his own body to contest popular caricatures and explore themes of invisibility and erasure. Similarly, Howardena Pindell continues to rely on the outline of her own body to remember untold histories of female slave abuse, violation and resistance. She has even gone as far as drenching some of her canvases in her own blood. More shockingly still, Kara Walker has revived eighteenth-century silhouette portraiture to create horrifying sexual-scapes of colliding, exploding and procreating black and white bodies which tear apart popular myths of master-slave relationships.

Finally, in the epilogue, 'A solitary body wrapped in canvas', I gesture towards twenty-first century directions for African American arts by summarising works by recent artists such as Jefferson Pinder, Kerry James Marshall, Michael Ray Charles, Laylah Ali and Renée Cox.

The Enslaved Body, Spectacle and Resistance in *From Here I Saw What Happened and I Cried* (1995–6) by Carrie Mae Weems

Carrie Mae Weems's photographic print series, *From Here I Saw What Happened and I Cried* (1995–6), introduces a number of the themes which appear repeatedly in this book. The majority of African American artists are similarly preoccupied with narrative, aesthetic experimentation, racist iconography, representation, autobiography, ancestry, witnessing, memory and identity in their works. With very few exceptions, many artists share her fascination with the '"tangled web of history ... the rough edges, and the bumpy surface, the mess just beneath the veneer of order"' (in Patterson, 2000: 78). Whether they reveal, hide, signify upon or resist the 'mess just beneath the veneer of order', countless African American artists experiment with ways to weave webs, unravel tangles, negotiate the rough edges and probe beneath the bumpy surfaces. They repeatedly examine aesthetic issues at the same time as they explore tensions of race, class, gender and nationality in their works.

'YOU BECAME A SCIENTIFIC PROFILE'. 'A NEGROID TYPE'. 'AN ANTHROPOLOGICAL DEBATE'. '& A PHOTO-GRAPHIC SUBJECT'. Carrie Mae Weems sandblasts this text on to the glass surfaces of four prints in her recent series, *From Here I Saw What Happened and I Cried* (1995–6). Weems's haunting late twenti-eth-century images of naked and scarred black women and men have their origins in a series of 'slave daguerreotypes' produced over one hundred and fifty years ago. In 1850, European scientist, Louis Agassiz, commissioned white American daguerreotypist, Joseph T. Zealy, to create fifteen views of seven slaves belonging to different tribal groups in Africa. These images are all that are now left of the lives of Alfred from the Foulah tribe, Jem from the Gullah, Fassena from the Mandingo and two sets of fathers and daughters, Jack and Drana from the Guinea and Renty and Delia from the Congo, all of whom were kidnapped or born into slavery in the American south. Mired in a nineteenth-century visual language of scientific racism, the black, white and grey textures of these original silver plates illuminate the lines, scars, bones and veins

of these women and men. Just as they provide intimate views of their physiognomies, musculature and genitalia, these images tell us nothing concerning the untold lives of these enslaved Africans. Zealy adopts an anthropologist's eye to show Alfred, Jem, Fassena, Jack, Drana, Renty and Delia from different angles, in long and short view, in profile and full frontal, to satiate audience demands for the graphic display of black bodies. As Brian Wallis writes, Agassiz's aim was not to individualise but to 'analyze the physical differences' of racial types and 'prove the superiority of the white race' (Wallis, 1995: 40). By experimenting in these works, Weems negotiates the 'problem of a white-dominated art world that does not usually conceptualize blacks as visual producers', as well as a historical and political context by which black bodies were raped, sold and denied agency under slavery and segregation in the United States (Wallace, 2004: 186).

In these prints, Weems confronts this shocking and abusive history by drenching the bodies of Jack, Drana, Renty and Delia in an ethereal blood-red glow, at the same time that she inscribes white slogans across their chests. She thwarts voyeuristic inspections of her enslaved subjects by typing 'AN ANTHROPOLOGICAL DEBATE' over Jack's body, just as she inserts '& A PHOTOGRAPHIC SUBJECT' over the body of his daughter, Drana. Similarly, Weems decorates Renty's body with 'A NEGROID TYPE' while across his daughter, Delia, she states, 'YOU BECAME A SCIENTIFIC PROFILE'. Weems's symbolic use of colour in a red filter, white inscriptions and a black telescopic frame appropriates racist imagery and discourse to problematise their objectivity and contest their accuracy. By juxtaposing text and image, she shows how a twentieth-century African American female artist can subvert, destabilise, and negate nineteenth-century white male racist iconography. Weems's blood-soaked prints indict racist objectifications of black women and men as if they were no more than a 'scientific profile', a 'Negroid type or a 'photographic subject'. She exposes a problematic visual history within which black bodies have been subjugated, violated, marginalised and even erased by white mainstream culture. Weems's works also critique a tradition within which popular and scholarly representations objectify black women, men and children as scientific specimens, political touchstones and voyeuristic spectacles for white entertainment. Her decision to imprint poetic text on to the bodies of Jack, Drana, Renty and Delia subverts a history within which slaves have been physically branded and abused. By superimposing racist text on to problematic images,

she opens up a new space within which to re-imagine otherwise elided African American narratives, histories and experiences. As she admits, 'I also insert myself as the narrator of history' (in Patterson, 2000: 79).

Collectively titled, *A Negroid Type / You Became a Scientific Profile / An Anthropological Debate / & A Photographic Subject*, works such as these take critics to task for interpreting the original images of Jack, Drana, Renty, and Delia as 'detached, unemotional, and workmanlike' and as confronting the viewer with 'faces like masks' (Wallis, 1995: 40). While all four black individuals may have come to life in images in the service of scientific racism, they differ from popular representations of African Americans as victimised slaves begging for liberty or powerless pieces of property waiting to be bought or sold. Either standing erect or seated, their contemplative expressions, thoughtful eyes, furrowed brows and closed mouths accentuate rather than detract from their emotional forcefulness by directly confronting the viewer. Given the intricacy of these daguerreotypes which not only show up every scar but communicate every detail of each face, the hidden lives of Jack, Drana, Renty and Delia hover just beneath the surface. For viewers not blinded by racist expectations, they tell tales of slave sorrow and humanity through the expressive individualism of their eyes and the forcefulness of their gaze.

Weems's red filter and circular cropping of full frontal images of Jack, Drana, and Renty in *A Negroid Type / You Became a Scientific Profile / An Anthropological Debate / & A Photographic Subject* blur anatomical details to reinforce their latent subjectivity and draw attention to their expressive yet enigmatic faces. Even Delia who is shown only in profile gains heightened dignity in Weems's hands. While her newly inserted text partially covers Delia's breasts, she crops this image to conceal her half-removed dress and thwart audience tendencies towards voyeuristic viewing of the half-naked slave woman's body. As Wallis argues, Weems 'saw these men and women not as representatives of some typology but as living, breathing ancestors. She made them portraits' (Ibid.: 59). In these prints, Weems's two sets of fathers and daughters testify to an African tradition of resistance by showing the failure of white attempts to destroy black familial bonds.

Regarding their wider implications for an African American arts tradition, Carrie Mae Weems's prints signify upon a popular tendency among artists to revisit historical daguerreotypes, illustrations and drawings in their works. By returning to eighteenth- and nineteenth-century racist iconography, they frequently juxtapose fragments of texts with haunting

imagery to contest problematic representations of victimised, passive and brutalised African American bodies. Many artists recycle artefacts and images to create new and enigmatic art objects characterised by a visual poetics of resistance. For the majority of African American artists working across the centuries, their experimentation with a new and alternative aesthetic language reflects an ongoing search for agency.

'The Slave who Paints': Beginnings and the Visual Arts Tradition

Dave the Potter – James P. Ball – Harriet Powers –
Edmonia Lewis – Henry O. Tanner

Alain Locke argues that a full history of African American art would see the 'Negro ... gradually evolve from the white-wash pail and brush to the painter's brush and palette and from the jack-knife and whittle-stick to the carver and the graver's tools' (Locke, 1936: 5). However, Locke's comment barely scratches the surface when it comes to examining the experimental features of an African American visual arts tradition which began with the arrival of enslaved Africans during the sixteenth, seventeenth, eighteenth and nineteenth centuries. Despite the gaps caused by missing artefacts and incomplete records, early artisans experimented in the arts to counter white racist legislation inscribing black bodies into law as objects to be bought and sold. While many early artists, enslaved and free, may not have seen themselves as artists or even have self-consciously been engaged in producing art, their quilts, paintings, pots, musical instruments, sculptures, daguerreotypes and religious objects played a fundamental role in the creation of an African American visual arts tradition. Irrespective of the conditions of their creation or the intentions of the artist, these works helped to establish African American subjectivity in the face of 'an unrelenting and generally contemptuous objectification' (Wallace, 2004: 186). Moreover, the existence of these artefacts and art objects proves that many enslaved and free women and men were in search of ways in which to express their subjectivity, beyond the dehumanising effects of soul-destroying labour. In this chapter, I focus on five nineteenth-century artists – Dave the Potter, James P. Ball, Harriet Powers, Edmonia Lewis and Henry O. Tanner – to examine their developments in forms as diverse as pottery, daguerreotypes, quilts, sculpture and painting.

Before going into any depth on these specific artists, this chapter opens

by outlining some of the discoveries made in recent archaeological excavations. Although handed down to us only in unsatisfying glimpses, the artefacts unearthed at these sites prove that a rich legacy of African and African American visual arts existed in the early period. By getting to grips with the lost histories of artists for whom neither names nor works have survived, we can begin to question assumptions such as Locke's that '[s]lavery not only physically transplanted the Negro' but also 'reduced him to a cultural zero', as well as Cedric Dover's statement that slaves 'produced no surviving art' (Locke, 1936: 2; Dover, 1960: 13). We can also start to challenge claims made by twentieth-century black artists such as Aaron Douglas who believed that it was 'just as difficult for an enslaved people or an impoverished people, to produce great art as it was for a "camel to go through the eye of a needle"' (*ADP* 4520, Douglas, 'The Negro Too in American Art', November 1948: 6). 'When we realise that a hundred years intervened between the first works of these metal craftsmen and the emergence of the first named artist,' he observed, 'we can form a picture of the great waste of our artistic inheritance' (Ibid.).

Any research into African American artists living and working before 1900 proves that these years were far from 'wasted'. On the contrary, evidence suggests that vast numbers of enslaved Africans became experts in countless professions following their arrival into the Americas and enforced deportation from diverse tribal groups and regions. Enslaved and free women, men and children drew on knowledge gained in Africa and the Americas to become quilters; dressmakers; potters; sculptors; daguerreotypists; printers and engravers; portrait, landscape and religious painters; ironworkers; carpenters; blacksmiths; silversmiths; musicians and much more. Even the most utilitarian artefacts became art under their expert hands as they decorated and embellished everyday objects to challenge their mundane status. As African American artist, Romare Bearden, asserts, 'As soon as they had an opportunity ... black artisans and craftsman [sic] in this country, showed they could add artistic charms to function' (*URBP*, Bearden, 'The Black American', n.d.: 1). Even Aaron Douglas was forced to admit that the eighteenth-century ironwork wrought by slaves represented an 'eloquent manifestation of the potential skill, intelligence, and sensitiveness of artistic expression possessed by the African people prior to their Europeanisation' (*ADP* 4520, Douglas, 'The Negro Too in American Art', November 1948: 6). Ongoing discoveries by archaeologists and researchers leave us in no doubt that early artisans created art objects and artefacts to keep their

oral traditions alive and defend their right to an aesthetic imagination. As
Robert Farris Thompson demonstrates, cut adrift in a 'hostile white sea',
they preserved a distinct cultural identity despite white attempts to deny
African and African American creativity (Thompson, 1983: 28).

Archaeological Discoveries: Burial #340 and the *Iron Man*

One reliable source for tracing the hidden tradition of black art has
emerged not from research within Art History or African American
Studies but from recent discoveries by archaeologists excavating
plantation sites and black settlement areas across the United States. A
case in point is the unearthing in 1991 of the African Burial Ground
in downtown New York. The artefacts discovered on this once sacred
ground offer further proof that African artistic practices and cultural
rituals survived their transportation in the suffocating holds of European
slave ships during the Middle Passage. These remains demonstrate that
men and women fought hard to preserve their cultural legacy and resist
captivity, not only on board but upon their arrival into the Americas. At
this site, hundreds of skeletons were found facing east towards Africa.
Large numbers of female remains were discovered still decorated with
necklaces and waist adornments made from brightly coloured beads
which must have been carried from West Africa. These discoveries make
it impossible to doubt that these African bodies were buried according to
non-European cultural practices. The grave of one unnamed woman in
particular, poignantly known only as Burial #340, includes a 'strand of
about 111 waist beads' consisting of cowrie shells as well as glass and
amber beads (Hansen and McGowan, 1998: 41). This discovery was
remarkable because '[n]o burial had ever been found in North America
with beads used in this way' (Ibid.). Instead, these beads are known to
have been popularly used in West Africa in rituals of 'birth, marriage
and death' as mourners believed that they could 'help the individual
make the journey into the afterlife' (Ibid.). Other archaeological finds
have shown that 'blue beads' are 'disproportionately present on African-
American sites in the Southeast' (Thomas, 1998: 545). Brian Thomas has
gone so far as to suggest that these blue beads had a symbolic signifi-
cance in associations with 'good luck' and, as such, reveal that a 'shared
belief system' existed among African Americans from the early period
onwards (Ibid.: 546).

Other excavations have unearthed sculptures such as the late
eighteenth-century *Iron Man* found hidden under a blacksmith's cabin

floor in the American south. This work is wrought in an abstract-figurative style and represents a male figure with elongated limbs and barely delineated facial features. For scholars such as Elsa Honig Fine and John Vlach, this artefact proves that a 'transplanted style' existed between Africa and the Americas (Fine, 1973: 14). More specifically, Vlach argues that this 'minimal image' resonates with the 'wrought iron sculpture of the western Sudan' (Vlach, 1991: 26). Hidden treasures such as decorative jewellery used in burial rites and iron figures stowed under cabin floors testify to the creolisation of cultures. This evidence points to the fusion of African, European and American forms which suggests that aesthetics practices were 'continuously transformed by intercultural contact' (Landsmark, 1998: 277).

In contrast to the vast majority of early utilitarian and decorative art by enslaved Africans, the concealed location of the *Iron Man* shows that it was not produced for white buyers who exacted a 'consumer's approval over the forms and styles produced by these black artisans' (Ibid.: 272). Similarly, the burial of African bodies according to indigenous religious beliefs resisted the cultural norms of Europeans and their repeated preference for denying black bodies any ceremonial rituals or grave markings. For Sharon Patton, the unearthing of objects such as the *Iron Man* proves that 'Africans or African-American slaves sometimes commissioned works' (Patton, 1998: 48). This discovery is vital to the history of African American art in light of struggles by twentieth-century African American artists to reach a black patronage class. The possibility, however remote, that African Americans, even as slaves, could have been commissioning artworks suggests that a vigorous black visual arts tradition may have existed prior to white demands and long before black patronage of the arts in the 1920s.

At various other sites and in addition to the discoveries of burial grounds and works of abstract-figurative sculpture, archaeologists have unearthed an array of artefacts ranging from the self-explanatory to the enigmatic and unfathomable. Their finds include marbles, buttons, buckles, beads, cloth fragments, drums, grave-markers, pottery, tools, weapons, utensils, baskets, clay pipes, harmonicas, iron figurines, hand charms, ritual burial remains, conjurors' kits, bells and even inkwells. As Camilla Cox observes, the recovery of these objects not only allows us to begin to 'trace more fully the transformation of West African cultural traditions in the American south' but also helps to fill in the gaps concerning the lives of those African Americans who are without

a written legacy (Cox, 2006: 1). While the legally enforced illiteracy among many African Americans and the poor record-keeping and racism of Europeans and European Americans may have succeeded in leaving vast numbers 'unnamed to history', this does not mean the 'typical Negro hand' was reduced to a 'gnarled stump' (Porter, 1942: 14; Locke, 1936: 3).

On the contrary, as Regenia Perry argues, the 'process of acculturation enforced by slave owners was far from successful' (Perry, 1989: 35). Similarly, John Vlach's hunt for evidence of African influences in African American art has shown that an 'Africanism is not an isolated cultural element but an assertive proof of an alternative history' (Vlach, 1991: 2). His conviction that, unless we realise that early artisans possessed an 'improvisational aesthetic', we run the risk 'of mistaking imagination for error, variation for imprecision' must be taken into consideration when analysing these artefacts (Ibid.: 5, 6). In particular, he establishes the importance of a legacy of improvisation which has crossed over from the early period to become fundamental to African American art produced in the late nineteenth and throughout the twentieth and twenty-first centuries. Ultimately, both the range of these works and their aesthetic and thematic continuities with later artists prove the 'ability of the condemned slave' to show that 'his heart though burdened could still sing' (Porter, 1942: 14).

The evidence provided by these remains confirms that slaves possessed conjurors' kits, enacted ritual burials, kept hand charms, carved wooden statues, made musical instruments and sculpted iron figurines. Archaeological findings leave no doubt that African spiritual beliefs, aesthetic interests and cultural practices survived the journey to the Americas. For example, the remains of drums and harmonicas reveal that African musical influences became an important part of community life. Slave ownership of weaponry further challenges myths of black passivity and assimilation by revealing the inheritance of warrior knowledge among many tribal groups. The cloth pieces, buttons, buckles and beads celebrate African American resistance through dress. Equally, the discovery of inkwells shows us that literacy was far more widespread than a history of exceptional slave narrative survivors would have us believe. While it may be relatively straightforward to recapture the lives of fugitive slave writers such as Frederick Douglass and Harriet Jacobs who have left behind their narratives, it is far more difficult to re-imagine the daily lives of those who lived and died in the antebellum south.

Dead men may tell no tales but they may leave behind clues buried under cabin floors. As the unearthing of sculptures such as the *Iron Man* has shown, 'slave cabins' which had 'secret cellars' were a common feature of early African American architecture (Ferguson, 1992: xxxvi). These hidden areas were storage hotspots which often contained 'coins, usable tools, imported ceramics, and discarded food bones' and proved that 'slaves found a way to assert their culture' in the face of great obstacles (Ibid.: 58). These archaeological treasure troves validate James Porter's claim that the 'creative "folk culture" of the Afro-American began in this country much earlier than many would surmise' (Porter, 1967: 7). These findings also prove that the enslaved African did 'introduce certain assimilable as well as ineradicable traits of African culture into the total fabric of American culture' (Ibid.). Thompson's research goes even further by tracing call and response patterns of exchange within a Diasporic African Atlantic tradition. In particular, he shows how the 'rise, development, and achievement of Yoruba, Kongo, Fon, Mande, and Ejagham art and philosophy fused with new elements overseas, shaping and defining the black Atlantic visual tradition' (Thompson, 1984: xiv).

In light of their experimental features, recurrent themes and hidden meanings, enslaved and free African artists have had a far-reaching impact on the African American arts tradition which has developed in the twentieth and twenty-first centuries. And yet their works have also raised difficulties for historians, critics and even other artists. For Alain Locke and Elsa Honing Fine, it was a problem that early black artists avoided the 'Negro subject like the black plague itself' and 'shunned Negro subject matter' (Locke, 1936: 10; Fine, 1969: 33). Similarly, Samella Lewis criticised their works because they 'contributed little to the development of a consciousness of ethnic expression' (Lewis, 2003: 57). Her disappointment that they 'generally avoided African American themes' has encouraged contemporary artist, Faith Ringgold, to dismiss their work for having 'no connection with Black people' and 'no vision of anything that had their image' (Lewis, 2003: 23; in Graulich and Witzling, 2001: 198). These opinions have also found unlikely endorsement from James Smalls who has conceded that they were 'restricted in what they could depict and how racial subjects could be represented', which meant that they created artworks 'partially based on pathos, self-doubt, the need to "sell" a product (i.e. race), and classism' (Smalls, 1994: 4). Although Smalls is right to suggest that early black artists were 'restricted' and plagued by 'self-doubt', his interpretation risks detracting

attention from the all too frequently overlooked formal features of their works. Far too little attention has been paid to the ways in which African American artists often played with patron and even audience expectations to subvert, resist and signify upon the difficulties presented by racist contexts and conditions of enslavement.

The artefacts and art objects of early enslaved and freed artists working and living in the United States are far more complicated and ambiguous than they first appear or than many critics would have us believe. Nineteenth-century quilters may not have included overtly 'Negro subject matter' but many designed abstract geometric patterns which became codes used to assist fugitive slaves escape via the Underground Railroad or ad hoc network of safe houses by which fugitive slaves escaped to freedom in the nineteenth century. Certainly, Harriet Powers's quilts are crammed full of abstract-figurative motifs which suggest a vast repertoire of symbols and culturally relevant events, the full extent of which we have yet to grasp. Equally, slave pots and figurines from the early period may not overtly reference an African heritage but this does not prevent them from engaging with political issues. For example, critics argue that the physiognomy of one wooden figure represents George Washington, famous emancipator of slaves on his death, while Dave the Potter's works include poetic couplets which rely on literary imagery to discuss slavery, the government and religion.

Turning to early forms of photography, many of James P. Ball's daguerreotypes celebrating the prosperity of rich whites also document members of the artist's family, slave leaders and murdered victims. In terms of the fine arts, nineteenth-century painter, Henry O. Tanner, completed numerous portraits of black everyday life and heroism, despite being more widely known as a painter of religious scenes, while even Edmonia Lewis's allegorical sculptures of religious figures and classical myth reverberate heavily with themes of race and gender oppression. Just as twentieth- and twenty-first-century artists battle for recognition as artists rather than social commentators and political activists, the early art of their enslaved and free forebears was equally characterised by formal experimentation in a powerful act of cultural resistance. Given a history of political disfranchisement and racist exclusion, their engagement with formal issues was often the only way in which these early artists could negotiate the 'problem of a white-dominated art world that does not usually conceptualise blacks as visual producers' (Wallace, 2004: 186). Their determination to subvert the demands of white patronage and

resist racist censoring of their works has resulted in slippery art objects which may include no overt 'ethnic expression' but which have helped to lay the foundations for an African American visual arts tradition.

Dave the Potter and Afro-Carolinian Face Vessels

'Dave belongs to Mr. Miles/wher the oven bakes & the pot biles'

African American slave potters improvised out of necessity by creating artworks out of otherwise utilitarian objects. Early artisans were forced to work with the materials provided by white masters and create objects in compliance with their demands. Their success in carving out a space for their own artistic agency in spite of these difficulties establishes connections between art, political protest and an oppositional aesthetics which continue on into the twentieth and twenty-first centuries. The most famous potter of the nineteenth century is a slave known only to the official records as 'Dave'. The fact that we are not even sure of his last name, although recent scholarship suggests it may have been 'Drake', resonates with ambiguities surrounding the birthdates and biographies of many black artists. Similarly, perhaps the most original surviving artefacts in this period are the Afro-Carolinian face vessels. While we have no idea concerning the identity of these slave creators, enigmas remain surrounding their origin, imagery and purpose. These incomplete records highlight the difficulties in researching early African American artisans and leave us wondering how many more are simply lost to history.

Dave the Potter (c.1780–1863)

'I made this jar for cash/ Though its called lucre trash' (22 August 1875) (in De Groft, 1998: 251). Dave the Potter's legacy consists of over one hundred 'great and noble' jars fired to store food in southern plantations (Ibid.: 250). These large works can be identified via their decorative rims, incised and arched handles and rich brown and grey glazes of glossy textures. However, the poetic couplets etched on to the glazed surfaces of these pots are far more astonishing than their epic size. As Aaron De Groft argues, these 'usable' artefacts became 'vehicles of covert, yet overt, protest in that Dave not only signed and dated his creations but also incised verses into his pieces' (Ibid.: 249). Dave's opening couplet reveals that he created these works out of economic necessity – 'I made this jar for cash' – at the same time, however, that his hatred of 'lucre trash' registered his rejection of his status as a slave

available for purchase. Dave's inclusion of poetry on objects destined for use by enslaved labourers challenged their status as domestic artefacts. In his gifted hands, they became works of art and touchstones of protest. These works testify to Dave's 'attempt to communicate', given that he was 'creating an audience and teaching slaves to read' in fearless opposition to South Carolina laws banning slave literacy (Ibid.: 255). As Cox argues, 'Dave's use of the poetic form' created a 'legitimate cultural space from which to articulate and inscribe a valid and practicable sense of self' (Cox, 2006: 8).

Dave's highly visible poetic lines which he commonly situated near the rim of his jars mitigated against dehumanising drudgery to argue for the right of the black slave to an artistic identity. His pioneering practice transformed his status from dutiful slave potter to radical poet and loose cannon capable of advocating resistance under the master's gaze. These pots which were made to store food would have been used by slave labourers far beyond the eyes of white masters. In this context, a seemingly innocuous utilitarian and domestic object became a statement not only of artistic independence, given that Dave claimed ownership by signing these works, but also of radical protest. Dave's success in spreading literacy and incendiary politics in the heart of the slaveholding south during a period of black subjugation mirrors the works of slave quilters who developed coded patterns by which to assist slave runaways in their escape north. In an era of slavery and black cultural annihilation, early African American artists improvised with existing materials to argue for the right to create art out of everyday artefacts. Their technique of indirect artistic expression should signal caution to audiences otherwise tempted to see only abstractly patterned quilts or glazed earthenware with no awareness of their hidden dimensions.

Dave's engraving of poetic text on jars 'appears to be unique in the history of pottery' (De Groft, 1998: 249). His couplets address common themes in African American visual arts including labour, history, slavery, identity, nationalism and religion. John Burrison's argument that most of Dave's couplets 'relate directly to the pots themselves' as they become 'integrated with their medium' overlooks how even his most descriptive couplets revel in his agency as an artist (Burrison, 1983: 339). These couplets not only offer advice concerning the use of his pots but also celebrate their 'greatness' and size – 'Great and Noble jar/ Hold sheep, goat, or bear' (13 May 1859) (in Patton, 1998: 64) and 'A very large jar which has four handles/ pack it full of fresh meats – then light candles'

(1858. Ibid.: 65). One of Dave's earliest inscriptions – 'Dave belongs to Mr. Miles/ wher the oven bakes & the pot biles [sic]' (31 July 1840) (in De Groft, 1998: 250) – is open to multiple readings. On the surface, these phrases communicate factual statements reflecting Dave's status as a slave and the purpose of his jar to assist in domestic chores. However, as a poet, he operated by understatement by leaving his declaration – 'Dave belongs to Mr. Miles' – unexplained on the grounds that his enslaved audience would have identified with his plight. His use of rhyming in 'Miles' and 'biles' questions the slave-owner's authority by associating him with the domestic chores undertaken by slaves on the plantation. Furthermore, the phonetic spelling of 'wher' and 'biles' highlights his use of an African American spoken vernacular to demonstrate the richness of a distinct oral tradition. Ultimately, Dave experimented with literary language on his pots to resist his chattel status.

While it is likely that Dave's intended audience was enslaved men and women, this may not be the whole story. Among his couplets are many which offer warnings including: 'If you don't listen at the bible, you will be lost' (25 March 1859. Ibid.: 256); and 'I made this Jar all of cross/ If you don't repent, you will be lost' (3 May 1862. Ibid.: 256). These lines are most likely to have been directed towards his black viewers to raise their religious awareness. However, as De Groft argues, these couplets no doubt refer to 'Christ's crucifixion and death for the sins of man' (Ibid.: 256). Could they, therefore, also have been intended as a warning to slaveholders? By associating the suffering of slaves with the crucifixion of Christ on the 'cross', might Dave have been taunting his white audiences with their sins? He may have been unafraid of whites seeing his poetry – particularly given their highly visible placement at the top of these jars – as he asked them to 'repent'. 'I made this Jar all of cross' not only highlights his artistic agency but the connotations of 'cross' align African Americans with Christian martyrdom. Dave's poetic couplets rely on irony and satire to generate thematic ambiguity. As Thompson sees it, parallels exist between Dave's poetry and early developments in black music. He argues that Dave placed 'the same rhyme' on 'more than one vessel', not only to betray his 'wit' but also to 'recall the sparing style of the three-line blues' (Thompson, 1983: 35). Dave's repetition with variation as well as his use of off-rhyme in 'cross' and 'lost' introduce jarring effects which complicate attempts to interpret his works. Moreover, he was not afraid to discuss American politics: 'The fourth of July is surely come/ to blow the fife and beat

the drum' (4 July 1859) (in De Groft, 1998: 251). The irony of Fourth of July celebrations of white freedom would not have been lost on Dave or his captive audience.

The impact of Dave's work arises in the jarring juxtaposition of poetic text with domestic artefact. His understated textual fragments contrast with his epic-sized jars to underscore the invisible and elided aspects of black narratives and histories. Viewers can immediately take in the enormity of his earthenware but they have to peer closer to unearth his buried text. Dave performed as an African American griot or storyteller whose work can be understood alongside later pictorial narratives by Harriet Powers, narrative series by Jacob Lawrence, photographic fragments by Betye Saar and photomontage projections by Romare Bearden. Samella Lewis claims that Dave's works got to the 'heart of community life' by representing 'images common to African American lives' (Lewis, 2003: 4). His inclusion of poetry 'hidden in plain view' educated his black audiences that it was possible to survive and resist cultural annihilation (Tobin and Dobard, 2000). Ultimately, Dave's ongoing sense of isolation which he admitted in couplets such as '"I wonder where is all my relation/ friendship to all – and every nation"' (16 August 1857) captures the struggles facing early black artists in their fight for an artistic identity and an audience for their works (in De Groft, 1998: 259).

Afro-Carolinian Face Vessels

'Grotesque'. 'Voodoo'. 'Monkey'. These words have been in popular use to describe the small jugs of between '4 to 9 inches' produced in a twenty year period between 1860 and 1880 and recently unearthed in South Carolina (Patton, 1998: 65). Thompson redesignated these artefacts 'Afro-Carolinian face vessels' because he was unhappy with their problematic associations (Thompson, 1983: 34). He describes these objects as 'stoneware vessels shaped in the form of a tormented human face' (Ibid.: 33). The majority of these works were produced during the American Civil War when a slaveholder ordered his 'Afro-American potters to fashion earthen jars, pitchers, cups, and saucers' (Ibid.: 34). By 1863, however, the 'slaves suddenly were fashioning on their own initiative small vessels with human faces on them' (Ibid.: 34). Thompson argues that these works were inspired by the eighteenth-century tradition of the English toby jug, representing a 'short, corpulent, grinning man', and Congo-Angola traditions of 'multiple media in figural sculpture' in their 'similar mixing of the white medium of kaolin

with darker glazed pottery' (Ibid.: 38, 39). These patterns of aesthetic influence transcend national borders to suggest the importance of Africa and Europe for African American artists throughout the period.

One particular Afro-Carolinian face vessel dated at c.1860 contrasts the green-grey glaze of an unknown visage with startlingly white protruding eyes and teeth. Thompson argues that the 'eyes project intensity' while the teeth demonstrate 'bestial ferocity' (Ibid.: 33). The diminutive size and asymmetry of the face provided by one eye raised above another and the lack of alignment in the ears compound the viewer's sense of anguish and contortion. The ambiguity of the facial features insinuate parallels with African masks used in ceremonial and religious rituals. Masks remain a fundamental feature of twentieth and twenty-first century African American sculpture, painting, mixed-media assemblage and installation art. They carry symbolic and spiritual significance to suggest origins in Africa, rituals of religious worship, performance and disguise. Their popularity may emanate from the power of the mask to ascribe private interiority to African American subjects by concealing their emotions. As Burrison argues, these 'face vessels may have been powerful artistic statements of the frustration and resentment of a people in bondage, masks seldom revealed more directly to the white masters' (Burrison, 1983: 345).

These slave artists successfully subverted the use value of their works at the same time as they refused to provide a clear-cut symbolism or accessible visual language. They replaced the 'pitchers' and 'jars' of the white master's decree with diminutive objects which refused to 'tell' their aesthetic origins, symbolism and intended function. These works show how objects commissioned by whites could assume a life beyond their patron's imagining. In contrast to Dave's large earthenware jugs, the diminutive size and small openings of these artefacts suggest they may have been created to fulfil other functions – possibly ceremonial, ritualistic or even ornamental. Perhaps they started life as white commissioned artefacts but evolved to circulate within the black community. Vlach claims that these 'miniature vessels' which were 'sculpted as human heads' had a 'symbolic, rather than utilitarian, purpose because of the care taken in modelling the very small bodies' (Vlach, 1991: 34). Thompson's assessment that they were perhaps 'containers of magical substances' suggests parallels with African art which jars with their intended use by whites (Thompson, 1983: 41).

The most interesting feature of these objects is their highly figurative

depictions of human faces. On these grounds, Thompson celebrates their 'imaginative transformation of gross ceramic structure into human expression' (Ibid.: 33). He claims that they were most likely bought by whites who interpreted them as 'amusing craft curiosities, a kind of visual minstrelsy' (Ibid.: 39). Burrison's argument that the 'olive-glazed figure' of one slave potter may have presented a 'satiric likeness' of an 'Anglo-American' man of the period opens up another possibility for readings of these mysterious face vessels (Burrison, 1983: 345). Is it possible that interpretations of these works as visual tales of slave anguish are not the whole story? Thompson is right to argue that slaves 'made these vessels for themselves and their people for traditional reasons of their own', given that '[u]nder the noses of their masters they succeeded in carving out a world of aesthetic autonomy' (Ibid.: 39). On the same principle that Dave inscribed text on to works used by slaves to protest against racial oppression beyond the white gaze, can it be argued that these works are as likely to be caricatures of white physiognomies, as perceived by African American slaves? As such, they could be the first of their kind. The exaggerated and contorted features as well as the frowning expression of the extant Afro-Carolinian face vessel (c.1860) suggest that this work is as likely to reflect the satirical likeness of a white master as it is to depict the sorrow of an enslaved African. For the slave potter there was more to be gained by caricaturing whites rather than blacks. By stereotyping white facial features so that slave owners would not recognise themselves, black artists may have found a way to obtain agency and defeat white racist illusions of superiority. Given that they challenged white tendencies to objectify black physicality and reduce African Americans to no more than their chattel status, the power of these images may arise in their ability to convey both realities at the same time. In the same way that Thompson argues it is 'dangerous to assume monofunctionality', perhaps these works carry multiple interpretations (Thompson, 1983: 42).

As Cox writes, the existence of Afro-Carolinian face vessels demonstrates that the '"folk" productions of slaves contained a subtext of resistance whilst simultaneously allowing concealment of this resistance because of the colonisers' innocuous understandings of the slaves' conduct' (Cox: 2006: 4). The discovery of Afro-Carolinian face vessels in the 'areas of the Underground Railroad' and at slave burial sites undoubtedly establishes a close relationship between early African American utilitarian objects and a visual poetics of resistance (Ibid.).

Even a brief examination of enslaved African potters and their aesthetic practices shows that critics must read against the grain to gain further insights into the otherwise elided complexities of African American art produced during the early period.

James P. Ball (1825–1904)

'[F]ugitives are men of daring fortitude'

'The Virginians rushed in crowds to his room; all classes, white and black, bond and free sought to have their lineaments, stamped, by the artist [James P. Ball] who painted with the Sun's rays' (anon. 1855 in Willis, 1993: 250). Variously working in different parts of the United States and Liberia, West Africa, James P. Ball, Jules Lion and Augustus Washington were African American pioneers in the history of daguerreotyping. As the most daguerreotyped African American of the nineteenth century, the fugitive slave-turned-orator, Frederick Douglass, was enraptured by the opportunities for racial equality presented by this invention which would make it possible for '[m]en of all conditions' to 'see themselves as others see them' (in Blassingame, vol. 3 1985: 454). Douglass welcomed daguerreotypes for their ability to fight against the 'disappearance' of African Americans from the 'canvas of art' only to reappear 'in the background corner as a clownish, grotesque object setting off the glory of his master' (Locke, 1936: 9). Ball, Washington, Lyon and others extended the usual repertoire of African American daguerreotypists which consisted of rich and even criminal whites, lynching victims and fugitive slaves to include portraits of African American politicians, lawyers, business men, soldiers, masons, writers, philanthropists, activists and prosperous families. Early images by Ball and Washington, in particular, commemorate the births, deaths and marriages of everyday African Americans. They proved Douglass right by presenting '[m]en of all conditions', and especially black men, with an opportunity to record their personal lives, as long, of course, as they could afford it.

Daguerreotypes by Ball and others established an alternative iconography by which African Americans could be represented as subjects and not objects of white consumption. At the same time, the proliferation of daguerreotypes and later photographs showing members of an emerging black professional class resisted their status as scientific specimens, political touchstones and cultural stereotypes. Their artistic compositions, experimentations with light and use of theatrical properties illuminated their subjects and paved the way for later developments

in black photography. During his career and despite his eclectic choice of human subjects, Ball expressed his fundamental commitment to the fight for an end to racist discrimination by repeatedly returning to race and antislavery politics in his works. He not only portrayed numerous African American activists but also experimented with text and image to create an abolitionist panorama titled *Ball's Splendid Mammoth Pictorial Tour of the United States* (1855). In 1896 and towards the end of his life, he returned to racist iconography by producing a series of photographs dramatising the trial, execution and funeral of black 'murderer' and seeming anti-hero, William Biggerstaff.

Ball's Splendid Mammoth Pictorial Tour of the United States (1855)

In 1855, James P. Ball exhibited a groundbreaking antislavery panorama titled *Ball's Splendid Mammoth Pictorial Tour of the United States, Comprising Views of the African Slave Trade* (1855). This work was a collaboration between Ball and the African American landscape painter, Robert Scott Duncanson, who created an epic canvas of '2400 square yards' to accompany the daguerreotypist's written text (in Willis-Thomas, 1993: 249). Unfortunately, only Ball's literary descriptions have survived. Readers are advised to consult Deborah Willis-Thomas for a facsimile reproduction of this text (Ibid.: 239–99). In brief, Ball's antislavery panorama dramatises romanticised beginnings in Africa, the horrors of the Middle Passage, the Slave Trade and slavery, sexual violation, white American racism, separations of families and slave resistance. Highlights from Ball's sections include 'Natives of Africa', 'Inhumanity of the Traders', 'Efforts to Destroy the Trade', 'Congo Dance', 'Slave Auction', 'Negro Dogs' and 'Runaway Slaves.' (Ibid.: 245). With the benefit of hindsight, these topics read as a pocket-guide to the preoccupations of works by many twentieth-century African American artists.

On the one hand, Ball's description of life in an 'African Village' reverberates with an essentialising mythology of black culture. In one section, he writes that the 'Negro is under all circumstances a joyous being, ready with song and dance, to drive away the pang of hunger, the griefs of captivity, and the risings of wrath provoked by cruel and debasing slavery' (Ibid.: 254). While celebrating creativity as the one way in which Africans could resist their captivity, Ball's challenge to the popular view that Africans were dehumanised by slavery reinforced other stereotypes. On the one hand, by describing the slave as 'joyous'

and 'ready with song and dance' he confirmed white caricatures of black identity popularised through vaudeville traditions of blackface minstrelsy. On the other hand, however, Ball tackled the taboo possibilities guaranteed by art: 'Slaves are forbidden... to engage in any... handicraft trade, without a permit from their masters' (Ibid.: 263). As he argued, white decisions to ban slave 'handicrafts' as well as slave literacy betrayed the close relationships between art for everyday use, slave narratives and slave rebellion. By the same token, Ball refused to shy away from endorsing overt physical resistance: 'Many of the fugitives are men of daring fortitude, and defy their pursuers even in death. Were they white men, the list of heroic expletives would be exhausted in extolling their deeds' (Ibid.: 278). His works proved prophetic given that it was not long before black heroism was to become and remain a major theme in twentieth- and twenty-first-century African American art. John Stauffer is right to argue that 'Ball downplays his identity as an artist and depicts images of black oppression and degradation' (Stauffer, 2006: 21). At the same time, however, Ball's fascination with taboo 'handicrafts' betrayed his preoccupation, however faint, with the incendiary politics presented by art as an end in and of itself.

William Biggerstaff Series (1896)

Long after the end of slavery but during the brutal reprisals of the Ku Klux Klan, Ball created the four 'most graphic pictures of his career' – Portrait of William Biggerstaff, The Execution of William Biggerstaff, Hanging of William Biggerstaff and William Biggerstaff in Coffin, all appearing in 1896 (Driskell in Willis-Thomas, 1993: xi). As horrifying as they are, these works can be situated within the late nineteenth- and early twentieth-century tradition of lynching photography popularised by whites. Although Biggerstaff received a trial and, in that sense, was not lynched, Ball drew on a wider history of lynching photography to contest the fairness of an all-white judicial system in these works. One of the most shocking features of lynchings by which black men, women and children were ritually mutilated and murdered by whites in acts of visual terrorism was the circulation of postcards after the event. Haunting and disturbing images of black bodies hanging from trees – the 'strange fruit' of Billie Holliday's lament – were bought and circulated by whites. Spectators inscribed their own messages on to these cards which they then sent to family and friends. For sheer barbarity, these postcards take their place alongside mid-nineteenth-century practices by which the skin

of the heroic slave, Nat Turner, was turned into purses and the bodies of rebellious slaves were sold for medical experiments. Twentieth- and twenty-first-century artists continue to grapple with a history of white consumption of black bodies as violated spectacle. One of the most controversial images, Charles Alston's 1930s untitled charcoal drawing portraying a caricatured white man holding the dripping penis of a prostrate black man, has been repeatedly banned from public exhibition.

A former slave, Biggerstaff was condemned to death for the murder of 'Dick' Johnson, another African American, after a quarrel. Biggerstaff argued he was acting in self-defence. However, given that the majority of white Americans had no interest in the deaths of black men, murderously slain or otherwise, Ball's daguerreotypes suggest that Biggerstaff's murder reflected the determination among whites to intimidate and control black masculinity, popularly stereotyped as pathologically deviant and bestial. His decision to portray this event in not one but a series of photographs was deliberate. By relying on the photographic series, Ball subverted the tendency, popular among photographers of lynching, to foreground victimisation by producing only one image of a hanging black body. He relied on the series format to humanise his subject by framing his two central images of Biggerstaff's execution with two unconventional works, one showing the victim in a dignified portrait and the other proving that he was given a Christian burial. Ultimately, Ball's use of the series format countered assumptions made by whites in mainstream iconography that the totality of black masculinity could be contained in a single image.

Ball's first work – *Portrait of William Biggerstaff seated in a chair with his hand on his face, wearing a flower in his lapel* – intervenes into mainstream representations of African American masculinity by dramatising Biggerstaff's humanity. This image resonates with conventional portraits of dignified subjects to portray Biggerstaff in a relaxed pose, seated in an ornate chair and with his right hand resting beneath his chin. This is not the grisly killer popularised in media accounts – far from it. Biggerstaff is well-dressed and wearing formal attire, complete with buttonhole and handkerchief which suggest refinement and an elevated class status. His contemplative gaze detracts from his physicality to establish his emotional complexity and agency. By including a cherub and flowers, Ball relies on a symbolic use of properties to suggest the black man's entitlement to an afterlife which he was otherwise denied in white racist propaganda.

The shocking content of the two images which follow – *Photograph of the Execution of William Biggerstaff, hanged for the murder of 'Dick' Johnson* and *Hanging of William Biggerstaff (flanked by Fred Hoss and Henry Jurgens)* – contrasts significantly with Ball's opening portrait. While the first image encourages viewers to question Biggerstaff's alleged crime and barbaric hanging by portraying him as a well-to-do member of society, these subsequent representations juxtapose representations of a now hooded and unidentifiable figure with the individual expressions of the white men standing beside him. Unlike Biggerstaff's contemplative pose in his opening portrait, his now shrouded head conceals his expression while the physiognomies of the white men are painstakingly delineated. They stare directly at the camera in attitudes of stern confrontation. *Hanging of William Biggerstaff (flanked by Fred Hoss and Henry Jurgens)* in particular contrasts the mutilated body of a now unknown man with the grim expressions of the white men standing on either side. These white men are dressed in suits, wear hats and parade their watchchains to reinforce their status as respected members of the community. For Ball, theirs is a greater inhumanity as they show no signs of regret for what they have seen and done in cold blood and with due process of law. This work signifies upon a history of lynchings to communicate the terrifying reality that, rather than being the crackpot work of extreme individuals, vigilante mob rule had the approval of mainstream white society. A major source of the dramatic tension in these works stems from the fact that the white men confronting the viewer are, first of all, staring at the black photographer while he takes the picture. Their failure to intimidate is shown by Ball's decision to take their photograph and record their inhumanity.

Even more striking in this image, however, is the fact that the viewer is forced to rely on his or her imagination to reconstruct Biggerstaff's face. The anonymity of the hood dramatises the ways in which white culture removes, erases and denies the personal subjectivities of black men. Literally faceless, as viewers we are forced to rely on the opening portrait to reconstruct Biggerstaff's physiognomy. This fact necessarily reinforces the drama produced by the juxtaposition of such different representations – one a dignified studio portrait, the other a record of an anonymous criminal. Ball's determination to portray this event over four images clearly problematised tendencies among whites to circulate images of violated black bodies as if they could capture the entirety of an individual's identity.

The final work depicts Biggerstaff lying in a coffin to restore his humanity and show that he was given a proper burial. The light-coloured silver handle of the coffin combines with its richly padded interior to draw attention to Biggerstaff's wedding ring and suggests he had been a husband and father before he had become a convicted killer. The luxurious coffin and the thick gold band visually recall the ornate chair and formal attire of the opening portrait to celebrate his humanity. These details suggest that Biggerstaff was a respected member of the community and that his crime was an aberrant incident rather than a stereotypical manifestation of an inherently 'depraved' African American masculinity.

Early African American developments in daguerreotyping draw attention to a widespread tendency among black artists to politicise relationships between artists, artworks and audiences. Popular images and literary accounts in the eighteenth and nineteenth centuries frequently reduced African Americans to bodies for exploitation, dissection and inspection by white buyers, scientific researchers and voyeurs. By comparison, representations of black subjects captured in daguerreotypes and, less frequently, in early painted portraits were often the first time African Americans had been able to counter the caricatures of black identity proliferating within the white mainstream imagination. For nineteenth-century slave narrator, Harriet Jacobs, in particular, the experience of seeing portraits of African Americans for the first time was an emotional one. 'I had never seen any paintings of colored people before,' she admitted, 'and they seemed to me beautiful' (Jacobs, 1861: 162).

Early African American daguerreotypists such as Ball and painters such as Edward M. Bannister sought to prove that 'black is beautiful', not only to white audiences familiar with dehumanising caricatures but also to black viewers, many of whom had internalised white racist standards. In Ball's specific case, he refused to be restricted to themes of domesticity and financial success by repeatedly turning to feats of black activism. For example, he experimented with lighting techniques in an 1860s' daguerreotype of Frederick Douglass to accentuate this freedom-fighter's grey hair and lined face. By highlighting Douglass's frailties, Ball proved that he had weathered the storms of slavery and indicted racist injustices by insinuating that, if he, and other activists like him, had been 'white men, the list of heroic expletives would be exhausted in extolling their deeds'. There can be little doubt that early black daguerreotypists such as James P. Ball and Augustus Washington repeatedly

captured the lives of African Americans from a range of backgrounds to resist widespread stereotyping within white mainstream visual culture. However much works by Ball, Washington and others differed, the vast majority of African American daguerreotypists and photographers in this period were keen to portray the injustices and psychological devastation wrought by slavery and its aftermath.

Harriet Powers (1837–1911)

'Sermon in Patchwork'

One of the most important African American quilters of the nineteenth century, Harriet Powers, believed her purpose was to '"preach the gospel in patchwork"' (in Perry, 1994: 4). Born a slave like Dave the Potter, as little is known of her personal biography. During her lifetime, she remained illiterate and, as far as we know, created only two 'Bible Quilts' in 1886 and 1898. For their survival, as well as the preservation of Powers's artistic statements, we have her white patron, Jennie Smith, to thank. However, their relationship was far from unproblematic. Powers fought to retain her rights as an artist over the '"darling offspring of her brain"' despite white patron demands (in Adams, 1983: 68). As far as we can tell from the quilts which have survived, Powers's abstract compositions and figurative tableaux populated by human, animal, religious and mythic figures are unprecedented in the history of African American and American quilting. Just as poetic text had rarely, if ever, been inscribed on pots before Dave the Potter's jars, Powers's quilts seem to have been entirely new. In these artefacts, she assumed the role of storyteller to create multi-panel works which brought scenes from the bible, history and folklore to life.

The representational content and abstract compositions of Powers's bible quilts contrast starkly with those which have survived and were produced by other enslaved women. For example, the pieced quilt by an anonymous slave created c.1800 consists entirely of abstract and geometric patterns. Similarly, slave quilter, Louiza Francis Combs, created her wool blanket (c.1890) from 'broad asymmetrical patterns' by drawing on 'African – specifically Mande – religious precepts' (Farrington, 2004: 29). Even groundbreaking quilts by slave narrator and seamstress, Elizabeth Keckley, lack Powers's abstract motifs and symbolism. As Regenia Perry argues, Powers's 'technique of appliquéd designs' was specifically inspired by 'similar practices in the People's Republic of Benin (formerly Dahomey), West Africa' (Perry, 1994: 2). As she argues, 'while there are

no American prototypes for Powers's quilt designs', the 'proportions of her figures are Western' (Ibid.).

Bible Quilt (1886)

Harriet Powers called the first bible quilt she created in 1886 a '"Sermon in Patchwork"' (in Perry, 1994: 4). She confessed that she used these works to '"preach the gospel in patchwork, to show my Lord my humility ... and to show where sin originated, out of the beginning of things"' (Ibid.). Eleven panels of varying sizes criss-cross one another to suggest points of interconnection and divergence across these visual chapters. The inspiration for this quilt stemmed from stories in the bible including the 'tempting of Eve in the Garden, the killing of Abel, Jacob's dream, Judas at the Last Supper, and the Crucifixion' (Adams, 1983: 69). A cautionary note should be sounded against attaching too much meaning to Powers's colour symbolism as it appears today. As Patton shows, the quilt has 'faded considerably: the light tan background was originally deep pink, and the brown sashing between squares was green' (Patton, 1998: 69). The current light cream, brown, beige and orange colour scheme suggests a harmony which was not present in the original composition. Powers's original choice of discordant colours such as pinks and greens may reflect what Maude S. Wahlman and John Scully identify as a tendency among African American quilters to 'improvise' as they 'master a pattern and then attempt to break it with an irregular choice of colour combinations' (Wahlman and Scully, 1983: 89). In this quilt, Powers experimented with colour changes, thematic breaks and symbolic gaps to create jarring relationships between sections and complicate the thematic relationships within her narrative sequences.

The individual panels of Powers's first quilt are multi-directional and open-ended. She leaps from one bible story to the next to encourage viewers to make connections across her discordant symbolism. The first panel telling the story of Eve's temptation in the Garden of Eden adopts a flat picture plane to depict a grey Adam, a white Eve, a snake and an assortment of animals including an elephant, leopards and a deer. Powers's representation of the snake overwhelms the human figures and the picture frame by its enlarged size, anthropomorphic feet and black and orange stripes. The serpent not only symbolises human frailty and the risks of temptation within Western Christian iconography but also carries other connotations in light of its sacred power in some African cultures. The imagery in this scene recalls a walking stick (c.1867)

created by a slave, Henry Gudgell, and decorated with 'a lively reper-
tory of abstract and realistic motifs' including 'a slender serpent ... a
man with bent knees, a bent branch with a single veined leaf, a lizard
and a tortoise' (Perry, 1989: 39–40). However, their shared choice of
form is more important than any similarities of imagery. Both Gudgell's
walking sticks and Powers's quilts relied on an abstract-figurative style.
These parallels illustrate that Powers relied on abstraction to simplify her
human and animal figures and create visually accessible, if challenging,
works.

One of the most striking features of Powers's first panel showing
the temptation of Eve is that it is decorated with small crosses. These
symbolic markings mirror those included in the final image illustrating
the birth of Christ to suggest a call and response relationship as well as
repetition with variation between individual scenes. Powers explained
that '"[t]hem is the crosses which he [Christ] had to bear through his
undergoing"' (Perry, 1994: 5). As Perry argues, Powers's 'nonchrono-
logical placement of the Nativity' in the last panel was 'intentional and
symbolic' (Ibid.: 3). Perhaps Powers substituted the horrors of Christ's
crucifixion with the joys of his birth to focus on the possibilities of moral
redemption rather than the perils of sin. Her dramatisation of the cruci-
fixion appears four panels earlier, complete with 'globular objects', to
'represent the darkness over the earth and the moon turning into blood'
as she sought to '"[w]ipe it [sin] out in the world"' (Ibid.: 5). Powers's
insertion of this scene between panels showing an angel's visitation to
Jesus and Judas's betrayal suggests the innate corruptibility of man
which can only be redeemed through God. These panels also represent
biblical heroes such as 'Moses, Noah, Jonah, and Job', famous 'men
who experienced not only God's harsh judgment but also His power to
deliver them', to show that man's salvation can only be secured by divine
intervention (Adams, 1983: 71).

Powers's 'nonchronological' sequencing of her biblical stories may
even have been designed to challenge viewing practices. Perhaps she did
not intend her audiences to read left from right, top to bottom but from
right to left, bottom to top or even to dip across and focus on individual
images, depending on the religious instruction they needed. Powers
may have designed this quilt to encourage her viewers to concentrate
on individual stories by explicating a specific moral issue. Her repetition
across scenes of diminutive crosses, spherical stars, erect and prostrate
grey and white bodies, panthers, deer, leopards, elephants, birds and

cockerels transgresses the boundaries of individual panels to blur relationships between the temptation of woman, the crucifixion of Christ, the tempting of Judas and the wrongdoing of Satan. Powers complicated her moral allegories by repeating motifs and symbols across these scenes to encourage audiences to search for their own spiritual message in her otherwise unresolved narratives. Adams's praise for Powers's first quilt which unites 'carefully tended arrangements and threatening chaos' into a 'dynamic equilibrium' heightens our awareness of her self-reflexive aesthetic practices (Adams, 1983: 70).

Bible Quilt (1898)

Over a decade later, Harriet Powers completed a second much larger bible quilt in 1898. This elaborate work consists of fifteen experimental and abstract panels as human, animal and religious figures interweave, blur and collide to create compelling religious, mystical and folkloric scenes. As Perry argues, Powers's representation of animals in this work is 'strikingly similar to African examples' (Perry, 1994: 2). In this later quilt, Powers created dynamic contrasts between panels and figures by adopting a much more ambitious colour scheme. She also added meteorological phenomena and local stories to her typical array of black, brown, and white human, religious and animal figures. The final panel revisits the crucifixion of Christ from panel eight of the previous quilt. This time Jesus no longer carries his cross but is instead nailed to it. His suffering body stands between a white star on the left and a black star on the right. The depiction of a white star on a black circle and a black star on a white circle symbolically positions Christ between these objects to represent racial conflict. His greyed body metaphorically operates as a site of racial mixing to dramatise the inextricable relationship between the races, as well as the importance of faith to transcend physical and psychological differences. The weeping brown female figures at Christ's feet suggest parallels between the crucifixion and black martyrdom at the height of white racist persecution and during a period of increased lynchings in the late nineteenth century. Powers relies on a stark black-and-white colour scheme to communicate themes of death, martyrdom and grief in this quilt at the same time as she examines tensions of racial difference.

Powers's decision to include radical content in her 'most iconographically enigmatic' scene, panel thirteen, reinforces the political implications undergirding her quilts (Ibid.: 6). On first glance, this section seems innocent enough by portraying two erect human figures dominated

by a large animal in the foreground. However, Powers's commentary suggests a vengeful subtext by identifying the figures in this panel as "'[r]ich people who were taught nothing of God'" (Ibid.). They were "'Bob and Kate Bell of VA'" who "'told their parents to stop the clock at one and tomorrow it would strike one and so it did'", which she interpreted as the "'signal that they entered everlasting punishment'" (Ibid.). The ongoing impossibility of identifying 'Bob' and 'Kate' encourages Perry to wonder, "'Were they Powers's former owners, or had they caused Powers or her family some hardship?'" (Ibid.). Powers supports this reading by providing grey and black representations of these figures with upraised hands and, in Kate's case, flowing skirts, to suggest wealth and authority. In this scene, the pendulum of a clock occupies the space between these figures to prophesy the imminent expiry of their mortal souls.

What is most striking about this quilt, however, is Powers's inclusion of a large brown animal in the foreground. By identifying this animal as the "'independent hog that ran 500 miles from GA to VA'", she admitted that she was inspired by local legends and folklore (Ibid.). Perry postulates that this animal represents a 'veiled reference to the Underground Railroad', revealing that 'her independence is analogous to Powers's own emancipation' (Ibid.). Whether or not this animal symbolises the Underground Railroad does not detract from the problematic comparison she would have been making in identifying herself with a hog in an era of slavery. On the whole, Powers's decision not to specify the racial identities of Bob and Kate or even her thematic emphasis confirms her decision to retain artistic agency in an ongoing experimentation with ambiguous content and abstract forms.

Speaking of Powers's quilts, Patton asserts, 'Scripture is more here than a story about salvation and redemption; it becomes a metaphor for freedom' (Patton, 1998: 69). And yet, even if the overt message in her works was religious redemption, Powers's underlying 'sermon' preaches black resistance. She borrows from African techniques and themes by combining pictorial design with geometric patterning to include narrative sequences in her quilts. For Floris B. Cash, Powers's decision to work within the 'American tradition while retaining elements from her African heritage' confirmed the 'existence of a "black aesthetic"' (Cash, 1995: 34). However, the tendency to see Powers's quilts as the point at which we can identify a set of black artistic principles risks obfuscating the earlier experimental practices of Dave the Potter, James P. Ball and

others, as well as concealing the dual heritage of African American artists who were both African and American. It is more accurate to suggest that Powers's original works emerged within an already existing African American visual arts tradition whose full history remains to be written.

Powers relies on abstract symmetrical designs and geometric patterns in both her bible quilts to create allegorical scenes which would tell stories reflecting back upon black religious beliefs and community life. There can be little doubt that Powers 'functioned in her African American community as a *griot* (oral historian) or storyteller' (Perry, 1994: 3). Her sophisticated technical abilities prevent these works from becoming illustrative or didactic sermons because of their complex reliance on abstraction. For audiences unaccustomed to reading visual images, Powers's ambiguous scenes characterised by flat picture planes, distorted perspectives and symbolic colour juxtapositions are challenging in their elliptical shorthand. In these quilts, she signifies upon African and African American art traditions to speak the unspeakable concerning black personal histories and narratives. Michelle Cliff identifies a significant history in which black female artists countered forces of marginalisation, social exclusion, racism and stereotyping in their works by writing that it is 'not that far a distance from Lewis's *Hagar,* to Catlett's *Homage*, to Powers's Betts, to Betye Saar's *Aunt Jemima*' (in Robinson, 1987: 155). By drawing parallels between Powers's quilts and works by twentieth-century black female artists, Cliff argues for a long tradition of black female resistance. In this context, Powers's quilts are not what they first appear. Straightforward visual records of black cultural life in Africa and the Americas do not emerge from her fusion of African animal imagery and Western forms. Instead, her quilts rely on religious allegory and abstract symbolism to withhold as much as they reveal.

Harriet Powers's two bible quilts hold an important position in the early African American visual arts tradition. They offer a useful starting point from which to investigate the rich history of African American quilting from its beginnings in the nineteenth century on down to significant contemporary quilters such as Linda Pettway, Annie Mae Young and many others (Beardsley and Arnett, 2002; Carey, 2004). Researchers are only now beginning to explore how slave women and men 'introduced a distinctly African-American aesthetic into textile and clothing design' (White and White, 1995: 150). As critics such as Graham and Shane White show, their expertise led to new styles, patterns and dyeing techniques. For example, many created rainbow-coloured cloth to secure

a 'surprising degree of social and cultural space' (Ibid.: 155). In the same way that Dave the Potter and the anonymous artisans who created the Afro-Carolinian face vessels were forced to improvise, early quilters worked with inferior materials to assert their own style and undermine prescriptive white demands. They experimented with dyeing techniques and clothing designs to subvert white attempts to homogenise black culture and display their artistic agency. As White and White contend, slave women issued with regulation '"Negro cloth"' frequently 'used European textiles to fashion items of African design' (Ibid.: 9).

However much they differed from the techniques and designs of African American made quilts, runaway slave advertisements provide a useful resource for accessing the ways in which slaves used clothing to assert their identity. For example, the notice for the apprehension of Harriet Jacobs admitted she was a 'good seamstress' who had 'a variety of very fine clothes' and 'will probably appear ... tricked out in gay and fashionable finery' (Jacobs: n.d.: n.p.). For White and White, the 'slave's carefully constructed appearance was an act of cultural *bricolage*' which signalled the 'mediation of an African-born slave in a new, European-dominated environment' (White and White, 1999: 19). Gladys-Marie Fry similarly identifies an 'African-American Design Aesthetic', by observing that 'slave quilters, who were forced by plantation rules to work within a Euro-American tradition, found inventive ways to disguise within the quilt improvisational forms and elements from African cosmology and mythology' (Fry, 2001: 7). Moreover, their garments were frequently 'described as looking like a quilt' (Ibid.: 24).

The history of African American quilt-making remains closely tied to slave resistance by providing enslaved women with 'unique opportunities to socialise without supervision' (Cash, 1995: 32). By providing women with autonomous spaces within which to debate political issues and keep their oral traditions alive, quilting parties, also known as 'quilting bees', were hotbeds of political activism. They shared stories beyond prying white ears as they stitched. Equally, the history of the Underground Railroad would be incomplete without examining the role played by quilts. For example, Jacqueline L. Tobin and Raymond G. Dobard's recent book, *Hidden in Plain View*, relies on Ozella McDaniel Williams to recreate the 'Underground Railroad Quilt Code' handed down through her family for generations (Tobin and Dobard, 2000).

Any researcher trying to recover the history of African American quilting in the early period faces serious difficulties. The 'scarcity of

data concerning slave women in written historical sources' operates in conjunction with the difficult 'task of documenting slave-made quilts' to hinder attempts to map this early tradition (Fry, 2001: 3). Important quilters such as those found working in Gee's Bend, a small region in Alabama, and exhibited as recently as 2002 are being discovered all the time. Similarly, the tradition has continuously been revived by numerous artists such as Malissa Banks, Rosie Cox McLaurin, Faith Ringgold and Dorothy H. Holden, among countless others. As experimental paintings by Romare Bearden show, a quilting legacy can also be traced in the collaging techniques developed by later African American artists. For many African American artists, quilts communicated stories of survival within their stitched seams at the same time that they offered hope in creativity as a redemptive force which can transform the hardships of everyday life.

Edmonia 'Wildfire' Lewis (c.1843–c.1911)

'I have a strong sympathy for all women who have struggled'

When Alain Locke observed in the 1930s that the 'majority of the outstanding Negro sculptors have been women', Edmonia Lewis must have been prominent in his thoughts (Locke, 1936: 28). Lewis's marble sculptures represent the beginnings of an African American female sculpting tradition since popularised by late nineteenth- and early twentieth-century artists such as Meta Warrick Fuller, May Howard Jackson, Edna Manley and Nancy E. Prophet. These early African American female sculptors in turn paved the way for their mid-twentieth-century descendents in later artists including Elizabeth Catlett, Barbara Chase-Riboud, and Renée Stout. Beginning with Edmonia Lewis, the groundbreaking works of these sculptors examine the lives of black women who were otherwise represented only as caricatures in white mainstream visual arts. They broke with tradition to experiment with taboo topics and represent the realities of violated, abused and assaulted African American adult and child bodies. Their works not only inspired future black female sculptors but also black male artists such as Sargent Johnson, Richmond Barthé and William Artis. Confessions such as Edmonia Lewis's that 'I have a strong sympathy for all women who have struggled' not only betray her bias towards female experiences, irrespective of race, but also echo the visual manifestos of later artists such as Elizabeth Catlett who strove for '"women's liberation"' (in Lewis, 1984: 102).

As the 'Founding Mother' of African American sculpture in the

nineteenth century, Edmonia Lewis fought for the right to artistic agency in a period during which vast numbers of black women were bought and sold as 'breeders' to increase plantation 'stock'. Her mixed racial origins, given that she was part African, Native and European American, influenced her choice of subject matter and form. She faced repeated instances of racist brutality throughout her lifetime. As a result of unfounded allegations that she had poisoned two of her white female schoolmates, Lewis was brutally beaten by a white mob and left for dead. It is no surprise, therefore, that themes of death, social ostracism, freedom and slavery combine with myths of African and Native American folklore in her work. In light of practical difficulties in tracing many of Lewis's sculptures which have simply been lost or destroyed, those which have survived and which I will discuss below include *Forever Free* (1867), *Hagar in the Wilderness* (1869) and *Death of Cleopatra* (1876).

Forever Free (1867) and *Hagar in the Wilderness* (1875)

Edmonia Lewis's sculpture, *Forever Free* (1867) depicts an erect male figure holding his broken fetters in one hand while he rests the other on a kneeling shackled ex-slave woman who clasps her hands together in attitudes of prayer. This sculpture has been heavily criticised for reinforcing stereotypes of female passivity and internalising European standards of beauty. In this work, Lewis contrasts an image of triumphant African American masculinity with that of downtrodden femininity at the same time as she elides racial difference by portraying these figures according to European standards. Lewis's tendency to minimise the racialised features of her black figures in favour of situating them within a white European and classical tradition has led to her dismissal by many other artists and critics. Thus, while Kirsten P. Buick celebrates the fact that the 'subjects of her sculptures are African-American and Native American women', she is disappointed to find that 'their features follow idealized, western European models' (Buick, 1995: 5). Buick's only way of redeeming Lewis is to suggest that, by 'eliminating ethnic identity, Lewis eliminated the stereotype as well' (Ibid.: 14). While Lisa Farrington agrees with Buick's interpretation that freedom for Lewis was a 'masculinized process', she defends *Forever Free* for proving her commitment to the 'political struggles of African Americans' (Buick, 1995: 9; Farrington, 2004: 56). A thorough examination of Lewis's marble sculptures shows that, even if her representations of African American physiognomies remain problematically assimilationist, her

choice of subject matter pushed existing boundaries to position the lone heroic male exemplar alongside, not apart from, the difficult lives of black women. By suggesting that the struggle for the emancipation of enslaved women had only just begun, the pose of Lewis's enslaved woman in *Forever Free*, still shackled and on her knees, provides an ironic indictment of ongoing gender as well as race discrimination.

Perhaps it was Edmonia Lewis's awareness of these problems which inspired her to create *Hagar in the Wilderness* less than a decade later in 1875. This work dramatises the brutal treatment and abandonment of the biblical Egyptian slave woman used by Abraham to bear his children. Despite Hagar's history of suffering and victimisation, this sculpture contrasts with *Forever Free* by representing an erect female slave to undermine popular depictions of passive black womanhood. This time the enslaved woman is no longer on her knees as Hagar looks directly ahead as if to challenge the viewer. As such, this work forestalls Barthé's later sculpture, *The Negro Looks Ahead* (1940) which supported Harlem Renaissance myths of linear trajectories towards black progress and 'racial uplift'. While her long hair flows as freely as that of the female figure in *Forever Free*, Hagar's enigmatic and concentrated facial expression hints at her psychological complexity. For Judith Wilson, *Hagar* offers a symbolic record of the 'plight of black women who ... were often compelled to yield to white men's sexual demands, only to be reviled by white women for doing so' (Wilson: 1991, 94). But this sculpture also presages hope because this black woman chooses not to beg for alms. Lewis's decision to represent a slave woman from biblical lore relied on religious allegory to protest against the injustices facing African American women in her immediate social and political milieu.

Death of Cleopatra (1876)

A later sculpture, *Death of Cleopatra* (1876), establishes remarkable shifts in Edmonia Lewis's aesthetic direction at the same time that the work itself has an astonishing history. Viewers of this sculpture where it is now exhibited at the Smithsonian American Art museum can little imagine that it had long been missing, presumed lost. In the 1970s, nearly a hundred years since it was sculpted, the sculpture was rediscovered as the tombstone of a racehorse and restored by Boy Scouts before it was even identified. The sculpture portrays Cleopatra seated on her throne, clasping the asp in one hand while her arm and head are thrown back to suggest her passing from one life into another. The viewer of

this work need have no imagination to appreciate Cleopatra's legendary beauty. In this sculpture, the monumentality of her body dominates her throne while the sensuous folds of her loose-fitting dress expose one of her breasts and the contours of her body. Lewis insinuates sexualised overtones for this heroic female figure by sculpting closed eyes and a lounging frame which hint at the ecstasy of death by suggesting orgasmic release. This work shocked audiences by adopting a graphic realism given that, '[p]ure classicism yields to realism portrayed in a moment of death' (Patton, 1998: 97).

In *Death of Cleopatra*, Lewis's representation of this queen reclaimed taboo subjects of sexuality and desire which formerly had led only to racist caricatures of a promiscuous African American femininity. Moreover, her portrayal of Cleopatra's suicide introduced themes of female heroism and self-sacrifice into the history of African American art. Lewis's decision to dramatise the suicide of this Egyptian queen in *Death of Cleopatra* challenges assumptions made by later artists such as Faith Ringgold that she had seen no African art. Both critics and even reproductions of this work fail to do justice to the fact that Lewis etched Egyptian hieroglyphics on to the sides of the throne. Thus, while her portrayal of Cleopatra may simply confirm her familiarity with myths popularly circulated in Western art criticism, her inclusion of hieroglyphics may suggest that she possessed knowledge beyond white mainstream traditions. This sculpture ultimately resists straightforward readings in light of Cleopatra's ambiguous facial expression and Lewis's untranslated pictorial language, both of which compound Western ignorance regarding a mythic and ancient Africa.

Lewis's *Death of Cleopatra* can be usefully examined alongside later black female sculptor, Meta Warrick Fuller's early twentieth-century bronze work, *Ethiopia Awakening* (1914). Both sculptures mark the transition in African American visual arts from neglect in the nineteenth century to popular revival by the early twentieth century. Thus, while Lewis's sculpture mourns the death of Egyptian royalty, Fuller's celebrates the 'awakening' of black female creativity. Unlike Lewis's work which was carved out of marble, Fuller's was cast in bronze to embrace the beauty of blackness and celebrate a cultural legacy of African arts. And yet, both Lewis's Cleopatra and Fuller's unknown female figure look off to the right as if refusing to be fully exposed to the viewer, at the same time that they seem to turn from the past to envision new futures. Just as Lewis dramatised the life and death of a

monumental queen, Fuller's unknown mummified woman is literally being unwrapped from her shrouded bonds. Despite their obvious differences, these visual echoes suggest that works by Lewis and Fuller ultimately heralded the rebirth of a black visual arts via the mythic resurrection of a romanticised Africa.

The monumental sculptures of Edmonia Lewis single-handedly prophesied the black cultural awakening of the 1920s Harlem Renaissance. Working from the twentieth century onwards and inspired by her example, later African American female sculptors have since chiselled images in marble, bronze, terracotta and wood to protest against black suffering and celebrate female heroism and artistic agency. They share many of Lewis's thematic concerns by addressing issues related to racial origins, family, ancestry and a mythic Africa. Many of their works also experiment with religious allegory and iconography to examine ongoing themes of martyrdom, dispossession and disenfranchisement. However, these later female sculptors have gone a stage further than Lewis by visualising mothers, wives and daughters visibly mourning the lives and deaths of black husbands, fathers and sons who have suffered discrimination, assault and even lynchings. They have also celebrated music and song to dramatise the survival of the human spirit and pave the way for the prominence of blues and jazz in twentieth- and twenty-first-century black art. Despite these differences, they remain indebted to Lewis's sculptures for their complicated revisionary histories of black protest which repeatedly dramatise the lives of the vulnerable and dispossessed alongside heroic fighters for black freedom. Queens, saints, Madonnas and cherubs exist alongside freed slaves and political protesters in Edmonia Lewis's sculptures to oppose a history of African American stereotyping in white mainstream culture. Works not only by Lewis but also later African American female, and some male, sculptors hold fast to her assertion that '"I have a strong sympathy for all women who have struggled and suffered"' (in Buick, 1995: 11). Many follow on from her determination to experiment in art to undermine plantation mythologies of the maternal 'mammy' and the lascivious 'jezebel', advertising images of the pancake-baking domestic 'Aunt Jemima' and literary constructions of the unruly wild child 'Topsy'.

One of the great losses to African American art history is Lewis's sculpture, *The Freedwoman on First Hearing of Her Liberty*. All we have is the description provided by nineteenth-century reviewer, Henry Wreford. 'She [the freedwoman] has thrown herself to her knees, and,

with clasped hands and uplifted eyes, she blesses God for her redemption,' he explained. 'Her boy ... hangs over her knees and clings to her waist. She wears the turban which was used when at work. Around her wrists are the half-broken manacles, and the chain lies on the ground still attached to a large ball' (Ibid.: 9). As long as Wreford's description can be trusted, this sculpture reveals Edmonia Lewis's fight for aesthetic freedom by protesting against the enslavement of black women. Lewis's decision to portray her 'Freedwoman' still wearing the 'turban which was used when at work' not only signifies upon racist mammy stereotypes but also confronts the harsh realities of black female labour during slavery and in its aftermath. Stripped of religious allegory or myth, this work portrays the plight of the 'freedwoman' in confrontational and hard-hitting terms. Speaking of this sculpture herself, Lewis commented, '"Yes ... so was my race treated in the market and elsewhere"' (Ibid.). Here and elsewhere in her epic-sized sculptures dramatising the lives and hardships of monumental black figures, Lewis showed that slavery's influence extended far beyond the auction blocks and plantations of the south to survive undamaged long after emancipation. In bold statements such as 'so was my race treated', she inspired future generations of artists by admitting her commitment to using art for social and political change. During her lifetime, Edmonia Lewis's marble sculptures pushed the boundaries of form and technique to protest against black female suffering and resist slavery's legacies.

Henry Ossawa Tanner (1859–1937)
'[I]n search of artistic truth'

Henry Ossawa Tanner occupies a contested position in African American art history. In a career bridging the nineteenth and twentieth centuries, he not only battled scepticism from white audiences unwilling to recognise the genius of a black artist on racist grounds but was also heavily criticised by black scholars and intellectuals. Critics such as Alain Locke were disappointed in Tanner because, although he was 'a professed painter of types, he has devoted his talent mainly to the portrayal of Jewish Biblical types and subjects, and has never maturely touched the portrayal of the Negro subject' (Locke, 1927: 264). This failure left Locke in no doubt that '[w]e ought and must have a school of Negro art, a local and racially representative tradition' (Ibid.: 266). Even Romare Bearden, one of Tanner's greatest fans, admitted, 'As I grew older I became disenchanted with Tanner. I felt that he had divorced himself

from the task of developing a statement that reflected the crucial social problems of his time' (*URBP*, Bearden, 'Review', n.d.: 3). Recent critics remain equally conflicted. Albert Boime argues that Tanner's work sometimes 'challenged the standard images of American genre paintings and at other times acted in complicity with them' (Boime, 1993: 416). Even more damningly, for Edward Lucie-Smith, Tanner's paintings remained 'indistinguishable' from works by 'his white contemporaries if we know nothing of the origins of the artist and simply look at the paintings themselves' (Smith, 1994: 12).

Critics often forget that, during his lifetime, Tanner repeatedly painted scenes of African American poverty, heroism and family life in works such as *An Old Couple Looking at a Portrait of Lincoln* (1892–3), *The Banjo Lesson* (1893), *The Thankful Poor* (1894), *Portrait of the Artist's Mother* (1897) and *Booker T. Washington* (1917). He was the first to admit that he painted '"Negro subjects"' because of the '"newness of the field and from a desire to represent the serious and pathetic side of life among them"' (in Boime, 1993: 419). He hoped that these canvases would undermine existing works which '"represented Negro life"' by only seeing the '"comic, the ludicrous side of it"' and which have '"lacked sympathy with and appreciation for the warm big heart that dwells within the rough exterior"' (Ibid.). By dramatising dignity in adversity and the survival of the human spirit, he sought to counteract the damaging effects of prejudice which had made the 'Negro half-ashamed of himself' and caused 'racial subjects' to be 'avoided or treated gingerly in soft-pedalled Nordic transcriptions' (Locke, 1936: 61).

Towards the end of his life and in an interview with African American artist, Hale Woodruff, Tanner maintained that the '"human form, that is to say, man himself, is the most timeless and significant theme in all life and art"' (*HWP* N70–60, in Hale Woodruff, 'My Meeting', 1970: 9). He insisted on an art of empathy by suggesting that '"through the artists' various views of man we can *all* see ourselves"' (Ibid.). Thus, although Tanner favoured religious and landscape paintings devoid of black subjects, he also created many African American portraits and genre scenes on the grounds that the 'human form' is the most 'significant theme in all life and art'. His canvases dramatising scenes and individuals from black community life were intended to cross racial divides by establishing that it is only through the artist's vision that 'we can all see ourselves'. Tanner's experimentation with form and technique in these works foregrounds aesthetic issues to reinforce his belief that all artists,

regardless of race, must be in '"search of artistic truth"' in their work (*HTP* 107, Tanner in Hans Bhalla and Edmund Barry Gaither, 1969: n.p.).

The Banjo Lesson (1893)

Henry Tanner's *The Banjo Lesson* (1893) is perhaps his most famous and frequently reproduced painting. Locke celebrated this work for showing a 'possibility that, had it developed, would have made Tanner the founder of a racial school of American Negro art' (Ibid.: 23). This large full-colour canvas depicts an elderly African American man seated in front of a fire in a rural cabin while a young boy sits on his lap as he teaches him the banjo. Tanner's use of light to illuminate his figures highlights the imaginative possibilities of art which can transcend the worn floorboards, scuffed boots and cracked walls of an impoverished southern cabin. Richard Powell describes this work as a 'painted Negro spiritual' (Powell, 2002: 26). By celebrating an exchange of oral stories and art traditions, this painting clearly provides a visual elegy to black community survival. As Boime argues, this work shows Tanner's determination to portray African Americans not as an 'object of white entertainment but as the subject of black education' (Boime, 1993: 423). Tanner's use of light, composition and reliance on conventions of realism in *The Banjo Lesson* displaces the stereotypical associations of black musical performers with blackface minstrelsy. He highlights differences in facial expressions and skin tones to individualise and dignify his representations of grandfather and grandson.

One of the major technical achievements of *The Banjo Lesson* derives from Tanner's experimentation with colour and tone. 'I had assumed [*The Banjo Lesson*] to be a dark monochromatic work,' Bearden admitted, 'until I saw the rich blue, gray, and tan accents that gives this original much more depth' (*URBP*, Bearden, 'Review,' n.d.: 2). As he explained, 'Tanner used a mixed technique of oil and tempera, the exact details of which he kept secret. This partly accounts for the luminous and often remarkable impastoed surface ... and also, why the subtle and varied nuances of color are so difficult to reproduce' (Ibid.). Tanner's technical experimentations in new mixtures of paint create a warm glow to illuminate the absorbed faces of both man and child in this work and suggest survival through the preservation of oral traditions and musical performance. By choosing to depict a banjo rather than any other instrument, Tanner brought audiences of this work back to Africa. As Bearden

and Henderson explain, this painting 'celebrates the music of African-Americans through their invented instrument, the banjo' (Bearden and Henderson, 1993: 88). Tanner's decision to set this painting within a black rural cabin further suggests that this 'banjo lesson' is taking place within the culturally autonomous space of the black community and far from the white-owned minstrel stage. In so doing, he established that black resistance did not end with those early artefacts hidden under cabin floors but survived via the exchange of skills across generations. Convincing, detailed and atmospheric, this work was inspired by Tanner's many trips to the American south.

As Boime suggests, there is an 'unsentimental affection' between the two figures in *The Banjo Lesson* who both remain 'oblivious of the spectator's presence' (Boime, 1993: 423). The concentration of Tanner's two protagonists suggests that the African American musical tradition was not about entertaining whites but about educating future genera-tions for black creative fulfilment. Tanner included blurred works of art on the wall to prove that 'art is life' and a necessity which can transform destitute lives. This interest in art as spiritual salvation continued on into the twentieth century in works by artists such as Horace Pippin and Jacob Lawrence. Many of their paintings offset scenes of urban and rural poverty by including artefacts which proved that African American creativity in the arts had survived. Originally titled *The First Lesson*, Tanner's *The Banjo Lesson* celebrates the ways in which improvisa-tion and creativity made it possible for African Americans to transcend everyday suffering via an escape into the arts. By showing the impor-tance of artistic exchange, in particular, Tanner explored the role played by oral traditions in preserving family histories and protecting wider cultural legacies.

The Thankful Poor (1894)

In stark contrast to *The Banjo Lesson*, Henry Tanner's later painting, *The Thankful Poor*, is a much bleaker genre scene. This time an African American grandfather and grandchild are destitute and denied any form of creativity which might brighten their struggle for survival. This work provides an unforgiving and emotionally charged view of black rural poverty as Tanner refused to sentimentalise his subjects by providing close-ups exposing the harsh realities of their lives. Bearden and Henderson praise this work for its 'emotional intensity' (Bearden and Henderson, 1993: 89). In this stark and evocative canvas, he did not shy

away from representing the realities of hunger and destitution. The hands and neck of the old man show his age to compound the vulnerability of both figures whose only hope is in prayer. The grandfather and grand-child who neither look at nor talk to one another in this painting contrast with those in *The Banjo Lesson* whose faces are pressed together. The old man's face cast in shadow mirrors the boy's closed eyes to show the ways in which poverty, like slavery, can destroy familial bonds. Tanner's ironic choice of title for this canvas, *The Thankful Poor*, reinforces his protest against racial and class inequalities. The grandfather and grandson sit opposite one another, the former wearing a waistcoast and the latter a sleeveless shirt. The similarity of their clothing not only suggests their respectability in the face of poverty but also their parallel lives – the boy may well be destined to grow up to become the mirror image of his grandfather. This painting shows how older generations can fall short as role models for the young and may betray Tanner's own conflicted sense of his role as a mentor for later black artists. Unlike the off-canvas fire which bathes the central figures in a warm redemptive glow in *The Banjo Lesson*, the window in *The Thankful Poor* illuminates their impoverished circumstances. While works such as *The Banjo Lesson* prove that Tanner believed hope could come through the survival of improvised art forms, he provided no such escape for his subjects in *The Thankful Poor*.

Twentieth-century black artist, Hale Woodruff, praised Tanner for being 'critically aware of the aesthetic implications of art and of the relevance to it of his own work' (*HWP* N70–60, Hale Woodruff, 'My Meeting', 1970: 7). Thus, despite brief forays into social and political protest, Tanner's paintings proved his belief in art, first and foremost, as a forum within which to solve artistic questions of light, form, colour and spatial arrangements. And yet, he remained preoccupied with the polit-ical and social struggles facing black artists. When Woodruff met Tanner towards the end of his life, Tanner asked him if life was any better for an African American artist in the United States. 'Does a young artist of color find any semblance of a conducive atmosphere in which to work?' he asked, before explaining that, 'I left the country some years ago because of the unbearable racial prejudices' (Ibid.: 11). Woodruff's answer offered little comfort by suggesting that the African American artist's struggles were far from over: 'I'm afraid little or nothing has changed ... he [the black artist] wants to be judged and treated as a man' (Ibid.: 12).

Notwithstanding a recent flurry of biographical volumes and critical discussions on Henry Tanner and his life, many gaps remain concerning

this artist and his aesthetic practice, particularly within the African American community. Teaching an African American art class in the second half of the twentieth century, Norman Lewis was shocked to realise that 'nobody' had heard of him (in Ghent, 1968a: 16). Similarly, Romare Bearden admitted, 'Tanner is one of the four or five great American painters. And you never see his name mentioned' (in Ghent, 1968b: 17). Scholarly neglect and misunderstandings aside, there can be little doubt that, if Edmonia Lewis is the 'Founding Mother' of African American sculpture, then Henry Tanner remains the 'Founding Father' of black portrait, genre and religious painting.

Conclusion: 'The Door of No Return': The Middle Passage, Slavery and Artistic Legacies

In the 1990s, African American artist, Joe Overstreet, revisited a history of African slavery in the Americas by journeying to Gorée Island, West Africa. He saw for himself the '"horrible"' slave houses where men and women were incarcerated before they were led, as cargo, through what became infamous as the '"door of no return"' to slave ships awaiting on the coast (in Piché, Jr, 1996: 16). This experience inspired his 1993 series, *Facing the Door of No Return*, which consists of numerous densely textured and abstract colour paintings. Their dimensions convey the enormity of African experiences by replicating the proportions of the holding rooms within the slave houses. The layered and crowded surfaces of these paintings are overwhelming. Their chaotic intensity emerges from the tensions between indistinguishable forms created by blurring swathes, fields and drips of black, white, red, yellow and blue paint. These colours intimate confused kaleidoscopes of black and white bodies split apart by violence. As Overstreet urged, 'I needed to personalize my experience there through abstraction ... I didn't want to paint in sorrow ... I ... wanted to capture the sense of the burden of African history' (Ibid.).

By highlighting the importance of 'abstraction' in attempts to represent the 'burden of African history', Overstreet's painting suggests that a close relationship has always existed between formal concerns and thematic expression in works by African American artists. As we have seen, for artists such as Dave the Potter, James P. Ball, Harriet Powers, Edmonia Lewis, Henry Tanner and, much more recently, Joe Overstreet, many continuities as well as divergences can be traced in their art objects and artefacts. Archaeological discoveries and ongoing research demonstrate

that African cultural legacies and African American experiences of the Middle Passage and slavery repeatedly feature in the poetic texts on pots, as well as the many allegorical, religious and abstract motifs embedded in the quilts, daguerreotypes, sculptures and paintings produced by a range of artists across the centuries.

Over a decade ago, abstract sculptor, Melvin Edwards, celebrated the aesthetic richness of an early African art tradition on the grounds that, 'before the Africans had ever encountered the Europeans, they had made art out of anything they wanted, and their art had run the range from realism to total abstraction' (in Brenson, 1993: 9). As he explains, 'It had been decorative; it had been functional; it had been ritualistic; it had been done for throw-away purposes ... it had been done to build societies' (Ibid.). By emphasising the role played by abstraction in these early works, Edwards reiterates Overstreet's view by drawing attention to the experimental and innovative practices of early black artisans and artists. Just as their art may have lacked an 'overt ethnic expression', these artists established their artistic freedom by creating works which resisted popular representations of Africans in the European American imagination.

As early as 1938, African American art historian, Charles C. Seifert, wrote *The Negro's or Ethiopian's Contribution to Art*, a pamphlet in which he countered the scepticism of black rather than white artists and critics who questioned, 'Has the Negro a heritage?' (Seifert, 1938: 13). He was appalled by their disbelief that anyone would want to 'delve in the wreckage of slavery' (Ibid.). Seifert challenged black artists who wanted to 'forget about our African background' by arguing that an 'African artistic and cultural background must play an important part in the Negro's development, if he would return to his pristine primacy in the world of art' (Ibid.). As the next chapter shows, African American artists of the Harlem Renaissance such as Aaron Douglas, Archibald J. Motley, Jr and Charles Alston must have heeded his advice. They were determined to establish an 'art era' which would be built on the dual heritage of an African and an African American past. By creating socially self-conscious and artistically experimental murals, portrait paintings and abstract canvases, Douglas, Motley and Alston paved the way for Melvin Edwards's later belief that, 'if you make things esthetically better, you improve life' (in Brenson, 1993: 17).

'Establishing an Art Era' in the Harlem Renaissance

Aaron Douglas – Archibald J. Motley, Jr –
Charles Alston

'[A] big city that was entirely black, from beginning to end you were impressed by the fact that black people were in charge of things' was how Aaron Douglas described Harlem in the early twentieth century (in Collins, 1971: 3). In the 1920s and 30s, this 'black city' inspired prolific outpourings by artists, writers and musicians. They experimented with paint, sculpture, dance and music to capture the sorrows, joys, hardships and dreams of a new generation of urban African Americans. Speaking of these times, Douglas explained, 'We were constantly working on this innate blackness that made this whole thing important and unique' (Ibid.: 5). During this period, Douglas and other black artists were inspired by his newly discovered realisation that, the 'Negro really never stopped creating art ... from the day he was put ashore in chains at Jamestown, Virginia, in 1619, until the present' (*ADP* 4520, Douglas, 'The Harlem Renaissance': n.d.; n.p.). Abandoning his earlier belief that slavery had suppressed black cultural forms, he was now convinced that the 'fury of his dance could never be stilled' and the 'song never ended' because the 'rhythm of the drum's beat never failed to pierce through the agony of the middle passage, the degradation of slavery, the ecstasy of liberation' (Ibid.).

Ascent of Ethiopia, painted in 1932 by African American artist, Loïs Mailou Jones, typified this new cultural consciousness. Jones experimented with composition, colour and content to cram her canvas with the sounds and sights of Harlem. She inserted black artists and performers into the city's skyline to exalt black accomplishments in music, the fine arts and drama. Gone were her earlier portraits dignifying the lives of lynched black men and labouring black women. Ancient pyramids, Ethiopian headdresses, easels, palettes, pianos and theatrical masks told

new narratives of survival through creative expression in the arts. In this painting, a female figure in Ethiopian ceremonial dress contrasts with a series of diminutive silhouetted black figures in various stages of 'ascent' towards the skyscrapers of modern America. Jones celebrated twentieth-century developments in black arts not as a beginning but as a revival of their ancestral origins in a mythic and ancient Ethiopia. No longer shamed but inspired by their African heritage, bowed and bent black figures ascend from the blue, black and purple depths of this painting to become pianists, theatrical performers and painters in a golden city of promise. Jones's symbolic use of colour proved the redemptive power of art to transform the blues. More generally, *Ascent of Ethiopia* intro-duces many of the new directions begun in the Harlem Renaissance as twentieth-century artists fought to establish a black arts era.

'What kind of picture, what kind of world does a black artist see?' were questions which inspired Aaron Douglas, Loïs Mailou Jones and many other early twentieth-century African American artists (Douglas in Shockley, 1973: 12). More specifically, experimental canvases by Aaron Douglas, Loïs Mailou Jones, Archibald J. Motley, Jr and Charles Alston explode with the agonies and ecstasies of blues and jazz rhythms, cabaret and nightlife, slave history, urban and rural poverty, Civil Rights marches and mythic re-imaginings of Africa. Vivid, epic, poignant and romanticised, these works proved that the arts of early free and slave men and women were not lost but were reborn in the Harlem Renais-sance. In this chapter, I focus on works by Aaron Douglas, Archibald J. Motley, Jr and Charles Alston to examine their particular contributions to African American mural art, genre painting and portraiture, as well as their formal experimentation with abstraction, colour symbolism and compositional arrangements.

In the 1920s, 'Harlem was in vogue' (Lewis, David Levering, 1997: title) for the first time, as white patrons sought black artists, poets and writers to satiate their desires for the 'exotic' and 'the primitive'. Douglas, Motley and Alston fought for aesthetic independence in the face of these demands at the same time that they celebrated an arts legacy in Africa and protested against slavery in explicit and aesthetic terms. All three artists used their art to interrogate and challenge derogatory and stereotypical representations of African Americans in white mainstream imagery. Like many other African American artists in this period, they revisited, subverted and reconstructed popular representations of black humanity as objects of vilification, fear, caricature or humour. Their resistance to

popular stereotypes ranged from Douglas's stylisation of human forms in his murals to Motley's realistic portraits aspiring to scientific exactitude, as well as Alston's abstract canvases which fragmented the picture plane to provide abstract representations of human figures. Their works continue in the vein of the early efforts among black artists to prove to audiences that 'black is beautiful'. As Douglas argued, 'We are possessed ... with the idea that it is necessary to be white, to be beautiful. Nine times out of ten it is just the reverse' (in Kirschke, 1995: 61). Alston was equally disappointed to find that 'whites were more willing to accept Negro beauty as Negro beauty, insofar as it looked like white beauty, in those days at least, than Negroes were' (in Murray, 1968: 7).

'Your problem,' Aaron Douglas wrote to poet, Langston Hughes, 'my problem, no our problem is to conceive, develop, establish an art era' (in Kirschke, 1995: 78). Douglas's determination to create 'an art era' signalled a fresh start for twentieth-century black visual arts. He was the first artist to theorise the techniques and motifs which would become popular among artists such as Alston, Motley and numerous others who wanted to create works according to the 'new racial idiom' and 'school of Negro art' envisioned by Locke (Locke, 1927: 266). Douglas was determined that this new 'art era' should be built on the 'Negro heritage' that had figured too infrequently in works by black artists produced during an earlier period. Harlem Renaissance artists drew on their immediate social and political contexts to dramatise events from black history and establish their right to artistic experimentation. Far from being exclusively a Harlem phenomenon, black artists in this movement emerged from cities as far apart as Chicago and San Francisco and from as far afield as Haiti. According to David Driskell, Douglas preferred to describe the Harlem Renaissance as the 'Negro Renaissance, thereby giving it wider boundaries beyond New York' and 'extending into all of black America' (Driskell, 2007: 87). Readers interested in researching works by other artists are advised to consult Appendix B at the end of this book.

As W. E. B. Du Bois insisted, in this new era, 'our new young artists have got to fight their way to freedom' (Du Bois, 1926: 297). As it turned out, they had to fight for freedom not only against white racist demands but also against the prescriptive views of some black leaders. As Douglas explained, Du Bois 'reacted negatively' towards our 'interest in certain cabaret life, night life' because he 'was afraid' that whites 'would think that this was what Negro life was essentially and completely' (in Collins, 1971: 19). Undeterred, black artists of the Harlem Renaissance battled on

to create an 'outrageous' and 'outlandish' art which would capture the full gamut of African American life (Ibid.: 20).

Aaron Douglas (1899–1979)

'Not white art painted black'

'Let's bare our arms and plunge them deep through laughter, through pain, through sorrow, through hope, through disappointment, into the very depths of the souls of our people,' urged Aaron Douglas, 'and drag forth material crude, rough, neglected. Then let's sing it, dance it, write it, paint it ... Let's create something transcendentally material, mystically objective' (in Kirschke, 1995: 78–9). As an experimental muralist, easel painter and illustrator, Douglas quickly became celebrated as the 'Dean' and 'prodigal son' of the Harlem Renaissance (*ADP* 4520, Douglas, 'Harlem Renaissance: n.d.: n.p.). The first artist to write that the black experience, however 'crude', 'rough' and 'neglected', was the source of his art, he evolved new artistic techniques and included alternative subject matter to 'paint' from the 'souls of our people' in the United States. As Douglas admitted, '[W]e were so hungry at that time for something that was specifically black' (in Collins, 1971: 6). He urged other artists to adopt an experimental approach which would dramatise the realities of African Americans and contribute to a new art history. As this book goes to press in 2008, the first retrospective of works by Douglas is on national tour in the United States (Earle, 2007). The previous absence of any exhibitions of this 'father of African-American art' offers yet further proof of the ongoing neglect typically experienced by African American artists (Kirschke, 1995: xiv).

'Negro life', Aaron Douglas argued, was a 'gold mine if you can write or draw it' (in Collins, 1971: 11). One of the most important ways in which he challenged representations of African Americans in art was by turning to black working-class lives. He held firm that the 'man in the streets' was the 'thing on which and around which this whole idea was developed' (Ibid.: 4). As a measure of his success, Langston Hughes was convinced that Douglas's 'strange black fantasies caused the smug Negro middle class to turn from their white, respectable, ordinary books and papers to catch a glimmer of their own beauty' (in Kirschke, 1995: 41). By celebrating the 'laughter' and 'sorrow' of factory workers, farm labourers and the dispossessed, Douglas challenged taboos of appropriate black content and advanced new directions for African American art. He presented 'black life' on its own 'terms' by revelling in epic and

mythic representations of a tribal Africa (in Collins, 1971: 14). Moreover, he experimented with abstraction and symbolism to communicate the tragedies and joys of rural and urban life, north and south. Douglas's ambitious works relied on oral testimony and folklore to address issues surrounding black history, class conflict, spirituality, ancestry and a fight for survival in the modern era. As he insisted, 'We must let down our buckets into our own deep souls' (in Hemenway, 2007: vii).

The controversies surrounding Aaron Douglas's works betray many of the intellectual differences dividing early African American art critics, James Porter and Alain Locke. While Locke urged artists to search for a new 'racial idiom', Porter believed that 'racial traits and racial themes' were the 'twin devils which assail the peace of the artist' when they become the criteria on which to judge African American art (Porter, 1942: 16). 'How do racial traits then particularise the racial theme?' he asked. 'What signs betray the presence of biological and psychological traits indicating race in art?' (Ibid.: 17). On the one hand, Porter reviled Douglas's work for its poor imitation of the 'surface patterns and geometric shapes of African sculpture' (Porter, 1984: 94–5). He was offended by Douglas's 'species of exoticism, fanciful and unpredictable rather than controlled, pointing to an effort to find an equivalent in design for the imagined exotic character of Negro life' (Ibid.: 103). His insistence that Douglas's characterisation was 'imagined' refused to approve of his representation of black heroic exemplars alongside the poverty-stricken and dispossessed. 'Notably individual, but developed out of the academy tradition', Locke, on the other hand, believed that Douglas was 'one of the pioneer Africanists' (Locke, 1936: 67). His style which had developed 'successfully to a modernized version of African patterns' made him 'an outstanding exponent of Negro types and design motives' (Ibid.: 68). More recently, Bearden and Henderson argue that Douglas 'combined a sharp, angular style with a sophisticated sense of design, using symbolic silhouettes of black people and objects' (Bearden and Henderson, 1993: 127). For Michael Harris, his experimentation with simplified silhouettes of African American anatomies revived conventions of Egyptian art to visualise 'Negro aspirations, histories, and legacies' as well as scenes of 'racial violence' (Harris, 2003: 218).

In this chapter, I examine Douglas's multi-part mural series, *Aspects of Negro Life* (1934), and his painting, *Into Bondage* (1936, Plate 1). An analysis of these works establishes the ways in which the visual tensions which characterise Douglas's murals and paintings are derived from

his self-conscious juxtaposition of taboo content with highly aestheti-
cised forms. The first artist to insist that black art must not be 'white art
painted black', Douglas's call for a separate African American visual arts
tradition inspired many future artists (in Kirschke, 1995: 78). During
his lifetime, he pushed the boundaries of appropriate subject matter
and available iconography to unveil the psychological complexities of
African American life in the United States. 'Technique in itself is not
enough,' Douglas insisted, on the grounds that the artist must 'develop
the power to convey emotion' (in Bearden and Henderson, 1993: 135).

Aspects of Negro Life (1934)

'I tried to keep my forms very stark and geometric with my main emphasis
on the human body' was how Aaron Douglas explained his representa-
tion of black subjects in his oeuvre (in Bearden and Henderson, 1993:
130). Determined to 'put out the whole of negro life', he single-handedly
ushered in a new generation of black artists (in Collins, 1971: 20). By
popularising a tradition of African American mural painting, inspired
by Mexican and Social Realist movements, Douglas sought to redefine
nationalist paradigms and reclaim the black workers whose lives had
'gone into the building of America' (Ibid.: 32). His epic works were
also influenced by didactic nineteenth-century antislavery panoramas
which voiced political protest by exploding the myths surrounding black
history. As Douglas explained, his murals provide 'a panorama of the
development of Black people in this hemisphere' (Ibid.: 31). They often
begin 'in Africa' and trace 'the slave situation' through 'emancipation
and freedom' (Ibid.). Painted in 1934 for the Harlem branch of the New
York Public Library, his most famous mural series, *Aspects of Negro Life*,
follows this structure. The titles of the individual panels are self-explan-
atory: *The Negro in an African Setting*, *An Idyll of the Deep South*, *Slavery
through Reconstruction* and *Song of the Towers*. Black silhouetted figures at
work, at play and in protest dominate his mythic and abstract representa-
tions of African idylls, southern plantations and urban-scapes. In these
panels, Douglas's black subjects cease to be the footnotes as they become
the catalysts of American history.

Aaron Douglas's technique for representing black figures in his
canvases was unprecedented in African American art. He was inspired
by the 'Egyptian form' according to which 'the head was in perspective
in a profile flat view, the body, shoulders drawn to the waist turned half
way' (Ibid.: 13). He kept his figures 'broad' with as 'little perspective' as

possible and 'no face ... done in front view' (Ibid.: 12–13). The 'only thing that I did that was not specifically taken from the Egyptians was an eye I made,' he conceded (Ibid.: 13). Douglas's introduction of this 'eye' which withheld the enigmatic mask-like potential of his figures was designed to prevent them from becoming faceless and unreadable. However, audiences should be warned against establishing direct parallels between Douglas's works and Egyptian art. Because many of his 'Africanisms' were invented as taken from specific sources due to dead ends in his research, he 'tried to read and get up on this thing, but there wasn't much that you could get a hold of' (Ibid.: 32. Douglas's insistence that he was forced to portray 'everything not in a realistic' but in an 'abstract way', even to begin to approach the inner realities of black life, establishes a key feature of African American art. His design patterns and abstract stylisations exposed the limitations of realist or documentary modes ever to represent the distorted, marginalised and elided facets of black culture (in Bearden and Henderson, 1993: 130).

Douglas's *Aspects of Negro Life* takes shape not only from his signature style of flat Egyptian inspired forms but also via his experimentation with geometric compositions, concentric circles and a restricted palette. 'At that time,' Douglas claimed, 'blue was blue to me. I had very little range' (Ibid.: 134). On the surface, this multi-panel work endorses an uncomplicated trajectory of progress by tracing black history from its beginnings in Africa and on through slavery and Reconstruction into modernity. And yet, Douglas's Africa is far from the destitute, pagan realm of white racist thought while the urban north of his modern America bears very little resemblance to utopian representations. His use of abstraction and symbolism introduces ambiguities and paradoxes which should cause us to question his narratives of racial uplift. Just as the existence of early art objects and artefacts proved the extent to which art signalled resistance regardless of content, *Aspects of Negro Life* celebrates black survival through the artistic imagination. Each panel exalts in art forms such as the spirituals, jazz and the blues which slavery was not only unable to extinguish but almost undoubtedly inspired. The first panel celebrates African dance, drums, clothing and sculpture while the second, third and fourth revel in music and song. Throughout this series, Douglas juxtaposes highly aestheticised forms with disturbing and shocking subject matter to inspire different emotions in his viewers.

The first panel, *The Negro in an African Setting*, contrasts with the final work, *Song of the Towers*, to show how the 'strongly rhythmic arts

of music ... dance and sculpture' have 'influenced the modern world' (*ADP* 4520, Douglas, *An Autobiography*, n.d.: 18). The stylised and silhouetted bodies of two black dancers dominate this composition as both figures reinforce conventional gender roles. The female dancer wears a grass skirt and ornately dressed hair while her male companion dances with spears. Their juxtaposition evokes movement and energy as they weave in and out of Douglas's concentric circles. These spotlights layer the painting to create depth in distinct bands of light and brown, black, purple and white colour. Directly above the dancers hangs a fetish – a spiritual and magical talisman commonly used in ceremonies and rituals. This object, a human figure reduced to its minimal abstract form, celebrates the 'magic spell of the fetish' which 'plays so large a part in African religions' (Ibid.: 15). In this work, two sets of African onlookers armed with spears face one other across the bodies of the dancers. Their open mouths and upturned faces distract our attention away from their physicality to suggest spiritual transcendence. As Douglas argued, the 'fetish, the drummer, the dancers in the formal language of space and colour recreate the exhilaration, the ecstasy, the rhythmic pulsation of life in ancient Africa' (Ibid.). His otherwise sophisticated juxtaposition of dancers and onlookers in this panel draws attention to his essential-ising and romanticised dramatisation of the exhilarating, ecstatic and rhythmic 'aspects' of African life which countered popular views of African Americans as bereft of an arts legacy. However, Amy Mooney's suggestion that Douglas included 'a number of reductive, primitivising ideas' oversimplifies the complexities of his art (Mooney, 1999: 164). While he no doubt drew on essentialising myths to create a stereotypical Africa forged out of 'primitive' desire, raw emotion and energised physi-cality, his two 'tom-tom player[s]' in the foreground of this work invite alternative readings (*ADP* 4520, Douglas, *An Autobiography*, n.d.: 15).

Speaking of the murals he completed for Fisk University, Douglas identified the dance of his figures as the 'war dance' which was a 'boon to slavers' because it 'inspired many of the petty conflicts between tribes' (Ibid.: 15). Given that the spears held by the figures in *The Negro in an African Setting* suggest their warrior status, their bodily gestures may represent such a war dance and reflect Douglas's conviction that white slave owners encouraged these rituals to divide Africans and capitalise on indigenous cultural practices. According to this view, *The Negro in an African Setting* ceases to be a nostalgic pastiche and becomes a forceful work of protest. Furthermore, this painting contrasts with Motley's

Africa (1937) which portrays the colliding and chaotic brown, black, purple bodies of African men and women. However, the faces in Motley's work verge on caricature as they possess exaggerated lips and extended nostrils while they hold their spears aloft and dance around a burning fire. By comparison, Douglas's figures are understated, silhouetted and ambiguous; their mask-like profiles possess only the narrow slit of a single eye to show emotion. Douglas's angular, stylised forms evoke the aesthetic legacy of Egyptian paintings and masks to suggest that the ancestral arts of Africa existed long before the arrival of slaves into the Americas. He relies on call and recall across this series as unidentified, triangular shapes which loom behind the dancers and the onlookers in this first painting become transformed in *An Idyll of the Deep South* and *Slavery Through Reconstruction*. They lose their ambiguity to become the hoods of the Ku Klux Klan in these second and third works. While *The Negro in an African Setting* appears to perpetuate stereotypes of a mythic happy Africa, Douglas's abstract use of form and composition introduces ambiguity by awarding dignity to his black subjects at the same time that he tackles taboo subjects.

 An Idyll of the Deep South and *Slavery Through Reconstruction* are panoramic works whose monumental size and epic time frame display the contradictory lives of African Americans. Douglas combines historical fact with artistic licence to re-imagine the daily lives of those without a written legacy. *An Idyll of the Deep South* is no idyll at all as he split the canvas into three parts to show slaves in mourning, slaves in song and slaves at work. The first scene dramatises black, brown and beige men and women in attitudes of despair. On their knees, they look up at brown feet which hang ominously in the air next to a long slither of rope. There is no mistaking the lynching which has taken place off canvas. Douglas takes his technique of Egyptian stylisations of the black figure a stage further in this painting by removing the black body altogether. He denies audiences the satisfaction of gazing upon a mutilated black body to award agency to enslaved Africans and thwart white southern traditions of displaying bodies on auction blocks, postcards and in scientific journals. The scene on the far right includes hunched-over bodies which present a mirror image of the mourners in the first scene. However, these black figures do not mourn but are at work tilling the slave fields of the south. By depicting a solitary male slave who has ceased to work and holds an axe vertically above his head, Douglas contradicts representations of passive obedience by providing a gesture which visually echoes

the warrior spears of *The Negro in an African Setting*. White concentric circles illuminate his mask-like face as he listens to the musicians of the central scene to reinforce the interrelationships between music, art and political resistance which characterise this series as a whole.

Aaron Douglas's *Aspects of Negro Life* celebrates diverse forms of slave rebellion ranging from the retention of African practices to a refusal to work, suicide, flight and musical performance. The central scene of this panel, celebrating the 'idyll' of the title as slaves gather together to dance, sing and play banjos and guitars, is the most unsettling of the series. Douglas's concentric circles initially suggest that these are the 'happy darkies' of plantation mythology. However, by looking closer, we soon realise that the concentric circles reverberating outwards from the musicians illuminate the mourners and labourers in a blue wash to evoke the blues of black struggle. Douglas's decision to surround these slave singers and performers with visions of black suffering, death, labour and sorrow betrays the double meanings of the spirituals and musical performance during slavery. His third panel, *Slavery Through Reconstruction*, similarly juxtaposes Ku Klux Klan terrorism with black heroism. While the hooded figures of the Klan wield terror over black workers held back by cotton plants, a black figure dominates the foreground. Douglas's argument that this figure 'symbolizes the career of outstanding Negro leaders' prophesies the importance of black heroic figures as emblems of survival and resistance in twentieth-century African American mural painting (*ADP* 4520, Douglas, *An Autobiography*, n.d.: 18).

The African American figure of Douglas's final panel, *Song of the Towers*, mirrors the heroic leader of *Slavery Through Reconstruction*. However, instead of pointing towards a Promised Land while brandishing Abraham Lincoln's Emancipation Proclamation, this man holds a saxophone above the Statue of Liberty. Both works dramatise the ambiguities and paradoxes of the ongoing fight for black freedom in the United States. And yet, Douglas's title, *Song of the Towers*, emphasises that the 'song is the most powerful and pervasive creative expression of American Negro Life' (*ADP* 4522, Douglas, 'Interpretation', n.d.: n.p.). He specifies 'three different types' in this painting including 'Songs of Deliverance, Songs of Joy and the Dance and Songs of Depression and the Blues' (Ibid.). This eclectic mix of 'Songs' suggests a full range of emotions including sorrow, uplift, religious ecstasy and despair. At the same time, they also represent three stages of black masculinity – enslaved, emancipated and 'free' – which Douglas portrays as a man prostrate, a man half-stooping

and a man fully erect. He complicated his own view that this work 'repre-
sents the will to self-expression' in the 'anxiety and yearning from the soul
of the Negro people' by providing an ambiguous trajectory of progress
(*ADP* 4520, Douglas, *An Autobiography*, n.d.: 18).

In *Song of the Towers*, Douglas represented the first stage of black
manhood by including a downbeat figure which encapsulates both
the legacy of slavery and the 'confusion, the dejection and frustration
resulting from the depression of the 1930's' (Ibid.). Beneath him lies
the 'yawning, glittering chasm, the symbol for Harlem and all of our
other ghettos' (*ADP* Reel 4522, Douglas, 'Interpretation', n.d.: n.p.). By
comparison, the second figure runs up the cog of industry – a 'symbol
of industrial, urban life' – to represent the perils of black migration. He
barely escapes the 'clutching hand of bondage' symbolised by ghoulish
green ferns (*ADP* 4520, Douglas, *An Autobiography*, n.d.: 18). Even
the final central figure whose 'raised foot' taps 'out carefree rhythms
of joy and exultation' remains ambiguous (*ADP* Reel 4522 'Interpreta-
tion', n.d.: n.p.). In this work, the concentric circles and the moving cog
suggest that this man's emergence from slavery and ghetto poverty is far
from secure. However, his hold on the saxophone demonstrates that he
will survive through creativity in blues and jazz performances.

Concerning his fourth panel, Aaron Douglas admitted that he was
'careful to associate [his] figures so that they looked like the working
people' by giving their clothing 'ragged edges' to 'keep the thing realistic'
(in Collins, 1971: 15). Yet how far he captures the hardships of the black
labourer is moot, given that their expressions and emotional depth are
heavily guarded in his stylised representations. In this work, Douglas
complicated his celebration of Harlem as a source of progress and black
cultural revival by hinting at the despair of ghetto life. 'Art will take root
in the masses, if it is again to become a profound and moving force in the
lives of men,' he argued (in Kirschke, 2007a: 118). 'But if art is to be of
any real service and satisfaction to men, it must be loved and not simply
used' (Ibid.: 118). By emphasising an emotional connection with art over
and above its practical or 'use' value, Douglas asserted the importance of
interrelationships between aesthetics, politics and audience reception in
works by African American artists. Ultimately, Aaron Douglas's *Aspects
of Negro Life* betrays his belief that the Harlem Renaissance represented
'a quickening of the life rhythms in the souls of black folk which had
miraculously' survived 'two hundred and forty years of slavery' (*ADP*
4520, Douglas, 'Forward to the Harlem Renaissance', 1971: 2).

Into Bondage (1936, Plate 1)

'We were seeking in naïve and simple ways to kindle a fire, to infuse breath into the black man's inert body' was Aaron Douglas's claim for the aesthetic practices of Harlem Renaissance artists (Ibid.: 3). In later paintings, such as *Into Bondage* (1936, see Plate 1), he dignified black masculinity by returning to many of his earlier themes including a romanticised Africa, slavery, spirituality, the blues and black suffering. Exhibited as part of the controversial Texas Centennial Exhibition, this work started life as one of the murals adorning the interior of the 'Hall of Negro Life' (Ater, 2007: 95). As such, this large scale painting was one of a series of works, including *Aspiration* (1936), which were designed to dramatise the epic journey of African Americans in the struggle from slavery to freedom. Douglas's summary of a later Fisk University mural reads almost as an exact description of *Into Bondage*. Writing that 'a long line of slaves, chained together, march down to the sea', he suggested that the 'light of Christianity penetrates the encircling shadows and causes red and yellow ribbons of light to surround the figures' (*ADP* 4520, Douglas, *An Autobiography*, n.d.: 15). A key difference in these descriptions, however, concerns the symbolic use of colour in both works. While Douglas drenched the Fisk University mural in reds and yellows to suggest divine redemption, the slaves in *Into Bondage* are offered no such hope. They remain immersed in blues, browns, greens and purples to communicate the horrors of their experience. A red star in the top right of this canvas is the sole source of spiritual redemption as a diagonal strip of yellow light emanates outwards to illuminate the silhouetted facial features of the black male slave in the foreground. His tilted face looks upwards towards the light as if to offer hope by evoking an inner spirituality which may transcend the limitations of his fettered physicality. As he suggested, '[t]he past rather than constituting a burden on our backs or a stone around our necks can become, when properly understood, the hard inner core of life' (in Ater, 2007: 105). Critics who suggest that this star is the red star of Communism draw attention to Douglas's tendency to see parallels between the plight of slaves and the destitution of twentieth-century workers.

The central black male slave in *Into Bondage* stands on a plinth while lines of bowed and shackled women and men walk towards the slave ships waiting in the distance. This plinth may represent an auction block to show that slaves were bought and sold within Africa by European 'middlemen' and Africans colluding with European traders. Such an

interpretation complicates Douglas's inclusion of lush foliage which suggests a mythically idealised and exoticised Africa. The facial features of this slave are far more detailed than many of his earlier representations of black physicality. Douglas not only introduces his signature 'eye' to this flat silhouetted form but he also verges on caricature by including the lips and hair popular within racist iconography. He offsets his tendency towards stereotyping by exaggerating the exemplary musculature of this slave. In particular, this erect male slave contrasts with the black female slave on the left of this canvas who holds her shackled hands above her head as if begging for mercy. However, we should be careful not to read too much into what seems to be Douglas's representation of black male agency versus black female passivity given that he celebrated the heroism of black female freedom fighter, Harriet Tubman in an earlier mural titled, *Spirits Rising* (1930–1).

The major challenge Douglas faced was the search for ways in which 'to see the world as a black artist would have seen it imaginatively' (in Shockley, 1973: 13). His imaginative interpretations of black subject matter resonate with David Driskell's view that he 'came close to inventing his own painting style' in a 'commitment to creating a language for Black artists' (Driskell, 1994: 110). Douglas was convinced he was before his time: 'I still hope to involve people in an outlook on things that so far hasn't emerged' (in Shockley, 1973: 30). His success as an artist derives from his experimentation with silhouettes and design patterns to provide abstract representations of African Americans which rely on symbolism and allegory. By including concentric circles and stylised forms, he opened up new ways in which to visualise black experiences and suggested alternative approaches for future artists. Douglas argued for the necessity of abstract experimentation throughout his paintings by insisting on the difficulty of realist modes ever to recover visual narratives of black history. In many of his works, he revived a legacy of slavery alongside a lost heritage in Africa to answer Du Bois's question, 'What have we who are slaves and are black to do with Art?' (Du Bois, 1926: 297).

Recurring themes of struggle and martyrdom in Douglas's murals and paintings reflect his own sense of isolation and marginalisation as an artist. As Sharon Patton argues, one of his early works, *The Crucifixion* (1927) which shows Simon, a North African, attacked by arrows as he carries Christ's cross, may offer a 'metaphor for the African-American experience' (Patton, 1998: 119). Perhaps this painting relies on religious

allegory to comment upon the plight of the black artist who must similarly bear his burden in the face of persecution. Regardless of hardships and racist abuse, Douglas opposed white injustices by exalting in a sense of his own blackness. 'I am, however, beginning to realize how good it is to be black,' he asserted. 'Otherwise this awful grinding gristmill of mediocrity would long ago have devoured us. As it is we are free to think, to feel, to play with life, to enjoy life. Our white brother is sick. Spiritually sick. Sick unto death. He spoils everything he touches' (in Ragar, 2007: 83). By associating whiteness with destruction, Douglas celebrated blackness as a source of creativity and imaginative possibility. Ongoing research suggests that Archibald J. Motley shared Aaron Douglas's determination to address political issues at the same time as adopting an experimental aesthetic practice in his controversial canvases.

Archibald J. Motley, Jr (1891–1981)

'Every picture should tell a story'

'[T]o hell with racism ... We're all human beings' (Motley in Barrie, 1978: 15). If Douglas is the 'prodigal son' of the Harlem Renaissance, then Archibald J. Motley, Jr is the skeleton in its cupboard. As much as Douglas celebrated the Harlem Renaissance as a 'cultural experience' which 'had the possibility of being a base for greater development', Motley was as convinced that there had been 'no Renaissance' (in Collins, 1971: 3; in Barrie, 1978: 20). Confrontational statements, such as 'to hell with racism' and 'I don't give a damn what color my skin is', set Motley apart from Douglas, Alston and many other artists who protested against black suffering by celebrating a distinct cultural legacy (in Barrie, 1978: 21). He made himself unpopular by arguing that 'our people' have 'very little interest in art' because those with enough money buy 'nice Cadillacs' (Ibid.: 15). Motley did not mince words: '[M]y race was the most critical of critics,' he argued, even though 'they knew less about art than anybody else' (Ibid.: 16). Unwilling to let this overwhelm him, however, he experimented with aesthetic techniques and transgressed the boundaries of accepted subject matter to try to reach those black audiences he criticised.

Motley was the first 'nationally recognised' African American artist to paint 'black subject matter almost exclusively' (Raverty, 2002: 25). He was also one of the first black artists to introduce black labourers as suitable subjects for portraiture as well as to create scenes of black community life. 'I felt that my race had always had to struggle, to labour,'

he wrote, 'and that labour was its history in this country' (in Bearden and Henderson, 1993: 152). His second self-portrait, subtitled *Myself at Work* (1933), confirms the close relationship which he believed existed between artist and worker. His canvases dramatise African Americans dancing, drinking, singing, working, praying, dreaming and loving in impoverished and opulent urban settings. He went further than Douglas who believed that the 'man on the street' was 'a part of' a Harlem Renaissance 'he didn't understand', to experiment with his subject-matter to ensure that they would grasp his meaning (in Collins, 1971: 4).

Early in his career, Archibald Motley stopped painting portraits to create genre scenes on the grounds that the 'colored race' did not have the 'money to pay for commissioned portraits' (in Barrie, 1978: 13). These works fulfilled Motley's need to 'paint compositions and pictures that people will buy regardless of race, color or creed' and have since proved popular with critics (Ibid.). His life's mission was to 'instil' an 'appreciation of art' into black audiences by putting 'them in the paintings themselves, making them part of my own work so that they could see themselves as they are' (Ibid.: 15, 16). He was as committed as Douglas to creating his compositions around the human body: 'I build all of my paintings on geometrical forms which make up the human figure' (*AMP* 3161, Motley, 'How I Solve My Painting Problems', n.d.: 1). Motley fought to overcome the barriers presented by white patrons to reach black audiences and contribute to new developments in African American art. His lack of success was less likely to do with his choice of subject matter than with his selection of form. Paintings were expensive. Later black artists opted for black and white prints which could be mass reproduced and sold very cheaply.

As a forebear of the African American artists emerging from Chicago in the 1920s, Archibald Motley's contemporaries include Richmond Barthé, Eldzier Cortor, Hale Woodruff, Margaret Burroughs, Ernest Crichlow and Hughie Lee-Smith. His outpouring of portraits, genre scenes and political works contests Amy Kirshcke's view that Douglas was the 'sole visual artist of the Harlem Renaissance' (Kirschke, 1995: 126). He may not have emerged out of the Harlem tradition but he was as committed as Douglas to representing 'what they call the full gamut, or the race as a whole' (in Barrie, 1978: 12). While Douglas aspired to painting the 'man on the streets', it was Motley who realised this ambition. His works celebrate the opulent lives of black elites alongside the hardships and dreams of farm labourers, ex-slaves, street vendors, card and pool

players, lynched victims, factory workers, musicians, religious worshippers and dancers. Motley took up where Douglas's conviction that '[t] echnique in itself is not enough' left off to argue that 'subject matter plays a most important role in my art' (*AMP* 3161, Motley in Harold Haydon, 'A Painter', 1971: n.p.). In his paintings, he experimented with symbolism and allegory to create visual narratives which supported his view that, 'if a picture doesn't tell a story, then it's not a picture' (in Barrie, 1978: 13). Motley's determination that the story should be communicated either via 'subject matter' or 'technical expression' reflects his belief in the inextricable relationship between form and content (*AMP* 3161, Motley, 'How I Solve My Painting Problems', n.d.: 1). He reworked his compositions to create a dense, symbolic visual language on the principle that there should be a 'reason for every object put into a painting' (Ibid.).

One of the main criticisms levelled at Motley concerns his tendency towards stereotyping in his genre scenes of black urban life as well as his penchant for delineating light-skinned African-Americans in his portraits. Locke identified 'a broad, higher-keyed and somewhat lurid color scheme' in his works which emphasised the 'grotesque and genre side of modern Negro life' (Locke, 1936: 69). He argued that Motley dramatised this subject matter 'sometimes satirically, sometimes sympathetically' (Ibid.). For once Porter agreed, arguing that his was a 'naively romantic approach' fascinated by 'exotic subjects' (Porter, 1943: 105, 106). Wendy Greenhouse also criticises Motley for creating 'upbeat paintings' in which 'racial bigotry' was 'invisible' (in Robinson and Greenhouse, 1991: 33). However, Cedric Dover argues that they are 'social comments but not satires' while Elsa Fine suggests that they 'stop just short of caricature' (Fine, 1973: 112).

These ambivalent views sit uneasily with what Motley claimed he was doing. 'I was trying to fill what they call the full gamut, or the race as a whole,' he explained, 'not only, you know, being terribly black but those that were very light and those that were in between ... I try to give each one of them character as individuals' (in Barrie, 1978: 12). Despite the problematic implications of Motley's description of those who were 'terribly black', his determination to give each of his subjects 'character as individuals' should not be discounted. Contrary to popular belief, he was not trying to portray types in his art but was hoping to capture human idiosyncrasies. He created realistic portraits to protest against popular misconceptions in white racist mythologies of the 'Negro as the ignorant, Southern "Darky", to be portrayed on canvas as something humorous;

an old Southern Black negro gulping a large piece of watermelon; one
with a banjo on his knee; possibly a "crap shooter" or a cotton-picker or
a chicken thief' (*AMP* 3161, Motley, 'How I Solve', n.d.: 5–6). '[This]
material is obsolete,' he argued, claiming that the 'Negro is no more the
lazy, happy go lucky, shiftless person he was shortly after the Civil War'
(Ibid). Whether or not he succeeded in overturning racist stereotypes
depends on whether we are looking at his portraits, genre scenes or polit-
ical allegories. Either way, Motley's revisionist bias existed alongside his
own tendencies towards stereotyping and elitism.

The preoccupation among criticism with Motley's genre scenes has
contributed to an unjust neglect of his portraits and political works. In
this chapter, I examine Motley's portrait of his grandmother, *Mending
Socks* (1924, Plate 2), and one of his last paintings, *The First One Hundred
Years* (1963–72), to complicate dismissals of this artist as perpetu-
ating black stereotypes. On the contrary, it is more accurate to analyse
Motley's work in light of what Sharon Patton sees as his 'sub-theme
about social isolation' which David Raverty summarises as his 'search of
identity' (Patton, 1998: 138; Raverty, 2002: 25). '"Give the [artist] of the
Race a chance to express himself in his own individual way but let him
abide by the principles of true art, as our [white] brethren do",' Motley
insisted, '"and we shall have a great variety of art, a great art, and not a
monotony of degraded art"' (in Mooney, 2004: 164). Overall, Motley's
canvases endorse his belief in the black artist's right to artistic freedom so
that she or he could develop their own identity and create 'great art'. '"If
all Negro artists painted simply Negro types",' Archibald Motley urged,
'"how long would our Negro art exist?"' (in Raverty, 2002: 28).

Mending Socks (1924, Plate 2)

Archibald Motley's grandmother, a 'pigmy from British East Africa',
is the subject of one of his earliest portraits, *Mending Socks* (Motley in
Barrie, 1978: 1). As a former slave, he explained in an interview, she had
'told me so many wonderful stories' about slavery (Ibid.). Unlike the
enslaved victims of Douglas's canvases, Motley's grandmother 'loved
her master and mistress' (Ibid.). He described how he included the 'oval
painting' of 'her young mistress' to tell 'a very beautiful story' in this
portrait (Ibid.). His grandmother was given this picture 'when she was
freed' and she 'took care' of it 'like a very valuable diamond' (Ibid.).
Motley's examination of an idealised relationship between mistress and
slave prepares the viewer for an experience of slavery which contradicts

tales of anguish and horror. By representing his grandmother's excep-
tional story of better conditions during slavery, he confirmed his interest
in portraying African American individuals rather than 'Negro types' in
his art. As Wendy Greenhouse argues, his portraits 'broke new ground
in their assertion of the individual African American as worthy of formal
portrayal' (Greenhouse, 1998: 99). And yet, his lack of hesitation in
examining 'wonderful' stories which ran counter to revisionist histories
of black suffering in slavery establishes his frequently overly idealistic
bias. Many of his portraits and genre scenes eschew messy realities to
provide riotous, exuberant and upbeat fantasises of black life.

Archibald Motley celebrated *Mending Socks* as 'one of the best things
I've done' (in Barrie, 1978: 11). His impoverished circumstances at the
time of creating this work forced him to improvise and construct his
canvas from 'old railroad laundry bags' (Bearden and Henderson, 1993:
149). Clearly, this painting is neither a caricature nor a 'straightfor-
ward and simple' record of the life of a black female subject. As such,
this portrait can be compared with *Woman Peeling Apples (Mammy)*
(Nancy) finished in the same year. By comparison, in this work, a dark-
skinned African American female wears the multicoloured bandanna of
the plantation 'mammy' stereotype. However, Motley resisted tendencies
towards caricature by drawing on conventions of realism to personalise
her facial features and represent her strong but aged hands labouring over
the apples in her lap. *Mending Socks* similarly dramatises female labour
as his grandmother sits darning socks. However, while the work clothes
of the 'mammy' or 'nancy' of the other portrait suggest that she peels
apples in service to another, Motley's grandmother is 'mistress' of her own
traditional, middle-class domestic setting. The chore of 'Mending Socks'
is not imposed upon his grandmother but is one of her household rituals.
'Every day all socks were gathered to-gether for mending,' Motley wrote
(*AMP* 3161, Motley, 'How I Solve My Painting Problems', n.d.: 3). His
grandmother sits in an ornately carved wooden chair submerged in the
trappings of wealth while the surroundings of the woman 'peeling apples'
are unspecified. Unlike this woman who looks directly at the viewer,
Motley's grandmother retains subjectivity and emotional complexity
by hiding her expression as she bends over her work, oblivious to her
audience. Both *Woman Peeling Apples* and *Mending Socks* evoke conven-
tions of realism to undermine generalised stereotypes of black woman-
hood. While Douglas aggrandised his black figures by opting for a flat
Egyptian stylisation, Motley adopted a pseudo-scientific approach to

capture details of physiognomy and resist caricature. His admission that his portraits of African Americans represented not only 'an artistic venture but also a scientific problem' should not be read as objectifying but as humanising his black subjects who were otherwise victims of gross caricature in popular white American culture (Ibid.).

Mending Socks not only reflects Motley's desire 'to paint my people just the way they were' but also includes symbolic artefacts to act as touchstones for interpreting their individual histories (in Barrie, 1978: 16). He surrounded his grandmother with 'those things she loved best' including her 'old faded brick-red shawl' which 'she wore continuously and always fastened it to-gether with a hand-painted brooch of her only daughter' (Ibid.: 3). 'Above her head on the wall,' he explained, 'hangs her crucifix she loved so well and in the upper left corner of the canvas hangs a portrait of a young lady, her mistress during the days of slavery' (Ibid. 4). He justified the inclusion of a fruit bowl and books on the grounds that '[s]he was very fond of fruit and read the bible daily' (Ibid.). By celebrating his grandmother's personal history, these mementoes and artefacts highlight the idiosyncrasies of her story which ran counter to public narratives of slavery. Harris even argues that the 'Native American pattern' of the tablecloth comments on her mixed racial heritage while the shape of the piled socks insinuates 'her African birth' (Harris, 2003: 156). Thus, Amy Mooney may be right to assert that *Mending Socks* 'filtered the past through a nostalgic lens' (Mooney, 2004: 25). Motley's softened colours support interpretations of this portrait as a sentimental representation of the domestic, hard-working, respect-able, pious and maternal ex-slave woman. 'I purposely used subdued colors in conformity with my grandmother's age and general attitude,' he admitted and, at the same time, 'I tried to harmonize her age-worn and shaky hands with the age in her face' (*AMP* 3161, Motley, 'How I Solve My Painting Problems', n.d.: 4).

However, this reading is far from the whole story. As Kimberly Pinder argues, Motley set up a 'contrast between the grandmother and the stark white Jesus' in this work by positioning the crucified body of a white Christ directly above the grandmother's bowed head (Pinder, 1997: 224–5). This statue not only proves his grandmother's religious piety but may also symbolise untold stories of black martyrdom. Just because Motley's grand-mother did not suffer in slavery, it does not mean that she escaped hardship. The broken body of Christ crucified on the cross reflects a dominant theme within African American art and specifically echoes Douglas's earlier

painting, *The Crucifixion* (1927). Perhaps this statue operates as a talisman or substitute for the suffering of African Americans which was far more typically the case during slavery. In this context, Motley's choice of title, *Mending Socks*, may offer more than a literal description of the painting's activity. The subject of black female creativity is as much the theme of this painting as slavery. Set within a slave history of improvisation, the act of 'mending' signifies upon a tradition of quilting and patchwork. As we saw in Chapter 1, numerous slave women explored the possibilities of an artistic imagination by creating art from whatever materials they had. As Motley himself admitted, his grandmother was in fact 'artistically inclined' and, 'if she had only had the opportunity ... would have accomplished much in some branch of the arts' (*AMP* 3161, Motley, 'How I Solve My Painting Problems', n.d.: 3). Rather than providing a simple record of the life of an emancipated slave woman, *Mending Socks* eulogises the buried creativity of unknown enslaved artists.

Many critics of *Mending Socks* analyse the possible meanings of Motley's symbolic objects at the expense of his compositional devices. This is surprising given his fascination with composition as a means to free up 'your imagination' (in Barrie, 1978: 7). While his African grandmother dominates the canvas, the slave mistress, represented in a portrait within a portrait, is partially obscured. This detail may suggest a much more celebratory endorsement of the radical reversal of power dynamics following the end of slavery than the grandmother's 'love' of her slave owner admits. Now fully emancipated, Motley's grandmother has taken charge of her domestic life by owning herself and her labour. By relying on a symbolic use of light and dark in this painting, he illuminates every line of his grandmother's skin and every strand of her hair while the features of the slave mistress are barely visible. It is not likely that this is accidental given his 'love of the play of light in painting' (*AMP* 3161, Motley, 'How I Solve My Painting Problems', n.d.: 2). *Mending Socks* is much less an idealised vision of racial harmony as it is an unresolved retelling of the hidden histories embedded in the interwoven lives of white slave mistresses, African ex-slave women and mixed-race daughters.

The First One Hundred Years (1963–72)

'WHITES ONLY'; 'WE WANT FREEDOM NOW'; 'GO HOME NIGGERS AND GET YOUR RELIEF CHECK'; 'WE SHALL OVERCOME'; 'WHITE POWER' – these are just some of the slogans which haunt one of Motley's last paintings which he began in

1963 and which remained unfinished but abandoned in 1972. *The First One Hundred Years: He Amongst You Who Is Without Sin Shall Cast the First Stone: Forgive Them Father For They Know Not What They Do* is his single most political painting. Started in the same year as the March on Washington and discarded in the early 1970s, Motley's canvas was painted over a period which saw the rise and fall of the Civil Rights Movement and the advent of Black Power. The sombre colour scheme of blacks, purples, reds, blues and whites dominates this painting to animate Motley's grisly representations of symbolic objects including a barren tree, a gothic mansion, the hanging heads of Abraham Lincoln, John F. Kennedy and Martin Luther King, Jr, a lynched body of a half naked black man, a broken body of a black man beaten by white police, burning bleeding crosses, a white skull, an African mask and a Confederate flag. This canvas proves the importance of Motley's belief that 'subject matter plays a most important role in my art' far more than any of his other works (*AMP* 3161, Motley in Harold Haydon, 'A Painter', 1971: n.p.). This painting's disturbing content bridges Aaron Douglas's 1930s optimistic mural series, *Aspects of Negro Life*, and Charles Alston's dark visions of political upheaval from the 1950s onwards. As a mural in miniature, Motley's painting reproduces many of the stories narrated in Douglas's work by including a lynching, the Ku Klux Klan, white religious hypocrisy, the blues, racism and death. Just as Douglas evoked the blues of black struggle metaphorically through his use of colour, Motley explained, "'I used a lot of blues in it'" because "'I have got that blue feeling'" (in Bearden and Henderson, 1993: 156).

This work has all but disappeared in African American art history. Just as Meta Warrick Fuller's celebratory sculpture, *Ethiopia Awakening*, has been favoured over her indictment of black female suffering in *Mary Turner (A Silent Protest Against Mob Violence)* (1919), critics praise, even as they criticise, Motley's exuberant and colourful scenes of black life in paintings such as *Blues* (1929), *Barbecue* (1934), *Black Belt* (1934), *Saturday Night* (1935) and *Bronzeville at Night* (1949). There may be good grounds on which to argue that these genre scenes are more compositionally successful than *The First One Hundred Years*, a far more uneven and chaotic work. However, the shift in style and content of this canvas proves the limitations of mainstream appraisals which identify Motley as a painter of idealised and stereotyped folk culture. Instead, this condensed painting is crammed with symbolic and juxtaposed objects and figures which hint at Motley's evolving aesthetic practices.

As this work shows, Motley's dystopian vision contrasts with Douglas's trajectory, however ambiguous, of black uplift through the arts. Unlike the saxophone held high above the Statue of Liberty in Douglas's *Song of the Towers*, the trumpet in Motley's *The First One Hundred Years* lies abandoned. Not only that but his musical instrument stands upright far from the Statue of Liberty whose flame burns next to a lynched black body and beneath the death mask of Martin Luther King to indict national symbols of freedom available for 'WHITES ONLY'. In this painting, Motley refused to shy away from graphic representations of violence in the same way that Alston populated his canvases with bleeding, dying black bodies. His decision to begin *The First One Hundred Years* in 1963 'to celebrate the 100th anniversary of the Emancipation Proclamation' which ended slavery in the United States reveals his satirical condemnation of white national rhetoric (Ibid.: 155). By juxtaposing a history of slavery with the contemporary fight for civil rights, Motley followed a popular trend among African American artists to dramatise injustices in the present by evoking a history of oppression.

Theresa Robinson's view that this painting represents 'catharsis for the artist rather than a mournful cry of despair' is hard to maintain in light of Motley's bleeding, broken, dying and dead black men who contrast heavily with Douglas's dancing, singing, and labouring figures (Robinson and Greenhouse, 1991: 27). Given the ongoing horrors of this painting, it is difficult to find catharsis in this work. Motley reiterated the religious and allegorical dimensions of *The First One Hundred Years* by quoting from the bible in the title, *He Amongst You Who Is Without Sin Shall Cast the First Stone: Forgive Them Father For They Know Not What They Do*, and by decorating his canvas with white crosses and a stained-glass window. His representation of a stained-glass window depicting a religious scene, populated by white mothers and children, contrasts with the white crosses held by a Klansman in a parade, as well as the inclusion of a burning cross next to a sign which reads 'WHITES ONLY'. The white figures depicted on the stained-glass window support Motley's condemnation of white supremacism and religious hypocrisy. They also suggest alternative ways of reading the white body of Christ on a crucifix above his grandmother in *Mending Socks*. Motley's inclusion of white racist and black radical slogans side by side reflects a tendency among African American artists to experiment with the relationship between text and image, not only as a way of speaking the unspeakable but also of seeing the unseen.

Paintings such as *Mending Socks* and *The First One Hundred Years* reflect Motley's determination, in the words of Douglas, to resist the temptation to create a 'white art painted black'. He failed to see why the '"Negro painter, the Negro sculptor"' should '"mimic that which the white man is doing when he has such an enormous colossal field practically all his own"' (in Robinson and Greenhouse, 1991: 15). He was convinced that the black artist should represent '"his own people, historically, dramatically, hilariously, but honestly"' (Ibid.). Archibald Motley's criticism that there was '"too much imitation and not enough originality"' among African American artists was taken up by Charles Alston who shared his certainty of '"who knows the Negro race, the Negro Soul, the Negro heart, better than himself?"' (Ibid.).

Charles Alston (1907–77)

'The Ivory Tower' versus 'The Nitty Gritty'

In the 1960s, Charles Alston stated that the black artist faces a 'unique predicament' (*CAP* N/70–23, 'Artist Statement', 1969: n.p.). 'As an artist, formed culturally and environmentally in the traditions of western man,' he urged, 'I am intensely interested in probing, exploring the problems of color, space and form' (Ibid.). 'However, as a black American,' he explained, 'I cannot but be sensitive and responsive in my painting to the injustice, the indignity and the hypocrisy suffered by black citizens' (Ibid.). As an African American painter and sculptor, Charles Alston defined the battle between the responsibilities of an artist to solve aesthetic issues versus the burden of heeding a social conscience as the tensions between the 'Ivory Tower' and the 'Nitty Gritty' (Ibid.). The problems of the 'Negro painter' were 'different' from those of a 'white painter' because while 'you're concerned' with the 'aesthetics of art', 'you cannot but be concerned about what's going on around you and how it affects you, your people' (in Murray, 1968: 9).

While Douglas believed that technique alone was 'not enough' and Motley argued subject matter played an 'important role' in his art, Alston asserted that the artist's social responsibility should never come at the cost of his artistic freedom. A staunch defender of the 'aesthetics of art', he believed black artists were 'torn' in two directions (Ibid.). They were not only plagued by aesthetic questions such as 'Is this the way I should paint?' but they also shouldered the burdens of a political conscience, as he asked, 'Should I commit my painting to visualising, as I see it, the struggle that's going on?' (Ibid.). Added to aesthetic questions, Alston,

like Douglas and Motley, was convinced that the black artist had their own sets of issues. One of the most significant experimental painters, sculptors, muralists and teachers to emerge from Harlem, Alston is another under-researched figure in African American art history. Seeing himself not as a black artist but as 'an artist who happens to be black', Charles Alston followed on from Motley by questioning the usefulness of the term 'black art' (in Henderson, 1990: 8). 'I don't believe there's such a thing as "Black art",' he asserted, 'though there's certainly a Black experience, I've lived it' (in Coker, 1990: 17). He was convinced it was futile to adopt 'a separate set of rules and qualities for Black art' (Ibid.). Although the term may describe an artist's choice of subject matter, for Alston it was doomed to failure when it came to measuring an artist's experimentation with aesthetic issues. Form, if not content, could never be racially categorised. 'I don't think the standards are black, white, green or what not' (in Murray, 1968: 10). Black art, however defined, Alston insisted, had to have the 'aesthetic quality' of 'any art' (Ibid.). He distinguished between what he saw as the empty category of 'black art' and the rich separate tradition of 'African art' which would 'hold up under any universal standards of quality' (Ibid.).

If Douglas and Motley disagreed on whether the Harlem Renaissance had existed and, if it had, whether artists could capture an 'innate blackness', Alston contested whether there was a separate African American visual arts tradition with its own aesthetic standards. In his paintings, murals and sculpture, he drew on an eclectic mixture of European Modernist, Abstract Expressionist, Social Realist and African art influences. In contrast to Douglas's fight to found an 'art era' which would express the 'gold mine' of black culture, Alston shared Motley's exasperation that 'squabbling about somebody being white, or somebody being red or black or yellow' is 'never going to get you anywhere' (in Barrie, 1978: 15). He believed that the struggle between social responsibility and aesthetic issues was ultimately nothing to do with race but 'the predicament of any artist, black and white, concerned with the dignity of man' (*CAP* N/70–23, Alston, 'Artist Statement', 1969: n.p.). More specifically, Motley and Alston fought to achieve 'tones of universality' and reach beyond the 'plight of the black man in Harlem' to represent the 'plight of any disadvantaged person anywhere' (Alston in Murray, 1968: 10).

In concrete terms, Charles Alston's artistic practices countered Aaron Douglas's view that '"[t]echnique in itself is not enough"' (in Bearden

and Henderson, 1993: 135). For Alston, technique was the life blood of thematic expression. He believed that an artist could only 'make a statement' and 'speak out politically with great authority' once she or he had gained a 'mastery of the tools involved' (in Murray, 1968: 10). Given that a 'mastery' of form was the only way in which to breathe new life into themes, Alston consistently pushed the boundaries of acceptable forms and techniques within African American art. By experimenting with abstraction, realism and modernism in his portraits, genre scenes, sculpture and non-figurative canvases, he refused to be 'pigeonholed' (Ibid.: 15). 'I do a series of abstract paintings concurrently with a series of figurative paintings,' he explained. 'I'll do very realistic things – I don't mean academically realistic things – and very far out avant-garde things' because 'I want to explore different and new unknown territory' (Ibid.). He was convinced astute viewers would be able to identify formal consistencies in his work: 'I think for any painter who paints honestly, if you look at a body of his work and you are perceptive, you can see his signature' (Ibid.).

Scholars remain divided on the efficacy of Alston's formal experimentation. For Bearden and Henderson, 'his many different styles' meant that 'he never evolved a readily identifiable personal style' (Bearden and Henderson, 1993: 260). James Porter, however, believed he was a 'versatile artist' who did not 'weaken his medium or suppress the effect of a design in order to attain some half-understood and largely extraneous race-wit' (Porter, 1943: 107). By contrast, Ann Gibson asserts that he 'alternated between figuration and abstraction' in his works as a form of 'resistance' (Gibson, 1999: 107, 113). Her view assists in developing new readings which interpret Alston's self-reflexive search for new forms and techniques as a way in which to 'resist', subvert and play with themes and aesthetic issues typically associated with African American art. At the same time, Alston's preoccupation with aesthetic freedom did not detract from his hunt for radical subject matter.

Towards the beginning of his career, Alston protested against the controversies which erupted over his murals, *Primitive Medicine* and *Modern Medicine*, which he had designed for a Harlem hospital. He faced severe criticism for including 'a lot of references to Negro history' and for dramatising 'racial integration' by depicting many 'brown and black people' (in Phillips, 1965: 7). The director rejected the murals on the grounds that this 'wasn't a Negro hospital' (Ibid.). Eventually, Alston won the battle and the murals were installed but it proved an invalu-

able lesson concerning narrative authority. 'Usually if somebody wants a mural on his wall,' he realised, 'he wants his story on there' (Ibid.: 8). So while Alston experimented with portraiture, landscapes, genre scenes, murals and sculpture to defend his right to aesthetic freedom, he also pushed the boundaries of appropriate forms in a fight to tell his own 'story' in art. While it is difficult to categorise his style, he identified 'several recurrent themes' including 'the family', 'the blues', 'African themes' and 'protest' (in Murray, 168: 15). Viewers in search of white subjects will be as disappointed by Alston's paintings as those by Douglas and Motley. Like Douglas who explained that he 'couldn't be concerned' with whites, Alston commented, '"I've somehow been more interested in Blacks aesthetically"' (in Coker, 1990: 15). In this chapter, I discuss Charles Alston's *Jazz* (c.1950, see Plate 3) and *Confrontation* (1969) to examine his abstract-figurative style in experimental representations of performers, musicians and Civil Rights activists.

Jazz (c.1950, Plate 3)

'I used to sit in Bessie Smith's rumble seat when she was going to record,' Charles Alston told Harlan Phillips, '[s]o I knew that era and this was my subject matter' (in Phillips, 1965: 11). Numerous paintings by Douglas, Motley and Alston are immersed in the forms and themes of jazz, spirituals and the blues. Douglas's summary of his painting, *Song of the Towers*, as celebrating, 'Songs of Deliverance, Songs of Joy and the Dance and Songs of Depression and the blues' can be mapped on to Charles Alston's music paintings (*ADP* 4522, Douglas, 'Interpretation', n.d.: n.p.). Alston's abstract-figurative canvases are similarly crowded with jazz and blues musicians, performers and singers as they explore the power of art and the imagination to transform suffering into joy, sorrow into ecstasy, pain into jubilation. *Swing Low, Sweet Chariot* (1928–9) by Malvin Gray Johnson, a much neglected artist of this period, similarly celebrates the power of the spirituals to release slaves from their sorrow.

While Douglas introduced concentric circles to capture reverberating sound waves and Motley manipulated his compositions to convey dance rhythms, Alston experimented with abstraction to evoke sound and movement in the relationships between colour, texture and perspective in his canvases. On the one hand, Douglas's music paintings such as *Congo* (1929) and *Music* (1930) show how his experimentation ran the full gamut from black and white drawings to colour paintings and

murals. He relied on juxtaposed and improvised abstract design patterns of concentric circles, spotlights, colliding lines and waves to surround and interweave the angular stylised bodies of his black performers. On the other hand, popular paintings by Motley such as *Blues* (1929), *The Jazz Singers* (1934) and *Saturday Night* (1935) generate movement in uneasy compositions which emerge from destabilising perspectives. They establish a call and response relationship via Motley's experimentation with the visual tensions created by merging and contrasting colours. As his canvases show, Charles Alston joined both artists in exalting black music and introducing taboo experiences of black dance, sexuality and desire as appropriate subjects for African American art.

In the 1950s, Charles Alston created many music paintings including *Jazz* (c.1950, see Plate 3) and his *Blues Singer* series celebrating the lives of female performers. In particular, *Jazz* portrays the interwoven bodies and instruments of a pianist, trumpet player, double bassist and singer. This work resists Gilbert Coker's view that Alston's 'sympathetic understanding' emerged from 'beneath a surface of caricatures' (in Henderson, 1990: 15). This statement may be true of Motley's earlier painting, *Jazz Singers* (1934), but can in no way be applied to Alston's *Jazz*. In this work, Alston experimented with cubist abstraction not to revise or engage with but to dismiss popular caricature. He fractured the picture plane to create highly stylised and ambiguous figures which countered the singing, banjo-playing African Americans of white racist mythology. By relying on stark forms and painted layers, he evoked African sculptural forms to strip away details of physical anatomy and minimise facial expressions.

In *Jazz*, Alston betrayed the influence of European Modernism by introducing cubist techniques to fragment, distort and split the bodies of his four figures. His lines, etched over blurred blocks of colour, evoke the improvised, experimental and jagged edges of jazz itself which also changes direction to create complex and layered rhythms. Alston visually translated these rhythms in his picture plane via the varying intensities of his colour juxtapositions as well as his textured layering of paint. The stops and starts of Alston's composition in *Jazz* reflect his struggle to break free of the boundaries of visual expression to translate the temporal sounds of music into spatial arrangements. In this work, he captured the dynamism of abstract forms of jazz rather than the physicality of his performers which became the focus of his later *Blues Singer* series.

One of the most experimental aspects of Charles Alston's *Jazz* is his

use of abstraction to reinterpret the physical anatomy of the female jazz singer. In this painting, the curves of the double bass mirror her torso while the spherical shape of the trumpet replicates the dimensions of her head. Alston's experimentation with abstraction refracts the black female singer's body into musical parts to reinforce the inseparability of the black body and music in the moment of performance. He identified the female singer by an elongated neck and mask-like features which contrast with the hidden or only partially revealed faces of the three musicians. *Jazz* leaves the details of black physical features unspecified to withhold rather than display black anatomical detail. Whereas Motley dramatised the musical activities of his *Jazz Singers* by providing carica-tured representations of black performing bodies, Alston's painting relies on a tradition of African sculpture and masks to conceal internal complexities. In comparison with his dramatic use of colour in his *Blues Singer* series, *Jazz* offsets its balance of greys, whites and blacks with only flashes of brown and yellow. In these compositions, Alston's limited use of colourful, forceful brushstrokes and abstraction in both compositions reinforces the political and potentially subversive role of jazz in black cultural survival.

The sculpted, mask-like features of the female singer in *Jazz* can be compared with those of Alston's performers in his *Blues Singer* series. Both the *Jazz* singer and the female performer in *Blues Singer #4* (1955) possess similarities in their angular mask-like features and elongated necks which are characteristic of African sculpture. As Bearden and Henderson explain, Alston's 'singers are often intensely expressive, occasionally sentimental' and 'detached and monumental', as they possess the 'structural characteristics of expressive African sculpture' (Bearden and Henderson, 1993: 263). By relying on 'formal stylization' and a 'Cubist structure' he creates individual figures and mask-like faces suited to withholding rather than displaying emotion (Coker, 1990: 16). '"There was just something earthy and lusty about these people that intrigued me. It was so direct, so real!"' Alston admitted. '"I suppose there were certain aesthetic aspects ... They were all big women – so three-dimensional! I like to do sculpture and they were sculptural"' (in Bearden and Henderson, 1993: 263).

However, there are stark differences between these paintings. While the singer in *Jazz* is clothed in white, *Blues Singer #4* wears a vivid red dress, white flower corsage and blue gloves. In contrast to the *Jazz* singer who evokes the still monumentality of sculpture by folding her hands and

replicating the static shape of the double bass behind her, *Blues Singer #4* pushes back her shoulders, thrusts her hips forward, extends her hands and opens her mouth as if in mid-song. In both cases, however, the sculpted, minimalist heads and elongated necks of Alston's performers offset the explicit reds, blues, yellows and even whites of their dresses. Their clothes contrast with the browns and blacks of their skin to thwart audience voyeurism and celebrate African American female creativity in musical performance. The lack of detail in their facial features betrays Alston's 'fascination' with African masks. He was enchanted with Alain Locke's collection which offered him the 'chance to hold them and to feel them' (in Murray, 1968: 5). He admitted that 'they have played a tremendous part in my work', in the 'plastic feeling about the figure' (Ibid.). In contrast to paintings by Aaron Douglas and Archibald Motley, Charles Alston's monumental female blues singers possess an exemplary physique and emotional strength which accentuate their heroic, mythic, and iconic status.

Confrontation (1969)

'"[T]his is the way a great deal of white America sees black America. Sees them as faceless. They don't know them"' (Charles Alston in Bearden and Henderson, 1993: 269). The 1950s and 1960s witnessed a shift in Alston's art as he replaced his earlier themes of African art, music and the black family with overtly political paintings representing the struggles, fears and horrors of the Civil Rights Movement. In canvases such as, *Walking* (1958), *You never really meant it, did you, Mr. Charlie?* (1965), *Black Man, Black Woman, U.S.A.* (1968), and *Confrontation* (1969), Alston addressed Motley's concerns that there was too much 'imitation' and not enough 'originality' in African American art. '"I wonder whether most of the expression I observe in Negro painting",' he asked, is perhaps '"only reflections of a dominant culture and not truly indigenous"' (in Siegel, 1966: 51). Alston's insistence that the '"Negro artist might have a more personal 'thumbprint'"' found full force in paintings such as *Confrontation* (Ibid.). This disturbing abstract work of bleeding black humanity not only commemorates the racist brutalities, conflicts and deaths of the Civil Rights struggle but also signalled new directions for African American art. *Confrontation* visualises Alston's disappointment and disillusionment with the Civil Rights Movement in abstract combinations of black and brown bodies which bleed into and spill down the canvas in a cacophony of body parts. This work is an abstract and horrifying adaptation of his

earlier canvas, *Walking*, painted over ten years before and in which he celebrated the united movement of multicoloured men, women and children. As Alston explained, *Walking* was inspired by the '"idea of a march"' given that he '"called it *Walking* on purpose"' because it '"was a very definite walk – no going back"' (in Bearden and Henderson, 1993: 266). By comparison, the fragmented and faceless bodies of *Confrontation* replace the confident marchers of *Walking* to dramatise the disappointments of Langston Hughes's title poem of his collection, *Montage of a Dream Deferred* (1951) (in Hughes, 1995).

Charles Alston's blurred forms and merged colours in *Confrontation* undermine the agency of his distorted and barely distinguishable black and brown figures dressed in blues, reds, greens, yellows and oranges. His black and brown figures merge with one another to suggest a collapse of individual agency and the loss of collective will. These split-apart bodies are defined and confined by whiteness as they huddle together against a white background. Flecked with red, blue, black, yellow and brown, the white background of this work may suggest a vision of assimilation and integration. However, this painting is more likely to represent Alston's protest against the subsuming of black culture within a dominant white order. Nonetheless, *Confrontation* may not be quite the despairing antithesis to *Walking* that it at first appears. Close examination shows that this later work is awash with blue to suggest the power of the blues and the spirituals to revive hope in the face of despair. Dying and faceless these black figures may be but they are not hopeless as they stand together to confront the viewer. Alston's inclusion of a solitary individual resonates with other black paintings of the period by exalting in black heroism to suggest the possible rise of future race leaders. Although his static and abstract figures bleed and blur, their elongated, minimalist forms and masked features share similarities with his *Blues Singer* paintings as their simplified bodies replicate the angular forms of African sculpture. A forceful and ambiguous work, *Confrontation* elaborates on Alston's conviction that 'before you're a painter you're a human being and you're involved in what happens' (in Murray, 1968: 9). In many of his later paintings, murals and sculptures, Alston experimented with abstraction to defamiliarise the black struggle for Civil Rights and heighten audience awareness of political issues.

You never really meant it, did you, Mr. Charlie? (1965) is another of Charles Alston's paintings which he produced during the Civil Rights era. This work which was 'based on black children going to school in Little

Rock, Arkansas' is one of his most disturbing canvases (Bearden and Henderson, 1993: 266). As Alston admitted, this painting represents the 'simple figure of a Negro man against a red sky looking as frustrated as any individual can look' (in Murray, 1968: 9). Clearly, this canvas dramatises Alston's sense of 'hurt' and 'disappointment and disillusionment' with white promises of integration (Ibid.). In this work, he accentuates his sense of injustice by depicting a martyred, faceless and emaciated brown figure standing outlined before a cross. As colours bleed on to the canvas, the brown but dissolving body of the central Christ-like figure merges with the blood-red background to collapse on to a black rather than a white cross. This figure is desolate rather than triumphant as he disappears into the weight of a collective struggle for civil rights. The horizontal axis of the cross punctures this black man's torso while a tear falls down his face to foreground African American suffering and physical mutilation. The uneven and rough textures of Alston's brushwork replicate the horror of brutalised black masculinity sacrificed as a result of white persecution and in the fight for black equality and citizenship.

In another painting from the same period, *Black Man, Black Woman, U.S.A.* (1968), Alston depicts two faceless black male and female figures seated against an abstract background. Continuing his trademark dramatic use of colour, the black woman's crimson dress bleeds through other parts of the canvas to drench parts of the black man's white shirt. In contrast to the swaying, moving, singing bodies of his earlier blues singers, the black woman in this painting is not only lifeless but mutilated as she has no arms. Alston's reliance on abstract representation to convey physical suffering reiterates the erasure, denial and fragmentation of black culture in a context of police-beatings, racism and assassination. The mask-like faces of both figures provide the only hope in this painting. Furthermore, Alston's characterisation of black figures as 'artistically indebted to Egyptian portraits of pharaohs and kings in its regal simplicity' not only invites parallels with Douglas's technique but also provides optimism in a prophetic return to the heroic archetypes of a mythic Africa (Bearden and Henderson, 1993: xvii).

Charles Alston's concern with finding a new 'thumbprint' for African American art resonates with Douglas's determination to establish an 'art era'. Both artists fought to establish new ways in which to represent what Motley identified as the 'full gamut' of the black experience. 'Let's get the language', Alston's rallying cry to fellow black artists in the 1960s, helps to explain all three artists' experimentation with form and subject

matter in their works (in Murray, 1968: 20). Douglas, Motley and Alston fought for the right to 'experiment and explore' in a bid to obtain their artistic freedom (Alston in Phillips, 1965: 3). All three artists were on the hunt for a visual vocabulary within which to tell their own story. Once 'you've got to know the language', Alston was convinced 'you can mold it into any pattern that you want to mold it into' (in Murray, 1968: 20).

Conclusion: 'The Janitor Who Paints'

Artists of the Harlem Renaissance 'art era' such as Aaron Douglas, Archibald J. Motley, Jr and Charles Alston created experimental works across a range of genres. Their paintings testify to the emergence of a self-critical, self-reflexive and self-consciously experimental African American visual arts tradition in the early twentieth century. Producing anything but a 'white art painted black', they established new art forms and themes in their search for answers to long-standing aesthetic questions. One of the ongoing contradictions among these artists, however, concerned their ability or otherwise to dramatise the lives of the 'man on the street'. For Cornel West, the 'Harlem Renaissance was a self-serving construct concocted by rising black middle-class artistic figures to draw attention to their own anxieties over their individual and social identities and to acquire authority to impose their conceptions of legitimate forms of black cultural productions on black America' (West, 1993: 50). While this view is hard to sustain in light of the complexities of their paintings and personal statements, West is on to something by identifying a class bias when it comes to determining the appropriate forms and identities of black artists. Nowhere is this more clear than in the attitudes of Douglas towards the self-taught ex-slave sculptor of the next chapter, William Edmondson. Regardless of the fact that both were artists working and living in Tennessee over a significant time period, Douglas never contacted Edmondson. Worse still, he dismissed him as a '"person with very little education and none at all from an art viewpoint"' given that he '"worked from an instinctive point"' (in Bearden and Henderson, 1993: 354). An art teacher in Harlem in the 1920s, Charles Alston, on the other hand, single-handedly inaugurated a new era in African American art history by discovering the painter, Jacob Lawrence. His ability to see an African American master in a 'kid' who attended his after-school art class for impoverished black children sets the stage for recovering the lives of self-taught folk artists (Ibid.)

I would like to end this chapter by examining *The Janitor Who Paints*

(c.1939–40), a painting by Harlem Renaissance artist, Palmer Hayden, himself a janitor-turned-artist. In this work, the uneven floorboards and bare walls of the impoverished janitor-turned-artist's studio show another side of Harlem. Hayden replaced the mythic Africa of Jones's *Ascent of Ethiopia* and the black genteel life of Motley's *Mending Socks* with an unflinching portrayal of African American working-class poverty. He documented the struggles of art in adversity by dramatising a black janitor-painter at 'work' painting the portrait of a lighter-skinned African American mother and child. Despite the janitor-turned-artist's obvious destitution, Hayden juxtaposes the garbage can with his palette and the bare light bulb, mop and broom with his paint brush and easel to celebrate the achievements of the working man as an artist. He shows how far too many critics and patrons celebrate the miracle of the 'janitor who paints', 'the ex-slave who sculpts' and the 'homeless man who draws' with too little regard for their aesthetic concerns. Hayden's painting satirises work by scholars who deny black artists the right to form and experimentation by suggesting that, while you can take the labourer out of the artist, you can never take the artist out of the labourer. The next chapter examines works by William Edmondson, Horace Pippin and Jacob Lawrence to take these issues to task and highlight the experimental and abstract practices of *soi-disant* untrained artists. 'Let's get the visual language' was no less a defining feature of their sculpture, oil paintings and watercolours (in Murray, 1968: 20).

Struggle, Survival and Early Abstraction

William Edmondson – Horace Pippin – Jacob Lawrence

'"My work is abstract in the sense of having been designed and composed",' Jacob Lawrence insisted, '"but it is not abstract in the sense of having no human content. An abstract style is simply your way of speaking"' (in McCausland, 1945: 251). The urgent pleas of Aaron Douglas and Charles Alston that African American artists should establish an 'art era' in their search for a new 'thumbprint' were answered in the sculptures, oil paintings and watercolours of William Edmondson, Horace Pippin and Jacob Lawrence. While Lawrence has been revered as a 'sophisticated' artist, critics interpret Edmondson and Pippin's use of ad hoc materials, repeated scenes, unfinished surfaces, rough textures and flat perspectives as signs of inferiority (Wilkin, 1995: 34). However, a close investigation of their otherwise hidden complexities shows that works by Edmondson and Pippin were as experimental as those produced by artists who had been academically trained. This chapter analyses the paintings and sculpture of Edmondson, Pippin and Lawrence to get to grips with their abstract-figurative style and oppose assumptions such as Karen Wilkin's that '[a]esthetic issues are what ultimately define the gulf between Pippin and Lawrence' (Ibid.: 36).

As a man who had lived through slavery and Reconstruction only to become homeless in the segregated south, African American artist, Bill Traylor, produced works which are as artistically complex as those created by Edmondson, Pippin, and Lawrence. And yet, his reputation has similarly suffered from the same racist myths of the black artist as untutored naif which have afflicted Edmondson, Pippin and even Lawrence on occasion. It is worth briefly discussing Traylor's work on the grounds that his destabilising use of perspective, symbolic compositional arrangements, minimalist style and experimentation with

abstraction resonates with their sculptures and paintings. Born a slave on a plantation in the American south in 1854, Bill Traylor died an artist in 1949. His twelve to fifteen hundred pencil drawings of an antebellum and post-war rural south came to life on smudged scraps of salvaged cardboard. Abandoned by his former owners and living homeless in the doorway of a funeral parlour, Traylor relied on abstraction to dramatise a carnivalesque world in which black and white women, men and children, slaves and masters, owners and workers carouse, fight, talk, laugh and love.

Throughout his works, Bill Traylor was preoccupied with themes of black artistry and creativity. In *Blacksmith Shop* (1939–42), for example, he juxtaposed black drinkers and labourers with tools of the blacksmith's trade to offset poverty and drudgery by highlighting achievements in craftsmanship. Throughout his lifetime, Traylor created a series of mule drawings signifying upon thankless histories of black labour to reinforce his preoccupation with resistance, play and allegory in his works. Speaking of a mule in one drawing in particular, he stated, '"He's sullin'. He won't work. Minute he sees a plow he start swinging back. You can't make him go"' (in Maresca and Ricco, 1991: 26). Themes of anarchic play dominate other drawings such as *Chicken Toter Being Chased* (1939/1942) and *Figures Chasing Bird on Construction* (1940/1942). In works such as these, he dramatises collapsing, falling and stick-wielding black women and men joined by dogs in hot pursuit of a rabbit. Human figures stalking one another are common in Traylor's drawings which frequently provide allegorical examinations of tensions in race relations. Furthermore, in works such as *Figure/Construction with Blue Border* (c.1941), Traylor relied on an abstract-figurative style to create ambiguous scenes of southern black life.

In the same period that Traylor took up his pencils, William Edmondson carved his first incisions in stone, Horace Pippin burned his first lines into wood and Jacob Lawrence painted with his first poster colour on 'brown wrapping paper' (in Greene, 1968: 18). All four African American masters improvised with found materials to create works which would contest the appropriate forms and subject matter for black art and challenge its reception in white mainstream criticism. Lawrence's conviction that 'struggle is a very beautiful thing' reflects on the ways in which aesthetics, politics and protest are intertwined in the visual language of all four artists (in Wheat, 1986: 105). Their search for a 'way of speaking' demonstrates that the African American visual arts tradi-

tion has never been monolithic or homogenous. By adopting an 'abstract style', these artists emphasised the importance of 'human content' at the same time that they produced works characterised by formal experimentation to represent the multiplicity of African American histories and narratives.

One of the first artists to see the limitations in mainstream art criticism, Jacob Lawrence, insisted that 'Pippin is surely one of the finest painters America has ever yet produced, bar none' (in Major, 1977: 23). He interpreted Pippin's neglect as 'usual for blacks' in 'the history of American art' and was horrified by white art critics who 'call him a primitive' despite the fact that 'aesthetically, plastically' he is 'a much greater painter' (in Major, 1977: 23; in Greene, 1968: 24). For Lawrence, Pippin's dismissal was symptomatic of racist double standards by which 'the negro artist who is as successful in his way as the white artist does not get the same material' recognition (in Greene, 1968: 25). Lawrence was no less inspired by Edmondson whose sculpture, he revealed, 'had a great influence on me' because 'in content it meant a lot' (Ibid.: 15, 14). There can be little doubt that Lawrence's critical re-evaluation of works by Pippin and Edmondson helps us to recover their otherwise elided experimental aesthetic practices. Edmondson's limestone sculptures and Pippin's oil paintings can be considered alongside Lawrence's watercolour narrative series in their search for a new visual language. The impact of these works emerges from their reliance on an 'abstract style' to represent their preferred 'human content' of public and private narratives related to African American culture. Like Harriet Powers, Dave the Potter and countless others before and after them, all three artists acted as oral storytellers or griots of black community life. Robert Farris Thompson's description of Edmondson as the 'consummate insider' can be applied to all three artists (Thompson, 2000: 3). In comparison with Douglas, Motley and Alston who were looking in from without, Edmondson, Pippin and Lawrence created art for and by the 'man in the streets' who was not only the subject but repeatedly the viewer and sometimes buyer of their art works.

Living in the rural south and working far from any mainstream art influences, ex-slave Edmondson may not have received a formal art education but he was trained as a stonemason. This should make us wary of oversimplifying his statement, 'I ain't got much style' (in Fuller, 1973: 20). Similarly, we should be no less cautious when interpreting Pippin's conviction that he '"paint[s] things exactly the way they are"' (Stein,

1993: 16). These admissions should be trusted as much as slave narra-
tive rhetoric falsely proclaiming an 'unvarnished tale' to disguise literary
artifice. Equally, Jacob Lawrence may not have received formal art
training but he attended after-school workshops in Harlem at which he
benefited from the expertise of artists such as Charles Alston and Augusta
Savage. He maintained close working relationships with fine artists,
Romare Bearden and Hale Woodruff, at the same time that his work
was inspired by Horace Pippin and William Edmondson's minimalist
human figures and eclectic subject matter. As a result, Woodruff praised
Lawrence for his 'forcefully compelling sense of design' as he 'triumphed
in the quest for an esthetic language which formulates reaction to environ-
mental experience' (*UJLP* Hale Woodruff, 'Preface', *Ten Negro Artists*,
1966: n.p.). 'Achieving a compatibility of subject, form and content,'
he explained, Lawrence 'established an artistically harmonious fusion of
three qualities which are often regarded as unreconcilable' (Ibid.). In
general terms, Lawrence's success in finding a new aesthetic language
capable of dramatising the lives of black communities has contributed
to his reputation as one of the most repeatedly exhibited and reproduced
twentieth-century painters.

There can be little doubt that experimental relationships between
'subject, form and content' equally characterise the neglected aesthetic
practices of Traylor, Edmondson, and Pippin. Just as Lawrence relied on
cheaply available poster paint to produce his narrative series, Edmondson
improvised with railroad spikes to construct the chisels with which he
carved his minimalist limestone sculptures. Furthermore, Pippin relied
on a hot poker to burn lines into wood and create oil paintings charac-
terised by askew but symmetrically balanced compositions and textured
surfaces. In contrast to Douglas, Motley and Alston who produced
large-scale works, these three artists shared a preference for creating
concentrated and distilled epic narratives from small-size compositions.
While Edmondson worked with the diminutive size of discarded curb
stones, Pippin intensified the effects of his thematically rich and detailed
paintings by favouring a small scale. Lawrence also restricted himself
to small-sized watercolours to tell epic narratives of African American
history '"in many episodes"' as if they were '"chapters in a book"' (in
Grant, 1989: 523). By experimenting with an abstract-figurative style in
their works, Edmondson, Pippin and Lawrence explored many of the
issues facing African American artists which had been left unresolved by
Harlem Renaissance painters and sculptors.

William Edmondson (c.1863–70/1874–1951)

'Slave time is over'

'TOMB STONES FOR SALE. GARDEN ORNAMENTS. STONE WORK WM EDMONDSON' (in Thompson, 2000: 82). This handmade sign hung over William Edmondson's repeatedly photographed sculpture yard in Nashville, Tennessee, in the 1930s and 40s. Schoolteachers, Christs, preachers, nudes, rams, foxes, birds, boxers, squirrels, mermaids, angels, 'critters', lions, frogs, turtles and rabbits vied for the attention of prospective customers in his home-made and improvised gallery. '"I see these things in de sky. You cain't see 'em but I can see 'em",' Edmondson declared (in Porter, 1943: 138). Defending his right to spiritual inspiration and artistic agency, he captured his sense of artistic compulsion by admitting, '"I can't help carving"' (in Fuller, 1973: 3). Edmondson's stone sculptures not only introduced new 'human content' to African American art history by representing folk heroes and black female and male nudes but also new 'animal content'. He relied on oral traditions and trickster tales to populate his sculptures with anthropomorphic animals and figures from tradition, myth and legend.

'"I saw in the east world, I saw in the west world, I saw the flood",' Edmondson often proclaimed (Ibid.: 10). Repeated photographs of this sculptor draw attention to his faith and mysticism by depicting Edmondson holding a chisel and leaning against one of his works in a natural wilderness, as if to suggest his status as a visionary prophet. Throughout his lifetime, he argued that his '"heavenly daddy"' came to him in a vision. '"God was telling me to cut figures. First He told me to make tombstones; then he told me to cut the figures",' he stated (Ibid.: 8). If Harriet Powers's quilts are 'Sermons in Patchwork', Edmondson's sculptures are 'Sermons in Stone'. He similarly relied on symbolic characterisation and allegorical storytelling to communicate his morality and trickster tales. Furthermore, photographs of Edmondson by Louise Dahl-Wolfe taken in 1937 contrast the graininess of the white curb stone with the aged lines of his black skin to reinforce the importance of the artist as labourer within an African American art tradition.

'"How old I is got burnt up",' Edmondson explained (in Fuller, 1973: 3). The loss of the family bible in which Edmondson's birthdate was written has caused controversies to rage. While Bearden and Henderson argue he was born between 1863 and 1870, Thompson suggests it was as late as 1874. Edmondson's biography is no less shrouded in mystery.

We know only that he was the son of ex-slaves and he became a full-time sculptor after working as a stonemason's assistant and a hospital janitor. However, a lack of information has not prevented critics from mythologising Edmondson's rural southern slave origins to endorse a romanticised vision of folk heroism. For example, Bobby Lovett argues that Edmondson's parents possessed the 'strong, proud physique of West African people' (Lovett, 2000: 15). 'Years of working in the hospital among people who were sick and dying', Bearden and Henderson contend, inspired his sculptures by teaching him 'how to use his fantasies to amuse and ease people' (Bearden and Henderson, 1993: 351). A desire to substitute mortal pain with the joys of the imagination explains Edmondson's avoidance of politicised subjects in favour of animals, religious icons and fantastical creatures. His angels, 'critters', birds and mermaids take their place alongside his schoolteachers, preachers, mothers and daughters to suggest escapist narratives of subversion and play. '"I am tired working too hard",' Edmondson admitted, '"I'm going home and relax. God don't intend nobody to work themselves to death. Slave time is over"' (in Fuller, 1973: 6). By rejecting service to whites in favour of liberating his artistic imagination, Edmondson's decision to become a full-time sculptor constituted an act of resistance. Just as Motley believed that '[e]very picture should tell a story', the narrative possibilities of Edmondson's works suggest that '[e]very sculpture should tell a story.'

While many of his works remain undated, the majority were sculpted in the 1930s and 1940s. Just as early slave women made improvised quilts from cast-off materials and painters such as Clementine Hunter relied on discarded paints, Edmondson's sculpting tools were also home-made. He 'used old railroad spikes and a hammer to chisel away at the stone' (Lovett, 2000: 23). His raw materials were the 'leftover stones' donated by 'Negro workers' (Ibid.). He also 'salvaged limestone blocks' for his larger sculptures (Bearden and Henderson, 1993: 351). Bearden and Henderson argue that Edmondson's 'greatest limitation' was not his lack of a formal art education but his poverty. As they suggest, he worked 'all his creative life on poor quality stone in small sizes' (Ibid.: 351, 355). And yet, the cracks and rough surfaces of Edmondson's 'poor quality stone' resonate with Traylor's smudged cardboard by showing how these artists improvised imaginatively to create art out of the only materials they had. Edmondson's spontaneous artistic process by which he carved 'directly without making preliminary drawings or models' is

very similar to Lawrence and Pippin's preference for making few sketches (Ibid.: 349). During his artistic career, Edmondson's style evolved from creating simple tombstones to producing decorative grave markings and free-standing sculptures.

Edmondson was the first twentieth-century black artist to make his name by selling his works to poor black patrons, given that the majority of his sculptures and grave markers were commissioned by black patrons for use in Mount Ararat, the segregated black cemetery in Nashville, Tennessee. During the Depression, Edmondson survived by selling his tombstones and statues for very little money to members of the black community seeking to memorialise the lives of their dead. As a result, his sculptures were created directly out of an individual's needs in rituals of commemoration and a celebration of ancestry, history and oral testimony. On a visit in 2006, I discovered that these tombstones have all but disappeared. One reason is their removal for exhibition in art galleries. The other explanation is the inferior quality of the coffins which has caused the graves to sink back into the earth. This fact testifies to a history of racism in the United States. Black bodies have been dismissed and disrespected even in death at the same time as black art objects have not only been neglected but destroyed. If it is difficult to tell the history of African American art in the face of scant documentation, it is almost impossible to tell it when its artworks disappear.

Edward Weston's photographs of Edmondson's yard which were taken in 1941 reveal just how much is lost by viewing his sculptures as single objects in art galleries. As Grey Gundaker warns, these 'figures were once members of a loosely knit group of players cast in a dramatic repertoire of stories' and only became 'exemplars of an artistic oeuvre' when the 'academy made them so' (Gundaker, 2000: 66). Just as the paintings in Lawrence's narrative series produce new readings in the relationships between individual panels, the range of meanings for Edmondson's sculptures is opened up by considering the ways in which they were originally positioned in relation to one another. New communities are created out of possums, angels, eagles, jezebels, schoolteachers, nurses, birds and preachers who visually 'talk' to one another and interact on equal terms. The chaotic placement of works on top of, beneath and beside one another as they are half-hidden in long grass underscores the spontaneous, unforced and natural links between the artist and the community. They are not expensive, untouchable and detached art objects but sculptures for practical use in rituals of commemoration.

Weston's photographs of Edmondson's yard highlight the accessibility of these works by inviting us to walk among them and touch their smooth and textured surfaces. The tactility generated by his incisions in stone resonates with the thick surfaces of paint on Pippin's diminutive canvases. Just as Pippin's *Holy Mountain* (1944–5) series depicts humankind and the animal kingdom side by side, Edmondson's yard situates boxers next to birds, married couples next to religious figures, rams next to angels, rabbits next to nurses, teachers next to lions, female nudes next to preachers and jezebels next to ladies to contest hierarchies of class, human versus animal consciousness, race and identity.

Robert Farris Thompson's argument in favour of 'links between yard shows and cemeteries' as the 'living call on the dead for love and surveillance' applies to Edmondson's arrangement of his yard (Thompson, 2000: 4). By simulating a graveyard environment as 'the stones advertised his art', he celebrated black ancestry in grave markers which operated as talismans of memory (Ibid.: 4–5). His tombstones constituted a powerful act of resistance by celebrating black dignity, professional status and family-belonging in the face of a history in which African Americans were buried in unmarked graves. John Vlach identifies graveyards as spaces in which an 'overt black identity could be asserted' (Vlach, 1991: 110). He describes how a 'gathering of slaves at a funeral' could lead to 'plans for escape or rebellion' (Ibid.). Against this backdrop of resistance, Edmondson's sculptures can be interpreted as spiritual touchstones celebrating continua between life and death, human and animal, male and female, black and white, mythical and divine.

Judith McWillie interprets Edmondson's admission that he carved '"stingily"' as 'giving his work a syncretic association with abstraction' (McWillie, 2000: 53). Vlach's view that the 'statues are barely released from the original block' also underscores Edmondson's minimalist style (Vlach, 1991: 118). His figures only barely break free of their stone as the majority of his works are abstract-figurative. By balancing representational and stylised forms, Edmondson produced sculptures whose effects are enhanced rather than restricted by their diminutive size and poor quality stone. Differences in the size and style of his works chart his development from bas-relief to free-standing sculpture and from representational to abstract-figurative motifs and dramatisations. As Rusty Freeman argues, critical appraisals of Edmondson as a divinely inspired artist neglect to show how his 'work is filled with folk motifs, real people, and mythological characters' (Freeman, 2000: 33). He became a

'vibrant voice of his community's ideals and an immortalizer of its more important heroes' (Ibid.). For contemporary black artist, Kerry James Marshall, however, a 'history of slavery is woven into the very fabric of their [Edmondson and Traylor's] lives' (Marshall, 2005: 120). He argues that the 'recognition' of both artists 'simply confirms the legitimizing prerogative ... that white Americans assume in the critical discourse on value' (Ibid.). While there are strong grounds for Marshall's critique, his view risks undermining the artistic vision of both artists whose works celebrate an autonomous and experimental aesthetic imagination, regardless of racist contexts.

In this chapter, I examine Edmondson's abstract-figurative works, *Critter* (c.1940, see Plate 4) and *Jack Johnson* (1934–41), in terms of their experimental ambiguities. His love of humour, fantasy and storytelling should encourage us to recognise his embedded protests and self-identification as a trickster artist. As Dahl-Wolfe claims, '"William was very playful and fanciful"' and would '"make up things on the spur of the moment to explain things"' (in Bearden and Henderson, 1993: 354). This view runs counter to the opinion of James Porter who saw Edmondson's 'arbitrary' subject matter and choice of form as a weakness (Porter, 1943: 138). Clearly, Edmondson's eclecticism operated in the same way as Charles Alston's by providing him with a freer rein to introduce new subjects and experiment with different techniques.

Critter (c.1940, Plate 4)

'"I didn't know I was no artist until them folks come told me I was",' William Edmondson stated (in Bearden and Henderson, 1993: 349). Just because Edmondson proclaimed he 'didn't know' he was an artist does not mean that he was not a self-conscious and experimental practitioner of his craft. As Lowery Stokes Sims argues, Pippin and Edmondson exhibited 'a directness, purity of formal invention, and sense of abstracted form' (Sims, 2000: 74). Despite his belief that he was one of Jesus's '"disciples"' and that his works were '"miracles"', the dominant subjects in Edmondson's sculptures are not topics of religious revelation but matters related to everyday human and animal life (in Fuller, 1973: 3). For example, more than one version exists for his animal works including *Talking Owl, Rabbit, Lion, Three Bear Cubs on a Log, Ram, Horse, Squirrel, Two Frogs, Turtle* and *Eagle*, all sculpted in the late 1930s and early 1940s. In contrast to Horace Pippin and Jacob Lawrence who both worked within the white mainstream art world, William Edmondson sculpted within

his rural southern community. Although he was one of the first African American artists to have a one-man show at the Museum of Modern Art in 1937, he continued to sculpt in his yard.

Critter (c.1940, see Plate 4) is not Edmondson's only work with this title but it is his most abstract and 'stingily' cut. Other works such as *Critter (Fox)* and the identically titled *Critter* resemble real-life animals, however much they represent mythical beasts. *Critter (Fox)* is hunched as if about to spring with an upraised face, pointed ears and a happy expression suggestive of an 'anthropomorphic quality' that can also be found in the human face Edmondson attaches to *Talking Owl* (Thompson, 2000: 168). Close inspection shows that he marked the surfaces of these sculptures with indentations and grooves to suggest the texture of fur and invite the viewer's touch. Edmondson's animal sculptures possess carefully delineated bodies which heighten their allegorical symbolism by capturing the traits associated with these animals in folkloric traditions. While *Squirrel* holds his nose with both front paws and parades a busy tail, *Two Frogs* possess exaggeratedly large eyes and delicately webbed feet. The round throat and smiling mouth of *Turtle* are as lively as the expressive beaks and large wings of his *Eagle*. *Three Birds*, *Two Birds* and *Bird* draw attention to his preoccupation with freedom by revealing his fascination with birds as 'signifiers of liberation' (Thompson, 1999: 12).

In general, William Edmondson's animal sculptures evoke Joel Chandler Harris's *Uncle Remus* stories from the 1880s onwards which were devoted to the exploits of Br'er Rabbit, the thinly veiled substitute for enslaved Africans who gained agency by outwitting the machinations of whites as represented by wily foxes. These folkloric associations shed light on Edmondson's repeated versions of rabbits which are among his most sculpted animals. The ambiguous expressions of his rabbits highlight their function as tricksters. These works operate in contrast with the clear-cut facial features of his other creatures, including his smiling foxes, statuesque horses, dignified rams, swaggering lions, regal eagles, thoughtful owls and nervous-looking squirrels. Edmondson's rabbits are often as minimally carved and lack as few 'identifiable characteristics' as *Critter* (Ibid.). These works reinforce his experimentation with 'geometric stylization' in a 'love of melding disparate forms' to create abstract human and animal bodies (Ibid.).

Critter (see Plate 4) consists of an angular diamond shaped body with an incised hole for an eye, a dent for a nose, a slit for a mouth

and two blocks for legs. 'There is a Euro-American mainstream. There is an Afro-Atlantic mainstream,' Thompson observes, and 'Edmondson's forte was to sail boats in both streams. He carved angels from one current and cryptic diamond-form patterns and ecstatic gestures from the other' (Thompson, 2000: 3). While the abstract body of *Critter* suggests Edmondson's 'Afro-Atlantic' influence, the title of the work evokes African American folklore and belief systems which existed beyond the 'Euro-American mainstream'. *Critter* contrasts with his other animal sculptures by relying on an abstract composition. By constructing a rectangular form from flat untextured surfaces, he reinforced this sculpture's symbolic ambiguity. The 'stingily' carved body of 'critter' invites a multiplicity of readings. There is a playfulness to this sculpture in the diagonal incision of the mouth which suggests that the 'critter' is smiling, while Edmondson's choice of title evokes vernacular idioms and an African American oral tradition.

The ambiguity of this animal's species contrasts with Edmondson's other 'critters' which resemble foxes and possums much more obviously. By comparison, *Critter*'s radical abstraction suggests that this work has far more in common with sculptures such as *Abstract Angel* (Ibid.: 162). *Abstract Angel* possesses neither the secular humour of *Angel with Pocketbook* nor the spiritual intensity of his repeated winged *Angel* sculptures. Edmondson constructed this abstract work from two diamond shapes for a body and shoulders on to which he placed a spherical ball representing a head. The stark minimalism of *Critter* and *Abstract Angel* resonates with Traylor's abstract-figurative drawings by similarly relying on a symmetrical angularity to withhold detail. Both artists experimented with materials, form and style to push against the boundaries of accepted folk and outsider art. While William Edmondson may have begun by sculpting fairly representational replicas of animals, as his artistic career developed, he honed an abstract-figurative style to strip his animal and human subjects back to their essential forms.

Jack Johnson (1934–41)

'"Slave time is over",' William Edmondson insisted (in Fuller, 1973: 6). Edmondson's sculpture of black boxing legend, Jack Johnson, stands out amidst his usual sculptures of animals, religious figures and working women and men. Johnson's body is far from 'stingily' carved. He adopts a boxing pose and stands ready to fight, legs apart, shoulders tight and gloved fists stretching out in front of him. Edmondson's minimal carving

of the boxer's facial expression insists on his heroic status. The uneven texture of his hair, lined details of his boxing outfit and smooth surfaces of his skin animate Edmondson's otherwise generic representation of black masculinity in this work. As legendary a folk hero as the steel-driver John Henry who was immortalised in a series of paintings by Palmer Hayden, Johnson represents Edmondson's celebration of black heroism. What better way to celebrate the reality that '[s]lave time is over' than via a black heroic figure who had crushed white masculinity in physical combat?

The ambiguity of Jack Johnson's facial features provides an apt preface to the critical debates surrounding race and identity in William Edmondson's works. Samella Lewis argues that the 'facial features' in his sculptures are 'similar to those seen in the stylised sculptures of numerous African cultures' (Lewis, 2003: 106). While Lovett agrees that Edmondson's figures 'had strong, African bodies', he sees an 'absence of large noses and big lips' as confirming 'Edmondson's years of cultural isolation ... where whites and mulattos epitomized human beauty' (Lovett, 2000: 30). A close examination of the facial features in *Jack Johnson* and other works such as *Preacher*, *Schoolteacher* and *Girl with Cape* makes it difficult to conclude either way. Just as it is impossible to establish the species of *Critter*, Edmondson's minimalist abstraction accentuates the futility of categorising his figures according to race. Freeman's view that Edmondson was a 'transcendent community griot' captures his search to find the transcendental in everyday life (Freeman, 2000: 43). As such, it is no exaggeration to argue that Edmondson's *Jack Johnson* has much in common with his different versions of *Crucifixion*. In one version, for example, Christ's body emerges strongly from the cross as he moves forward to meet the viewer, while the carefully patterned lines of his body and the etched lines of his hair correlate with those of Jack Johnson. These similarities confirm Edmondson's equal admiration for secular and religious heroism in his sculptures as he equated folk resistance with Christian martyrdom.

Edmondson's stone works differ from paintings by Pippin and Lawrence because so few are explicitly devoted to protest and social criticism. However, his content dramatising everyday lives of African Americans resonates with these artists' subject matter. By celebrating black female labourers, boxers, Christs and angels, he opposed white mainstream representations of African Americans. Edmondson's sculptures brought animal trickster tales to life to reinforce his subversive

playfulness, while the racially indeterminate physiognomies of his human figures resisted racist caricatures. Edmondson's sculptures representing black male and female nudes in works such as *Nude Woman Seated on Stool* and *Reclining Man* (1933–40) were also cutting-edge because they were unprecedented in African American art. The nudity of *Reclining Man* was a subject which remained off-limits for black artists until the 1960s and 70s, with the exception, of course, of Beauford Delaney's nude portrait, *Dark Rapture (James Baldwin)*, painted in 1941.

Towards the end of his life, William Edmondson's experimentation with abstract and minimal carving became more pronounced as his skills developed. He carved 'stingily' so that his sculptures would signify upon a multiplicity of meanings. As viewers of his work, we are uncertain whether we are being deliberately misled or played upon by Edmondson's minimalist poetics. Perhaps Traylor and Edmondson's most important contributions to twentieth-century African American art reside in their celebration of humour and play to transcend moral and didactic frame-works and create alternative visions of black humanity. While the paintings of Horace Pippin leave little room for humour in their treatment of historical subjects and political issues, they share William Edmondson's belief in the power of art to transcend human suffering.

Horace Pippin (1888–1946)

'I can never forget suffering, and I will never forget sunset'

'"Do I tell you how to run your foundation? Don't tell me how to paint",' was Horace Pippin's famous declaration of independence to white patron, Albert Barnes (in Stein, 1993: 15). On returning from trench warfare in World War I, Pippin began painting to regain the use of his right arm and exorcise the traumas of physical combat (in Rodman, 1947: 51). In 1925, he started by using a hot poker to create his '"first burnt wood panels"' which, he said, '"brought me back to my old self"' (in Bearden and Henderson, 1993: 359). Contrary to many critical accounts, Pippin's 'war-crippled arm' did not detract from but contributed to his aesthetic complexity because it 'forced him to work each stroke out mentally, constructing entire relationships of color and design in his head' (Ibid.: 356). These influences can be identified in the multilayered surfaces and contrasting colours of his oil paintings which create dynamic tensions to replicate the visceral struggles of his experience. Despite many popular accounts, Pippin did not work within a visual arts vacuum. One of his part-time jobs was to 'crate pictures' when he would 'run his fingers over

the rough canvases' and discover the strong sense of texture and tactility which would characterise his own paintings (Rodman, 1947: 33).

In his paintings, Pippin went further than Edmondson (who 'couldn't help' carving), expressing his sense that art was the only way out of his '"blue spells"' (in Stein, 1993: 24). Artistic experimentation was not only a means to self-expression for Pippin but also a way of reconnecting with his pre-war identity and 'old self'. As he regained the use of his arm, he was able to work with paint brushes on fabric and canvas. His unsentimental works examine scenes from everyday life and American history as well as southern poverty, religious piety, heroism, literary myths and cultural icons. His dramatisations of military conflict are unprecedented in African American art history. Pippin drew on his personal memories of military bloodshed to celebrate the sorrows and joys of living in his paintings. 'I can never forget suffering, and I will never forget sunset,' he insisted, because 'I came home with all of it [World War I] in my mind and I Paint from it to Day [sic]' (*HPP* 138, Pippin, 'Letter to Dear Friends', c.1920: 2).

Horace Pippin's ambiguous compositions and unresolved textures lend force to his conviction that art '"came the hard way with me"' (Ibid.: 2). More specifically, the surface contradictions of his paint-laden and tactile canvases mirror his struggles to represent black histories and narratives otherwise neglected within white mainstream and 'blackstream' visual arts (Fine, 1971: 374). The sculpted quality of his painterly textures and the diminutive size of his paintings encourage parallels with the unfinished surfaces and dimensions of Traylor's and Edmondson's works. His decision to create religious and history paintings as part of a narrative series was also indebted to Lawrence. Pippin's viewers have to stand close to his small-scale paintings to comprehend the intricacy of their compositions and brushwork, otherwise repeatedly lost in reproductions. Given his experimental artistic style and wide-ranging content, the 'reality which 'dominates' in Pippin's works is '*his*' own (Bearden and Henderson, 1993: 356).

'"You know why I'm great",' Horace Pippin told black painter, Claude Clark. '"Because I paint things exactly the way they are ... I don't do what these white guys do ... I paint it exactly the way it is and exactly the way I see it"' (in Stein, 1993: 16). Pippin's insistence that he painted according to his own aesthetic vision betrays none of the pressures which weighed heavily on earlier black artists tussling with the demands of their patrons. His fight for independence contradicts the

views of critics such as Powell who argue that he produced paintings to 'indulge his overwhelmingly white, affluent, and racially tolerant clientele' (Powell, 1993: 78). On the contrary, Pippin battled hard to explain his artistic vision to white patrons. '"I am in a bad way at this time for I do not know what I am doing",' he wrote to white dealer, Robert Carlen. '"I am doing the best that I can ... if you do not know af[ter] this, how important art is I put it in your hands to do what you will"' (in Stein, 1993: 33). His statement, 'if you do not know ... how important art is', operates in the same way as his declaration, 'Don't tell me how to paint', to register his battle to become free of white demands. In his life and art, Pippin was as isolated a figure as Archibald Motley but for different reasons. He was not only misunderstood by white critics but resented by black artists. He often despaired, '"I don't understand why they want to fight me"' (Ibid.: 26).

Pippin's art navigates a fine line between the canvases of formally trained artists such as Douglas, Motley and Alston who fought to create visual narratives of uplift, and the drawings of Traylor and Edmondson which provide tragicomic testaments to black community life. He liberated himself from a '*folk yoke*' by experimenting with form and content to arrive at his own abstract-figurative style (Powell, 1993: 78). As George L. Knox argues, Pippin created 'complex modern works' which 'demonstrate his participation in the movement toward abstraction in American art' (in Stein, 1993: vi). He carved his own path and was resistant to the restrictions imposed by a formal art education. Not lacking but choosing to ignore opportunities for formal training, Pippin 'snoozed' through white-taught art classes before finally dropping out on the grounds that it was '"impossible for another to teach one of art"' (in Stein, 1993: 15; in Bearden and Henderson, 1993: 364).

Controversies rage concerning critical approaches to Horace Pippin's art. Bearden and Henderson remain convinced that 'stereotyped thinking has prevented full recognition of Pippin as a master artist' (Bearden and Henderson, 1993: 369). Porter and Locke, however, were as divided in their responses to Pippin as they had been in assessments of Douglas. Porter dismissed Pippin's canvases as the 'painted analogues' of Edmondson's 'rustic figures' both of which 'fall short of the representational because of their technical inefficiency' (Porter, 1943: 139). Although 'puzzled for an opinion', Locke took the opposite view by identifying Pippin as a 'startlingly original painter' (in Stein, 1993: 21). He described him as 'a blend of the folk-artist and the sophisticated

stylist, the "primitive" and the technical experimenter, the genre-painter and the abstractionist, the Negro historical folklorist ... and a Blakeian religious mystic' (Locke, 1947: n.p.). Locke's admission that Pippin's art 'puzzles' him, in conjunction with his summary of his artistic personas, usefully encourage critics to look beyond limited categorisations of his art in recognition of his complexity.

As one of the very few single-authored books to discuss Pippin's work, Selden Rodman's 1940s' study has provoked negative responses from Bearden and Henderson for helping to 'frame the stereotyped way in which Pippin was seen by others' (Bearden and Henderson, 1993: 369). At a loss concerning how to categorise Pippin's art, Rodman suggested that he falls 'somewhere between' the categories of '"great painter"' and '"talented primitive"' (Rodman, 1947: 16). By focusing on Pippin's 'pride in being black' and 'a part of his race's heroic struggle out of slavery and toward self-fulfilment', he allows very little room for understanding his experimental artistic practices (Ibid.: 13). Even in the last decade or so, critical assessments have scarcely moved on as they continue to dismiss artistic issues in favour of sociological imperatives. For example, Karen Wilkin claims that Pippin arrives in 'Lawrence's territory ... by default' because he is 'just doing the best he can' (Wilkin, 1995: 37). Equally, by suggesting that 'Pippin's artistic process was always influenced by what might be called a documentary impulse', John W. Roberts emphasises political rather than aesthetic issues (Roberts, 1999: 19). His insistence on interpreting Pippin as an 'an ethnographic agent' rather than an 'ethnographic subject' similarly risks reducing this artist's work to sociological interest (Ibid. 22).

At the opposite end of the spectrum, Bearden and Henderson recover Pippin as 'one of America's great masters of color and design' by applauding the 'extraordinary quality of his aesthetic consciousness' (Bearden and Henderson, 1993: 356). In this chapter, I examine *John Brown Going to His Hanging* (1942) and *The Barracks* (c.1945) to investigate the relationship between Pippin's experimental practices and his creation of alternative histories and narratives related to African American culture. His works celebrate trajectories of hope and uplift at the same time that they do not flinch from sorrow and despair. As Pippin argued, '"My opinion of art is that a man should have a love for it, because it is my idea that he paints from his heart and his mind"' (Ibid.: 364).

John Brown Going to His Hanging (1942, Plate 5)

"'If a man knows nothing but hard times he will paint them, for he must be true to himself, but even that man may dream, an ideal",' Horace Pippin stated (in Rodman, 1947: 91). In a bid to 'dream' his 'ideal', Pippin offset the horrors of his wartime experiences by turning to religious subjects and heroic figures from American history. However, he was drawn not to histories of black freedom fighters but to white activists as he produced two series of paintings on the 'Great Emancipator', Abraham Lincoln, and the fiery abolitionist, John Brown. Pippin decided to dramatise John Brown's revolutionary attempts to free the slaves in a series of three works: *John Brown Reading His Bible*, *The Trial of John Brown* and *John Brown Going to His Hanging* (see Plate 5), all painted in 1942. His horror at what he saw of World War II may have inspired him to turn to white heroes from American history to reaffirm his faith in white humanity. These works not only highlighted ongoing injustices but also countered his sense of desolation that "'the world is in a bad way at this time'" (in Bearden and Henderson, 1993, 369). Pippin sought a reality other than the one in which "'men have never loved one another'" (Ibid.). While it is likely that Pippin's John Brown series was inspired by Lawrence's *Life of Toussaint L'Ouverture* (1938) which 'had some impact on him', whether he saw Lawrence's *Life of John Brown* (1941) series completed a year before remains a subject for conjecture (Ibid.: 365). Either way, John Brown remains a recurring figure in African American art. Since Augustus Washington's famous daguerreotype in the nineteenth century, Brown has appeared in watercolours by Jacob Lawrence and William H. Johnson, charcoal drawings by Charles White and gouache works by Kara Walker. His determination to resist slavery by encouraging a slave revolt resonates so fiercely with African American artists and activists that he is consistently recuperated as a black hero in whiteface.

Horace Pippin's three paintings capture Brown's complexities by portraying this heroic figure simultaneously as a religious leader, an injured victim and a sacrificial martyr whose devotion to African American suffering sent him to the gallows. Nothing could be further from popular accounts of Brown as a murderer and a madman than his first painting, *John Brown Reading His Bible*. In this work, Brown wears a sorrowful expression and sits in contemplation before an open bible. The only real colour in this canvas is the red flame of the candle on the table which illuminates the furrowed lines in Brown's face and the downward expression of his eyes. Pippin's stark juxtaposition of black and white

generates dramatic tensions in this work. He contrasts the ghostly white-
ness of Brown's skin with the blackness of his hair, eyebrows and coat.
While Brown's face and neck are a pasty white, his clenched hands,
however, are a rich brown to suggest the ways in which his heroic sacri-
fice on the altar of black freedom literally transforms his body into a site
of racial ambiguity. The setting for his meditation is a destitute cabin
dominated by grey and black horizontal wooden boards and striped
curtains. Pippin's symbolic composition traps Brown between the
horizontal lines of the walls and table to capture the imprisoning force
of his environment.

In this oil painting, Pippin insists on Brown's exemplary Christ-like
status in a crusade against injustice by representing this white hero as
a solitary figure. While on the surface this work privileges religious
martyrdom over heroic combat, a closer look reveals Pippin's inclusion
of an axe next to a bucket. Just behind Brown, this axe appears next
to his right arm which is half raised as if to dramatise his capacity for
violence. While Pippin's paintings are unaccompanied by the captions
which characterise Lawrence's narrative paintings, his inclusion of
symbolic objects such as a bible and axe convey Brown's importance
as a divinely sanctioned military leader. In these works, Pippin adopted
symbolic spatial arrangements and colour schemes at the same time that
he included telling objects to show that his was an imagined rather than
an 'authentic' representation of history (Rodman, 1947: 29). Rather than
'just doing the best he can' to create 'authentic embodiments of the black
experience', Pippin's self-conscious paintings experiment with form and
colour to create revisionist histories of white heroism (Wilkin, 1995:
37, 38).

By comparison, the second panel, *The Trial of John Brown*, recalls
James P. Ball's *William Biggerstaff* series by portraying John Brown
powerless before a white jury. A persecuted prophet, he looks towards an
open bible while his full beard and overgrown hair suggest the passage of
time to heighten his mythic and religious associations. Brown resembles
Pippin's representations of Christ in his religious paintings such as *Christ
Before Pilate* (1941). The splash of red which colours the gash on Brown's
head resonates with the bleeding face of Christ in *The Crucifixion* (1943).
Pippin adopts a symbolic use of red in *John Brown Reading His Bible* and
The Trial of John Brown to contrast divine light, as represented by the
candle, with bodily mutilation, as conveyed via his scarring. The white
men who sit behind Brown evoke a tradition of lynching photography by

surrounding his prostrate body and staring directly at the viewer. These associations draw attention to John Brown's racial ambiguity given that his victimised form visually replicates the spectacle of the lynched black body. Pippin's inclusion of a rifle and bible in this painting resonates with his earlier depiction of a bible and axe to celebrate religious justification in the violent overthrow of slavery.

While the axe of *John Brown Reading His Bible* foreshadows Brown's violent struggle for freedom, the rifle prophesies his death at the hands of cowardly whites. Pippin's composition positions the jury looking directly towards the viewer to critique their lack of empathy and further accentuate the racial differences between Brown and his white contemporaries as he became othered in the white imagination. Brown's limp body lying on vertical boards complements the horizontal divides of Pippin's first work to reinforce a nihilistic view of man literally floored by his environment in this series. However, in contrast to *John Brown Reading His Bible* which generates the drama of his suffering in a stark juxtaposition of blacks, whites and greys, *The Trial of John Brown* relies on sepia-coloured tones to evoke a historical past and contest the authority of any versions claiming to offer an 'authentic' account of this controversial figure's life. Horace Pippin's immersion of the canvas in a brown wash resonates with Traylor's yellowed cardboard to heighten the authenticity of his work and argue for the authority of the black painter's version of events over and above any other.

The final painting, *John Brown Going to His Hanging* (1942, see Plate 5), is the most thought-provoking of the series. For the first time the focus is not on the bound figure of John Brown riding to his hanging but on an elderly African American woman who stands in the bottom right of the painting. She looks neither at the scene nor at the viewer as her gaze is directed off canvas. Standing apart from the all-white crowd, she dominates the foreground. Pippin's use of a flat perspective ensures that she rivals Brown in her comparable physical proportions. Bearden and Henderson suggest that this woman was Pippin's grandmother who had 'personally witnessed the hanging of John Brown' (Bearden and Henderson, 1993: 364). As such, she becomes the 'storyteller, facing the viewer in the classic stance of the narrator in the theater' (Ibid.). However, close scrutiny shows that her gaze is no more directed towards us any more than it is towards the activity in the painting. 'How accurately Horace's grandmother must have remembered the occasion,' Rodman comments, 'is shown by the authenticity of every detail in the

painting' (Rodman, 1947: 28). And yet, Pippin's 'authenticity' which emerges from this oral testimony is nothing if not staged, invented and artificial. By juxtaposing a white mob and a bound white hero with a black female griot, Pippin suggests there are inextricable relationships between white heroism and black resistance. As Powell argues, this black female figure represents the 'only instance of a black presence in the Emancipation story, and a black point of view in regard to events in American history' (Powell, 1993: 75). Thus, Pippin's composition displaces Brown's heroism by focusing upon the individual subjectivity of his black female ancestors and an African American oral tradition.

While his decision to represent only white heroic figures may seem conciliatory, Pippin's inclusion of an African American storyteller of black history radically reverses hierarchies of power according to which black experiences have been elided or told only from a dominant point of view. The prominent inclusion of this African American woman ruptures rather than reinforces the illusion that the action of the painting is historically accurate. She evokes black folkloric practices and oral testimonies, replete with signifying practices and trickster ambiguities, to dramatise possible fictions and posit alternatives to the established 'facts' of white versions of black history. Horace Pippin's emphasis upon the oral testimony of his own family is crucial for understanding *John Brown Going to His Hanging*. As Powell argues, 'Pippin's implication that *he* – via a blood relative – was part of this historic event, demonstrated his deep sense that the shifting tides of history *did* impact profoundly upon him as well as other black Americans' (Ibid.: 76). In contrast to his earlier brown, black, white and grey paintings in this series, this work makes a symbolic use of blue. The black female figure wears a blue and white dress which distinguishes her from the crowd of black-suited white men and complements the colour of the sky. Unlike the white jury who confront the viewer in the last work, we see only the backs of these figures as they also look towards John Brown to reiterate his audience's complicity in Brown's martyrdom. Their concealed faces anonymise their guilt while their white, brown, red and purple scarves suggest their individual responsibility.

However, Pippin's one exception includes the white man who stands next to his grandmother. In contrast to the other faces we cannot see, he looks directly at the viewer while his head is exaggeratedly large and sits at an angle on his neck, thereby foreshadowing Romare Bearden's 1960s collage technique. He carries a whip which he does not inflict on

the black woman whose fearless belief in Brown seemingly insulates her from harm. Unlike Pippin's earlier burnt-wood painting, *The Whipping* (1941), his grandmother is not subjected to physical abuse but retains her agency. More importantly, and given the position of his grandmother in the bottom right-hand corner of the painting, Pippin suggests that she is in control of the visual narrative as it is her memory we are seeing. These white male figures have no existence apart from in her imagination. Pippin's decision to portray Brown on his way to, rather than at, his hanging holds back on violence to draw attention to his racial ambiguity by echoing Lawrence's tactic of including symbolic nooses rather than literal representations of black violated bodies.

As James P. Ball, Archibald Motley and Horace Pippin show, grand-mothers repeatedly symbolise African ancestry, slave history and cultural survival through storytelling in African American art. The presence of the black woman in Pippin's *John Brown Going to His Hanging* legitimises white male heroism. As Roberts explains, 'Pippin's tendency to create images that tell a story in multi-episodic fashion represents his attempt to create visual images that reproduced the style of African American oral narrators' (Roberts, 1999: 24). Pippin's use of a narrative series to portray John Brown's heroism communicates new themes in the relationships between individual paintings. By juxtaposing white solitary heroism with black community responsibility and white mob rule in these works, Pippin indicted the racist silences of official histories.

The Barracks (c.1945)

'FEAR DEATH MINUTES VOICES SQUAD' (Horace Pippin in *HPP* 138, Pippin, *Notebook*, c.1920: n.p.). This chaotic list of words captures Pippin's frustration with language when trying to communicate the horrors of World War I. '"I tried to write the story of my experience, but did such a bad job of it I gave it up",' he admitted (in Rodman, 1947: 62). His impatience should not be taken too seriously, however, given that he produced reams of diaries and notebooks. Despite the insights they provide concerning the genesis of his war canvases, his manuscripts have yet to be published. Many of these works began life as sketches within these pages. He developed a pictorial and oral literary style to dramatise his war experiences to his hoped-for 'dear reder [sic]' (*HPP* 138, Pippin, 'Written by Horace', 1920: 6). His fragmented prose mimicked his fear of 'no man's land', that 'tirebell, and hell place, for the houl intir batel feel were hell, so it was no place for any houmen been to be [sic]' (*HPP*

138, Pippin, *Notebook*, c.1920: 1). Pippin's phonetic spelling replicates vernacular speech to encourage a visceral re-imagining of his experiences from his readers.

A couple of examples soon dispel myths perpetuated by critics such as Rodman that there is 'no hint in any of the manuscripts that Horace was horrified by war' (Rodman, 1947: 35). In one extract, Pippin described how an aeroplane 'were a fire and came Down to rise no more. I wernt over to see it, and it were a site to see you could not tell what it were it were in Picess, and you could not make them out, there were two men in it and they looked like mush [sic]' (*HPP* 138, Pippin, *Autobiography*, n.d.: 21). In another section, he communicated the death of his 'Buddy' during a raid into German territory when 'every hart were beteing fast [sic]' (Ibid.: 27). 'I were made sad and mad all at the same time,' Pippin wrote, 'men were layeing all over the feel and Road men that I knoew all so my Budy. I looked to see if I could do him any good. I could not for he were Don for [sic]' (Ibid.: 42–3). Pippin's understated language works in the same way as literary techniques of omission by nineteenth-century slave narrators. Both made their horrific realities more palpable by highlighting the impossibility of paint or words to capture their enormity. Pippin's written and painterly styles are more compelling for their lack of finish. He was as unsentimental in his language as he was in his painterly style and both convey the horrors of his view, 'It were the hirdest job I ever had to drag a dead man over that roff noman land [sic]' (Ibid.: 49).

'Fighting no 369 inf,' Pippin wrote to friends, 'Brought out all of the art in me' (*HPP* 138, Pippin, 'Letter to Dear Friends', c.1920: 1–2). The only black artist to paint the horrors of World War I, his canvases include: *The End of the War: Starting Home* (c.1930); *Outpost Raid* (1931); *Gas Alarm Post* (1931); *Shell Holes and Observation Balloon* (1931); *Trenches* (1935); *Mr. Prejudice* (1943); and *The Barracks* (1945). In his small-size canvases, he populated otherwise idyllic rural scenes with colliding human figures and military equipment. In particular, *The End of the War: Starting Home* reveals his compulsion to paint as a way out of despair. He coated this canvas in a hundred layers of paint to exorcise his 'blue spells'. The picture's handmade frame replicates the horrors of the canvas by bursting with carved representations of shells, rifles and grenades covered in smatterings of red paint. For Bearden and Henderson, this is 'one of the most antiwar works created in modern times' (Bearden and Henderson, 1993: 360). Pippin juxtaposed the soldiers with the enlarged fence posts decorated with barbed wire and

tree limbs to highlight the fragility of human life. As he wrote in his diary, 'The bullets were singeing their death song throu the air. And they would hit the wire and glance off and hum like a bee every minut [sic]' (*HPP* 138, Pippin, 'Written by Horace', 1920: 47).

This painting tells the untold story of black military heroism. African American soldiers blur with the dark browns and greens of the under-growth to accentuate their military prowess in *The End of the War*. The Germans' white faces and grey uniforms highlight their vulnerability in the face of black bravery as they raise their arms in surrender. Unlike the bloodied Germans, African Americans soldiers push forward unharmed to secure a victory that Pippin could only have imagined as he was discharged before the end of the war. Recalling his *John Brown* series, Pippin's works drew either on personal experiences or the testimony of family members to convince his audiences of their authenticity. The title of this work, *The End of the War: Starting Home*, dramatises a longing for home born out in his notebooks in which Pippin wrote, 'A thought of home and I could see it right in front of me. I wonder if I will see it again' (*HPP* 138, Pippin, *Notebook*, c.1920: 10). As Bearden and Henderson argue, '*Home* is the deepest theme in Pippin's work' (Bearden and Henderson, 1993: 360–1).

Pippin's painting, *The Barracks*, was completed in 1945 at the end of World War II but looks back to his own experiences during World War I. He divided the composition into small segments to represent each soldier's cramped living conditions as the abstract grid-like structures reiterate the uniformity of military life. In the foreground, two African American men hunch over pieces of white cloth by flickering candle-light. Apart from the red flame, the absence of any other colour on this canvas resonates with *John Brown Reading his Bible* to suggest the close relationship between heroism, sacrifice and religious martyrdom in both paintings. The men are sewing what appear to be parts of their uniform in a masculine revisioning of Motley's *Mending Socks*. This painting celebrates the strength, endurance and heroism of African American manhood as soldiers retained normalcy and an illusion of home by performing domestic chores even when surrounded by the parapher-nalia – guns, ammunition, backpacks – of war. The anonymity of the soldiers in *The Barracks* suggests that black heroism can be found in everyday activity. Whereas Pippin went to great lengths to distinguish the soldiers in his 'Study' for this work, the black men in *The Barracks* have no distinctive facial features.

By contrasting the naked upper bodies of the two soldiers in the foreground with the white shadows projected behind them, Pippin symbolically evoked the ways in which segregation in military combat reinforced tensions in race relations. The two men occupying the middle ground of *The Barracks* are far less active than those mending their uniforms. The man on the left lies reading a letter with a contented expression on his face while the man on the right looks sorrowful as he huddles his shrunken and diminutive body down under a blanket. The two top bunks contain only abandoned blankets to suggest the absent bodies of martyred black men. Pippin employed a symbolic use of candle size in this painting. For the two soldiers sat mending and the man reading the letter the candles are long and burn brightly. However, for the man lying awake in the dark and the two empty bunks, the candles are unlit stumps. By contrasting the graininess of the wooden beams with the smoothness of the men's skin and the coldness of the white floor, Pippin draws attention to the rough materiality of their experiences as well as the fragility of their humanity. In *The Barracks*, Pippin's ambiguous physiognomies encourage audiences to work harder to recreate their own visual narratives of war.

Throughout his lifetime, Pippin's traumatic experiences of military conflict haunted his art. Speaking of his *Holy Mountain* series which purportedly envisions 'peace', Pippin argued that this work "'would not be complete if the little ghost-like memory did not appear in the left of the picture. As the men are dying, today the little crosses tell us of them in the First World War and what is doing in the South'" (in Bearden and Henderson, 1993: 367). Pippin's small white gravestones, blood-red poppies, grey men running with guns, aeroplanes falling from trees and tanks hiding in the undergrowth complicate his *Holy Mountain* idyll by demonstrating his battle to dramatise the 'struggles' and 'sunsets' of his own experiences. Given Pippin's celebration of home in his war manuscripts, it is no surprise that some of his strongest works are his domestic scenes. These include paintings such as *Saturday Night Bath* (1941), *Man Seated Near Stove* (1941), *Giving Thanks* (1942), *Asleep* (1943), *Domino Players* (1943), *Saying Prayers* (1943), *Sunday Morning Breakfast* (1943) and *Interior* (1944).

In these works, Pippin's idealised representations of African American southern life are visual counterparts of Motley's northern urban-scapes. They contrast heavily with the bleakness of Lawrence's *Harlem* paintings and *Migration of the Negro* series, also produced in the early 1940s.

By including representations of black cultural icons and home-made artefacts, Pippin offset the poignancy of black families living with peeling walls, a lack of light and bare floors. Brightly coloured and patterned rugs, quilts, tablecloths and clothes decorate an otherwise desolate cabin in *Giving Thanks* to suggest the transformative power of an artistic imagination to ensure cultural survival. As Cornel West argues, Pippin's works aggrandise the 'quotidian lives of people' by dramatising African Americans 'outside of the white normative gaze that requires elaborate masks and intricate posturing for black survival and sanity' (West, 1993: 44, 49).

Claude Clark's view that Horace Pippin was 'exploited to the hilt' and never 'fully treated as a human being' is no less relevant to critical assessments and public exhibitions of this artist's work today (in Stein, 1993: 31). In his last painting, *Man on a Park Bench* (1946), Pippin reflected on his own sense of alienation and loneliness. As West warns, 'Pippin's art still reminds us of how far we have *not* come in creating new languages and frameworks that do justice to his work' (West, 1993: 52). This critique not only exposes the limitations of current approaches to Pippin's work but also sheds light on the underdeveloped state of current African American art scholarship. Too many critics still find it difficult to account for the search for agency in works by African American artists. No one expressed the fight for independence better than Pippin when he explained that his story was '[m]y life story of art, that is my art, and no one else' (*HPP* 138, Pippin, 'Letter to Dear Friends', c.1920: 1).

Jacob Lawrence (1917–2000)

'Struggle ... is a beautiful thing'

The Life of Toussaint L'Ouverture (41 panels, 1938). *The Life of Frederick Douglass* (32 panels, 1939). *The Life of Harriet Tubman* (31 panels, 1940). *The Migration of the Negro* (60 panels, 1941). *The Life of John Brown* (22 panels, 1941). *Struggle ... From the History of the American People* (30 panels, 1954-6). Jacob Lawrence was the first African American painter to create multi-panel narrative series examining black heroic figures and events from United States and Caribbean history. 'We don't know the story, how historians have glossed over the Negro's part as one of the builders of America,' he urged (in Greene 1968: 36). Lawrence's research was taken from oral histories as well as library sources. As he admitted, '"I've been hearing the stories of these heroes and heroines ever since I was a child"' (anon.: 'The Booklist Interview', 1994: 1048).

Mapping the past onto the present, he urged the contemporary relevance of his historical subjects: "'I didn't do it just as a historical thing, but because I believe these things tie up with the Negro today. We don't have a physical slavery, but an economic slavery'" (in Wheat, 1986: 40). As Nathan Grant argues, these works produce a 'revision of history' by creating a 'severe irony or tension' as '[c]anvas and caption, united in their storytelling value, create a broad new realm of narrative' (Grant, 1989: 525–8). Lawrence is one of the first artists to explore in any depth the experimental possibilities presented by ambiguous relationships between text and image in his works.

Lawrence created these series by working simultaneously on small-scale panels to maintain consistencies of symbolism, colour and composition. Individual panels within each series tell stories within stories to complicate the oversimplified and dominant narratives popular in epic-size murals. He was convinced that "'what I couldn't do in one painting I could do in a series of paintings'" (Ibid.). The slippery relationships between text and image suggest that accurate representations of black experiences could only be arrived at in the untold stories represented by the gaps, ellipses and breaks within and across his works. As Grant suggests, '[A] painterly semiotics synthesizes with linguistic elements to produce a new narrative category, a phenomenology of a history, a rewriting of a culture' in Lawrence's watercolours (Ibid.: 524).

There can be little doubt that Lawrence's narrative series were inspired by the epic histories dramatised in the murals of Douglas, Motley and Alston. He designed his works to be both aesthetically challenging and pedagogically accessible. "'For me a painting should have three things: universality, clarity and strength",' he explained. "'Universality so that it may be understood by all men. Clarity and strength so that it may be aesthetically good'" (in Wheat, 1986: 192). Lawrence was as determined to communicate his themes within and beyond the black community as he was to produce high quality and instantly comprehensive paintings. "'Struggle … is a beautiful thing – beautiful in the sense that there's some hope",' he urged. "'I'm not just thinking in terms of the racial thing … It would be very unfortunate if … we don't have the will … to put up a resistance'" (in Wallis, 1996: 61). Lawrence's subtexts of anger and satire in his exposés of black struggle are among the most neglected features of his art. Repeatedly described as a griot for the African American community, Lawrence pushed beyond racial differences to get at the heart of what it means to be human. "'The Negro's

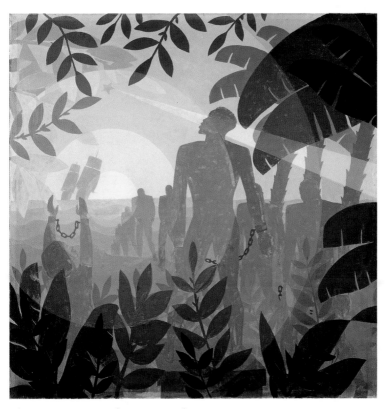

Plate 1 Aaron Douglas, *Into Bondage*, 1936

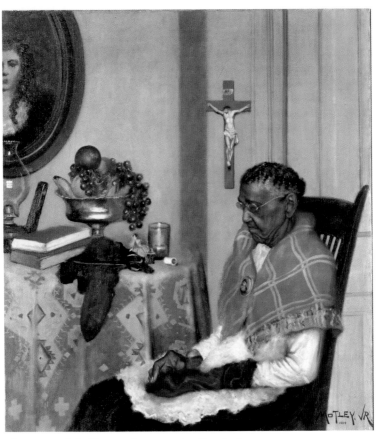

Plate 2 Archibald J. Motley, Jr, *Mending Socks*, 1924

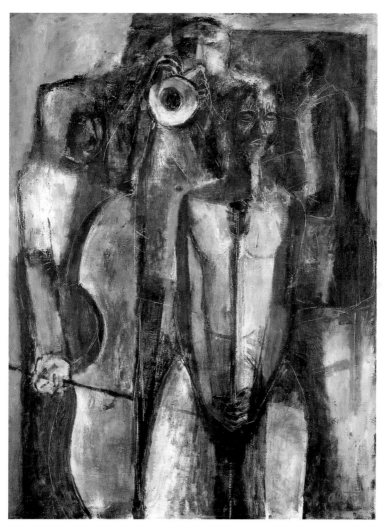

Plate 3 Charles Alston, *Jazz*, c.1950

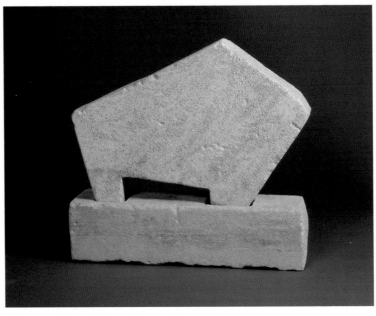

Plate 4 William Edmondson, *Critter*, c.1940

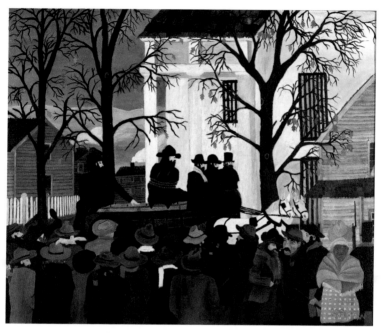

Plate 5 Horace Pippin, *John Brown Going to His Hanging*, 1942

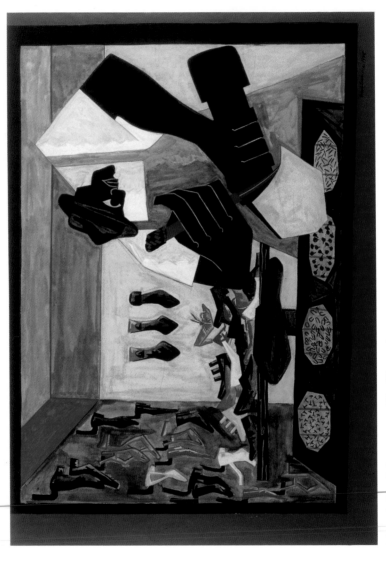

Plate 6 Jacob Lawrence, *The Shoemaker*, 1945

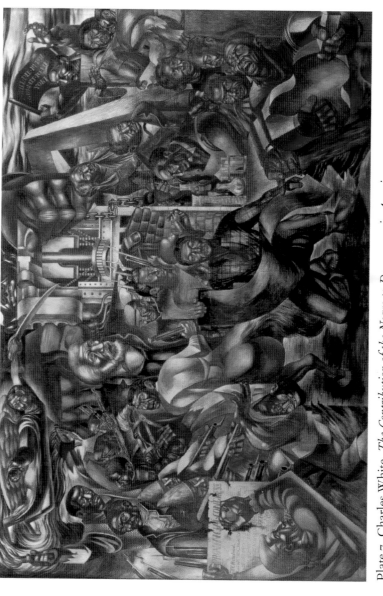

Plate 7 Charles White, *The Contribution of the Negro to Democracy in America*, 1943

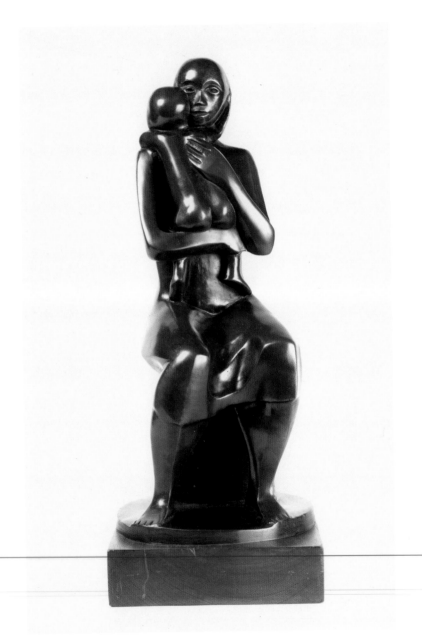

Plate 8 Elizabeth Catlett, *Mother and Child*, 1972

struggle is a symbol of man's struggle, from my point of view"' (in Wheat, 1986: 105). He was as influenced as Pippin and Edmondson by the 'black aesthetic' or visual arts tradition of the African American community. While he initially told interviewers that no one in his family was '"artistically inclined"', he later admitted. '"[M]y artistic sensibility came from this ambiance"', given that he was '"surrounded by art"' (in Turner, 1993: 21). '"Our homes were very decorative, full of a lot of pattern",' he explained. '"Because we were so poor, the people used this as a means of brightening their life. I use to do bright patterns after these throw rugs; I got ideas from them, the arabesque movements and so on"' (in Wheat, 1986: 29). In contrast to Harlem Renaissance artists who were trying to represent the lives of 'men on the street' from their middle-class positions, Lawrence came from a single-parent family and lived among the tenements. '"I wasn't on the outside looking in, I was on the inside looking out",' he admitted (in Wallis, 1996: 60). Admitting that his '"paintings have always been sort of autobiographical"', there can be little doubt that he experienced the lives of the African American poor firsthand (in Berman, 1982–3: 97). Just as Harlem Renaissance artists Motley and Douglas were convinced that art should dramatise individual lives, Lawrence similarly believed that the 'human subject is the most important thing' (in McCausland, 1945: 254).

In the majority of his works, Lawrence was drawn to the 'water medium [sic], like egg tempera, gouache, casein' on the grounds that he loved 'to tell a story and the water media on paper ... dries very fast' (*UJLP*, Lawrence, 'Unpublished Interview', 1992: n.p.). Throughout his lifetime, he experimented with 'a very limited palette' of 'pure color' because he had 'never learned color in an academic way' (in Greene, 1968: 19). He 'mostly' painted using the 'primary colors plus black and white, and sometimes the secondary colors' (Lawrence in Berman, 1982–3: 28). Lawrence's unmixed palette offsets his use of distorted perspectives, grotesque anatomies and abstract geometrical shapes to dramatise the 'struggles' and 'sunsets' of human experience. '"Limiting yourself to these colors ... forces you ... to work with a degree of economy, and out of that you could get a stronger work than you might get otherwise",' he argued (in Wheat, 1986: 34). Following these methods, Lawrence relied on a restrained colour symbolism to create strong, pared-down and unsentimental works which dramatised slavery and civil rights, black migration, military conflict, nuclear war, psychiatric illness, labour, performance, poverty, history and heroism.

Critical debates surrounding works by Lawrence focus upon his experimentation with narrative, history and aesthetics. 'One does not look to this gifted young Negro for realism so much as for the essence of realism,' Locke argued, 'His records are full of emotion' (Locke, 1942: 478). Porter also praised Lawrence for being 'gifted with an unfettered imagination that loves to release itself through the laconic force of abstract symbols' (Porter, 1943: 141). For Bearden and Henderson, he 'burst like a furious rocket' upon the African American visual arts tradition (Bearden and Henderson, 1993: 293). They praise his 'direct' representations of inner city poverty which distinguished him from Motley who 'romanticized his basically realistic scenes' (Ibid.). Both critics suggest that the 'faces of his subjects are mask-like, utterly free of sentimentality' while many of his scenes resemble 'simplified news photos of the moment' (Ibid.: 297, 299).

For Patricia Hills, Lawrence remains the 'pictorial *griot*' of his black community (Hills, 1993: 42). Her view that his 'expressive cubism, with its flat shapes, controlled outlines, and limited range of color, kept the emotion restrained, the conceptual goals clear, and the sequences moving' can be applied not only to his history series but to his aesthetic practice as a whole (Ibid.: 46). Ellen Harkins Wheat also warns that Lawrence's 'simplicity' does 'not preclude the complex aesthetic decisions' exhibited in his works (Wheat, 1986: 15). Moreover, David Driskell is right to identify Lawrence's fascination with fragmentation by claiming he was 'interested not in perfect form but in perfect distortion which penetrates through mere outward appearance to the essence' (Driskell, 1976: 71). As Aline Saarinen argues, Lawrence's 'reality' is 'made manifest in artifice' rather than authentic representations (Saarinen, 1960: 4). By emphasising artifice rather than authenticity, distortion rather than realism, these critics warn audiences against oversimplified readings of his works. In this chapter, I examine Lawrence's *Migration of the Negro* series (1941) and *The Shoemaker* (1945) to extrapolate the experimental features of his groundbreaking narratives which foreground aesthetic issues alongside themes of black exodus, labour, violence, racial conflict and history.

The Migration of the Negro (1941)

'"My entire statement ... my experience as an American, as an Afro-American, is summed up in that one work"' was Jacob Lawrence's claim for his widely celebrated *The Migration of the Negro* series, completed in 1941 (in Wallis, 1996: 62). The first series to bring the history of African

American experiences in the United States up to date, *The Migration* provides a bridge between his earlier works eulogising black heroism and his later paintings depicting the gritty realities of contemporary urban life. Lawrence's series was inspired by and exhibited in Harlem community centres to educate black audiences concerning the legitimacy of their own histories as the appropriate subjects of art. This work consists of sixty panels and draws on a tradition of antislavery panoramas and murals to examine early twentieth-century black migration from the south to the north. In *The Migration of the Negro*, he examined the impact of race and class discrimination, poverty, starvation, lynching, homelessness, labour exploitation and physical abuse on black southern families. He contested popular myths of the north as the Promised Land at the same time as he investigated the behaviour of black elites towards the newly arrived southern poor.

The captions of these panels gesture towards but do not explicate their content as they experiment with a deliberately ambiguous relationship between text and image. Lawrence's juxtaposition of utopian statements with dystopian scenes strengthens the ironic relationship between literary and visual language in these works. For example, he experimented with abstraction in *After arriving North the Negroes had better housing conditions* (no. 31) to accentuate the grid-like uniformity of towering tenements. *Living conditions were better in the North* (no. 44) similarly shows only a slab of meat and a piece of bread to reinforce rather than detract from his bare surroundings. As an extension of black northern suffering, *In the North the Negro had freedom to vote* (no. 59) betrays how black voters were intimidated by white violence. In other instances, however, the captions offer the only explanation of his otherwise abstract imagery. For example, the didactic caption of panel seven, *The Negro, who had been part of the soil for many years, was now going into and living a new life in the urban centers*, contrasts with its non-figurative subject matter which consists solely of abstract planes of interlocking reds, yellow, blues, blacks, whites and browns. Thus, it is only within the context of Lawrence's textual explanation that this image can be understood as symbolising an African American exodus from the south. Many of Lawrence's panels accentuate the tragedy of the series by introducing a symbolic use of colour. No better example of this can be found than in panel forty-seven for which the caption reads, *As well as finding better housing conditions in the North, the migrants found very poor housing conditions in the North. They were forced into overcrowded*

and dilapidated tenement houses. In this watercolour, Lawrence under-
mined the despair and lack of agency suggested in the accompanying
caption by covering the small bodies of the black children lying on a
metal bed with individually patterned and beautifully coloured quilts.
These multicoloured quilts celebrate African American survival, in
the face of an imprisoning environment, through the preservation of a
distinct cultural legacy. This work was inspired by Pippin's domestic
interiors which similarly argued for the power of improvisation to trans-
form oppressive surroundings.

Lawrence's experimentation with the relationships between panels in
serial works such as the *Migration of the Negro* series opens up alternative
readings of his visual stories. The front cover of this book reproduces
panel sixteen of the series which represents a bowed African American
female figure. The bold angularity of her hunched-over frame and the
anonymity of her face which she protectively hides from view unsen-
timentally convey her sorrow. Lawrence dramatised the rawness of
his subject's emotion by her disfigured limbs as a left arm hangs limply
down to reveal a claw-like hand. The fierce red of her smock-like dress
suggests the violence and terror described in the caption as he relied on
the powerful tensions produced by colour to dramatise hope and despair
repeatedly throughout this series. Lawrence's focus upon the plight of
the African American woman was intended to rectify his conviction that
'"[t]he Negro woman has never been included in American History"'
(in Wheat, 1986: 47). In this particular work, he experimented with an
unnerving use of perspective to communicate the impoverished circum-
stances of this unidentified female figure. The bowl and table are about
to come crashing down to highlight the terrors of her spartan surround-
ings. The panel's caption explains the source of this black woman's grief:
*Although the Negro was used to lynching, he found this an opportune time
for him to leave where one had occurred.* However, the lynched body over
which she grieves is nowhere in sight. This absence is significant and
presages the importance of considering each of Lawrence's images in
relation to one another.

Thus, in the preceding image, panel fifteen, Lawrence depicted a
similar but smaller figure in red, also bent over in lament and sitting
underneath an empty noose which looms against a white background.
The caption for this work reads, *Another cause was lynching. It was found
that where there had been a lynching, the people who were reluctant to leave at
first left immediately after this.* In these works, Lawrence's symbolic use of

colour in his juxtaposition of red, black and white and of objects such as the heavily loaded noose and the bowl operate as an elliptical shorthand for transcribing the complexities and ambiguities of black experiences in the United States. Both images endorse a slippery relationship between text and image by withholding the spectator's anticipated viewing of the spectacle of the brutalised, tortured and lynched black body. Psychological trauma, rather than physical mutilation, remains the focus here as Lawrence chose to dramatise the emotional realities of black experiences. It is no accident that his female figure in panel sixteen sits on a piece of rough wood which echoes his representation of slave auction blocks elsewhere. In these works, he drew parallels between a history of slavery and the ongoing injustices of discrimination in a contemporary era of 'economic slavery'. Lawrence relied on a noose to represent the absent black body and highlight the impossibility of ever conveying the full horrors of an African American experience simply by the exhibition of its victims. He staked his claim for the agency of his sufferers in *The Migration of the Negro* series by focusing on their internal complexities rather than their physical vulnerabilities.

The tendency among critics to underestimate Lawrence's aesthetic ambiguities in *The Migration of the Negro* series is no different from the short-sighted readings of works by Pippin and Edmondson. Audiences and scholars inscribe an authentic naivety on to these artists which the aesthetic complexities of their works negate. While Wheat argues that the 'written texts accompanying the pictures tend to be simple and factual', in Lawrence's *The Migration of the Negro* series, African American artist, Kara Walker, distinguishes between 'what I love', which is its 'ability to be artful', and 'what I hate' which is its 'overbearing explanation' (Walker, 1999: n.p.). *The Migration of the Negro* is much more 'artful' than either Wheat's or Walker's assessments allow. Elizabeth Catlett's view is far more accurate. By suggesting that he '"strips his material to the bone"', she demonstrates the ways in which '"his style of painting with almost elemental color and design is a perfect means for the expression of the fundamental needs of the Negro"' (in Turner, 1993: 141). Too many critics interpret a direct approach as a simplified one and an aesthetic practice characterised by distortion and fragmentation as confirming the limited capabilities of an 'untutored' folk artist.

The Shoemaker (1945, Plate 6)

'"The human body is like a tool ... I think of it as man's aspiration, as a constructive tool – man building"' (Lawrence in Wheat, 1986: 143). One of the major themes of Jacob Lawrence's various narrative series concerns his preoccupation with labour and the role of African Americans in building the nation. As recently as 1998, he completed his influential *Builders* series. However, this theme had been present much earlier in paintings such as *The Shoemaker* in which Lawrence betrayed a lifelong fascination with collecting tools and tool manuals (see Plate 6). 'During my youth I was exposed to the various tools of a workshop,' he admitted. 'In formalistic terms, I have attempted to achieve the rhythm, shape, and color of tools, and the atmosphere in which people use them' (*UGKP*, Lawrence in Bruce Guenther, *Fifty Northwest Artists*, n.d.: 74). In this canvas, Lawrence's shoemaker is at work and surrounded by the paraphernalia of his trade while his enlarged hands dominate the foreground to symbolise African American craftsmanship. The blackness of his skin resonates with the blackness of his tools and work surface to reinforce the extent to which Lawrence used tools in '"a compositional way"' so that they could become '"an extension of the hand"' (in Wallis, 1996: 64).

In this painting, Lawrence argued for a continuum between black art and identity by making it difficult for viewers to establish where the shoemaker's hands end and the tools begin. His symbolic use of colour maps the anatomy of the human body on to the tool itself to suggest that the black labourer is at one with his craft. He accentuated the angular body of the shoemaker by raising his left shoulder in this painting to offset the angular lines of his dungarees and contrast geometric shapes and separate fields of colour. Lawrence's representation of the shoemaker in profile borrows from Aaron Douglas's earlier Egyptianising techniques by including only the outline of an eye and mouth to create an emotionally complex and mask-like face. By experimenting with cubist techniques, Lawrence distorted the physiognomy of the shoemaker to undermine stereotypical representations of African Americans in mainstream visual culture. Neither realist nor grotesque, Lawrence's abstract representations of black physicality reject racist oversimplifications. *The Shoemaker* illustrates Lawrence's statement that he used tools in his work as some 'other painter might use fruit and flowers' while reiterating his view that, the 'tool box' is 'a wonderful symbol of creation, of building' (*UGKP*, Lawrence, 'Unpublished Interview', 1992: n.p.).

In *The Shoemaker*, Jacob Lawrence's unmixed reds, blues and yellows offset his browns and greens to suggest the ways in which labour can offer an escape from alienating and destitute circumstances. Although the shoemaker is engaged in a repetitive task, Lawrence argues for the artistry of his craft. Four delicately and differently patterned blue soles in the foreground of the work draw attention to the uniqueness of the craftsman's finished artefacts. By exhibiting the shoemaker's shoes in various stages of completion, Lawrence emphasised themes of construction to examine the aesthetic process itself rather than the finished object. The stacking of shoe parts echoes Traylor's representation of tools which take on life-size proportions in drawing such as *Blacksmith's Shop*. *The Shoemaker* represents Lawrence's wake-up call to white artists concerning the fundamental but neglected importance of African American labour. 'Has he not helped erect skyscrapers and tunneled subways,' he insisted, 'as well as swept the corridors of these same skyscrapers and subways?' (*JLP* D4572, Lawrence, 'Friends', n.d.: 1). Charles Alston's definition of the 'consistent thread' running through Lawrence's work as that of a 'race memory' reflects this artist's concern with drawing on personal experiences and oral histories to dramatise everyday black lives (in Murray, 1968: 15). Lawrence's experimental narrative series and individual paintings reiterate a view shared by Edmondson and Pippin that '"[m]en dying, men being shot, they're heroes"' but also that '"[i]t's the little things that are *big*. A man may never see combat, but he can be a very important person"' (in McCausland, 1945: 251). All three artists refused to exalt exemplary heroic figures over and above the factory labourers, nurses, washerwomen and teachers of everyday community life.

Jacob Lawrence was one of the first African American artists to debate the relationship between black arts and 'the black aesthetic', a subject of ongoing controversy in African American art. 'I was inspired by the black esthetic by which we are surrounded, motivated to manipulate form, color, space, line and texture to depict our life, and stimulated by the beauty and poignancy of our environment,' he asserted (Lawrence, 1970: 266). However, he remained as sceptical as Charles Alston concerning whether there was an 'African American idiom' or even a 'particular black American style' (in Major, 1977: 18). He acknowledged that any 'black aesthetic' must be influenced by 'African, Oriental, and European esthetics' just as much as by 'our fellow black artists' (Lawrence, 1970: 266). Regardless of anxieties of influence, Lawrence's works ultimately

reflect his concern with the ways in which '"things I have experienced extend into my national, racial and class group"' (in Wheat, 1986: 192). More specifically, his aesthetic practices opposed white stereotypes according to which the 'Negro is too often treated in a manner inconsistent with his true life' (*JLP* D4572, Lawrence, 'Friends', n.d.: 1).

Conclusion: Storytelling, Resistance and *Nat Turner*

'I myself feel like a primitive man, like one who is at the same time both a primitive and a cultured painter' was how William H. Johnson summarised the paradoxes facing black artists in the early twentieth century (*WJP* 3829, Johnson in anon., *Land Og* [sic] *Folk*, 1947: n.p.). As is the case with Edmondson, Pippin and Lawrence, paintings by Johnson have been repeatedly categorised as authentic translations of an untutored folk spirit, despite the fact that he was a 'modern primitive' with a 'formal art education' (*WJP* 2678, Jacob Landy, 'William H. Johnson', 1958: 167). However, close inspection shows that Johnson's was a faux-naif style as he decided to '"paint according to [his] own conception"' (*WJP* 3829, in anon., 'Exotic Painter,' n.d.: n.p.). He created visual narratives of African American life to establish his right to an independent artistic vision. '"In all my years of painting, I have had one absorbing and inspired idea",' he explained, '"to give, in simple and stark form – the story of the Negro as he has existed"' (*WJP* 3829, Johnson in Nora Holt, 'Primitives on Exhibit', 1946: n.p.). Ultimately, Johnson saw no better way of communicating this 'story' than by adopting a stripped-down style indebted to folk idioms and modernist influences which can also be traced in works by Edmondson, Pippin and Lawrence.

As a brief example, Johnson's painting, *Nat Turner* (1945), repeats many of these artists' concerns with the suffering caused by violence and war. This work is a history painting in the tradition of those produced by Pippin and Lawrence but with a twist. According to Powell, the facial features of nineteenth-century slave revolt leader Nat Turner betray a 'shade of self-portraiture' (Powell, 1991: 203). Johnson's decision to map his own identity as an artist on to the legacy of a heroic freedom-fighter draws attention to the connections between art, resistance and storytelling in African American art. By suggesting that a struggle for artistic agency could be read through a history of slave resistance, works such as *Nat Turner* extrapolate the neglected protest dimensions of works by Edmondson, Pippin and Lawrence. *Nat Turner* is by no means the only painting by Johnson to echo the minimalist style, symbolic colour

schemes and abstract compositions of works by William Edmondson, Horace Pippin and Jacob Lawrence.

In general terms, paintings and sculptures by Edmondson, Pippin, Lawrence and Johnson challenge white mainstream attempts to stereo-type African American identities, histories and cultural practices. Their experimental dimensions defy critical assessments of black artists as unsophisticated, instinctive and authentic. For example, out of Edmondson's sculptures emerges an anarchic, free-spirited and yet spiritually imaginative world of folkloric heroes and religious tableaux. These figures can be situated within a trickster tradition of oral story-telling which subverts white systems of domination. By comparison, Pippin turned to oil painting to exorcise the traumas of war, examine scenes from American history and portray the imaginative possibili-ties embedded in the everyday lives of the rural black poor. The raw finish presented by the heavy paint and highly tactile nature of his works is evidence of an aesthetic design rather than inferior artistry. His uneven and unpredictable textures dramatise the emotional urgency and complexity of his hard-hitting material. In a career spanning nearly a century, Jacob Lawrence fought for the right to paint whatever moved him, be it moments in history, life in Harlem, atrocities in Hiroshima or white patients in psychiatric hospitals. Throughout his narrative series, he highlighted the omissions and distortions of black history and culture within white official records.

Artists such as Lawrence, Pippin and Edmondson repeatedly reached out to African American audiences and artists in their works. As one of the many fan letters to Lawrence admits, 'You tore my heart out ... Where, how may I purchase a small drawing. I don't have much money but I'm rich in spirit' (*UGKP*, Rachel Ascher, n.d.: n.p.). As chapter four demonstrates, Jacob Lawrence's sense that the 1930s and 40s were 'a period when a man did his Native son' found full force in works by Charles White, Elizabeth Catlett and Gordon Parks (in Greene, 1968: 39). These artists turned to murals, prints, paintings and drawings in the search of a 'people's art' (*ECP* 2249, in Clara Hieronymus, 'It's a Double', 1973: 10).

'Images Are Weapons': History, Narrative and a People's Art

Charles White – Elizabeth Catlett – Gordon Parks

'"Paint is the only weapon I have with which to fight what I resent"' was the repeated cry of muralist, painter and draughtsman, Charles White (in Barnwell, 2002: 3). Similarly photographer, journalist and composer Gordon Parks remained convinced that 'even the cheap camera I had bought was capable of making a serious comment on the human condition' (Parks, 1992: 74). He discovered that, 'among the squalid, rickety tenements that housed the poor, a new way of seeing and feeling opened up to [him]' (Ibid.). Still working today, sculptor and printmaker, Elizabeth Catlett, has been no less determined to use art to fight injustice. She describes how she creates '"linoleum prints because this is a suitable medium for public art – easy and inexpensive and you can make the editions as large as you need them"' (in Zeidler, 1993: 8). All three artists created panoramic murals for display in public buildings, stark black-and-white prints to hand out to individuals, iconic photographs to appear as breaking news across the world and public sculptures for exhibition within African American and 'Third World' communities. These artists changed the face of African American art history by extending what Jacob Lawrence described as the preferred 'human content' of African American art to include prostitution, alcoholism, domestic violence and the graphic horrors of political conflict. While earlier artists celebrated a proud heritage in a mythic Africa and lost themselves in the rhythms of blues and jazz and epic narratives of progress, Catlett, White and Parks provide hard-hitting works exposing the previously censored lives of the urban poor, the unheroic and dispossessed. At the same time, they continued the practice of delving into American history and current events in a search for role models to dramatise black struggles against slavery and the fight for civil rights.

The dilemma Charles Alston faced in being torn between the 'Ivory Tower' and the 'Nitty Gritty' was a luxury White, Catlett and Parks could not afford. '"Until the Negro in Harlem finally gets a decent place to live and food in his belly," Hale Woodruff explained, "maybe he'll have no time to go look at our pictures"' (in Bearden, 1969: 260). These artists adapted the insistence of African American writers such as Richard Wright that 'words are weapons' to suggest that 'images are weapons'. 'My work takes shape around images and ideas that are centred within the vortex of a Black life experience,' Charles White claimed, 'a nitty-gritty ghetto experience resulting in contradictory emotions: anguish, hope, love, despair, happiness, faith, lack of faith, dreams' (*UCWP*, White, 'Statement', 1975: n.p.). Given their fascination with the lives of the marginalised and dispossessed, works by Catlett, White and Parks have much in common with Lawrence's controversial Harlem cycle of 1943. In paintings such as *The Rooftops Seem to Spread for Miles*, Lawrence portrayed scenes of black male alcoholism and gambling. Black figures collapse in the after-effects of binge drinking while the imprisoning grids of bare rooftops reinforce their social ostracism. A crucifix formed from interlocking washing lines suggests black sacrifice on the altar of white persecution.

However, White, Catlett and Parks failed to share Lawrence's conviction that '"I've always made my statement through my work"' because '"I've never been a physical person, going out and walking picket lines"' (in Wallis, 1996: 64). Instead, works created by these artists were not a substitute for but a complement to their political activism. As White explained, their struggle was to reach the 'masses of Black people' (*UCWP*, White, 'Statement', 1975: n.p.). Catlett's insistence that a sculpture 'has to be more than just representation' offers a useful guide to White and Parks's aesthetic vision as well as her own (*ECP* 2249, in Stephen Lafer, 'Elizabeth Catlett', 1978: 15). All three artists were part of a new generation which shared Parks's conviction that '[a] beautiful sunset over the lake was just a beautiful sunset', as they turned instead to the 'Chicago's south side – the city's sprawling impoverished black belt' (Parks, 1992: 74). White, Catlett and Parks painted, photographed and sculpted out of a sense of social and political compulsion. As Parks admitted, '[I]f I should lose both arms I am sure I would try painting with my toes' (Ibid.: 22).

Working in the same period and still alive today, African American photographer, Roy DeCarava, shares White, Catlett and Parks' preoccupation with dramatising scenes of black urban poverty which he has often described as 'beautiful yet squalid, warm and terrifying, light

yet dark, real and unreal' (Roy DeCarava in Rowell, 1990: 868). In 1955, he collaborated with the poet, Langston Hughes, to create *The Sweet Flypaper of Life*, a photographic short story dramatising the lives, loves, struggles and hopes of women, men and children in Harlem. Resisting the documentary essay format, Hughes played with literary language to create the fictionalised character of an African American woman, Sister Mary Bradley. Throughout this work, it is her voice which interprets DeCarava's photographs to dramatise the 'sunsets' and 'struggles' of black working-class life in Harlem. Image and text work in close and slippery relation to one another. For example, in a photograph accompanying Sister Mary's lament, 'But some children, maybe they don't have nobody', DeCarava portrays a black child sitting on a disused basket and surrounded by the detritus of ghetto life. He is as cast out and forgotten as the debris piled around him. DeCarava's abandoned black boy resonates with Gordon Parks's photograph of 'an ill-dressed black child wandering in a trash-littered alley' as well as Charles White's 1964 charcoal drawing, *Birmingham Totem*, which depicts a destitute black boy sifting for scraps (Parks, 1992: 74).

In this work, DeCarava and Hughes blurred the boundaries between fact and fiction to re-imagine untold working-class histories. They balanced their visions of impoverished lives by dramatising the 'sweet flypaper of life'. Numerous photographs of black musicians, artists and actors offset vistas of despair to illustrate Sister Mary's conviction that 'we got some fine people in our race' (DeCarava and Hughes, 1955: 38). The combination of literary language and aesthetically self-conscious images in *Sweet Flypaper of Life* results in a work which is far more ambiguous than other popular photographic essays such as Richard Wright's *Twelve Million Black Voices* (1941). 'I'm not a documentarian,' DeCarava insists. 'I think of myself as poetic, a maker of visions, dreams, and a few nightmares' (in Miller, 1990: 852). Nevertheless, viewers of works by DeCarava and Hughes, as well as those by Gordon Parks, Charles White, and Elizabeth Catlett, have a repeated tendency to interpret their photographs, drawings and sculptures solely within a documentary tradition. While this is no doubt a large part of the story, these views often neglect their 'poetic' and experimental aesthetic practices which were designed to provide new perspectives on the 'dreams' and 'nightmares' of black working-class life.

Just as they were committed to using their art to effect social and political change, White, Catlett and Parks never lost sight of the impor-

tance of artistic questions. They were as careful as Hale Woodruff to distinguish between the '"hot-headed art of the moment"' and '"real artistic insights"' (in Bearden, 1969: 253). They supported his view that the '"sensibility of the artist, his beliefs and his convictions and his aspirations, must come through and control it"' to create art whether it be '"black, white, green, or blue"' (Ibid.). They developed an accessible visual arts language which they intended would contribute as much to the 'aesthetic development' of their black audiences as to their realisation of political injustices (*ECP* 2249, Catlett, 'My Art Speaks', 1960: 94). In particular, all three artists were as keen to experiment with the aesthetic possibilities of the narrative series as earlier artists such as Aaron Douglas, Horace Pippin and Jacob Lawrence had been. Thus, the majority of their visual vignettes testifying to race and gender discrimination, poverty, slavery, heroism, labour, segregation, civil rights and rural and urban life rarely fitted into a single work. For this reason, White, Catlett and Parks created multi-panel images to register the ambiguities and contradictions embedded in marginalised narratives. By experimenting with the series format, they established the ongoing necessity of a range of media to represent the otherwise fragmented and distorted lives of a suffering but surviving black America.

Charles W. White (1918–79)

'[T]he Negro fight for freedom, is the motivating impulse underlying all my works'

'"There is a woman seventy years old, who lives in Chicago ... She's my mother. She's been a domestic worker since she was seven years old ... I paint about this woman"' (Charles White in Barrett-White, 1994: 155). Growing up 'very very poor', White was drawn to the lives of working-class men, women and children as well as those of heroic exemplars taken from history and contemporary cultural icons (*UCWP*, White in Janice Lovoos, 'Remarkable', 1962: 96). As he admitted, he and other artists 'spent time experimenting to find ourselves in our work, to find a form, an image to deal with, and how to deal with that image' (Ibid.: 56). More often than not, he 'would go on the streets' to 'paint the slums and its people' in a search for new ways in which to 'paint black' (*UCWP*, White, 'Charles White', 1968: 54). White's search for an image and form hints at his experimental aesthetic practices which are often neglected by critics. In early paintings such as *The Drinker* (1937), for example, he relied on cubist techniques to accentuate the

work's emotional impact. By fragmenting the picture plane, he distorted his subject's physical features to externalise his psychological complexities. In these and other paintings, he described his practice by insisting that 'only a deep and penetrating study of the internal coupled with the study of the external can lead to the formulation of profound concepts (*CWP* 3190, White, 'Memo', 1956: 2). By examining the 'internal' lives of alcoholics and other destitute figures in his works, White contested tendencies among Harlem Renaissance artists to romanticise rather than examine the realities of black working-class life.

Critics have repeatedly interpreted Charles White's opposition to an abstract style as meaning that he had no interest in aesthetic issues. This was far from the case. White's anger was directed towards Abstract Expressionist artists, in particular, not for their experimentation but for '"thumbing their noses at society and speaking in an esoteric language"' (*UCWP*, White in Janice Lovoos, 'Remarkable', 1962: 119). He dismissed their work on the grounds that it was '"devoid of anything to believe in"' rather than because it favoured abstraction (Ibid.). In one handwritten note, White doodled phrases such as 'THE MAN SAYS, SAYS THE MAN' and 'WHY INTEREST IN BLACKNESS' (*CWP* 3190, White, 'Untitled', n.d.: n.p.). These broken statements illustrate White's preoccupation with the pressures facing black artists who sought to use their work to debate aesthetic as well as political issues. As he explained, 'If we accept the premise that this is a racist society then there can be no Black art or scholarship that can be non political' (*CWP* 3190, White, 'Address to Negro Artists', 1959: 1). Despite his commitment to the politics of art, the experimental properties of White's work betray his refusal to lose sight of artistic debates. As he insisted, the 'question of craft is an important one to resolve, as well as the question of concept' (*CWP* 3190, White, 'Memo', 1956: 3). While the 'mastery of the tools of a craft often seem to elude us', he urged, 'skill must not, for if it does, the esthetic qualities are lost too' (Ibid.). Given his dual beliefs in 'craft' and 'concept', White fought for freedom on aesthetic no less than political and social terms in his works. Under no illusion that the 'quest' for 'abstract truths' came with 'enormous social responsibilities', he remained convinced that all artists had a moral obligation to 'deal with ideas as an educator or philosopher' (*UCWP*, White, 'Statement on Personal Philosophy', n.d.: n.p.; *UCWP*, White, 'Statement by the Artist', 1975: n.p.). As this chapter shows, while White was caught up in didactic imperatives to create a politically relevant art, he also used his

works as a platform on which to explore 'abstract truths'.

Of the little attention they have received, White's full-colour murals, charcoal drawings, prints and paintings have attracted mixed criticism. On the plus side, Bearden and Henderson applaud his works for 'affirming the humanity and beauty of black people' because they 'moved many who had never previously recognised the aesthetic qualities of black figures' (Bearden and Henderson, 1993: 405). Charles Corwin similarly identifies the ways in which White's 'forms are simplified in order to achieve greater clarity' and 'distorted in order to make their meaning more emphatic' (*UCWP*, Charles Corwin, 'Charles White', 1950: 11). However, he warns that White's archetypical black figures 'threaten to slide into a stereotype of the heroic' (Ibid.). Supporting this view, Henry Seldis argues that they were 'highly romanticised' and 'overly senti-mental' (*UCWP*, Seldis, 'White's Visual Spirituals', 1964: 6). These criti-cisms have held no sway with David Driskell for whom there is 'no other artist who presents with visionary clarity a psychology that succinctly summarizes the state of nonbeing' (in Barnwell, 2002: vii). He believes that White 'invented his own style of realism, one that invites inquiry while it dispels mystery and draws the personal out of invisibility' (Ibid.). Driskell's emphasis on White's preoccupation with an African American state of 'nonbeing' and 'invisibility' not only reinforces Parks's examina-tion of marginalised lives in his photographs but also echoes Catlett's search for the elided lives of black working-class women in her sculp-tures and prints. Driskell's sense that White 'invented his own style of realism' also sheds further light on the inextricable relationship between aesthetic techniques and social issues in his work.

The emotional impact generated by White's murals and drawings supports Aaron Douglas's view that '"[t]echnique in itself is not enough"' as the artist must '"develop the power to convey emotion"' (in Bearden and Henderson, 1993: 135). By introducing new subject matter and experimenting with form, White invited black audiences to experience catharsis by witnessing their lives as the appropriate subject matter of fine art and not as the stuff of journalistic exposés. He shared Lawrence's desire to create 'a universal symbol, related to a social theme that all mankind can personally relate to' (*UCWP*, White, 'Statement', n.d.: 1). In this work, he expressed the 'dignity of man – not only of black men, but of all men' (*UCWP*, White in *Soul Magazine*, 1968: 54). However, just as photographs and sculptures by Catlett and Parks foregrounded the plight of black womanhood, White's emphasis on a struggling

black masculinity was not at the expense of the lives of black heroines, mothers, wives and daughters. In this chapter, I examine White's mural, *The Contribution of the Negro to Democracy in America* (1943, see Plate 7), and his mixed-media *Wanted Poster Series* (1969–71). Throughout his life and works, White was no detached observer. By rejecting Westernised views of the artist as 'a luxury item', he adopted the beliefs held in 'so-called primitive societies' which relied on 'art and the artists' as a 'life-giving force' (*CWP* 3190, White, 'Address to Negro Artists', 1959: 1). In the 1970s, Black Arts poet, Nikki Giovanni, eulogised Charles White's importance as a 'life-giving force' in the black community. 'White and his art live in my heart and the heart/ of our people,' she explained (*UCWP*, Giovanni, 'Untitled', 1973: n.p.).

The Contribution of the Negro to Democracy in America (1943, Plate 7)

The 'point of my awareness of blackness', Charles White admitted, was the 'discovery of black history' (*UCWP*, White, 'Charles White', 1968: 57). As he explained, 'I never knew Negroes wrote novels, that they wrote poetry, that they were outstanding leaders ... I discovered Negro history ... and man, it just blew my mind!' (Ibid.). For Charles White, '[n]o theme is more demanding of you', as a black artist, 'than that of Negro history and their great national figures. For the people must be able to relate to those meaningful qualities of personality, that while universal are sacred to the depth of national pride' (*CWP* 3190, White, 'Memo', 1956: 2). For this reason, he created numerous murals including: *Five Great American Negroes* (1939–40), *A History of the Negro Press* (1940), *The Contribution of the Negro to Democracy in America* (1943, see Plate 7) and *Mary McLeod Bethune* (1978). For White, the mural was the 'strongest' medium he could find because it offered him the 'room' to visualise the 'beauty', 'dignity' and 'spiritual' truth of the 'inner-man' (in Hoag, 1965: 13, 14). In these large-scale, full-colour and cubist inflected works, White represented important events and individuals from African American history. He encouraged black audiences to identify with his subjects by advocating a heroic continuum according to which the suffering of black families, workers, and activists were aggrandised in their juxtaposition with nineteenth-century historic and cultural leaders. These works were also inspired by his determination to oppose the denial of African American history in white mainstream culture. As a teenager, he had been furious to discover that the 'book

that was the standard book at that time for U.S. history devoted only one line to the 400 years of black history' (*UCWP*, White, 'Charles White', 1968: 57).

White admitted that the creation of *The Contribution of the Negro to Democracy in America* was an 'enormous job' (in Hoag, 1965: 11; see Plate 7). He executed the mural in egg tempera directly on to an interior wall of the music department at Hampton University, a historically black college, where it still stands. Standing in front of this mural a year ago, I realised just how much is lost in small-scale reproductions. They fail to capture the intricacies of White's black figures whose epic proportions reinforce their mythical status. White chose Hampton because he wanted to instil a sense of pride and heritage into African American university scholars. This town was also an apt location given that it was the place in which he had been forced to the back of a bus at gunpoint. For a painter who insisted his works were not satirical, it is difficult not to see an ironic subtext here. In general terms, the visual drama of this work derives from White's experimentation with an abstract composition, symbolism and symmetry. As such, this mural can be compared with Romare Bearden's later photomontage projections. Both epic-size works generate interpretative ambiguity in their crowded spatial arrangements and experimental colour symbolism.

As one of his most spatially concentrated and crowded murals, *The Contribution of the Negro to Democracy in America* explodes with the colliding black and brown bodies of soldiers, freedom-fighters, orators, scientists, musicians, workers and families. As White explained, this mural dramatised the 'key to this whole struggle' as the fight for black rights (in Hoag, 1965: 10-11). The densely populated picture plane dramatises the ways in which forms of political, social and cultural resistance were intertwined in African American history. His crowded composition ruptures hierarchies of gender and class to expand temporal frameworks and contrast monumental heroism with feats of survival in everyday life. White described his aesthetic process as follows: 'I started with the American Revolution, depicting Crispus Attucks the first man to die in the Revolution, came on through using individuals like Frederick Douglass, Booker T. Washington, George Carver, Harriet Tubman and Sojourner Truth and Marian Anderson' (Ibid.: 9). His purpose was to 'take the contributions both through physical revolt of fighting for the abolition of slavery, and also the contributions that had been made in the sciences as well as the arts, as well as politics' in order to 'cover

the contribution to many facets of American life' (Ibid.: 10). This mural commemorates the untold 'contributions' of shackled slaves, exploited workers and anonymous soldiers alongside the lives of heroic freedom-fights to celebrate their shared fight for 'Democracy in America'.

In contrast to Aaron Douglas's multi-panel *Aspects of Negro Life*, White's murals tend to consist of only one epic-size work. As Lizzetta LeFalle-Collins suggests, he 'tried to visualise the subject without being overtly linear. He depicted the past and present at once, achieving historical distance through the pictorial device of foreshortening which suggests depth' (LeFalle-Collins, 1995: 41). In works such as *The Contribution of the Negro*, these constraints intensify White's iconography. Bereft of space, White was forced to be selective and to create complex layers of black history, labour and the arts. He developed a symbolic and flexible aesthetic language within which to examine themes of heroic resistance, political activism and cultural survival. In murals such as *The Contribution of the Negro*, White's panoramic coverage subverted chrono-logical histories by creating new relationships out of anachronistic juxta-positions. Deciding to jumble nineteenth- and twentieth-century figures together by placing Frederick Douglass next to Booker T. Washington, Marian Anderson next to a fugitive slave and black Civil War soldiers next to contemporary factory workers, White imagined new relation-ships between activists, writers and artists. Murals such as *The Contribu-tion of the Negro to Democracy in America* establish White's determination not to idealise but to humanise his black heroic exemplars by inviting audiences to identify with the dramas, struggles and fight for creativity in this work.

The four corners of *The Contribution of the Negro* offer visual vignettes of black resistance. As Andrea D. Barnwell argues, the top left corner represents slave fighter and martyr Nat Turner brandishing a torch of freedom, while directly above him flies a black female angel carrying a sword of vengeance (Barnwell, 2002: 32). White's black angel militates against racist accounts of Turner as a bloodthirsty cut-throat by supporting his self-appointment as a spiritual visionary. Similarly, the top right corner depicts another rebel slave, Peter Still, holding aloft his famous slogan, 'I WILL DIE BEFORE I SUBMIT TO THE YOKE'. White's inclusion of this incendiary text prevents audiences from inter-preting fettered black bodies as passive victims. One of the aims of this mural was to reassure black audiences that the fight for civil rights had its origins as far back as the eighteenth century in black rebels who would

rather die free than live to be slaves. In the bottom left-hand corner, White shifted thematic focus by depicting the only white figure in the entire mural. He represented the paradoxes of American freedom expressed in Thomas Jefferson's 1776 *Declaration of Independence* by holding up a piece of parchment which reads, 'PROVINCIAL CONGRESS. IV. Resolved, THAT THIS CONGRESS ... WILL NEITHER IMPORT FOR ... OR PURCHASE ANY SLAVE ... ED FROM AFRICA OR ELSEWHERE ... SIGN... 1775)'. White's decision to include this text in a work depicting the escaped slaves turned heroic leaders, Frederick Douglass and Sojourner Truth, complicated the antislavery implications of this rhetoric. In this work, he showed how European American legislation attempting to ban the international slave trade not only actually succeeded in intensifying the horrors of the internal trade but also gave birth to its undoing by inspiring radical protestors such as Douglass and Truth.

In this mural, the nail held in the white man's fist pierces both this parchment and the torso of a well-dressed slave standing directly above. Similarly, the murdered body of Crispus Attucks, the first casualty of the American War of Independence, falls next to this white man. These examples of brutalised black masculinity conflict with White's portrayal of a well-dressed white man to suggest how white freedom was obtained on the backs of enslaved individuals. In this mural, White contrasted the horrific realities of black suffering in the lives and deaths of Peter Still and Crispus Attucks with hopes for survival in African American 'contributions' to the arts. Thus, in the bottom right-hand corner, he depicted black singer, Marian Anderson, performer, Paul Robeson, and blues artist, Leadbelly. While Leadbelly plays his guitar, actor and protester Paul Robeson stands behind him to suggest the redemptive power of music and the arts to transform a legacy of slavery. White signposted black struggles for survival not only in Leadbelly's song but also in his colour scheme of browns, blacks, greens and whites suffused with a symbolic use of blue. His 'blues' illuminate the industrial machinery, racist laws, slave shackles, soldier's uniforms and guitars to celebrate black cultural, political and social survival in *Contribution of the Negro*.

By juxtaposing the dying body of Crispus Attucks in the American War of Independence with the march of the black 54th Civil War regiment, White attacked racist amnesia in this mural. He dramatised the role African Americans had played in the national fight for freedom to record the ways in which African Americans 'contributed' to the fight

for 'democracy' in the United States. The enlarged figure of Frederick Douglass occupies a dominant position to communicate his significance as the 'founding father' of black history. His epic-sized hands embrace the full gamut of black life by simultaneously reaching out to men in the Civil War regiment, a mother and child, a male worker and the slave heroes, Crispus Attucks and Denmark Vesey. However, White complicated Douglass's heroism by including the enlarged and clenched fists of a half-hidden black figure which overshadow this civil rights leader. By portraying an anonymous black man with his hands wrapped around industrial machinery just as his partially concealed face disappears off canvas, White exposed what Driskell describes as a black status of 'nonbeing' and 'invisibility'. The unknown worker's fists interlock with the chains of three shackled slaves to suggest parallels between slave labourers and factory workers. White's compositional choices in *Contribution of the Negro* demonstrate that black struggles lasted well beyond Douglass's era in a new fight against conditions of industrialisation and racist discrimination.

The unknown man's clenched fists support Nat Turner and Peter Still's resistance at the same time that they prefigure the Civil Rights Movement and Black Power activism. His incomplete visage and omniscient positioning contests didactic readings of this mural to suggest that White opposed black visual objectification within mainstream discourse by privileging an aesthetics of unknowing. White's insertion of three shackled slaves between Nat Turner and Frederick Douglass further accentuates the horrors of unremembered lives. By providing contrasting representations of male and female heroism, he also reinforced gender differences. Unlike Douglass who turns his back on these fettered slaves, Sojourner Truth reaches out as if to save an anonymous male slave before he disappears from the edge of the mural. White positioned exceptional exemplars alongside those whose lives remained lost to history to create a more inclusive definition of black heroism in *Contribution of the Negro*. 'In the historical figure (or portrait),' he argued, 'a fascination [sic] range of ideas is open to the artist to grapple with. Particularly in terms of a figure that is both an individual personality as well as an epic symbol' (*CWP* 3190, White, 'Memo', 1956: 2).

White visualised his preoccupation with the struggle for survival among contemporary African Americans by depicting a black mother, child and father before steel machinery and in the immediate foreground of this mural. This unknown family contrast with his representations of

black Civil War soldiers to suggest generations of black resistance which have ranged from military campaigns to everyday fights for existence. As LeFalle-Collins argues, this mural simultaneously dramatises 'resistance, the contribution of blacks to America, and the importance of black labor' (LeFalle-Collins, 1995: 39). She contends that the 'black worker' depicted 'at the forefront of the central family unit' carries 'a blueprint for building a new nation where all races and classes of people are equal' (Ibid.: 40). Stacy Morgan goes even further to suggest that 'White presents a self-portrait in the front and center of the mural' by arguing that 'it is the artist himself who holds the all-important blueprint' (Morgan, 2004: 69, 71). Whether this is or is not the case, while Douglas, Turner and Still stand with raised arms, this anonymous black labourer turned surrogate artist is on his knees. Thus, White's vision of exploited yet optimistic black masculinity and artistry in this mural suggests that the twentieth-century fight for black freedom in 'contributions' to politics, history and culture was far from over.

Wanted Poster Series (1969–71)

'1619/ IDA/ CLOTEL/ 19??/ EDMONIA'. In the 1960s, White found some 'pre-Civil War posters advertising slave auctions and WANTED runaway slaves' which he then used 'complete with wrinkles and folds as backgrounds for portraits of contemporary black Americans' (Bearden and Henderson, 1993: 416). These works were neither in black and white nor full colour. 'Rendered in a thin oil wash, combining sepia and black tones', Bearden and Henderson suggest that the 'historical elements give a haunting impact to these skilful portraits' (Ibid.). In these mixed-media works, White placed his realistic portraits of black men, women and children on to the abstract patterns created by the creased surfaces of these original posters. His use of sepia tones coloured his subjects in a brown wash to signify their racial identity and historical importance. By this point, White was beginning to create works solely in charcoal, ink and pastel, given the onset of tuberculosis which had forced him to abandon oil painting. This was no sacrifice for White who admitted, 'I've always had a stronger leaning for graphics and I found my own talents were best suited for the black and white media' (in Hoag, 1965: 13). While his *Wanted Posters* series was not executed in black and white, they rely on faded washes of yellow, brown and white to map the Civil Rights struggles of the present on to the sufferings of the past.

In the first work in the series, *Wanted Poster Series #1* (1969), White

superimposed the figure of an African American boy on to a creased nineteenth-century poster. The imperfect surfaces of this nineteenth-century document reinforce the black boy's sorrowful expression while their rough textures contrast with the smooth shading of his skin. White's detailed portrait of a black boy on an 'authentic' artefact provides alternative representations of black humanity to contest the legitimacy of racist caricatures. This portrait subverts the language of racist text which typically ascribed value to African American bodies only on financial terms: 'ELIJAH GIBBONS/ AGE ⋯⋯ 12 YRS/ THIRTY DOLLARS'. However, while the black boy's face remains clear and looks towards the viewer, the flesh of his body is disintegrating into the surface of the poster. Similarly, his white shift merges with the folds of its surface to render only parts of his anatomy visible. By inscribing this contemporary portrait on to a historical document, White exposed similarities between nineteenth- and twentieth-century racist contexts in which African Americans continued to be brutalised, victimised and erased. While African Americans in the 1960s were no longer bought and sold, the incompleteness of the black child's physicality in White's work suggests that they continued to suffer from exclusion in a perpetual state of 'nonbeing' and invisibility.

In *Wanted Poster Series #5* (1969), White's superimposed text goes a stage further by fragmenting the racist language of official records in broken parts such as, '1619/ IDA/ CLOTEL/ 19??/ EDMONIA'. These pieces of text collapse historical distances by juxtaposing the arrival of the first slaves in Virginia in '1619' with '19??' The non-specificity of '19??' warns against unknown racist horrors awaiting African Americans in the twentieth century. In this work, a central male slave, 'CLOTEL', stares at the viewer while he is flanked on either side by two African American women, 'IDA' and 'EDMONIA'. A halo of stars encircles Clotel's head to evoke the American flag and critique paradoxes of nationalism. By naming this enslaved male 'CLOTEL', White recalls the female protagonist of African American writer, William Wells Brown's nineteenth-century novel, *Clotel: or, the President's Daughter* (1853). However, in contrast to the plight of the mixed-race heroine of Brown's novel, this male slave presents White's audience with a vision of empowered black masculinity. In this work, he also portrayed two female slaves, Ida and Edmonia, standing either side of Clotel to emphasise the inextricable, but often hidden, relationship between black male and female heroism during slavery.

In his *Wanted Poster Series*, White protested against black cultural and political erasure by highlighting an ambiguous slippage between visual and textual representations, irrespective of historical period. His use of geometric shapes as backgrounds to works, which otherwise provide realistic portraits of African Americans, highlights his self-reflexive manipulation of an abstract-figurative style. White's contemporary portraits rewrite official histories of African American experiences during slavery by mapping the hidden realities of black bodies on to the censorious language of nineteenth-century advertisements. Juxtaposing a white historical artefact with a black artistic reinterpretation, White gave agency to slaves who had been written out of history and had only had value as commercial objects. As Bearden and Henderson argue, in the context of the Civil Rights Movement, 'White's moving portraits of black men and women against a background of old runaway slave WANTED posters effectively expressed the feelings of millions' (Bearden and Henderson, 1993: 405). White embedded historical epics of slave resistance within contemporary narratives of political injustice in these works. His mixed-media forms urged the necessity of aesthetic experimentation to recover black experiences otherwise elided in white mainstream culture. As Barnwell contends, these works are characterised by 'complex foreground-background relationships' which investigate the 'systems that made slavery possible and explore their relationship to contemporary life' (Barnwell, 2002: 88). By inserting non-caricatured but only partially visible black figures, White's *Wanted Posters* expose gaps in historical documentation. More specifically, his superimposed text replicates the typeface of nineteenth-century slave posters to contest the authority of official artefacts which collude in racist fictions of black identities.

Overall, Charles White's murals, drawings and prints support Hale Woodruff's view that there is 'always a heroic quality in his art' (in Fitzgerald, 1980: 183). Throughout his career, he created monumental works testifying to a search for freedom and survival within African American public and private narratives and histories. He exalted in the bravery of a 'Negro people' who had the 'courage and determination to forge ahead in spite of slavery, oppression and second-class citizenship' because of the 'life-giving force of his culture' (*CWP* 3190, White, 'Address to Negro Artists, 1959: 2). He also experimented with symbolism, composition and colour to externalise the psychological complexities of his iconic figures as they emerged as touchstones for black pride and resistance. 'I look to life and to my people as the

fountainhead of challenging ideas and monumental concepts' (*UCWP*, in Janice Lovoos, 'Remarkable', 1962: 96). As we see below, Elizabeth Catlett's prints and sculptures leave audiences similarly in no doubt that the 'history of the Negro people in America fills us with pride and serves as an inspiration in the struggle for equality that has consistently permeated the lives of our heroes' (in Lewis, 1984: 98).

Elizabeth A. Catlett (b.1915)

'I am interested in women's liberation'

'"The big questions are how do we develop to serve our people, what is our role in the community, what form do we use, what content, what priorities",' Elizabeth Catlett asks. '"How do we go about opening the door to get Black people, who have been principally involved in survival, interested in the arts?"' (Ibid.: 96). Still alive today, Catlett is perhaps the most significant African American sculptor and printmaker of the twentieth and twenty-first centuries. Born before Charles White, she continues to create epic sculptures in bronze, terracotta, mahogany, cedar and black marble, as well as black-and-white prints, lithographs and linocuts. As this book goes to print, numerous exhibitions of her work have appeared throughout 2006 and 2007 (Art Institute of Chicago, Hampton University Museum, June Kelly Galleries). While Catlett shares White's concern with creating public artworks to 'serve' the needs of black audiences, she has also inspired her viewers to become 'interested in the arts'. '"I want to do large, public works",' she explains, which will have '"meaning for Black people, so that they will have some art they can identify with"' and '"will be encouraged to explore what the museums and galleries have to offer them"' (Ibid.: 24).

Catlett's sculptures and prints urge black audiences not only to identify with her content but also to 'explore' art for its own sake. She is antielitist and non-hierarchical in her determination to break down barriers of racism, gender discrimination and class oppression. '"Art can't be the exclusive domain of the elect",' she insists, '"[i]t has to belong to everyone"' (Ibid.: 26). Early in her career, she taught art education to African Americans and was stunned to discover how, '"after a hard day's work, these people would take classes on Negro history, economics, painting, sculpture and drawing"' (Ibid.: 102.). The major themes of Catlett's works include black history, politics, slavery, civil rights, female heroism, mother-child relationships, resistance, labour, poverty, exploitation and black struggles for survival in African American and 'Third

World' contexts. More specifically, she takes representations of black womanhood in black male visual arts and white mainstream culture to task in her drive for 'women's liberation' (Ibid.). Catlett's works also address the otherwise neglected subject of the black female nude which continues to preoccupy many recent African American female artists.

In her public monuments, sculptures and prints, Elizabeth Catlett explores the dual burdens of race and gender oppression in light of her conviction that the denial of black culture and female identity is the 'same thing', as well as her determination to adopt a more inclusive definition of 'humanity' (Ibid.). Her works revisit the abused black female figures populating drawings and photographs by Charles White and Gordon Parks. She awards agency to her black women subjects by celebrating their literary and artistic creativity alongside the beauty of their physicality. As she admits, '"I do more work on Black Women than on any other single subject"' (*ECP* 2249, in Sharon Shaw, 'Elizabeth Catlett', 1974: 6). Given that the majority of 'artists are always doing men', Catlett identifies the 'need to express something about the working-class Black woman' (in Lewis, 1984: 102). She is the first black artist to suggest that there are essentialised gender differences by arguing that there is '"definitely a woman's estheticism, different from the traditional male estheticism"' (Ibid.: 104). '"I am interested in women's liberation for the fulfilment of women",' she insists, '"not just for jobs and equality with men and so on, but for what they can contribute to enrich the world, humanity"' (Ibid.: 102).

Regarding scholarly criticism, Catlett is as, if not more, neglected an artist as Charles White. This is particularly hard to understand when we consider her importance in broadening African American art history to include a diasporic context as well as her pioneering representations of black womanhood. As Jeff Donaldson suggests, Catlett's 'work speaks to the needs and concerns of black and Third World peoples' (*ECP* 2249, Jeff Donaldson, 'Commentary', 1973: n.p.). Driskell celebrates Catlett's experimental approach in works which present 'a viable Black ethos' via the 'meaning of a precise form not tied to a specific style' (*ECP* 2249, David Driskell, 'Commentary', 1973: n.p.). His emphasis on her aesthetic eclecticism further establishes the similarities between her works and the paintings of Charles Alston. Adopting a contrary view, Bearden and Henderson draw attention to Catlett's conviction that all black peoples remain 'imprisoned socially, economically, politically, and aesthetically' (Bearden and Henderson, 1993: 418). In contrast, for

Richard Powell, a 'visual essentialism' can be found in her representa-
tions of black womanhood 'which prides itself on clarity of message and
unambiguity of form' and which 'transforms the drawn human figure into
a protest, a plea, a banner, or a weapon' (in Ziedler, 1993: 51). However,
while Catlett's human figures are transformed into emblems of 'protest'
in her works, her experimental aesthetic practices complicate rather than
reinforce her 'clarity of message and unambiguity of form'. By experi-
menting with form and content, she suggests unresolved relationships
between aesthetic issues and political protest. Moreover, Thalia Gouma-
Peterson's view that, 'unlike White, she was not concerned with making
a grand statement', is hard to substantiate in light of her monumental
sculptures (Gouma-Peterson, 1983: 51).

Just as White was preoccupied with 'abstract truths', Catlett experi-
ments with symbolism and form to articulate competing 'ideas' in her
works. As she suggests, 'a sculpture has to be more than the data. It has
to be more than just representation. A work has its own life' (*ECP* 2249,
in Stephen Lafer, 'Elizabeth Catlett', 1978: 15). She shares Alston's view
that '"technique is so important! It's the difference between art and inept-
itude"' on the grounds that '"[y]ou can't make a statement if you can't
speak the language; here it's the language of the people, the language
of art"' (in Lewis, 1984: 148). For Catlett, as for White and Parks, the
'language of the people' and the 'language of art' are synonymous.
She departs from earlier trends within African American art history in
her sculptures and prints by interacting with black audiences to create
a community-based, collaborative art. Catlett is one of the first black
artists to look to '"so-called ordinary people – people who have no intel-
lectual knowledge of art"' for advice on her aesthetic choices '"because
I'm concerned when they don't understand what I'm doing"' (Ibid.: 151).
In contrast to the poverty-stricken backgrounds of Lawrence, White and
Parks, Catlett has made no bones about the inherited class biases from
which she had to break free. '"I was from a middle class family and had
always felt that poor people, ghetto people were inferior",' she explains.
'It was then that I realised I was inferior because I didn't understand
them. I've made them my business ever since"' (*ECP* 2249, Catlett in
Marsha Miro, 'Stark Art', 1979: 1c). In this chapter, I examine *I have given
the world my songs'* from Catlett's *The Negro Woman* series (1946–7), to
discuss her experimentation with printmaking and the narrative series as
well as her much later bronze sculpture, *Mother and Child* (1972, see Plate
8), to investigate her representation of black familial relationships.

'I have given the world my songs' (1946–7)

I am the Negro woman. I have always worked hard in America ... In the fields ... In other folks' homes ... I have given the world my songs. In Sojourner Truth I fought for the rights of women as well as Negroes. In Harriet Tubman I helped hundreds to freedom. In Phillis Wheatley I proved intellectual equality in the midst of slavery. My role has been important in the struggle to organise the unorganized. I have studied in ever increasing numbers. My reward has been bars between me and the *rest* of the land. I have special reservations ... Special houses ... And a special fear for my loved ones. My right is a future of equality with other Americans (in Herzog, 2000: 59).

So read the captions of Catlett's fifteen-panel series titled *The Negro Woman* (1946–7), which was 'conceived but not fully realised until she arrived in Mexico' (Ibid.). This series of black-and-white linocuts dramatises the unwritten lives of black female domestic workers alongside well-known historical heroines, writers, musicians and political activists. Catlett's choice of theme, size and interplay of text and image in these prints has a great deal in common with Lawrence's *The Migration of the Negro* series. However, she was determined to empower the grieving widows, labouring domestic workers and famished families of Lawrence's vision to amplify his sense that the 'Negro woman has never been included in American history' (in Wheat, 1986: 47). In the 1960s, Catlett re-titled the series *The Black Woman Speaks* to accentuate themes of black female agency, creativity, and heroism. '"I am interested in women's liberation for the fulfilment of women",' she urges, '"not just for jobs and equality with men and so on, but for what they can contribute to enrich the world, humanity"' (in Lewis, 1984: 102).

In *The Negro Woman*, Catlett revised Lawrence's aesthetic practices by adopting an autobiographical framework and a representative first-person perspective to empathise with her female subjects. For example, the captions to the first and last images read, *'I am the Negro woman'* and *'My right is a future of equality with other Americans'*. They collapse artificial barriers between artist and audience to encourage new narratives of identification. In these works, Catlett offers close-ups of black female faces which borrow heavily from her own physiognomy to prove that this '"I am" was revolutionary, for Catlett refused to occupy the position of subject commenting upon object' (Herzog, 2000: 59). In this first image, the only difference between her self-portraits and the face of

the 'Negro woman' is that this unknown and anonymous woman's face is lined and sorrowful as if to prophesy the struggles of black womanhood in the series as a whole.

In a series of small-size black-and-white prints, Elizabeth Catlett's *The Negro Woman* series creates an accessible art which will inspire her audiences by retelling previously hidden black female narratives of song, labour, slavery, segregation, heroism and resistance. Her narrative series establishes symbolic relationships between works to testify to reincarnations of black female slave, free and heroic identities across the nineteenth and twentieth centuries. She positions number five in the series, *'I have given the world my songs'*, between images of black female domestic labour and those of militant resistance, sacrifice and creativity in the arts. Thus, the images before *'I have given the world my songs'* depict black female domestic labour to support her captions, *'I have always worked hard in America'*, *'In the fields'* and *'In other folks' homes'*. However, those which follow dramatise black female heroism by illustrating scenes such as: *'In Sojourner Truth I fought for the rights of women as well as Negroes'*, *'In Harriet Tubman I helped hundreds to freedom'* and *'In Phillis Wheatley I proved intellectual equality in the midst of slavery'*. Catlett's positioning of these works after *'I have given the world my songs'* suggests that the blues woman can transform daily fights for existence into black female narratives of physical, spiritual and artistic rebellion. For example, her print *'In Phillis Wheatley I proved intellectual equality in the midst of slavery'* juxtaposes a contemplative Wheatley, enslaved African servant and poet seated with a quill in her hand and at work on one of her poems with the fragile bodies of three shackled women standing behind her. According to Catlett's *The Negro Woman* series, protest traditions of literature, music and physical resistance offer alternative ways for African American women to survive the cultural annihilation imposed by slavery.

Elizabeth Catlett's print *'I have given the world my songs'* counters Lawrence's representation of grieving widows in his *The Migration of the Negro* series. By representing a blues woman sitting upright and holding a guitar, Catlett celebrates African American imaginative survival through the arts. She relies on bold lines to delineate the contours of this woman's body and suggest sensuousness and beauty. Just as Catlett the artist can transform suffering in her art, this blues woman vanquishes her struggles through music. The force of this work emerges from black outlines and parallel shading which accentuate the monumentality of her

figure. However, the fact that there are different versions of this work complicates any straightforward readings. As Thalia Gouma-Peterson argues, *'I have given the world my songs'* was the 'only one in the series she reworked' and the only image Catlett coloured in a blue wash (Gouma-Peterson, 1983: 51). While the original version was executed in black and white and included only a single black female figure, Catlett later 'printed a second edition with the new title *Blues*' to which she added a 'light-turquoise-blue background' and 'marginal scenes' (Ibid.).

These 'marginal scenes' consist of a burning cross and a hooded white Klansman violently clutching a black man by the neck. As such, this print is a tragic prophesy of Catlett's penultimate image of the series, *'And a special fear for my loved ones'*, which visualises a black male figure lying prostrate on the ground. This work subverts the tradition of lynching photography by denying white men any agency as they are represented only by pairs of feet surrounding a murdered black man. Catlett inserted this image after prints representing the brutalities of segregation and poverty and titled, *'My reward has been bars between me and the rest of the land'*, *'I have special reservations'* and *'Special houses'* and immediately preceding her final image of hope, *'My right is a future of equality with other Americans'*. Catlett's emphasis upon a 'future of equality' demonstrates the extent to which the fight for civil rights in the 1940s was very much ongoing.

In the later version of this print, *Blues*, Catlett juxtaposed a vision of empowered black womanhood with representations of victimised and violated black masculinity to reverse tendencies within works by African American male artists to marginalise black female experiences. By contrasting an emblem of black creativity in a guitar, with a symbol of racist supremacy, a burning cross, Catlett celebrated black artistic resistance in the face of physical persecution and bodily sacrifice. Moreover, the black female blues performer in both versions of this image undercuts the masculine bias of African American music. By borrowing heavily from self-portraiture, Catlett depicts a black woman playing a guitar to suggest parallels between black music and the visual arts. As Gouma-Peterson argues, the 'singer in *Blues* may represent all black women, but it could also be a self-portrait' (Ibid.). Catlett's interplay of text and image communicates revisionist narratives of black resistance and artistic agency. She wrought strong effects on her audiences by juxtaposing the aesthetic properties of her images with the gritty realities of their content.

Elizabeth Catlett's widely circulated prints can be situated within a longstanding printmaking tradition which includes African American artists such as Margaret Burroughs, Dox Thrash, Robert Blackburn, Wilmer Jennings and Hale Woodruff. She was the first black artist to argue that, if '"we are to reach our audience on a large scale – our potential audience in the United States, in Latin America, in Africa, ... we must develop a public art, that is easily transported, easily exhibited, easily reproduced"' (in Lewis, 1984: 101). In her career so far, she has produced large numbers of '"linoleum and wood blocks, silkscreen, lithographs, etchings, and engravings"' to '"create an essentially American art"' and '"an authentic national expression"' (Ibid.). Despite their self-consciously experimental aspects, Melanie Herzog differentiates between her sculptures in which 'visual aesthetics are at the core' and her prints which functioned as 'social statements' in which 'aesthetics are secondary' (Herzog, 2000: 115). This view chimes with Catlett's own sense that, while her sculptures were preoccupied with the '"relation between form and emotion"', in '"printmaking, [she] was trying to get a message across"' (in Brenson, 2003: n.p.).

Mother and Child (1972, Plate 8)

She was pregnant, and on the slave ship her baby was stillborn. The birth left her crippled and when they reached America, her daughter was sold from her because nobody wanted a crippled woman. But the child refused to eat until her buyer came back and bought her mother (Catlett in Lewis, 1984: 6).

If Charles White was inspired by his mother, Catlett was inspired by her great-great-grandmother's stories of slavery and female resistance. The relationship between a black mother and child remains the most recurrent theme of her sculptures and prints. For Catlett, the existence of familial bonds undermines a system of enslavement by which African American women were inhumanely sold as 'breeders' to stock southern plantations. She represents African American mothers and children in materials as diverse as terracotta (1940, 1942–4, 1956, 1961), mahogany (1959, 1993), limestone (1940), cedar (1941), bronze (1972, see Plate 8) and black marble (1980). The majority of her works have attracted sincere praise from critics who see her sculptures as non-stereotypical, aesthetically self-conscious, dignified and communicating the message that 'black is beautiful'. 'In contrast to [Edmonia] Lewis's white marble

sculptures,' Michelle Cliff argues, 'Catlett's figures are done in brown wood or terra cotta', with the result that no 'white Western features replace the characteristics of Black and other Third World people' (in Robinson, 1987: 151). As Melanie Herzog asserts, Catlett adopts an abstract-figurative style in her mother and child sculptures via a 'process of working with an image over and over' which ensures 'simplification through generalisation or abstraction' (Herzog, 2000: 21). James Porter praised her sculptures for avoiding the 'pitfalls of sentimentality and over-elaboration' while admitting that the 'negroid quality ... is undeniable' (Porter, 1943: 132).

One of Catlett's earliest works, *Negro Mother and Child* (1940), was executed in limestone and is the only one of her sculptures to indicate racial specificity in its choice of title. This sculpture depicts a baby holding on to his or her mother as she enfolds him or her into her bosom in a gesture of loving tenderness. By revisiting a history of slavery in this work, Catlett showed how black familial bonds were able to survive despite racist legislation. The anonymous and unsentimental stylisation of the facial features of her black subjects recall African masks. As Lewis notes, Catlett 'used the mask as a symbol of facial expression' to 'Africanize' and transfer a 'special quality of dignified, restrained emotion' to her sculptures as well as suggest their origins in Africa (Lewis, 1984: 166). She carved an exposed breast and enlarged hands protectively wrapped around the baby's body to accentuate maternal strength and black female nurture. In another sculpture from the period, *Mother and Child* (1942–4), Catlett conveys an even closer bond between her two familial figures as the mother tucks her child's head protectively under her chin. This sculpture is far more stylised than *Negro Mother and Child* as the bodies of mother and child consist of complementary angular forms which reinforce their shared intimacy. Moreover, the 'rough-hewn' textures of this work replicate Edmondson's surfaces to hint at black physical hardships (Herzog, 2000: 34). Catlett's depiction of the mother's exemplary musculature in this sculpture dramatises the figure's monumental significance in feats of everyday heroism which have otherwise been lost to history.

A few decades later and in 1972 (see Plate 8), Catlett returned to the mother and child theme. In this version of *Mother and Child*, she experimented with the smooth surfaces provided by bronze to replicate the skin colour of her black subjects which had otherwise been elided in her earlier limestone and terracotta works. This time the black mother

holds her baby close to her body and looks directly at the viewer in this sculpture. Her physical figure is less monumental and exaggerated than in Catlett's earlier versions while her facial features continue to recall African masks in their simplicity and lack of individual specificity. Ultimately, this work illustrates Catlett's preference for creating archetypal figures to represent the emotional realities of her audiences and inspire their identification. In many of her sculptures, Catlett strips her works bare of individual details to encourage audiences to project their own emotional realities on to their open-ended surfaces. According to Richard Powell, she experiments with the relationship between abstraction and realism to borrow from a 'modernist art vocabulary' in her works (in Ziedler, 1993: 51). This is an accurate assessment of Catlett's bronze sculpture *Mother and Child* (1972), in particular, in which she simplifies the anatomical complexities of both figures to challenge stereotypes of black 'mammies' and 'pickanninies' within white mainstream culture. In this work, Catlett's iconic forms and evocative content merge to celebrate the view that 'black is beautiful' in African American culture. The intricate play of light and dark on the bronze surfaces heightens the dramatic force of this sculpture to commemorate the survival of black family life across the generations.

In her career so far, Elizabeth Catlett has created many more sculptures on the mother and child theme including works of the same title executed in cedar (1971) and black marble (1980). Herzog describes *Mother and Child* in cedar as her 'most abstract treatment of this subject' and her 'most impassioned image of maternity' (Herzog, 2000: 153). This work differs from her later bronze sculpture by depicting only the top half of the mother's torso and by representing the baby abstractly via spherical shapes and circular planes. For the first time, a black mother looks upwards in a gesture of prayer while one hand and arm are raised above her head to communicate angst and frustration. In all these works, the non-specificity of these figures' anatomies argues for the persistence of black female struggle and survival. An experimental, abstract and complex work, the facial features of both mother and child are almost entirely eroded to accentuate their representative, archetypal status and ambiguity. The symmetry and design of this sculpture suggest a coming to consciousness among black women to a sense of their own identity, culture and agency.

'"I am inspired by black people and Mexican people, my two peoples",' Catlett admits (*ECP* 2249, in anon., 1960: 94). Her realisation

that, '"[n]either the masses of black people nor Mexican people have the time or the money to develop formal aesthetic appreciation"', inspired Catlett to assist in '"their aesthetic development"'. She is the only artist in this book to have lived most of her life among the people's artists of Mexico. From the 1940s onwards, she took a lead role in the *Taller de Gráfica Popular* movement for which artists created their collaboratively produced and cheaply available prints. 'It was part of the people's art movement,' Catlett argues. 'We turned out albums, leaflets, brochures in big editions' to create an 'art serving the people' (*ECP* 2249, in Clara Hieronymus, 'It's a Double', 1973: 10). By taking part in an organisation which made 'books for adults just learning to read and write, and staged international exhibits', she immersed herself in the 'nitty-gritty' of black life in the United States and then later in Mexico where she '"learned about graphics and about working with the community"' (Ibid.). By contributing to the 'aesthetic' development of her black audiences, Catlett was determined to create an art which would 'serve' the people.

Catlett's repeated returns to 'aesthetic appreciation' and 'aesthetic development' in her sculptures and prints draw attention to her sense that an artistic awareness is as fundamental as a knowledge of political issues for her audiences. '"Combining realism and abstract art is very interesting to me",' she admits. '"People always try to separate them and say that you are either abstract or you are realistic, either you are abstract or you are figurative. And I don't believe it. I think that any good figurative artist relies strongly on abstractions"' (in Lewis, 1984: 85). Catlett's emphasis upon an abstract-figurative style reiterates Lawrence's insistence on holding on to '"human content"' because an '"abstract style is simply your way of speaking"' (in McCausland, 1945: 251). She interprets any decision to shy away from abstraction on the grounds that it would alienate black audiences as patronising and a gross distortion of the legacy of African art. As she explains, the 'need for realism in art is actually a part of me and I don't need to excuse it with the idea that my audience isn't "ready" for anything more "modern". They are accepting works of pure form. After all, abstract art was born in Africa' (Ibid.). Catlett's notion of developing an 'aesthetic appreciation' in her black audiences is collaborative rather than didactic. She builds on their existing knowledge to develop a new awareness at the same time that she does not deny her audiences the capacity to understand abstraction on their own terms. She is convinced that the '"contribution of experiments in line, color, form, and new materials"' are what "gives us a whole new

world of possibilities for expressing ourselves, with the Negro people as our principle source of inspiration"' (in Lewis, 1984: 101).

For Catlett, it is only by experimenting with formal concerns that new understandings of black social, political and cultural life can emerge. 'I try to use form symbolically in order to express different ideas', Catlett admits (Ibid.: 85). '"I want to do large, public works because smaller works wind up in private collections",' she urges. '"I want public art to have meaning for Black people, so that they will have some art they can identify with"' (Ibid.: 24). She refuses to lose sight of the relevance of black art for cultural survival. '"Are we ourselves familiar with our people so that we may express their desires and inspirations and ambitions?"' Catlett has asked, adding, '"When we are, it will be possible for us to offer the world a Negro visual expression"' (in Lewis, 1984: 99). Catlett's sculptures and prints reflect her determination not only to represent African American history, politics and working-class life but also to empathise with her individual subjects. By experimenting with abstraction, she generalises her black female figures to inspire identification from her audiences who are invited to project their own emotions and experiences on to her human forms. Elizabeth Catlett remains an early pioneer of the black woman's right to be an artist in an African American art world dominated by black men. 'If I am not anything else,' she insists, 'I prove that a black woman can be an artist' (*ECP* 2249, in Marsha Miro, 'Stark Art', 1979: 4). Working in the same period, Gordon Parks's photographs also explore the complexities, hardships and taboos of black working-class life.

Gordon Parks (1912–2006)

'[A]rmed only with our blackness against this violence, we would keep marching on'

'Where could I begin building pride?' (Gordon Parks, 1992: 5). While Charles White and Elizabeth Catlett have revisited themes of black heroism and history in their murals, prints, sculptures and paintings, Gordon Parks took his camera to Civil Rights marches and Black Panther rallies. He lived for prolonged periods with the black families who scraped out a bare existence in the segregated south and the black teenagers who fought on the streets of Harlem. Parks explained how he listened to their stories first 'without using [his] camera' (Parks, 1997: 228). 'No one can decipher the trials of oppressed people with more fire and passion than a black preacher,' he believed, 'and I tried to touch that

power with my camera' (Ibid.: xiv). Parks's definition of the photographer as a 'preacher' shows how he was determined to create visual sermons from his photographs. In his works, he emphasised the possibility for change, hope and uplift which could transform the lives of his black subjects in the face of despair. At the same time, his camera did not shy away from black-on-black violence and the atrocities of white and black conflicts born of racism. In particular, Parks's photography was inspired by his admiration of the fight for survival among black female domestic labourers, male industrial workers and homeless children. He believed that photography could not only preserve but could also bolster a distinct black identity which he saw as the only protection against racism. As he commented, '[A]rmed only with our blackness against this violence, we would keep marching on' (Ibid.: 169). In his fight against racial oppression, Parks relied not only on his talents as a photographer but also his exemplary skills as a film director and composer. This chapter examines his iconic photograph of an African American female domestic worker, *American Gothic* (1942), and *Harlem Neighbourhood* (1948, see Plate 9), one of a series of photographs accompanying his essay investigating gang wars in New York city. Both images reveal Parks's preoccupation with aesthetic properties to create works which would advocate social and political change.

American Gothic (1942)

'Washington now had a black charwoman, standing erectly with mop and broom before the American flag' (Parks, 1997: 31). Appearing as early as 1942, *American Gothic* is one of Gordon Parks's most famous photographs. This stark black and white photograph which captures the life of black female domestic labourer, Ella Watson, reflects Parks's emphasis upon the themes of black female resistance which undergird Catlett's aesthetic theory. Before he took this photograph, he described how he conducted an interview with Ella Watson in which she spoke of 'a lifetime of drudgery and despair' (Ibid.). Afterwards, he 'placed the mop in one hand and the boom in the other' and asked her to 'think of what you just told me and look straight into this camera' (Ibid.). 'Washington could now have a conversation with her portrait,' he argued, believing he 'had found a little justice in that sea of bigotry' (Ibid.). Parks's view of this work as having the potential to ignite a 'conversation' about race reflects his overall emphasis upon the dynamic relationship between photographs, audiences and political issues.

American Gothic has much in common with Roy DeCarava's aesthetic practice by which he adopted a symbolic use of light. In Parks's work, the black and white stripes of the American flag echo the shadows cast by the inverted broom and mop to signal their significance as emblems of protest. These objects of labour evoke inequities of race and class within national paradoxes of inclusion and exclusion. The polka-dot patterning of Ella Watson's dress complements the stars of the flag to highlight the injustice of her erasure within mainstream American politics and society. Parks's experimental use of light ensures that the shading of her face correlates with the light and dark stripes of the flag. In this image, he sets up a conflicted and ambiguous relationship between the black woman's body and the body politic, as symbolised by the national flag. However, this photograph was not intended to highlight Ella's victimised status but to reinforce her heroic ability to survive. By portraying her with the broom and mop inverted, he suggested that they are only significant as talismans of female resistance. Ultimately, his conscience-raising photograph is no less striking for its stylised and aesthetically complex effects as it is for its provocative subject matter. 'Photographing bigotry was ... very difficult,' Parks admitted. 'It didn't have a repulsive body with a head of horns. Yet it was there like a stone wall' (Parks, 1992: 84).

One useful way of approaching Gordon Parks's artistic practice is to consider his technique in light of Roy DeCarava's photographic theory. As DeCarava explains, 'My subject matter dictates how I print. When my subjects are dark, I have to be concerned about showing that' (in Miller, 1990: 849). 'I do have an affinity for the middle tones and the dark tones,' he argues, 'because they're beautiful, and they appeal to me on a very subjective level. I love the quality of so many different shades of dark, so many different shades of gray' (in Rowell, 1990: 865). Parks, on the other hand, claimed that he 'would learn to photograph an object or person by the feel of the light' (Parks, 1992: 22). A close examination of works by both photographers soon shows that the relationships between black and white, light and dark are as varied in Parks's photographs as they are in DeCarava's as he similarly manipulated tonal variations to create competing effects within his compositions and on his viewer. For example, in works such as *Grease Plant Worker* (1945), Parks adopted an ambiguous tonal scheme of blurring greys, blacks and whites to accentuate black male prowess. His grease plant worker manipulates oil barrels effortlessly as his black overalls offset the whites, greys and blacks of the steam to reinforce his sense that black men were 'refusing to die

off' (Ibid.: 169). Equally, Parks's reliance on dark tones in portraits of Harlem gang leader Red Jackson, in the late 1940s, and Muhammad Ali, in the 1960s, accentuates the variations of their skin colour to reinforce their heroic status within an African American tradition.

As DeCarava admits, his own photographs are 'dark because I like the full tonality' in comparison with '[c]ontrasty prints' which cut down on many intervening tones' (in Miller, 1990: 850). While works by Parks such as *American Gothic, Death Room, Fort Scott* (1949) and *Woman Dying* (1953) operate by the stark contrasts rejected by DeCarava, many of his portraits of African Americans and urban scenes such as *Harlem Rooftops* and *Daylight Rumble* capture the 'middle tones', 'dark tones' and 'many shades of dark' at the heart of DeCarava's aesthetic practice. In the majority of his works, Parks relied on 'intervening tones' to capture individual complexities and ambiguities of subject matter. Despite their technical innovations, Parks shared DeCarava's view that the main question to ask of any photograph is 'did I say what I wanted to say?' (Ibid.). In their aesthetic practices, both DeCarava and Parks endorse a multiplicity of meanings to dispense with prescriptive contrasts of black and white and examine their subject's psychological ambiguity. Furthermore, DeCarava's response to questions concerning which features turn photography into an art form comments upon Parks's practices as much as his own. 'The personality takes over when an image is produced,' DeCarava explains, 'that has the possibility of being art through the unique, subjective vision of the individual, making the process subordinate' (in Rowell, 1990: 861). Just as Charles White and Elizabeth Catlett experimented with the narrative series to capture a range of black experiences, Gordon Parks was inspired by Richard Wright, Langston Hughes and Roy DeCarava to create photographic essays of African American life.

Harlem Neighbourhood (1948, Plate 9)

'[A] certain excitement accompanied my first steps into Harlem. Of the sea of black faces I looked into, most seemed troubled' (Parks, 1992: 50). The Harlem of Parks's photographs has more in common with Jacob Lawrence's paintings which depict destitution and domestic abuse than it does with the canvases of Aaron Douglas and Loïs Mailou Jones which focus on black uplift through a rebirth in the arts. In the 1940s, Parks became the first black photographer for *Life*, a magazine devoted to all aspects of United States society. He admitted he was 'assigned to any

and everything, but if I could bring significance to a story because I was black, it was also given to me' (Ibid.: 164). During this early period, he created two photographic essays which took Harlem as their subject. The first dramatised the horrors of a Harlem riot which took place in 1943 and the second, completed in 1948, followed the lives and deaths of a Harlem gang and included his photograph, *Harlem Neighbourhood* (see Plate 9). Parks's controversial photographs were among the first to represent black men in attitudes of violence and rebellion in African American art history.

For Parks, there was no better expression of the 'anger' taking over Harlem than in the conflicts between street gangs. His *Gang Warfare Series* (1948) dramatises the life of sixteen-year-old, Red Jackson, a Harlem gang leader, and his followers over ten photographs. 'Despite their show of bravado,' Parks later explained, 'the gang members seemed to sense that death was lurking around every corner. Their families also lived in constant fear. With their sons caught up in beatings, knifings, and sporadic gunfire, they had good reason. Hostility claimed the lives of four boys during that brutal period' (Ibid.: 80, 85). *Harlem Neighbour-hood* is the ninth photograph in the series for which the other titles read: *Red Jackson, Harlem Rooftops, Gang Member with Brick, Neighbourhood of Gang Warfare, Fight, Daylight Rumble, Night Rumble, Gang Victim* and *Red Jackson and Herbie Levy Study Wounds on Face of Slain Gang Member Maurice Gaines.* A mixture of close-up individual portraits, panoramic urban-scapes and crowd scenes, these photographs investigate a partic-ular life story at the same time that they provide an overview of the deprivation afflicting African Americans in city tenements.

Works such as *Gang Victim* or *Fight, Daylight Rumble* and *Night Rumble* show that Parks did not flinch from portraying bloodied battles between black teenagers. For example, *Daylight Rumble* represents the interlocking bodies of four black teenagers with raised arms and torn clothing while *Fight* uses blurring techniques to capture tonal variations of black and grey and dramatise the intense brutality of one-on-one combat. Parks's images of black fights plunge the viewer straight into these conflicts to suggest the senselessness and cyclical nature of black-on-black violence. By comparison, the first photograph in the series offers a close-up profile and dignified portrait of the Harlem gang leader, *Red Jackson,* as he smokes a cigarette and stands in shadow before a broken window. Parks had to fight against the editors of *Life* who had chosen another photograph of Red Jackson holding a gun for the cover.

He was so convinced that the publication of this image would have 'sent him to prison' that he 'reclaimed the negative and then cut it to pieces' (Ibid. 85). Throughout his works, Parks sought not only to protect his black subjects from white patron demands but also to protest his right to tell his own version of the story.

In contrast to the cut-up negative, this photograph neither sensationalises nor sanitises Red Jackson's relationship to violence but instead captures his internal conflicts in a meditative pose. Parks's style recalls the 'dark tones' of DeCarava's aesthetic practice to show Red only partially emerging from his black backdrop in a crumbling tenement building. By suggesting his psychological ambiguities rather than his physical brutality, this teenager's unarmed stance contrasts with Park's later graphic image, *Gang Member with Brick*. Red's portrait also differs from the last image in Parks's series, *Red Jackson and Herbie Levy Study Wounds on Face of Slain Gang Member Maurice Gaines*, in which he also appears but which focuses on the senselessness of death instead. In stark juxtaposition with the first image in which Red is a solitary, contemplative figure, by the final image he has become a powerless spectator of murdered black masculinity.

Three photographs in this series, *Harlem Rooftops*, *Neighbourhood of Gang Warfare* and *Harlem Neighbourhood* (see Plate 9), contrast with these scenes of black violence by providing alternative representations of black community life. *Harlem Rooftops* adopts the dark tonal variations of his portrait of *Red Jackson* to accentuate the dirt, grime and poverty of a black existence in confining urban landscapes. This is the only image in the entire series in which Parks preferred not to focus on black subjects to show the extent to which human character is shaped by the environment. Figures are barely discernible as Parks reveals the exposed rooftops, streets and smoking factories of an imprisoning city scene. This panoramic photograph loses any specific details by concentrating on the abstract black and grey interlocking grids of building facades and rooftops which dominate an otherwise bleak and remote charcoal skyline. This photograph prophesies Norman Lewis's introduction of different shades of black to create dramatic and thematic tensions in his paintings. The ghostly smattering of white smoke in this otherwise all black photograph foregrounds the ways in which racism and poverty undergird internalised systems of self-hatred which are often at the root of black-on-black violence.

In *Harlem Neighbourhood* (see Plate 9), Parks dispensed with the

sensationalist material characterising this series to focus on street level activity instead. In this work, men and women walk down a rain-drenched sidewalk and away from the viewer. Parks's decision to photograph the backs of these figures contrasts with his preceding and succeeding images, *Gang Victim* and *Slain Gang Member*, which offer close-ups of mutilated and bleeding black bodies. In a startling volte-face, Parks's men and women in *Harlem Neighbourhood* are anonymous and raceless as they live their daily lives seemingly undisturbed. By inserting this image between photographs testifying to horrifying violence and death, Parks suggested that there are sides to Harlem which do not sit easily with the subjects which white audiences and magazine editors consider newsworthy. *Harlem Neighbourhood* could represent any urban community as well-dressed men and women living their uneventful everyday lives refute the stereotype of Harlem as the locus for violence and terror. Parks included partially hidden street signs in large type above his anonymous figures which read: 'SEA FOOD/ LUNCH/ FRIED /FISH 35¢' and 'RKO ALHAMBR/ DEALERS IN CRIME AND/ HOODLUM EMPIRE ALSO /WITH A SONG IN MY HE'. These signs announcing the realities of gun crime alongside food specialities, theatre life and a music tradition provide multifaceted insights into black culture. In particular, the film titles advertising 'Dealers in Crime', 'Hoodlum Empire' and 'With a Song in My Heart' reinforce stereotypes of Harlem as a site of violence, music and crime. In this photograph, Parks provided a broader sense of Harlem culture to critique sensationalised accounts of black masculinity and community life. His decision to end with a photograph which depicts one dead gang member lying in his coffin while two black teenagers peer closely over him reinforces black powerlessness to suggest that the responsibility for this senseless brutality lies beyond the confines of Harlem. This final image showing gang members grieving their dead invites white audiences to recognise their own culpability as a result of racist abandonment and stereotyping. In his 1940s' *Gang Warfare Series*, Parks called upon his white audiences to take responsibility for black cycles of abuse generated by violent environments in turn produced by racist discrimination.

Throughout his lifetime, photography remained a substitute for militant rebellion for Parks as he admitted that, 'Instead of striking back with violence … I put it in my camera' (in Doud, 1964: 5). As hooks argues, the 'camera offered African-Americans … a way to empower themselves through representation' (hooks, 1995: 57). She writes that

it was 'documentation that could be shared' and which 'offered a way to contain memories, to overcome loss, to keep history' (Ibid.). Parks supported this view by admitting, 'I felt it was my camera's responsibility to shed light on any condition that hinders human growth or warps the spirit of those trapped in the ruinous evils of poverty' (Parks, 1992: 179–80). For Charles White, Elizabeth Catlett and no less for Gordon Parks, the incriminating effects of poverty, destitution and racism lay at the heart of their artistic approach as they fought to examine the psychological effects of black violence and urban destitution.

Gordon Parks's photographs dramatise the lives of black cultural heroes alongside ghetto street fighters and poverty-stricken mothers, abusive fathers and fragile children to commemorate a rich panorama of black life. His work testifies to bell hooks's view that '[a]ccess and mass appeal have historically made photography a powerful location for the construction of an oppositional black aesthetic' (hooks, 1995: 57). Parks's 'oppositional black aesthetic' emerges from his determination to push the boundaries of his photographic practice to resist a straightforward documentary mode. By encouraging viewers to reconstruct, re-imagine and identify with the emotional lives of his subjects, his photographs are far from self-explanatory. 'I did a lot of thinking about the white man and his brutality,' Parks admitted on a visit to the south. 'I was suffering with the others now – those imprisoned in slave ships from Africa hundreds of years before, those strung up by their necks in hatred-filled Delta bottoms, those gunned to death for "looking the wrong way" at some Southern white lady' (Parks, 1992: 47).

Conclusion: Willy Causey and Norman Fontenelle

'I couldn't go on forgiving myself for my apathy toward those who were unable to do for themselves,' Gordon Parks explained. 'I began to think of them as people who slept out their nights on pillows of stone; who staggered to their feet every morning lost in nothingness' (Ibid.: 180). Parks's emphasis upon black lives lost in 'nothingness' resonates with Driskell's discussion of 'nonbeing' in Charles White's art, as well as Elizabeth Catlett's search for the forgotten experiences of working-class 'black women' (Catlett in Herzog, 2000: 23). In the same way that Catlett acknowledged her audiences' understanding of pure forms through African art, Parks's early inspiration came from photographs of 'migrant workers' who 'lived in shanties with siding and roofs of cardboard boxes, the inside walls dressed with newspapers' (Ibid.: 65). Their determina-

tion to 'dress' their walls with 'newspapers' recalls Zora Neale Hurston's 'will to adorn' by providing evidence of an aesthetic sensibility which prevailed within African American communities regardless of suffering (in Gates, 1997: 1020).

Two of Parks's most powerful photographic series dramatise the lives of a southern sharecropping family at the height of segregation in Alabama, *Willy Causey and Family* (1956), and the plight of a destitute northern family living in the urban tenements of Harlem, the *Fontenelle Family* (1968). These works summarise many of the interests of the three artists discussed in this chapter. On the one hand, Parks's series of photographs illustrate the Causey family's plight to protest against segregation which had devastating effects upon all aspects of black life and resulted in back-breaking labour in the cotton fields and chain gangs. On the other hand, Parks's photographs depicting life for the Fontenelle family in the north exposed their repeated visits to the 'Poverty Board' and fight for survival in rat-infested tenements. In both series, Parks juxtaposed the abuses of domestic violence with the poignancy of children's attempts to survive the difficulties of family life. He used these works to document the generational shift from hardships under slavery and segregation to the fight for Civil Rights and Black Power in the twentieth century.

Parks's aim in choosing to record the lives of the Fontenelle family was to answer the question of *Life*'s editor concerning 'why black people were rioting and why they were so discontented, especially in the big cities' (Parks, 1992: 228). The father of the family, Norman Fontenelle's response was self-explanatory: 'There's hardly enough food in our icebox to fill the baby's stomach' (Ibid.). Parks's opening text accompanying the Fontenelle Family photographs reads:

> What I am, what you force me to be, is what you are. For I am you staring back from a mirror of poverty and despair, of revolt and freedom. Look at me and know that to destroy me is to destroy yourself ... There is something about both of us that goes deeper than blood or black and white ... I too am America. America is me ... Try to understand my struggle against your racism (Ibid.).

Parks's aim in this series was to show how black men remained the 'darker brother' of white America, as Langston Hughes wrote in his poem, 'I, Too' (1955), and, as such, equally entitled to nationhood, citizenship and political rights.

Bessie and Little Richard the Morning After She Scalded Her Husband is one of the most controversial photographs in Parks's Fontenelle series. As Parks wrote in one of his autobiographies:

> Bessie was lying on her bed, groaning in misery. Little Richard had crawled beneath her arm. Her neck was scratched and swollen. She managed a painful half-smile. 'He gave me a going-over last night. My ribs feel like they're broken'. She began to cry. 'I just can't take it no more. It's too much for anybody to bear' (Parks, 1971: 126).

Parks's photographs not only provide uncensored and graphic examinations of black-on-black violence but also empathise with the hardships of female suffering. In an image which would otherwise suggest the mother and child intimacy of Catlett's sculptures, this photograph dramatises the child comforting the mother as a result of a brutal beating. This photograph relies on dark tonal variations to portray Bessie's arm which hangs limply rather than protectively over Richard while her other arm conceals her face from the viewer. The body of the mother which is partially obscured by the darkness on the left side of the photograph reinforces her status of 'nonbeing' and 'nothingness'. Parks's description elsewhere of Bessie Fontenelle's 'touch' poignantly reflects upon Catlett's search for a black 'woman's estheticism'. He shows how her attempts to transform her surroundings in 'dime-story paintings on the walls; the shredded scatter rugs covering the cracked linoleum; the wax flowers and outdated magazines' represent 'a losing battle' (Ibid.: 116). In contrast to paintings by Jacob Lawrence and Horace Pippin, there is no scope for art to transcend suffering in these works. Parks's photographs occupy a key position in African American art history by providing graphic representations of black experiences which fail to fit within heroic paradigms of moral uplift.

Aaron Douglas's view that the 'man on the streets ... didn't mould anything' when it came to art is antithetical to the aesthetic practices of these artists (in Collins, 1971: 5). Charles White, Elizabeth Catlett and Gordon Parks were part of the 1930s Chicago Renaissance of black artists who believed that artists had responsibilities as 'cultural workers making art for a popular mass audience' to improve the social and political plight of African Americans (Herzog, 2000: 27). They established an accessible art capable of communicating to 'adults just learning to read and write' (*ECP* 2249, Catlett in Clara Hieronymus, 'Double Celebration', 1973: 10). All three artists were as preoccupied as DeCarava with

recognising that the black artist 'grapples with staying alive' while he communicates 'integrated ideas about humanity' (in Miller, 1990: 847). Catlett summarised their aesthetic agendas by explaining that, "'I learned how to put art to the service of the people'" (in Lewis, 1984: 21).

Rather than arguing, as Aaron Douglas did, that an abstract sense of '[a]natomy is our base', White and others believed that '*the* most challenging, *the* most inspirational theme that an artist can face in his work is life, is people' (Ibid.: 35; *CWP* 3190, White, 'Memo', 1956: 1). They created an interactive, responsive and politically relevant art that was inspired by and accountable to black communities. 'Oppression was their subject matter,' Parks observed. 'With paint, pencil and charcoal, they had put down on canvas what they had seen, and what they had felt about it. Quite forcefully they were showing me that art could be most effective in expressing discontent' (Parks, 1992: 75). 'Chicago's South side was a remarkably pitiful place to start,' he admitted. 'The worst of it was like bruises on the face of humanity' (Ibid.: 74). Works by White, Catlett and Parks confirm Lawrence's sense that this was an era in which a man not only 'did his Native son' but also his 'Native daughter' (in Greene, 1968: 39). Just as Lawrence, Pippin and Edmondson sculpted and painted from the inside looking out, racist injustice was an everyday reality for all three artists. Five members of White's family had been lynched and he himself had been beaten and forced to the back of a bus at gunpoint. Parks barely escaped with his life when he was run out of the south by white vigilantes for photographing the plight of black share-croppers. Catlett's art career also encountered difficulties when racial discrimination barred her from the Carnegie Institute of Technology and led one of her teachers to commiserate, 'It's too bad she's a Negro, isn't it?' (*ECP* 2249, in Stephen Lafer, 'Elizabeth Catlett', 1978: 15).

Works by White, Catlett, and Parks address Lawrence's question, 'Isn't it sad that the oppressed often find themselves grotesque and ugly and find the oppressor refined and beautiful?' (in Bearden and Henderson, 1993: 310). They took the ragged working classes from the edges of Douglas's murals and Motley's paintings and made them centre stage. A comparison of works by all three artists reveals their determination to push the boundaries of form and theme to dramatise the forgotten lives of impoverished African Americans. As we will see in the next chapter, African American painters and installation artists, Norman Lewis, Romare Bearden and Betye Saar took a different path. They experimented with photomontage, collage, abstraction and assem-

blage to contest traditional narratives and histories of the black experience in the United States. However, they remained as preoccupied with protest and a radical aesthetic as Charles White, Elizabeth Catlett and Gordon Parks. Like so many artists in this book, these artists all shared Roy DeCarava's view that, 'I will not go away. I will not be quiet and I will not accept less. I will be heard' (in Miller, 1990: 853).

'Art comes to have a life of its own': Aesthetics, Experimentation and a New Visual Language

Norman Lewis – Romare Bearden – Betye Saar

'I believe there is an aesthetic that informs the art works of black peoples,' asserted African American painter and collage artist Romare Bearden (in Cousins, 1974: 189). From the second half of the twentieth century onwards, the Abstract Expressionist paintings of Norman Lewis, cubist inspired collages of Romare Bearden and found object assemblages of Betye Saar retrace old ground at the same time as they forge ahead into new terrain. As this chapter shows, in his abstract canvases, Norman Lewis's painterly surfaces play with colour and spatial relationships to blur the boundaries between the figurative and non-figurative in his works. He experimented with the dramatic tensions generated by black and white paint to create paintings signifying upon the complex relationships between aesthetic experimentation and racial tensions. Romare Bearden ripped documentary photographs apart to create crowded collages which would challenge viewer assumptions concerning the appropriate content and style of black art. He adopted the role of soothsayer and conjuror to appropriate, mix and riff upon Western classical myths and African American oral traditions. Jazz and blues forms inflect his experimentation with intervals, breaks and improvisation in his compositions. Still working as an artist today, Saar has taken to the streets to create artworks out of found objects as diverse as glass, metal, wood, jewellery, textiles, buttons, stones, string, toys, furniture, advertisements and photographs. Her experimental works include photographs, found objects, racist memorabilia and domestic artefacts to represent hidden histories and untold narratives.

All three artists experiment with an abstract-figurative style, improvisation, collage, the narrative series and a symbolic use of colour in their mixed-media canvases and installations. They share Bearden's belief in

an 'aesthetic' of 'black peoples' at the same time as they celebrate Lewis's conviction that the 'goal of the artist must be aesthetic development' (in Rosenfeld, 1999: n.p.). 'I realised that my own greatest effectiveness,' Lewis admitted, 'would not come by painting racial difficulties but by excelling as an artist first of all' (in Gibson, 1989: 65). Romare Bearden and Norman Lewis remained as preoccupied as Betye Saar with 'looking for a visual language' (in Hewitt, 1992: 20). Lewis unwittingly summarised the artistic visions of Bearden and Saar, in addition to his own, when he claimed that the African American artist, like all artists, has a '"responsibility to move toward an art for his time, by persistent curiosity and experimentation"' (in Gibson, 1989: 65).

In comparison with Catlett, Parks and White, who believed that art is life and life is art, Bearden urged 'a work of art is not life itself' as he was convinced that, 'Art is made from other art' (in Ghent, 1968: 23; in Schwartzman, 1990: 38). 'Art,' he suggested, 'is artifice, or a creative undertaking, the primary function of which is to add dimension to our existing conception of reality' (*RBP* N68–87, Bearden, 'Untitled', n.d.: 8). Lewis similarly believed that artistic experimentation should contribute to a 'universal knowledge of aesthetics' so that 'art comes to have a life of its own; to be evidence of the emotional, intellectual and aesthetic level of men', which is 'always changing and going towards greater understanding of human beings' (in Gibson, 1989: 64). By accentuating rather than concealing the mechanics of their artistic production in startling juxtapositions, unresolved perspectives and jarring forms, Lewis, Bearden and Saar draw attention to the artificiality of their works. Their self-reflexive approaches encourage audiences to interrogate the veracity of documentary, Social Realist or even abstract styles. Bearden and Saar shared Lewis's conviction that aesthetic experimentation can effect change by stimulating 'greater understanding' between 'human beings'. As viewers, we are forced to think critically to make sense of their challenging and elliptical artworks.

Even a most superficial examination shows that the epic, heart-breaking and evocative murals, charcoal drawings, sculptures and photographs of Charles White, Elizabeth Catlett and Gordon Parks were not for Norman Lewis, Romare Bearden, Betye Saar or even painter and muralist, Hale Woodruff, who came to prominence in the same period. Instead, their works support Woodruff's assertion, 'I think what is required is what is called a certain amount of "artistic distance"' (Murray, 1979: 77). In their canvases, collages and sculptures, Bearden, Saar, Lewis and Woodruff

all push aesthetic boundaries to cultivate 'distance' and produce defamil-
iarising effects for their audiences. Norman Lewis was the first to admit,
'I am sure that if I do succeed in painting a black experience I won't
recognise it myself' (in Ghent, 1968: 23). In their works, Woodruff,
Lewis, Bearden and Saar defamiliarised black narratives and histories to
reconceptualise the aesthetic criteria for African American artists and art
and resist audience and patron demands. For all three artists, an exper-
imental aesthetic approach was intertwined with their search for new
subject matter to inspire audiences to see familiar images and themes
anew. As committed as they were to social and political injustices, they
did not shy away from fighting for the right of aesthetic experimenta-
tion in and of itself. Lewis explained it clearly when he wrote that, the
'content of creative painting develops automatically with the choice of
form and colors, for the combination of composition and color *is* the
content' (in Gibson, 1989: 65, his emphasis).

Norman Lewis, Romare Bearden and Betye Saar exhibit Hale
Woodruff's same determination to establish their credentials as artists
rather than as social and political commentators in their works. As
Woodruff claimed, 'I am an *artist* ... Once the story is told, the relating
of that story lives in the dynamic and exciting language in which the story
is told' (in Washington in Amaki, 2007: 92, his emphasis). By stressing
the ways in which his themes were visually narrated as much as, if not
more than, the content of the paintings themselves, Woodruff's practice
reflects upon Lewis, Bearden and Saar's preoccupation with aesthetic
issues. In this regard, it is useful to discuss Woodruff's canvas, *Ancestral
Memory*, painted in 1967 at the height of the Civil Rights Movement and
the fight for Black Power (see Plate 10). Despite its political implica-
tions, this painting shares Lewis, Bearden and Saar's preoccupation with
artistic experimentation. In these and other canvases, Woodruff was as
determined to experiment with form, colour and composition to develop
new approaches to African American art.

In Woodruff's *Ancestral Memory* (see Plate 10), a blood-red mask
replicates the outline of the African continent to interrogate ideas of myth,
memory, spirituality and ritual. As he stated, 'The painting resulted in
a large red face, a mask-like face; it's quite human, not grotesque ...
I call it, "Ancestral Memory", because it had an ancestral quality and
the memory was not conscious' (*HWP* N70–60, in Melvyn Alexenberg,
'Interview', 1969: 1). Woodruff draws attention to the humanity rather
than the grotesqueness of this 'mask-like face' to reveal how Africans and

African Americans were forced to 'wear the mask', as poet Paul Laurence Dunbar insisted, in a fight against cultural, political and historical erasure (Dunbar, 1913: 71). Contrasting whites, blacks, reds, pinks and blues dominate this canvas to generate abstract patterns and unexpected juxtapositions. Dramatic tensions emerge from Woodruff's dark and light reds which symbolise blood and fracture the mask's painterly surface to insinuate the horrifying realities of European slavery and colonialism. The shape of the mask inscribes social rituals on to international politics by mirroring the geographical contours of the African continent. In works such as these, Woodruff created new narratives of black culture to suggest patterns of influence and interchange between African and African American art. The 'African and the American possess an intensity of vision, an imaginative inventiveness, and a high spirituality that is unique in art,' he stated (*HWP* N70–60, Woodruff, 'Art', 1961: 5). His decision to paint *Ancestral Memory* in the 1960s mapped histories of colonialism and slavery on to contemporary struggles for Civil Rights. He drew upon a mythic notion of 'ancestral memory' to internationalise the fight for a worldwide liberation of African peoples in the Diaspora. In keeping with the focus of this chapter, art and the art-process itself remain as important as representations of Africa, myth, radical politics and history in Woodruff's *Ancestral Memory*.

At the same time that he adopted an experimental practice, Woodruff also admitted, 'I somehow always come back to the so-called black image'; these tensions between art and politics were as resonant within his own work as within paintings and installations by Lewis, Bearden and Saar (in Murray, 1979: 78). By cultivating new aesthetic techniques and approaches, none of these artists sought to displace political or social issues. Instead, they relied on formal dimensions to encourage detached rather than emotive responses from their viewers. Theirs was not an art of catharsis but of dispassionate critique, social observation and incisive analysis. Woodruff's visual poetics of resistance which emerged from his experimentation with abstraction and an abstract-figurative style has much in common with works by Norman Lewis, Romare Bearden and Betye Saar. They similarly explore the possibilities of an aesthetic imagination and encounter the same difficulties as Woodruff who argued, 'It's very important to keep your artistic level at the highest possible range of development and yet make your work convey a telling quality in terms of what we are as a people' (in Murray, 1979: 76). Works by artists such as Lewis, Bearden and Saar reveal his same conviction that, 'while culture

and environment may provide ideas and themes, they are always, as art, filtered through the artist's own ... personal language' (Woodruff, 1966: n.p.). As Saar's search for a 'visual language' shows, these artists were as concerned as Woodruff with examining 'ideas and themes' through their own 'personal language'. His insistence that black artists should be involved 'more in the aesthetic problem than in the social or in the political aspects of social problems' found fertile ground in their works (in Murray, 1979: 72). As Lewis argued, there 'must be an aesthetic idea; the elements of painting constitute a language in themselves' (in Gibson, 1989: 65).

In their canvases and installations, Lewis, Bearden and Saar fragment, layer, break up and rip apart established forms, techniques and themes to revisit histories, recreate narratives, retell myths and relive rituals. They favour a return to African-inspired art practices by sharing Woodruff's view that the 'African's chief involvement are the *inner* concerns of man' (*HWP* N70-60, Woodruff, 'Art', 1961: 3, his emphasis). All three artists cultivate their own 'personal language' to capture the emotional difficulties facing African Americans. With their rough surfaces, eclectic objects and shredded photographs, these works testify to a belief in improvisation and a formal commitment to aesthetics as the only way to do justice to black narratives and histories inspired by Africa, myth, music, memory, ritual and politics. This chapter investigates works by Lewis, Bearden and Saar in light of Woodruff's warning, that the 'soil of the Black community must not only be productive and rich', but also that 'Those who till that soil ... must come in there with some real artistic insights' (in Bearden, 1969: 253). Working on the assumption that African American art must be artistically self-reflexive, they cultivate a similar relationship to their audiences as Woodruff who admitted that he was 'trying here to re-orient your out-look, and your aesthetic points of view' (in Washington, 2007: 92). Ultimately, Norman Lewis, Romare Bearden and Betye Saar set out on odysseys of discovery to learn 'what one can do in paint, what one can achieve, what visually excites you and what you want to see that hasn't been done' (Lewis in Ghent, 1968a: 22).

Norman Lewis (1909–79)

'I just see art. I don't see any black experience'

'I used to paint Negroes being dispossessed ... and slowly I became aware of the fact that this didn't move anybody,' Norman Lewis admitted. '[I]f

I had the guts to, which I did periodically in those days, it was to picket. And this made things better for Negroes' (Ibid.: 13). Avant-garde. Abstract Expressionist. Social Realist. Artistic visionary. Loner. All of these terms can be applied to Norman Lewis and his groundbreaking aesthetic practices which inspired new directions for African American art. His conviction, that 'painting pictures of protest didn't bring about any change', sets him apart from Charles White, Elizabeth Catlett and Gordon Parks (Ibid.: 15). 'Negroes were employed and they had jobs and stuff like that but it still didn't make my art any better,' he admitted (Ibid.: 13). Hale Woodruff similarly claimed that 'protest picketing' has 'nothing to do with painting a picture' (in Murray, 1979: 77). Lewis held the same opinion as earlier artists, Henry O. Tanner and Archibald J. Motley, Jr, that 'political and social aspects should not be the primary concern; esthetic ideas should have preference' (in Rosenfeld, 1999: n.p.). He shared Motley's frustration that the attempt to '"paint Black people in their struggle for existence ... was a waste of time because the very people who you want to see this kind of thing don't see it"' (in Gibson, 1989: 17). As Lewis admitted, 'Black people don't buy art and it's only just recently that you see them in museums' (Browne, 1974: 76).

Rather than opting for White, Catlett and Parks's tactic of disseminating prints, posters and photographs among black audiences, Lewis created expensive one-off paintings which ended up being exhibited in predominantly white-owned art galleries. He worked on the assumption that it was 'the excellence' of the black artist's art, rather than the political relevance of his or her content, which would offer the 'most effective blow against stereotype and the most irrefutable proof of the artificiality of stereotype in general' (Lewis, 1946: 63). Lewis experimented with colour, form, and composition in his abstract canvases to dramatise mythic landscapes, racial conflicts, social struggles, class tensions, musical forms, and political dramas. He dispensed with realism to push the boundaries of Abstract Expressionism and direct his audiences' attention to his self-reflexive experimentation with aesthetic issues. Lewis described how he 'grew from an over-emphasis on tradition and then propaganda to develop a whole new concept of myself as a painter' (Ibid.). At the same time, however, he produced artworks which included themes relevant to black history and politics. 'I didn't paint for black people or white people,' he explained, 'I just wanted people to see' (in Browne, 1974: 76). By insisting that, 'The goal of the artist must be aesthetic development, and in a universal sense, to make in his own

way some contribution to culture', Lewis adopted similar practices to the majority of artists in this book (Lewis, 1999: 65).

'White America is so goddamn aggressive that it destroys anything that gets in its way,' Lewis insisted (in Ghent, 1968a: 15). He admitted:

> I teach, I have driven a taxi, I have been an elevator operator, I have been a pants presser, I have washed floors, I have been a cook, I have been a seaman, I have sewed dresses, I have sustained myself in whatever ... has been necessary to just exist (Ibid.: 16).

Lewis's list of odd jobs resonates with those of William Edmondson, Jacob Lawrence, Charles White and Romare Bearden who were artists by night and cleaners, sign-painters and social workers by day. His description also invites parallels with the captions for Elizabeth Catlett's *The Negro Woman* series, discussed in the last chapter. Works by Catlett and Lewis prove that their cutting-edge practices emerged out of a determination to further the aesthetic awareness of their black audiences as well as their sense of racial injustice. Lewis was enraged to find that, 'Even the worst white artists get along better than the best black artists' (Ibid.: 11). He shared Lawrence's definition of 'our struggle' by arguing that there is 'something beautiful about black people that they manage to go on despite the hostility' (Ibid.). His own experiences of racism never let him forget 'where the hell you are' (Ibid.: 5). Living in poverty, he obtained an art education the hard way by buying his materials and teaching himself from books bought with gambling winnings. Just as Bearden, Lawrence and many other black artists suffered from psychological breakdowns, Lewis had many personal crises. 'And one of the things that I think started me drinking,' he told Henri Ghent, 'was the fact that I just felt that I didn't have' the 'freeness' to be an artist. 'Yet I had and I think this is a brainwashing which America does' (Ibid.: 12). Lewis's search for the 'freeness' to be an artist emerged out of his fight against racism and his own personal struggles. As he insisted, for 'white artists, their harassment and being bothered by the police was entirely different from the black cat being beaten by the police' (Ibid.: 9).

There is very little consensus among critics concerning Norman Lewis's aesthetic practice and choice of subject matter. As Ann Gibson argues, the 'aesthetic implications' of his works 'have not been fully grasped' (in Gibson, 1989: 10). Even Bearden and Henderson assume that, '[w]hile the canvases of many Abstract Expressionists reflected turbulent inner conflict, Lewis' work was quiet' (Bearden and

Henderson, 1993: 315). A brief look at Lewis's works with their expressive brushstrokes, evocative textures, complex uses of spatial relationships and colour juxtapositions reveals that they are anything but 'quiet'. However, Bearden and Henderson are right to argue that colour was the 'agent of his revelations' and to suggest that his 'frank discussions of aesthetics' inspired other artists (Ibid.). Ann Gibson's assessment that Lewis 'put these languages of abstraction at the service of his signifying practice' assists interpretations of his experimentation with genres and styles (Gibson, 1989: 16). She identifies his artistic practice as one which 'resisted narrative interpretation' (Gibson, 1998: 25). As Julian Euell notes, Lewis 'talked on several levels at the same time', while Ernest Crichlow describes how he 'would flip from one thing to another' (in Gibson, 1989: 52, 15). During his career, Lewis combined seemingly incongruous themes with unexpected forms to create original works out of startling juxtapositions and tensions. One of the most versatile African American artists, Norman Lewis overturned audience expectations by speaking in many visual languages simultaneously.

According to David Craven, 'Lewis was more interested in generating an ideological critique through the actual pictorial logic of his paintings than he was in making explicit political statements through their content' (Craven, 1998: 55). This may well be the case but it does not account for Lewis's continuing tussle with his obligations as an artist and his sense of responsibility as an activist. His abstract and ambiguous paintings prove he was torn in two directions. On the one hand, Lewis urged that the main question of the black artist should be, '[W]hat can I say that can arouse someone to look at and feel awed about[?]' (in Ghent, 1968a: 13). On the other, he warned the black artist away from becoming more 'concerned with what he is saying verbally than with what he is doing visually' (Lewis, 1949: 65). As such, Lewis's canvases pre-empt Woodruff's later abstractions in their experimentation with colour, form and spatial relationships which create original compositions to embrace improvisational play. As Lowery Stokes Sims argues, Lewis mirrored Woodruff by experimenting with form to 'create abstract designs and suggest narrative sequences' (Sims, 1998: 44).

In this chapter, I examine Lewis's paintings, *Fantasy* (1946) and *Post Mortem* (1964, see Plate 11) to investigate the tensions within Lewis's aesthetic practice. His works were as influenced by music, dance, performance and the carnivalesque as much as they were by the struggle for Civil Rights. He discovered new relationships of form, colour and

composition at the same time that he signified upon contemporary race and class conflicts. As much as he was committed to experimentation in and of itself, Lewis was as unable to liberate himself from the 'nitty-gritty' of African American experiences as other artists given that, 'Black artists have an entirely different problem from white artists' (in Ghent, 1968a: 19). In overtones of Charles White, his paintings reflect his determination to counter the fact that there is 'no history of black people that is nourished' (Ibid.: 8). Lewis was appalled that an art class for black students 'seemed like a class in Negro history rather than a class in how to paint' (Ibid.: 16). Painting during the era of the Civil Rights Movement in the 1960s and 70s, he was haunted by the horrors of racial conflict and became convinced that there was 'no escape' from the 'violence' of 'white people' (Ibid.: 8). His aim was to make his students see that 'they have an experience which is entirely very worth exploiting in America' (Ibid.: 17). Lewis's paintings blur the boundary between figurative and non-figurative art forms to support his search for the 'greater freedom for the individual to be publicly first an artist (assuming merit) and incidentally, a Negro' (Lewis, 1946: 63).

Fantasy (1946)

'I feel that color can evoke a great deal of visual excitement,' Norman Lewis stated in the 1970s (in Browne, 1974: 77). In comparison with his later Civil Rights paintings, Lewis's exploration of play and the imagination in works such as *Fantasy* (1946), *Carnivale* (1957), *The Charade* (1963), *Kites* (1962) and *Players Four* (1966) has gone virtually unnoticed. *Fantasy* is one of Lewis's first full-colour abstract oil paintings in which he celebrated the power of the artistic imagination by creating a dreamscape of shapeless colour and non-figurative images. The energy and force of this painting emerges from Lewis's combination of black swirls and scratchy, jagged lines which he juxtaposed with smooth blocks of contrasting whites, blacks and primary colours. His abstract forms share similarities with musical notations and invite thematic parallels with other canvases such as *Jazz Musicians* (1948). Kaleidoscopic colours generate a 'visual excitement' in *Fantasy* from Lewis's colliding yet separate blacks, whites, yellows, reds, greys, blues and browns. This painting overwhelms the senses by superimposing delicate, thinly executed lines on to intense colours to evoke the unruly freedom of uncontainable fantasy. Lewis produced disconcerting effects on the viewer by blurring the boundary between artwork and audience. His layers, textures, contrasts, markings

and blocks of colour invite us to freefall into the canvas to liberate our own fantasies. Lewis also suggested the barest outline of a mask-like face in the background of this painting by providing black swirls for eyes, straight lines for a nose and blocks of blue for the skin. However, this mask disintegrates into white nothingness by becoming framed by black brushstrokes and swathes of multicoloured fragments. In Lewis's *Fantasy*, his abstract swirling black markings are etched on to a painterly red, brown and white background to signify upon racist associations of the period which interpreted black art works as descended from primordial cave markings.

In *Fantasy*, Lewis contested the fixed presence of oil paint by blending and merging his colours to suggest themes of absence and presence which resonate with his Civil Rights paintings. His washes of colours in free style arrangements visually translate the temporal rhythms of music to evoke movement and generate mood swings in his viewer. This canvas relishes in abstract play to animate a dreamscape of unruly and contradictory emotions and capture psychological landscapes which exist beyond language and can only be released via abstract play. As a result, our viewing of *Fantasy* is a highly subjective experience with no guidelines for interpretation. While it is possible to begin to see human figures in his blocks of colour and scratchy lines, we cannot be sure as they remain hidden, fragmented and heavily distorted to suggest the subjectivity of individual fantasies and imaginations. Lewis's challenging painting may well suggest a spontaneous aesthetic style to imitate the improvisational forms of jazz music. As Sara Wood astutely observes, 'he incorporates the sensibility of the musical performer into his visual art' (Wood, 2007: 73).

In works such as *Fantasy*, Lewis played with abstract forms and non-figurative content to create new relationships from his juxtaposed colours and challenging spatial arrangements. This painting insists on the right of the black artist to aesthetic freedom by placing the onus on the viewer to create meaning from its seemingly spontaneous non-logical elements. *Fantasy* establishes Lewis's belief that the 'content of truly creative work must be inherently aesthetic or the work becomes merely another form of illustration' (Lewis, 1999: n.p.). He interpreted art as an 'activity of discovery' which was in search of 'ignored or unknown combinations of forms, colors, and textures and even psychological phenomena' to 'cause new types of experience in the artist as well as the viewer' (Lewis, 1946: 63). This painting relies on abstract forms to

encapsulate Norman Lewis's personal 'fantasy' of liberating his aesthetic practice. 'I never felt the freeness,' he explained. '[R]ather than being an artist, I am an oddity' (in Ghent, 1968a: 12).

Post Mortem (1964, Plate 11)

'If we had been allowed to pursue our own image historically, it would have been a Negro Image,' Norman Lewis informed other black artists in the 1960s (in Siegel, 1966: 51). His black-and-white painting, *Post Mortem* (1964, see Plate 11) is one in a series of his 'Civil Rights paintings' which include *Alabama* (1960), *American Totem* (1960), *America the Beautiful* (1960), *Ritual* (1962), *Evening Rendezvous* (1962), *Ku Klux* (1963), *Journey to the End* (1964), *Processional* (1964), *After Dawn* (1966), *Untitled* (1967), *Double Cross* (1971) and *Triumphal* (1972). Wondering '"what the hell to do"', Lewis admitted that he and other black artists '"came up with the idea that it was a white and black involvement"' and so '"decided to limit ourselves to white and black paint"' (in Gibson, 1998: 36). *Post Mortem* reveals Lewis's experimentation not only with the formal possibilities of black and white but also with the tonal variations, textures, and shades of black as a colour. As Lewis explained, he was '"seeing if [he] could use black with a brushstroke that went from light to dark or jet black – and in between that, just using it lighter on the canvas"' (in Henderson, 1996: 62). '"Just as dissonance in music can be beautiful, certain arrangements in color have the same effect",' he claimed. '"I wanted to see if I could get out of black the suggestion of other nuances of color, using it in such a way as to arouse other colors"' (in Bearden and Henderson, 1993: 321).

The dramatic tensions of *Post Mortem* and other works emerge from the 'little people' Lewis painted on black backgrounds (Ghent, 1968a: 13). Corinne Jennings describes these 'little figures' as 'resembling musical or dance notations' (Jennings, 1989: 7). His comment that these figures represent 'humanity in terms of the space in which you live' reinforces the symbolic weight he attached to blackness in *Post Mortem* and other paintings (Ghent, 1968a: 13). Lewis's use of black as the backdrop of *Post Mortem* not only surrounds but also separates his diminutive white figures, to communicate the fragility of whiteness in comparison with the strength of blackness. The fact that it is the colour black which animates these white figures complicates mythologies of blackness as absence, invisibility and 'nonbeing'. If this were an all-white canvas, these white figures would be invisible. By experimenting with positive and negative

space, *Post Mortem* supports Jorge Daniel Veneciano's view that '[b]lackness can function as a zone of both presence and absence in Lewis's paintings' (Veneciano, 1998: 39). During this period, Lewis created numerous all-black paintings on to which he then painted white subjects to politicise seemingly neutral notions of a 'blank canvas'.

In *Post Mortem*, Lewis's hooded figures which resemble members of the white supremacist organisation, the Ku Klux Klan, have much in common with his other paintings, *America the Beautiful* (1960), *Ku Klux* (1963) and *Journey to the End* (1964). These works all rely on different formations of white figures on black backgrounds to examine the relationship between individuals and collective groups. As Lewis admitted, his paintings were 'about how people followed each other and the movement of people' to reinforce his conviction that it was 'always the individual that was against the masses' (in Ghent, 1968a: 14). Gibson describes *Post Mortem*'s 'Klan-like figures' as emphasising the need to reconsider 'not only the ritual of the freedom marches, but also the rituals of the Klan' (Gibson, 1998–9: 37). Her reading of this painting confirms that Lewis muddied the differences between brutal Klan rituals and idealistic 'freedom marches' to interrogate mass activity of any kind and recover individual freewill. Lewis's choice of title *Post Mortem* suggests the need to enact a 'post-mortem' on the failures and disappointments of the Civil Rights Movement to effect change in the future. By describing another of his Civil Rights works as portraying 'white and black people who feel a togetherness so that you can't tell who is white and who is black', Lewis shed light on *Post Mortem*'s ambiguous white forms which are interwoven with a black background to suggest that whiteness could not exist without blackness (in Ghent, 1968a: 14). This work bears witness to Lewis's frustration with 'this whole goddamn thing of black and white' by which 'we haven't yet learned how to live as people together' (Ibid.). In works such as *Post Mortem*, Lewis dramatised racist acts of ritual killing which had been excluded from the official records as a result of white forgetting and denial.

Throughout his lifetime, Lewis's experimentation with abstraction was inspired by his determination to prove that 'you can't look at the subject matter just because it is black and say it was done by a black artist' (in Ghent, 1968a: 19). 'Political and social aspects should not be the primary concern; esthetic ideas should have preference,' he argued (in Siegel, 1966: 51). However, just as Woodruff felt compelled to return to the 'so-called black image', the struggles for racial equality in the 1960s

and 70s challenged Lewis's emphasis upon 'esthetic ideas' by forcing him to address the 'political and social aspects' of black life. Lewis was one of the founding members of the black arts organisation, Spiral, formed at the 'height of King's involvement in the South' and whose members included Hale Woodruff, Charles Alston, Emma Amos and Romare Bearden (Lewis in Gibson, 1998: 36). 'Our group,' he urged, 'should always point to a broader purpose and never be led down an alley of frustration' (in Siegel, 1966: 51).

'I find that civil rights affects me,' Lewis admitted, 'so what am I going to paint, what am I going to do. I don't know. And I am sure it will have nothing to do with civil rights directly but I just hope that I can materialize something out of all this frustration as a black artist in America' (in Ghent, 1968a: 23). In his works, Lewis experimented with abstract forms and techniques not to paint 'civil rights directly' but to defamiliarise this movement to encourage his audiences to reconsider its representation in mainstream journalism. His paintings gained their full force via an experimental use of form, composition and colour as he refused to explain events for his audiences. Lewis's elusive and enigmatic canvases obtain thematic coherence only in the personal interpretation of his viewers. Any audiences hoping for scenes of graphic violence are disappointed in Lewis's works which rely on ambiguous, diminutive figures to communicate social and political issues indirectly.

Norman Lewis remains an ambiguous figure whose life and works sit uneasily within an African American art tradition. '"I'm a loner and paint out of a certain self-imposed remoteness. When I'm at work, I usually remove my state of mind from the Negro environment I live in,"' he admitted. '"I paint what's inside, and like to think of it as a very personal, very individual environment"' (in Bearden and Henderson, 1993: 324). Lewis's conflicted relationship to the black community undergirds tensions in the visual dramas of his paintings as he fought to portray his own 'very individual environment' as well as the wider 'Negro environment'. Unlike White, Parks, Lawrence, Edmondson, Bearden and Saar who gained strength from living as part of a black community, Lewis described it as 'a death living there [Harlem], culturally because there wasn't the stimulus' for art (in Ghent, 1968a: 9). After 'many years' of trying 'to express social conflict though [his] painting', Lewis gave up (in Gibson, 1989: 65). As his abstract paintings such as *Harlem Courtyard* (1954) and *Harlem Turns White* (1955) show, he often relied on politicised titles to signpost politically relevant themes which were otherwise

missing from his paintings. For Sara Wood, 'the indeterminate visual images and their dynamic interplay with the suggestive and often deeply ironic titles that Lewis attaches to them seek to keep the interpretative possibilities circulating' (Wood, 2007: 86). This determination to 'keep the interpretative possibilities circulating' is an apt summary of Lewis's aesthetic practice as a whole which relies on aesthetic experimentation to express psychological conflicts and internal landscapes.

'I just see art,' Norman Lewis insisted, 'I don't see any black experience' (in Browne, 1974: 87). During his lifetime, he refused to be restricted to what were considered black subjects and black art forms. 'Being Negro, of course, is part of what I feel,' he explained, 'but in expressing all of what I am artistically, I often find myself in a visionary world' (Bearden and Henderson, 1993: 324). Lewis's emphasis upon a 'visionary world' encapsulates his fascination with creating abstract canvases which would challenge rather than educate his audiences. He believed that art 'breaks away from its stagnation in too much tradition and establishes new tradi-tions to be broken away from by coming generations of artists' (Lewis, 1946: 63). Lewis's explanation that he and 'Romie [Romare Bearden] were trying to find some identity' draws attention to the fraught relation-ship between formal concerns and thematic issues for African American artists. He admitted his own sense of isolation by saying, 'Romie calls me a loner because I have always been by myself' (in Ghent, 1968a: 8). For Bearden, Lewis was a 'very fine painter' who had 'his own way of looking at things in painting' (in Schwartzman, 1990: 82). Romare Bearden's pioneering epic-size collages were inspired by collaboration, improvisation and aesthetic play in a determination to break free of the social, political and cultural isolation plaguing artists such as Norman Lewis.

Romare Bearden (1914–88)

'You do something, and then you improvise'

'"[T]he Negro was becoming too much of an abstraction, rather than the reality art can give a subject",' explained Romare Bearden. '"What I've attempted to do is establish a world through art in which the validity of my Negro experience could live and make its own logic"' (in Golden, 1997: 39). With the exception of Jacob Lawrence, Romare Bearden is the most widely exhibited and critically acclaimed African American artist of the twentieth century. His crowded scenes of black urban and rural communities come to life on scraps of torn paper, foil, ink,

graphite, crayon, charcoal, fabric, photographs, string, pins, gouache and watercolour. His vast panoramic works variously dramatise the lives of black conjure women, farmers, nudes, jazz and blues musicians, artists, families and factory workers. Bearden relied on memory, myth, ritual, history, folklore and his own 'Negro experience' to animate the American south of his imagination. Whereas earlier artists had turned to a mythic Africa, Bearden admitted that the south was '"more in [his] work than any other place"' (in Rowell, 1988: 430). He also explained that he '"continue[d] quite often to use African images in [his] work"' as he turned to '"African sculpture for the pulse and the intervals and after that the melody which calls for repetition"' (Ibid.: 444). Bearden fought just as hard for aesthetic freedom as Norman Lewis did, claiming it was 'not necessary that the Negro artist mirror the misery of his people' because the 'artist's greatest service consists in making his individual creations as he can' (in Schwartzman, 1990: 131-32). 'Without going too far beyond reality,' he stated, 'I try to transform things, often as they are perceived conventionally, into an intense aesthetic statement' (*RBP* N68–87, Bearden, 'Untitled', n.d.: 5). In brief, Bearden complicated representations of reality to create 'intense aesthetic statements' which would open up new possibilities for African American art.

Bearden's fear that African Americans were 'becoming too much of an abstraction' inspired his search for a visual language which would be both aesthetically experimental and culturally relevant. His determination to create a space in which the 'Negro experience could live and make its own logic' led to groundbreaking collages, photomontages and projections. Bearden answered his own question 'What is reality?' by stating that it has 'different meanings for different people' (in Ghent, 1968b: 7). He asserted that the 'power of the artistic imagination and vision is such that we can accept as credible a new symbolic sense of reality, for very often the world of the artist is more real, more compelling than the world it supposedly represents' (*URBP*, Bearden, 'Hofstra', 1982: 4). His photographic and painterly surfaces rely on fragmentation, juxtaposition and distortion to create emotive, visceral and animated works which dramatise a 'new symbolic sense of reality'. In his works, he experimented with form and content to externalise the inner worlds of his black subjects. These collages capture multiple perspectives by celebrating rather than shying away from visual ambiguity.

'"You do something, and then you improvise"' was Bearden's summary of his aesthetic process (in Schwartzman, 1990: 30). 'I paint

out of the tradition' of 'the blues,' he claimed. 'And I'll call and recall. You know, you start a theme, and you call and recall' (in Berman, 1980: 25). The patterns and rhythms of jazz and blues are at the heart of his artistic practice. Bearden's artworks illustrate his belief that 'the blues ... is improvisation within a certain structure ... it's a feeling' and that 'ritual and myth are all part of the whole blues tradition' (Ibid.: 27, 34). By defining the 'art of painting' as the 'art of putting something over something else', he shows how he appropriated, riffed and signified upon existing forms and themes (Ibid.: 30). He identified visual '"intervals"' in his collages to '"reinforce the more solid forms and objects"' because '"it is the *spacing* of what you leave out that makes what is *in* there"' (in Schwartzman, 1990: 111, his emphasis). The interplay of presence and absence, interior and exterior and inclusion and exclusion forms the core of Bearden's self-reflexive approach. Just as it was blackness which defined the whiteness of Lewis's diminutive figures, a complex relationship between photographic and painterly media generates the startling juxtapositions in Bearden's works. He also destabilised audience expectations by finding 'other ways of using linkages to put things together' (in Rowell, 1988: 435).

Bearden's determination to collapse the barriers between artwork and audience led to his inclusion of an 'open space, which allows the onlooker to enter the painting' (in Schwartzman, 1990: 41). His unreadable mask-like faces and fragmented body parts thwart audience tendencies towards voyeurism in a consumption of black female and male bodies as spectacle. Bearden's audiences are denied any safe distance as they become implicated in his unnerving and disconcerting picture planes. Within the confines of a single work, his black-and-white and colour collages recall the anarchic play of William Edmondson's yard by juxtaposing male singers next to female labourers, boxing legends next to artists, children next to adults, animals next to female nudes and African masks next to photographed faces to create imaginary southern-scapes of untold black histories and narratives. Bearden's experimentation with art was informed by the need to 'make the communities, to use a cliché, more art conscious, or more aware of the Negro artist' because this 'will make for a better artist' (Bearden in Ghent, 1968b: 19).

A critical consensus surrounds Romare Bearden's experimental aesthetics and their contribution to a sea change in African American art. James Porter believed his works provide '"a new and influential integration of art and social interest"' (in Patton, 1991: 26). Ralph

Ellison similarly described Bearden as betraying 'the eye of a painter, not a sociologist' (Ellison, 2003: 694). His art, Ellison argued, replicates the 'sharp breaks, leaps in consciousness, distortions, paradoxes, reversals, telescoping of time and surreal blending of styles, values, hopes and dreams which characterize much of Negro American history' (Ibid.: 697). By identifying Bearden's experimental style as structurally reproducing the omissions, paradoxes and ambiguities of black history, Ellison introduces the complexities of his practice as a whole. Convinced that Bearden 'teaches us the ambiguity of vision', he also warns against didactic readings of his art (Ibid.: 694). Kimberly Lamm examines Bearden's 'thematics of *making*' in his 'fragmented layering of photographic images' which 'destabilise the supposed truth of the documentary photograph' (Lamm, 2003: 822, her emphasis). She insists that the 'shifting planes and dimensions, together with the variegated photographic textures and tones' of Bearden's work, 'suggest a complex relation between interior and exterior' (Ibid.: 821). 'Visualising myth through photomontage,' Gail Gelburd argues, Bearden 'used figurative forms within an abstract composition to create conceptual metaphors' (Gelburd, 1997: 36).

James Hall's view that 'Bearden would always insist on a "message"' in compositions which were 'always a pedagogical device' counters Ellison's conviction that, if he teaches us anything, he 'teaches us the ambiguity of vision' (Hall, 2001: 159; Ellison, 2003: 694). However, Ellison's emphasis upon 'ambiguity' can be more accurately applied to Bearden's 'message' which is anything but clear-cut. Bearden's aim was to teach audiences how to read against the grain by becoming more aware of the aesthetic dynamics of his works. Nonetheless, Hall's discussion of Bearden's realisation of the 'necessity for an art of *disintegration*' is a useful description of his fragmented process as he argues, if Bearden's interest is in the 'everyday, it is the everyday transformed into something aesthetically charged' (Hall, 2001: 168, his emphasis). Hall's assessment gets to the heart of Bearden's experimental aesthetic practices which transformed the mundane into the sublime to generate a sense of mystery and evoke awe in his viewers. Adopting a very different view, Judith Wilson raises an under-discussed but problematic area of Bearden's oeuvre by criticising his black female nudes which, she argues, reproduce 'pornography's standard tropes' (Wilson, 1992: 118). In this chapter, I discuss Bearden's *The Street* (1964, see Plate 12) and *Mecklenburg County, Railroad Shack Sporting House* (1978) to explore

the relationship between aesthetic issues and thematic concerns in his experimental works.

The Street (1964, Plate 12)

'I have incorporated techniques of the camera eye and the documentary film to ... personally involve the onlooker,' Romare Bearden explained (*RBP* N68–87, Bearden, 'Untitled', n.d.: 5). By experimenting with collage, photomontage and projection, he signified upon documentary and cinematic styles to encourage empathy from his audiences in his work. At one of the first meetings of the black artists' organisation, Spiral, he suggested that they all work together on a group collage. 'I thought that if we had photographs maybe we could each paste some down,' he explained. 'But they didn't seem too interested' (in Ghent, 1968b: 9). Bearden continued alone, admitting that he was engaged in '"precisely what the ladies (at the quilting bee) were doing"' (in Alexander, 2003: 62). Speaking of his aesthetic process, he explained, 'I first put down several rectangles of color ... I next might paste a photograph', after which 'I attempt ever more definite statements, superimposing other materials over those I started with' (*RBP* N68–87, Bearden, 'Untitled', n.d.: 4). Bearden's piecing method and experimentation with abstraction can be compared to Harriet Powers's abstract quilts designed from disused scraps. 'I try to move up and across the surface in much the same manner as I had done with the torn papers,' he continued, adding that he was in search of 'some compensating answer to place these movements back on the horizontal and vertical axis' (Ibid.). Bearden's hunt for a 'compensating answer' shows how his collages were as improvised as the call and recall of blues and jazz forms. Improvised sounds became improvised images by being similarly composed of a call and response relationship.

Romare Bearden's *The Street* (1964, see Plate 12) is a colour collage which he reproduced in black and white as part of his photomontage projection series which included works such as *Conjur Woman*, *The Dove*, *Pittsburgh Memories*, *Train Whistle Blues No. 1* and *No. 2*, *Cotton*, *Evening Meal of the Prophet Peterson*, *The Prevalence of Ritual – Baptism*, *Two Women in a Harlem Courtyard* and *Other Mysteries*, all created in 1964. Across these collages, Bearden experimented with photographic fragments and paint variously to depict black adults and children working in cotton fields and industrial cities, living in self-decorated cabins and tenements, playing music and participating in rituals of

baptism and folkloric magic. 'I did small collages, say, about the size of a piece of typewriter paper, out of certain magazine photographs and colored material that I put together,' Bearden told Henri Ghent, 'and these were photostated [sic] and enlarged to about four by five feet and the photostats were then mounted onto masonite [sic]' (in Ghent, 1968b: 11). But he soon ran into problems because this process was expensive and his paintings could not be sold for large sums because they were categorised as prints. This difficulty inspired him to adapt his technique to create collages as large as 'four by five feet' which he then 'colored and put them on a board' himself so 'that what was shown was the original' (Ibid.). Bearden's hand-coloured and mechanically reproduced versions simultaneously complicate the status of his artworks as original artifacts. He borrowed from techniques of documentary film-making and photography to create mixed-media collages which would challenge audience tendencies to define black art works as authentic expressions of black life.

'Although I am increasingly fascinated by the possibilities of empty space,' Bearden explained, in '"The Street" I was working for maximum multiplicity, without the surface fragmentation' (RBP N68–87, Bearden, Untitled, n.d.: 6). The version of this work that is reproduced in this book is of his full-colour original collage. Crowded with African American men, women and children at play, at work, in joy and in sorrow, The Street emphasises the 'maximum multiplicity' typical of his photomontage series. This work represents a claustrophobic urban-scape as Bearden interwove the anonymous faces, arms, hands and torsos of everyday black musicians with those of workers, children and animals. He constructed his individual figures from different photographic parts to suggest how African American identities have been fragmented, ruptured and split apart in white mainstream society. His close-ups of collaged faces and bodies distinguish between individuals in ways which were just not possible in Lewis's abstract figures. Bearden's experimentation with perspective and spatial arrangements which resisted 'surface fragmentation' was indebted to murals by Charles White and Aaron Douglas. In his works, he created non-hierarchical relationships between everyday black women, men and children, rich and poor, north and south. By juxtaposing his black figures with vertical and horizontal brick walls and sidewalks, he demonstrated the extent to which urban environments circumscribed free will. At the same time, the Brooklyn Bridge and the stone steps in the right-hand corner offer an escape route

by paralleling themes of ascent and progress also provided in works by Aaron Douglas and Loïs Mailou Jones. The blank surfaces of the walls, steps and sidewalks contrast with the angularity of his photographic bodies to provide visual 'intervals' and assist his viewers' interpretations of cross-sections of black community life.

On the right-hand side of *The Street*, Bearden positioned a farm worker next to a well-dressed northerner to symbolise north and south divides as well as class tensions. The overlapping figures of a man playing a guitar and a woman carrying a book dominate the lower middle foreground. They symbolise the intellectual and artistic realities of cultural survival through African American blues and jazz traditions as well as a formal education. The upraised arm of the female figure at the front of *The Street* formally responds to the other female figure's drooping arm to complicate representations of female struggle. Bearden constructed the enlarged face of the female figure in the immediate foreground from two photographic fragments. Her eyes are cut-outs taken from a different source to her face which he then coloured in brown tones to offset the dominant shades of black, white and grey. As Lee Stephens Glazer argues, in some of Bearden's work, the 'eyes are cut from images of a larger scale than those used for the rest of the face, resulting in an exchange of gazes that challenges the expected relationship between viewer and viewed' (Glazer, 1994: 423). By providing close-ups of two male and female faces in the right-hand corner of *The Street*, Bearden signified on the difficulties of ways of seeing. Their partially obscured vision, which he communicates in half-hidden sets of eyes, draws attention to the problems presented by fractured, distorted and limited perspectives and warns audiences against offering straightforward critiques of his work.

A close study of *The Street* further reveals the extent to which Bearden generated ambiguous emotional effects by drawing his viewers' attention to the 'absence of color' (in Ghent, 1968b: 23). Thus, he reinforced his black-and-white photographic representation of the central female figure's downcast expression and hunched angularity by including only a small amount of colour. Standing next to a musician similarly created from black, white and grey collaged fragments, he provides some hope for his central female figure by decorating her in a red scarf and positioning her underneath a blue window. These colours offset his otherwise dominant use of black, white and grey as well as his use of dark and light shades of brown to accentuate the skin tones of his female figure in the immediate foreground as well as the earthiness of street dirt and a wall. As Bearden

argued, these works represent an 'interplay between the photograph and the actual painting' given that, 'I constantly find myself adjusting my color to the gray of the photograph so that there won't be too much disparity in color between them' (Ibid.). At the same time, he admitted that, 'in spite of the fact that I have to restrict my color ... just using a few colors can give me quite a range' (Ibid.). As *The Street* shows, he interrupted his experimentation with greyed variations of black and white by including 'a few dissonant accents' in sharp breaks of colour (Ibid.). Bearden signified on jazz rhythms by replacing dissonant sounds with 'dissonant colors' to provide 'an entirely new significance and character to the other colors and forms' (*RBP* N68-87, Bearden, 'Untitled', n.d.: 7). In works such as *The Street*, he played as much with relationships between black, white and grey and colour as he did between the various painterly and photographic elements.

'Using the photographic image in painting which I have done is a kind of breaking of convention,' Bearden asserted (Bearden in Ghent, 1968b: 9). His photomontage series relies on photographic fragments and painterly surfaces to translate scenes of African American daily life through an aesthetic language designed to challenge that reality. He believed that, 'A photographic image when it's taken out of its original context and put in a different space than you saw it in the magazine can have another meaning entirely' (Ibid.: 23). Bearden's emphasis upon the ways in which interpretations are determined by competing contexts communicates his sense that knowledge is neither transcendental nor universal but relative and contingent. In collages such as *The Street*, he experimented with materials, composition and form to communicate that 'a work of art is not life itself' (Ibid.). By 'cultivating the artificiality,' he insisted, 'you make what you're doing seem more real' (Ibid.). In these collages, Bearden experimented with composition and colour to reproduce the unresolved conflicts that characterise everyday life. As he argued, art is 'artifice, or a creative undertaking, the primary function of which is to add dimension to our existing conception of reality' (*RBP* N68-87, Bearden, 'Untitled', n.d.: 8).

Ultimately, Bearden's *The Street* opened up a new space for African American histories and narratives by encouraging audiences to search out new perspectives and resist one-dimensional representations of black culture as provided in documentary photographs and films. His layering of photographic fragments and painterly surfaces combine with his manipulation of colour and spatial arrangements to support his aesthetic

practice whereby he encouraged his audiences to re-visualise black cultural life and re-see political, social and historical realities. Bearden played with the possibilities of collage in works such as *The Street* to accentuate the spaces, gaps and missing information and demonstrate the extent to which black histories and experiences have been elided or distorted within white mainstream visual culture.

Mecklenburg County, Railroad Shack Sporting House (1978)

'When I was old enough I found out what Liza's mother did for a living' (Bearden in Fine, 2003: 107). This textual caption accompanies Bearden's collage, *Mecklenburg County, Railroad Shack Sporting House*, which he produced in 1978 as part of *Profile/Part I, The Twenties*, his series inspired by his own early experiences. In these collages, he experimented with torn papers, ink, graphite and bleached areas as well as photographic fragments and paint. Bearden also revisited the aesthetic practices of Jacob Lawrence by adding captions to his works to create ambiguous relationships between text and image. *Mecklenburg County, Railroad Shack Sporting House* further attests to a controversial area of his aesthetic practice by drawing attention to his repeated representation of black female nudes in his work. In this collage, he displays two African American female nudes resting on dishevelled sheets in a threadbare 'railroad shack'. The brown colour of their bodies contrasts starkly with the white bed linen to display rather than detract from their nudity. Bearden suggests a problematic relationship between the black female nudes and the black-and-white portraits hanging on the interior walls in this collage.

Unlike the photographic close-up of the black female face represented in the top right of the work, both of Bearden's nudes are depicted in sexually available poses. He constructs the face of the black female figure on the left by relying on a photographic cut-out, while he portrays her body via a rich brown and yellow colour wash. Equally, the body of the black female figure on the right of this image is similarly on graphic display at the same time that her face is entirely concealed by the dress she is placing over her head. In an even more problematic sleight of hand, Bearden concealed the face of this woman and risked reducing her identity to a series of body parts. His caption for this image, 'When I was old enough I found out what Liza's mother did for a living', does little to thwart audience voyeurism by failing to prevent audience titillation and shocking audiences by highlighting the maternal status of a

female prostitute. As Judith Wilson argues, while Bearden was able to 'recuperate the nude black female body' in his works, he still betrayed a tendency towards 'voyeurism' in the 'romanticising of sex work, reliance upon dualistic stereotypes, and naturalization of female nudity' popular within pornography (Wilson, 1992: 118).

However, Bearden's visual practice of revelation and concealment, absence and presence, telling and withholding may offer a way to defend his aesthetic practice. It is possible to argue that he may have resisted his audiences' tendencies towards titillation and black female consumption by keeping his caption ambiguous and not showing the face of one of his female figures. As an interview between Bearden and Avis Berman shows, it was the female body which further inspired the development of his aesthetic sensibility. He told Berman how a 'poor woman' who was a 'prostitute' asked him, '"Why don't you paint me?"' when he was stuck for a subject (in Berman, 1980: 12). She told him, '[W]hen you can look in me and find out what is beautiful there, then you'll be able to put something on that brown paper of yours' (Ibid.). Bearden's confession that it was 'just that basic thing that really got me started thinking' makes it unlikely that his representation of black female nudes in this work was either unself-consciousness or intent upon objectification (Ibid.). The omission of the black female nude in black art remains a fraught area and has prompted outpourings of works by black female artists such as Elizabeth Catlett, Renée Cox, Lorna Simpson, Emma Amos and Adrian Piper. Their experimental practices counter problematic representations in works by African American male artists as well as the white American mainstream.

'An initial reaction to my work has generally been one of shock,' Bearden admitted (*RBP* N68–87, Bearden, 'Untitled', n.d.: 8). Throughout his lifetime, he faced criticism from black audiences who felt that his '"stuff was forced and deliberately painted to cater to what the critics think a Negro should paint like"', as he '"portrayed a type of Negro that they were trying to get away from"' (in Schwartzman, 1990: 121). Insisting that 'painting is an act of discovery', Bearden cut photographs out of magazines to create collages and photomontages which would represent an eclectic mix of black subjects who were neither monumentalised nor heroic but individual and everyday (in Ghent, 1968b: 7). Moreover, his fight to prevent the 'Negro from becoming too much of an abstraction' was partly indebted to advice which he received from Aaron Douglas. '"Remember, Romare",' Douglas cautioned, '"the

artist's technique no matter how brilliant it is, should never obscure his vision"' (*URBP*, Bearden, 'Farwell to Aaron Douglas', 1979: 165). He was also praised by Hale Woodruff for whom the 'true reality' of the 'folk' portrayed in Bearden's canvases emerged from the 'roles and the appearances they assume as they are transformed, through Bearden's art, into "art-life" imagery of "art-life" expression' (*URBP*, Hale Woodruff, 'Romare Bearden', 1976: n.p.). Given Bearden's insistence that 'art is not life', Woodruff's description of his 'art life expression' attests to this artist's ultimate preoccupation with representing themes related to African American experiences.

Romare Bearden was not only an exceptional artist but also one of the most accomplished scholars of black art. Co-authored with Harry Henderson, his volume, *A History of African-American Artists: from 1792 to the Present*, appeared in 1993. In this study, he explained that he was 'trying to write the history of the black artists in this country in a way that will be understandable to people without a long analysis' (in Ghent, 1968b: 21). Over ten years on and the analysis, knowledge and scope of this critical history of African American artists remain unchallenged. As an artist, Bearden experimented with collage to suggest how art 'serves to knit differences of race, language, and nationality into a rewarding intellectual and moral experience' (*URBP*, Bearden, 'Hofstra', 1982: 4). Romare Bearden's experimentation with stereotypes and emphasis upon photographic fragments has since experienced a renaissance in Betye Saar's installations and assemblages.

Betye Saar (b.1926)

'[T]hat slave ship imprint is on all of us'

'I'm looking for a visual language. I recycle ideas, emotions and elements' (Saar in Hewitt, 1992: 20). Betye Saar is the first mixed-media assemblage and installation artist to be examined in this book. Still working and exhibiting today, she remains as preoccupied as Norman Lewis and Romare Bearden with transforming black histories and narratives into an 'intense aesthetic statement' (*RBP* N68–87, Bearden, 'Untitled', n.d.: 5). Saar works primarily with found objects to create assemblages and installations equally inspired by Native, Hispanic and African American traditions. These works are influenced by her own 'ancestral history' which she describes as 'just made up' because 'my family is really mixed and integrated' (in Mason, 1996: 136). Bearden's aesthetic practices have found new life in Saar's recycled objects and materials from which

she creates three-dimensional works which invite a call and response relationship between artist and viewer. Beginning by 'using ordinary objects, objects that maybe come from technology, and integrating them with organic materials', she is one of the first artists in this book to construct 'ritual spaces' (in Hewitt, 1992: 8). 'I've always been intrigued by looking for something that somebody had left', Saar has explained (in Mason, 1996: 37-38).

Generally speaking, Saar's assemblages revisit myth, memory, history, folklore and autobiography to investigate issues surrounding slavery and stereotyping. More specifically, works by Betye Saar take us back to representations of slavery in drawings and paintings by Bill Traylor, Aaron Douglas and Joe Overstreet discussed at the start of this book. As recently as 1992, in an installation titled *500 Years: With the Breath of Our Ancestors*, Saar described how she painted 'a slave ship diagram ... in silver on the floor' to prove 'it would never wear out, because that slave ship imprint is on all of us' (in Hewitt, 1992: 19). With the exception of David Hammons, Betye Saar is the only artist in this book to have emerged from a Californian tradition of art production. As Jane Carpenter argues, her works betray 'multiple elements borrowed from the California milieu, including assemblage art, Latino altar building, pop, funk, feminism, and iconographies abounding in personal narrative' (Carpenter, 2003: 26). As a result, Saar's works are best understood alongside other African American artists such as Noah Purifoy who have been working on the West Coast during the same period.

By focusing upon Saar's participation in the 1960s Black Arts Movement, Kellie Jones suggests how she was inspired by these artists' examination of 'black heroes' in works which not only provided celebratory 'affirmations of cultural identity' but also established 'links with the African past' (Jones, 2005b: 30). In this respect, Saar has been even more influenced by African art than Hale Woodruff, Norman Lewis or Romare Bearden. A case in point concerns how her 'work changed' as a result of a 'new black awareness' following a visit to the Museum of Natural History in Chicago (in Mason, 1996: 118). She and David Hammons 'saw lots and lots of African art, Oceanic art, and Egyptian art' which inspired her to produce many 'ritual pieces' or 'mojos' (in Mason, 1996: 117, 118). She proclaimed, '"I want to make contemporary, powerful, ritualistic art"' (Ibid.: 118, 136). As Saar told Karen Anne Mason, both she and Hammons were deeply affected by the 'robe of an African chief' which was made from patterned fabric and 'composed of

a little bit of hair that was made into a hairball and sewn to this cloak' (Ibid.: 118). 'It was so powerful,' she admitted, 'because not only was it a rough fabric and beautiful to look at, but it had a little bit of everybody on it' (Ibid.: 118-19). Saar's assemblages and installations communicate her preference for artworks which have been constructed from the visceral matter of black bodies to underscore community involvement in art production. As she explains, it was 'what the elements were and how they were combined, that made it have a sense of power' (Ibid.: 136). By straining against specificities of race, gender and national identity, Saar's works appeal to different cultural contexts and historical periods. She describes how she tried to 'capture' a 'feeling of ancient history, but without being pinpointed to any particular place or time or era' (Ibid.: 23).

James Christen Steward's comment that 'many of the motifs of Betye's work ... are written about with surprising superficiality' represents a by now familiar pattern in African American visual arts criticism (Steward, 2005: 12). However, there are a number of critics who succeed in getting to grips with the complexities of Saar's aesthetic practice. For example, Jones identifies Saar as the 'first' African American artist 'to integrate actual historical objects ... into her pieces' (Jones, 2005b: 28). Similarly, Deborah Willis interprets the torn photographs of her assemblages as 'reminiscent of Romare Bearden's photomontages produced in the 1960s' (Willis, 2005: 20). Meanwhile, Steward himself identifies 'the photographic fragment' as having the 'power to dispel stereotypes, unravel personal histories, and signify the spiritual potency of the past' in Saar's works (Ibid.). Jane Carpenter goes even further by examining Saar's construction of 'assemblages that became containers in which objects, symbols, stereotypes, "blackness", the self, and society could be transformed at will though hybridization' (Carpenter, 2003: 33). This description of Saar's practices draws attention to her eclectic influences and preferred definition of art as ritual and a source of spiritual redemption.

Betye Saar herself describes some of her works as 'mojos' a 'term referring to a magical amulet or charm that either works magic or heals' (in Mason, 1996: 138). By emphasising Saar's role as a 'visual storyteller', Carpenter discusses the ways in which her works are 'filled with satire and humor but are deadly serious in their indictments of mainstream society' (Ibid.: 98, 28). For David Driskell, Saar remains 'a firm believer in self-empowerment, dignity of one's subject, and the power of revisionist imagery' (in Carpenter, 2003: v). His conviction that she

'creates, reclaims, and proclaims a new aesthetic in American art' is in tune with her determination to find a 'new visual language' in her work which reflects the practices of Norman Lewis and Romare Bearden as well as other artists working within an African American art tradition (Ibid.: ix). For Lucy Lippard, Saar's aesthetic 'process is a ritual itself' (Lippard, 1990: 11). Lippard's investigation of her work is guided by the artist's own discussion of the stages of her aesthetic practice as involving '"[t]he imprint – ideas, thought, memories, dreams ... [t]he search – the selective eye and intuition ... [t]The recycling and transformation – the materials and objects are manipulated ... [and t]he release – the work is shared ... The 'ritual' is completed"' (Ibid.). These four key areas reinforce Saar's determination to create mixed-media art forms which revisit found objects to produce ritualistic, interactive art pieces inspired by their everyday use in the community. In this chapter, I discuss *Sambo's Banjo* (1971) and *Sunnyland (On the Dark Side)* (1998, see Plate 13) to examine Saar's aesthetic technique and resistance to black caricatures proliferating within white mainstream culture as well as within works by emerging African American artists.

Sambo's Banjo (1971–2)

'I felt that entertainment was also a way that black people survived,' Betye Saar admits (in Mason, 1996: 125). Moving beyond one dimen- sional collages and paintings, she created large-scale assemblages and installations which take to task the epic representations of black survival and heroism in works produced by earlier African American artists. By signifying upon the demeaning stereotypes of African American men, women and children as invented in plantation mythology and Recon- struction fantasies, she has influenced a new generation of artists. As Saar admits, 'I began to recycle and transform Sambos, Toms and Mammies in my assemblages' (Saar, 1999: 3). 'I started doing assemblage pieces using derogatory images' because it 'became important for me to use an Aunt Jemima figure and turn her around to be a hero, a heroine, because I felt that that was one way that African Americans survived' (in Mason, 1996: 120–1). For Saar, these images expanded concepts of black heroism by showing that 'there are lots of ways to survive' (Ibid.: 121). This was particularly important in an era of 'black revolution and the death of Martin Luther King' as these images became 'a way to express anger; to start my own revolution with my materials and my symbols' (in Hewitt, 1992: 20). Saar's numerous works signifying on black stereotypes include

The Liberation of Aunt Jemima (1972), *Sambo's Banjo* (1971–2), *Let Me Entertain You* (1972), *Black Crows in the White Section Only* (1972), *De Ol' Folks At Home* (1972) and *Imitation of Life* (1975). From the late 1960s, she began collecting '[s]heet music and postcards and sculpture, little statuary pieces', now identified as 'black collectibles', to lend historical force to her works (in Mason, 1996: 122; Saar, 1999: 3). As Lisa Farrington argues, Saar 'chose to deconstruct these mementoes of Jim Crow, both literally and figuratively' by relying on 'real and figurative layers of symbolism' (Farrington, 2005: 164).

'I felt myself as a recycler,' Betye Saar has explained, 'not only of the material and the information, but of how to look at those images and not look at them in a derogatory way or a way to be ashamed – that we could look at them as heroes and heroines' (in Mason, 1996: 122). Saar's mixed-media assemblage, *Sambo's Banjo* (1971–2), consists of an upright, open battered banjo case in which she inserts a small dancing figure. The enlarged eyes and exaggerated smile of this cartoonish black man combine with his red spotted bow tie, green-and-black checked waistcoat and yellow-and-black striped trousers to suggest the Sambo stereotype of the happy, singing 'darky' of nineteenth-century blackface minstrelsy. A tradition which began in the nineteenth century, blackface minstrelsy required whites and African Americans to 'black up' in order to perform as African Americans for white entertainment. These comical caricatures of blackness reinforced white supremacist thought by suggesting that, while whiteness remained inimitable, African American identities could be performed, imitated and faked. In *Sambo's Banjo*, Saar inserts the body of the minstrel performer where the musical instrument should be to protest against black objectification and commodification in white mainstream culture.

In the neck of the banjo case, Saar contrasts her representation of a minstrel performer by juxtaposing a charred, black skeleton with a noose around its neck with a photograph of a lynched black man surrounded by white spectators. Her decision to colour the trousers of the lynched victim a garish purple resonates with the brightly coloured clothing of her minstrel figure. These similarities suggest that it was the same racist thought exalting in the Sambo stereotype of the happy slave playing the banjo which led to racist persecution and the hanging of lynched black bodies as alternative spectacles for white entertainment. In this work, Saar also includes a nineteenth-century drawing of a banjo-playing, dancing 'Jim Crow' on to which she added a rifle as long as his body in

the top of the banjo case. This weapon operates in the same way as the gun Saar gives her mammy in *The Liberation of Aunt Jemima* (1972) to suggest that a militant liberator is always concealed within black performances of servility and passivity. In *Sambo's Banjo*, Saar adds a replica slice of melon to critique plantation myths of happy, dancing, melon-eating slaves. In this assemblage, she presents artefacts within artefacts in the same way that Bearden created collages by relying on fragments of photographs to create unexpected juxtapositions and heighten audience awareness concerning the artificiality of caricatured images. By providing competing representations of black masculinity across a range of media, Saar evokes cartoons, advertisements and photographs to celebrate African Americans' resistance through death, dance and disguise. *Sambo's Banjo* reveals how African Americans were forced to play the role of the minstrel to inhabit derogatory stereotypes or otherwise submit to ritual killing. Many of Saar's works demonstrate her view that it was '"about evolving the consciousness in another way and seeing black people as human beings instead of the caricatures or the derogatory images"' (in Steward, 2005: 9).

Sunnyland (On the Dark Side) (1998, Plate 13)

'My concerns are the struggle of memory against the attraction of forgetting,' Saar insists. 'The washboard, a simple domestic tool has become my format. For years, I have collected vintage washboards and to me, they symbolize hard labor' (Saar, 1999: 3). 'By recycling them,' she contends, 'I am honoring the memory of that labor and the working woman upon whose shoulders we now stand' (Ibid.). In the late 1990s, Saar criticised the 'current trend' towards the 'reinvention of the negative black stereotypical images' among black artists (Ibid.). Speaking of artists such as Kara Walker, she argued that this revival represented 'a surfacing of the subconscious plantation mentality and a form of controlling black art' (Ibid.). Saar's series *Workers and Warriors: The Return of Aunt Jemima* was exhibited between 1998 and 1999 and includes her assemblage, *Sunnyland (On the Dark Side)* (1998, see Plate 13). Campaigning against the revival of racist iconography, she constructed this piece from a 'vintage washboard' to signify upon a history within which black female bodies had been enslaved, victimised and abused. Saar superimposed the photograph of a lynched black man in blue clothing on to the corrugated metal surface of the washboard. As we look more closely, we can see that he is surrounded by other lynched black bodies also hanging from trees

in an otherwise idyllic woodland scene. This horrifying image shows the tied hands of a man whose his head is obscured by a noose and hangs broken over his chest. Saar includes a small-scale United States flag and the words 'STRANGE FRUIT' immediately above this figure to indict white racism. By positioning the US flag between the handwritten text 'STRANGE FRUIT' and the typed text 'SUNNYLAND' which curves around the semicircle of a red sun, she exposes national ironies of inclusion and exclusion. She inserts the phrase '(on the dark side)' beneath the photograph of a lynched victim to draw attention to the graphic realities of the south which are far from the 'SUNNYLAND' of racist mythology.

In *Sunnyland (On the Dark Side)*, Saar further contrasts representations of violated black masculinity with those of black female strength by including a domestic worker hunched over a wash tub on the top of this washboard. She constructs her unknown and unnamed female labourer from moving wooden parts and levers that are attached to a handle which viewers are invited to turn as they enact the horrific history of black women who have been at the mercy of others. By creating a female worker from moving parts, Saar raises questions surrounding a rarely discussed aspect of her works concerning the ways in which she implicates her audiences by inviting them to open boxes, lift doors and turn handles. Saar's decision to create interactive installations dignifies black female survival in the face of a loss of agency. Audiences may turn the handle to make this black woman work but, in so doing, they are forced to critique their own assumptions of power by realising that she does their bidding only in the interests of personal survival. The bent-over faceless figure of the black female labourer contrasts with the hanging bodies of lynched black males to suggest that black female and male heroism takes infinite forms. Both *Sunnyland (On the Dark Side)* and *Sambo's Banjo* reinforce Saar's view of herself as a '"griotte"' which she defined as '"an African word meaning the historian, storyteller"' (in Steward, 2005: 13). This is not the first time that the term 'griotte', also spelled 'griot', has appeared as it has been used to describe other artists throughout this book. Saar's mixed-media assemblages share Archibald J. Motley, Jr's view that 'every picture tells a story' by arguing that 'pieces tell a story or fragments of a story' (in Shepherd, 1990: 49).

'"There's power in changing uses of a material",' Betye Saar argues, '"another kind of energy that is released. I am attracted to things because they have multiple meanings"' (in Lippard, 1990: 11). By emphasising

change, energy and 'multiple meanings', Saar's works have much
in common with the self-reflexive practices of Romare Bearden and
Norman Lewis. Her description of the ways in which she constructs '"an
alternative reality by integrating the photo with other media, materials,
and objects"' in a '"piecing together of forgotten lives"' resonates partic-
ularly with Bearden's collages (in Steward, 2005: 9). In 1992, Betye Saar
accompanied her exhibition *500 Years: With the Breath of Our Ancestors*
with a poem titled 'Diaspora', part of which reads:

> and some crawl deep in to the belly of
> a slave ship.
> In search of the unknown,
> my spirits pass through the Spirit Door,
> Seek the dark corner of the Ancestral Chair,
> Breathe on the embers of Africa and
> Recall the Memory of Fire
>
> <div align="right">(in Hewitt, 1992: 18–19)</div>

By evoking Africa, ancestry, music, slavery, history, memory and death,
her poem summaries many of the themes present in works by Bearden
and Lewis. Given their emphasis upon fragmentation, loss, struggle and
the unknown, perhaps it is possible to read Lewis's canvases, Bearden's
collages and Saar's installations as being concerned as much with death
as with life in their protest against a history of slavery and violence.
Their experimental practices draw attention to the rough edges of
memory and experience to highlight suffering and struggle in African
American public and private histories. As Betye Saar laments, '"Every-
thing revolves around death"' (in Lippard, 1990: 16).

Conclusion: *Measuring Measuring*

'I don't use the full figure' (Betye Saar in Mason, 1996: 160). Paintings,
collages and assemblages by Norman Lewis, Romare Bearden and Betye
Saar interrogate representations of the black body as portrayed in African
American and white mainstream art and society. While Lewis relied on
painterly abstraction to create diminutive, unreadable, figures, Bearden
created angular, disjointed bodies made from photographic cut-outs.
Betye Saar similarly fragments black bodies in her works by rarely
including the 'full figure' and instead relying on 'things that represent
the figure, like the hand or an eye or lips or the head, parts of the body'
(Ibid.). The determination of these artists not to reproduce the realistic

portraits of Archibald J. Motley, Jr, the dignified drawings of Charles White or the monumental sculpture of Elizabeth Catlett was symptomatic of an emerging post-1960s trend in African American art. Bearden, Lewis and Saar are the frontrunners in a new generation of artists who prefer to fragment and deconstruct black anatomies in their works. All three artists cultivate uncertainty in their viewers to show how black bodies have been fabricated, fictionalised and reinvented to suit white racist caricatures on the one hand and black monumental iconography on the other. They emphasise disintegration to produce non-naturalistic black bodies which confirm the impossibility for any visual language, however seemingly realistic or accurate, to capture black physicality objectively.

As one of the youngest original members of Spiral, a black arts organisation founded in the 1960s, Emma Amos creates mixed-media collages to interrogate representations of African American bodies in fine art and popular culture. In works such as *Measuring Measuring* (1995) she relies on acrylic, fabric and photographic fragments to deconstruct myths of classical beauty in the human figure. This collage contrasts abstract painterly surfaces of red, black, green and yellow which have been executed in vigorous brushstrokes with black-and-white photographic reproductions of a naked and headless black female torso, a black female figure whose calves are hand-drawn and a classical statue of a naked white man whose arms and feet are missing. Amos unevenly distributes fragments of measuring tape over the surface of the canvas to show the ways in which black female bodies have been dissected, measured and owned. In this light, her mutilation of classic white male physicality enacts black female vengeance on histories of appropriation and objectification. She communicates this theme powerfully in the body of the central black female figure who is only partially clothed as she stands before a half-revealed page of text. Typed on brown paper, some of the visible phrases read, 'male body in action at gymnasiums', 'sculptors had' and 'observe its proportions', to suggest that this page has been ripped from a volume of art history and to reinforce her critique of mainstream art traditions. In *Measuring Measuring*, Amos exposes the ways in which Western-dominated art worlds appropriate and objectify black female body parts. Her play with silhouetted and cut-out bodies not only reflects the aesthetic practices of Bearden, Saar and Lewis but also pre-empts the experimental works of David Hammons, Howardena Pindell, and Kara Walker which I will discuss in the concluding chapter.

Nowhere is Hale Woodruff's belief that the black artist has shown a '"concern with the broader problems of art itself"' more clear than in the works of Norman Lewis, Romare Bearden and Betye Saar (in Clothier, 1980: 138). Their canvases, collages and assemblages support Woodruff's view that it is impossible to identify 'a single thread which serves either as a racial or esthetic bond to link these works' (Woodruff, 1966: n.p.). He defended the 'eclecticism' of the African American visual arts tradition which reveals an 'intensity of spirit, profundity of the senses, and a vitality of statement' (Ibid.). The multimedia and hybrid aesthetic forms of Lewis, Bearden and Saar confirm the determination of African American artists to adapt mainstream techniques, forms and subjects to suit their own aesthetic agenda. Their works fulfil Woodruff's hope that the black artist will establish an alternative 'aesthetic groundwork' (in Murray, 1979: 76). They shared the determination of earlier artists such as Charles White, Elizabeth Catlett and Gordon Parks to 'contribute to the aesthetic development' of black audiences by creating self-consciously abstract, non-didactic and ambiguous collages, installations and paintings. As Norman Lewis argued, 'Painting isn't difficult, the difficulties are the ideas one tries to interpret in paint' (Lewis, 1946: 64).

An investigation of works by Bearden, Lewis and Saar establishes their belief that, while art can influence individual emotions, it is unable to change political realities. 'If you look at one of my paintings,' Romare Bearden asserted, 'it does not tell you to go out and vote, but it does tell you about the eternal verities of life' (in Rowell, 1988: 432). 'When that period comes around in America where black women and black men cease to be hustled, harassed, raped,' Norman Lewis insisted, 'it won't be because of an aesthetic, but just the fact that they belong to the human race' (in Browne, 1974: 87). Romare Bearden, Norman Lewis and Betye Saar's search for a new visual language has recently been taken to task by the street artists, performers and installation artists, David Hammons, Howardena Pindell and Kara Walker.

'Racist Pathology is the Muck': Towards a Transgressive Visual Poetics

David Hammons – Howardena Pindell – Kara Walker

> As long as I blame myself,
> Of course, I will
> suffer your blows –
> like a true masochist –
> directing her
> tormentor – to
> just the right spot –
> where history hurts, ropes burn, limbs
> separate from body
>
> (Kara Walker in Berry, 2003: 169)

The Middle Passage – this phrase takes us back to the first chapter of this book by evoking the trauma of Africans on their journey to the Americas during the transatlantic slave trade. However, unlike Joe Overstreet's abstract canvases inspired by African doors, in 1997, contemporary artist, Kara Walker, shocked her audiences by stripping this phrase of its epic history. Her stark black-and-white work, *Middle Passage* (1997), replaces Overstreet's colliding colours and evocative textures with a half-naked black girl. Bent double under a black sack of cotton, the white balls cascade over her head as a white boy stands behind her. Adopting an irreverent style, Walker complicates what would otherwise be a harrowing yet dignified image by showing the white boy's penetration of the black girl with the prow of a toy slave ship. Her pornographic imagery not only protests against but plays with racist myths of the black girl as a receptacle for white male fantasy and a source of physical labour. *Middle Passage* subverts the history of slavery

represented in the sculpture, murals, portraits, history paintings, collages and assemblages of artists in this book so far. Walker's representation of the ecstasies as well as the horrors of physical and psychological pain, sexual abuse and suffering in this and other works is groundbreaking. Gone are the abstract, dignified, monumental, iconic and public representations of suffering black families, heroic exemplars and martyred victims. Instead, Walker's installations, prints and drawings have much more in common with works by contemporary African American artists which rely similarly on satire, irony, caricature and bathos. Many recent mixed-media, installation and performance artists provide a cacophony of body parts in torn limbs, exposed orifices and escaping bodily fluids to show the holes, omissions and gaps within African American art and white mainstream culture.

The black women, men and children of Kara Walker's installations are hardly the heroic freedom-fighters which traditionally appear in African American murals, paintings and sculptures. Instead, they succumb to suffering by directing their oppressors to 'just the right spot – /where history hurts, ropes burn, limbs /separate from body'. As Walker's confession, 'As long as I blame myself', which appears in one of her many recent text cards, shows, she introduces taboo topics of voyeurism and sado-masochistic relationships during slavery in her work. The fact that this original text card has a line running through her confession further complicates the meaning of her text by crossing it out and making it difficult to read. In choosing to accentuate words by half-erasing them, Walker borrows from the earlier experimental practices of African Haitian artist, Jean-Michel Basquiat. He explained, '"I cross out words so you will see them more"', adding that '"the fact that they are obscured makes you want to read them"' (in Thompson, 1992: 32). Expressionist canvases and shocking installations by Walker and Basquiat draw attention to slippery relationships between revelation and concealment, visibility and invisibility, and presence and absence. They subvert, trick and play with audience expectations to challenge tendencies towards objectifying black female and male bodies. Furthermore, they take the juxtaposition of text and image of earlier artists even further to invert power dynamics and foreground the relationship between black bodies and erasure. 'Invisibility /can be a form of power,' Walker admits, although she is careful to stipulate that 'this doesn't play well in an art insitution [sic] /which is all about vision, seeing, looking' (in Berry, 2003: n.p.).

Blood. Dirt. Hair. Excrement. Skin. David Hammons, Howardena Pindell and Kara Walker shock, horrify, sicken and provoke audiences and critics in their installations, videos, body prints and canvases as they search for what Hammons has described as '"a new *fucking* vocabulary that I'm not used to, that frightens me to deal with"' (in Storr, 1994: 53, his emphasis). 'Confronting the viewer with the contradictory desires and interpretations that s/he cannot bear to acknowledge,' Walker insists, 'my work reveals images that I too am shocked to encounter in the dark alleys of my imagination. You may be seduced, you may be outraged. Therein lay the unspeakable trappings of our visual codes' (Walker, 1998: 49). In this concluding chapter, I examine the body prints of David Hammons, the mixed-media collages of Howardena Pindell and the black-and-white silhouette installations of Kara Walker to discuss recent developments in African American art and show how post-1970s black artists continue to unleash the 'dark alleys' of their imagination to speak the 'unspeakable trappings of our visual codes'.

Disturbing, upsetting and often X-rated, their canvases, street art performances, videos and installations challenge audience expectations concerning the content and forms of black art, at the same time that they resist a teleology of cathartic uplift in the African American visual arts tradition. David Hammons, for example, creates works with an expiry date to resist mainstream commodification by revealing the '"bowels, the grotesqueness"' of black life at the same time that he celebrates the fact that '"every culture has a side it's embarrassed by"' (in Rothschild, 1994: 45). For sheer playfulness, his installations which he constructs from the debris of material culture could not be further from the digni-fied murals of Aaron Douglas and Charles White, the evocative photog-raphy of Gordon Parks and Roy DeCarava and the textured war scenes and history paintings of Horace Pippin and Jacob Lawrence. However, while they may not communicate a teleology of uplift, a closer examina-tion soon shows that Hammons is just as determined to portray the reali-ties of dispossessed and poverty-stricken African American lives.

For contemporary collage and performance artist, Howardena Pindell, the history of black female violation in the United States and the African Diaspora becomes far more visceral than the inspirational images of black motherhood and labour displayed in the sculptures and assem-blages of Elizabeth Catlett and Betye Saar. Pindell drenches her split-apart, hand-sewn canvases in her own blood to examine public histories of loss, mutilation, violence and abuse. In contrast to Hammons and

Pindell, Kara Walker includes neither her own hair nor her own blood but instead revives the eighteenth-century tradition of silhouette portraiture. She replaces the genteel portraits of white artists with shocking, anarchic, pornographic, caricatured and uncensored sexual-scapes of colliding black and white bodies during plantation slavery. All three artists adopt experimental practices to open up new spaces within which to discuss issues surrounding identity, invisibility, loss and nihilism in representations of the black body. At the same time as they are intent on mapping new territory for African American art and artists, they are also concerned with revisiting familiar ground. In their works, they repeatedly testify to Gen Doy's view that, 'Black artists and theorists have been more reluctant than their white counterparts to abandon notions of history, truth, reality and conscious subjectivity' (Doy, 2000: 2).

David Hammons, Howardena Pindell and Kara Walker are part of a new generation of artists which may not feel as compelled to dignify, aggrandise and monumentalise black culture as those of an earlier era but who are still determined to signify upon theories of 'history, truth, reality and conscious subjectivity'. They echo Hale Woodruff's confession of a compulsive need to return to the 'so-called black image', by admitting, as Hammons suggests, that they still feel they have to '"get"' their '"message out"' (in Rothschild, 1994: 51). Thus, while their relationship with earlier black artists such as Charles White, Aaron Douglas, Elizabeth Catlett and Betye Saar may be complicated and fraught, their works testify to many continuities as well as divergences within a vital African American art tradition. Hammons expresses it best when he admits, '"Without them, I wouldn't be making art, but at the same time I can't afford to make art their way"' (in Powell, 2005: 134). As three conflicting and contrasting artists, Hammons, Pindell and Walker communicate their 'new *fucking* vocabulary' via an aesthetics of urban debris, human detritus, body parts and taboo imagery. Their works glorify in African American histories, narratives and bodies which have otherwise been violated, split apart and erased out of white mainstream history or cleaned up, monumentalised and exalted by African American artists.

David Hammons (b.1943)

'I am an art gangster'

'"I try to dazzle you with brilliance and bullshit",' David Hammons admits. '"What I try to do is talk in confusions so when I leave here nothing was really said. It all comes back to nothingness"' (in Rothschild,

1994: 46). In his installations, paintings, sculptures and performance art, Hammons plays the role of the trickster to debunk, demythologise and subvert tendencies within African American art towards grand narratives of heroic uplift. He creates works which 'talk in confusions' to 'make fun of life' and 'of myself, of you, of us and just give some humor' (Ibid.: 52). Hammons's fearless experimentation with parody, satire and the grotesque should alert us to the ambiguities, paradoxes and unresolved tensions of his signifying practice. Although he remains influenced by earlier artists such as Betye Saar and Charles White, Hammons's works are best understood in relation to recent developments in African American art. He shares the scepticism of installation and performance artists, Fred Wilson and Adrian Piper, who virulently oppose white mainstream art world and traditional gallery spaces. As Hammons and many African American artists argue, white galleries resemble a 'psychiatric ward' (Ibid.: 30). He explains that they are 'not the way [his] culture perceives the world' because 'everything is out of context' (Ibid.).

For this reason, David Hammons insists, 'I can't stand art' (Hammons, 'Interview', n.d.: n.p.). As a counter strategy, he defies art-world capitalism by creating works with a short shelf life to guarantee that '[t]here's no "I bought him"', as '[n]o one can say, "I've got a David Hammons on my wall"' (in Rothschild, 1994: 51). His installations and assemblages are made from the debris of everyday life including human hair, dirt, grease, chicken wings, chains, spades, wire, coal, ice, basketball hoops, elephant excrement, empty alcohol bottles and discarded paper bags. By creating art from throwaway or industrial materials stereotypically associated with African American and African culture, Hammons not only thwarts the demands of white collectors who '"won't buy"' works made from '"old dirty bags, grease, bones, hair"' but also encourages black artists to create art which is '"about us"' and '"about me"' and which '"isn't negative"' (in Zabunyan, 2005: 143). Speaking of his hair sculptures specifically, Hammons admits, '"Those pieces were all about making sure that the black viewer had a reflection of himself in the world"', given that '"[b]lack hair was the only thing then that was not of the oppressor's culture"' (in Finkelpearl, 1991: 84; in Neri, 1994: 68). Consisting of large, irregularly shaped stones on to which he glued particles of human hair, these sculptures are literally faceless as they critique the erasure of black identities in white mainstream galleries.

For Hammons, '"There's nothing negative about our images, it all depends on who is seeing it and we've been depending on someone else's

sight"' (in Zabunyan, 2005: 143). By attaching value to seemingly value-less objects, he politicises the racialised subjectivity of a white normative gaze. Hammons's work addresses the historical reality within which '"[w] e've always been called 'Uncle Tom' or 'buffoons' and we've been repre-sented tap-dancing while smiling like idiots. But to have a severe smile, a sinister grin, to tap-dance implacably, I've never seen that"' (Ibid.: 165). By describing himself as '"an art gangster"' and an '"unpaid ambassador for the African American community"', he communicates both a playful subversiveness and a determination to create a politically self-conscious and socially relevant art (in Rothschild, 1994: 51; in Zabunyan, 2005: 165). Thus, while Hammons admires '"people who have a vision that has nothing to do with presentation in a gallery"', he admits, '"I'm not free enough yet. I still feel I have to get my message out"' (in Rothschild, 1994: 51). Ultimately, his determination 'to get [his] message out' proves that, however much they differ aesthetically and thematically from artists working in the early period and in different forms, recent African American artists continue to protest against racist contexts within which black culture, histories and identities have been neglected, caricatured and distorted. In his installations and performance art, Hammons states, the '"things that I see socially – the social conditions of racism – come out like a sweat"' (Ibid.: 141).

'I do my street art mainly to keep rooted in that "What I am",' Hammons asserts (Hammons, n.d.: n.p.). He rejects the typical '"art audience"' which he describes as the '"worst audience in the world"' because it is '"overly educated, it's conservative, it's out to criticize not to understand, and it never has any fun"' (Zabunyan, 2005: 147–8). '"I'll play with the street audience",' Hammons explains, on the grounds that this '"audience is much more human and their opinion is from the heart"' (Ibid.: 148). Admitting that he '"spend[s] 85 percent of [his] time on the streets"', he goes on foraging expeditions for materials and regularly gives performances outside (Ibid.: 141). He exhibits his work on the streets '"just to get the feedback"' and to reach the dispossessed and homeless women and men who rarely set foot in an art gallery (in Storr, 1994: 59). One of the most controversial of Hammons's pieces is a billboard which critiqued stereotypes by portraying a blond-haired and blue-eyed Jesse Jackson on to which he sprayed, *'How Ya Like Me Now?'* (1988). This work was short-lived as 'young Black people damaged it with clubs' (Zabunyan, 2005: 159). At the suggestion of Jesse Jackson, the mangled board was subsequently exhibited in an art gallery with 'a

dozen clubs placed vertically, an American flag and the press cutting of Jackson's remark' which reads, '"It's not the picture that's the insult ... It's the reality behind the picture – that's the insult"' (Ibid.: 160, 159). By exhibiting one of his artworks, which had already been damaged by black protesters, in a traditional gallery space, Hammons contested the seeming detachment and ideological neutrality of the mainstream art world whose racist dynamics remain hidden rather than non-existent.

Hammons satirises the commodification of African American art in other performance pieces by selling different-sized snowballs in his *Bliz-aard Ball Sale* (1983) and exalting in folk art by erecting houses such as *Delta Spirit* (1985) which draw on centuries-old traditions of African American vernacular architecture. He also caused a stir by carrying a cotton bale through Harlem which provoked '[u]nbelievable stories' as black people said, '"I don't ever want to see that stuff again"' (in Storr, 1994: 59). Unperturbed, Hammons continues to decorate inner-city trees with the empty alcohol bottles of homeless men and women. He admires these objects for their ritual significance as touchstones of veneration. '"Ju-Ju pieces, Voodoo things. Black lips have touched each of these bottles",' he claims (in Ahearn, 1991: 25). These works were inspired by Robert Farris Thompson's research into the 'Kongo-derived tradition of *bottle trees* ... for protecting the household through invocation of the dead' (Thompson, 1984: 142). By evoking African spiritual practices, Hammons draws attention to an African legacy, oral traditions, memory and rituals of commemoration. As he states, '"Ritual is an action word"' (in Jones, 2005a:144).

Hammons's billboard, cotton bales, snowballs and bottle trees are just a few of his street art installations which demonstrate his commitment to an art which unsettles, provokes and often upsets both his black and his white audiences. In comparison with Romare Bearden's collages which rely on photomontage to represent black life on the streets, Hammons creates his visceral works from the dirt, debris and detritus of urban culture itself. His installations reinforce his love of 'doing stuff on the street' because the 'art becomes just one of the objects that's in the path of your everyday existence' (Hammons, n.d.: n.p.). These works emerge out of a call and response relationship with the wider community as Hammons urges others to '"[l]isten to these beautiful stories that are so deep-rooted in the culture. I dare someone to ignore them"' (in Storr, 1994: 59). By defying anyone to 'ignore' the stories embedded within African American culture, Hammons continues in the same vein as much

earlier artists such as Dave the Potter and Harriet Powers who also exper-
imented with everyday objects to tell visual narratives of black life.

'But you know, black people are born out of shock,' Hammons tells
Deborah Rothschild. 'I think it's because we saw our families separated
on the auction block' (in Rothschild, 1994: 52). Regardless of his playful
rejection of many of the concerns of African American artists, Hammons's
mixed-media installations and performance pieces testify to the ongoing
legacies of slavery, oppression, violence and racism. He tussles with issues
surrounding race, representation and identity in a fight for artistic agency
within his own works. '"We are completely colonized",' Hammons admits.
'"The unborn still doesn't have a ghost of a chance"' (Ibid.). His preoc-
cupation with broadening the scope, range, subject matter and approach
of black art continues the fight for agency begun by earlier artists such as
Aaron Douglas and Archibald J. Motley, Jr. He even risks paraphrasing
Motley by admitting, '"I'm trying to get away with the redundancy of
being an African-American or making African-American art. It's like a
double negative, a double noun"' (in Storr, 1994: 58). However, his admis-
sion that '"I'm trying to … hide the blackness and the culture as deeply
as possible"' because '"I'm not going to get trapped into making cultural
statements"' is fraught with complications and ambivalences (Ibid.). For
contemporary artists such as Glenn Ligon, African American attempts to
'hide the blackness' are rarely without consequences as they risk colluding
in white systems of black subjugation.

Overall, David Hammons's resistance to creating an art of 'cultural
statements' shows how emerging artists are determined to free themselves
from the dictates of earlier artists working within an African American
art tradition. While their works are heavily indebted to earlier techniques
and are preoccupied with many identical themes, Hammons and many
others sought to create their own distinct 'thumbprint'. Quoting Henry
Miller who stated, '"You have to get rid of your heroes"', Hammons
rejected the influences of earlier black artists by insisting, '"I'm not going
to let them wipe me out"' (in Rothschild, 1994: 48). In this chapter, I
examine David Hammons's body print, *Injustice Case* (1970, see Plate
14), to investigate his experimentation with heroism, masculinity and
identity in representations of the black body.

Injustice Case (1970, Plate 14)

'"I was making these things during the Watts riots",' David Hammons
explains. '"Buildings were burning. I got into the juxtaposition of Black

people against the American flag'" (in Ahearn, 1991: 25). In the midst of black rebellion and in the aftermath of the Civil Rights Movement, Hammons created a series of body prints depicting crumpled, gagged, broken, hanging and mutilated black men. As proof of their ongoing popularity, these 1970s prints have been exhibited as recently as 2006. They include works such as the ironically titled *Injustice Case* (1970, see Plate 14), *America the Beautiful* and *American Hang Up*. Hammons's method for creating these body prints was as follows: "'I used to put margarine on my body and sprinkle powdered pigment over the paper. I'd lay on the surface and the pigment would react to the grease'" (Ibid.). By experimenting with 'powdered pigment' and 'grease', Hammons's own body became a template for his art in these works. In body prints such as *Injustice Case*, fingers, chests, jaws, teeth, legs and eyes appear dislocated as individual physiognomies and torsos are similarly distorted and threatened with erasure by their white backgrounds. Over the last four decades, these works made from grease and powder have begun to disintegrate. In many cases, the partially visible black men depicted wrapped around, buried within and surrounded by American flags have all but vanished from their frames. The gradual disappearance of these bodies from Hammons's prints confirms his ongoing resistance to the buying and selling of his work, as well as his protest against the unjust erasure and distortion of black bodies within white mainstream culture. Their disappearance signifies upon the impossibility of white buyers ever to own black bodies, whether they are being bought and sold within a historical context of slavery or in a contemporary era of art capitalism.

In works such as *Injustice Case*, Hammons reveals his ongoing commitment to creating a culturally relevant art. As he admitted, it was his "'moral obligation as a black artist'" to attempt to "'graphically document what I feel socially'" (in Lewis and Waddy, Vol. 1, 1971: 101). This print supports Hammons's conviction that a work of art is "'only art when you're making it'" because, "'as soon as you put the last touch on it, it becomes a political object'" (in Rothschild, 1994: 48). As Richard Powell argues, he relies on his own body to represent 'former Black Panther party leader Bobby G. Seale' who appeared 'bound and gagged in a Chicago courtroom during a controversial, highly publicised trial' (Powell, 1995: 129). In this work, Hammons portrays the tied-up figure of a man seated on a chair and in profile to the viewer to signify upon diagrams of slave torture, daguerreotypes of scientific specimens, mug-shots of criminal types and the visual iconography of public executions. His use of grease

and powdered pigments does justice to the injustice of this visual narrative by depicting the barest outline of his own body to dramatise a man suffering from physical abuse, at the same time that he tilts his head back to suggest a determination to be free.

In *Injustice Case*, Hammons identifies the seams in the man's jeans and the rough textures of his shoes and sleeves with photographic clarity, while anatomical details such as his face, hair and torso remain only partially visible in a skeletal outline. Hammons's body print is defined as much by the physical details which are missing as those which are present, given that a spectral white background bleeds through the body parts and threatens to obliterate his black male subject. By relying on this artistic process, he encourages his viewers to use their imagination to reconstruct meaning from the fragments by signifying upon unjust depictions of the black body as a spectacle for white consumption. The body of David Hammons/Bobby Seale in *Injustice Case* operates as a site of racial, political, social and historical ambiguity. By mapping artist and activist identities on to one another, he argues for the incendiary potential of the artist's role which can similarly advocate dissent and resistance. For Hammons, no less than for Parks, images were significant insofar as they became 'weapons'. His decision to frame *Injustice Case* with a cut-out of a vertically positioned American flag accentuates the visual drama generated by black and white contrasts. The deliberately aged colouring of the flag's red and white stripes offsets the stark whiteness of the body print to evoke a history of slavery and indict ongoing paradoxes of American nationalism. Set against a backdrop of black suffering and persecution in the 1960s and 1970s, *Injustice Case* dramatises Hammons's conviction that the 'unborn still doesn't have a ghost of a chance'.

In *Injustice Case* Hammons's representation of a Black Panther activist evokes the contours of the artist's own body to blur the boundaries between black and white as well as visibility and invisibility and positive and negative space. As Sharon Patton argues, in this work the 'X-ray effect conjures a variety of allusions – nuclear extermination, impermanence of life, archaeological documentation of burial mounds, invisibility' (Patton, 1998: 199). Similarly, for Elvan Zabunyan, Hammons's body prints are not only 'visually close to photographic negatives but also radiography' (Zabunyan, 2005: 138). His play with 'photographic negatives', 'radiography' and the 'X-ray effect' negotiates the presences and absences of black masculinity within white racist iconography. However, critics frequently neglect to discuss the extent

to which Hammons's body prints contest their status as art objects by inviting comparisons with a Xerox or photocopy. His use of bold lines and grainy surfaces in this work reinforces associations with the black body and mechanical reproduction. I would argue even further that the disappearing body in *Injustice Case* relies on an 'X-ray effect' to evoke the charred and blackened flesh of rioting African Americans as well as historical contexts of lynching and racist persecution. In prints such as *Injustice Case* in which Hammons encourages audiences to see his representation of the black body not as the real thing but as a photocopy, he riffs upon the proliferation within popular, scientific, artistic and historical discourse of fictionalised black bodies masquerading as authentic types. Moreover, Hammons's *Injustice Case* exposes the difficulties experienced by African American men as they try to assert their humanity in the face of racist contexts which interpret them variously as advertising icons, bestial others or political touchstones.

'"Should I burn it? Should I sell it? Should I give it away? Who wants it?"', these are new questions which Hammons asks of African American art (in Rothschild, 1994: 48). While artists such as Betye Saar and Romare Bearden recycle various parts of their artworks, Hammons breaks with tradition to debate whether art should be destroyed altogether. In works such as *Injustice Case*, he relies on his own physicality to examine the ways in which black bodies have been politicised, historicised and aestheticised within white mainstream culture. As Richard Powell argues, 'Hammons, through his body prints, had discovered the analytic possibilities and declarative potential of representing *the self* in his art' (Powell, 2005: 131, his emphasis). As such, his body prints introduce the controversial collages of Howardena Pindell which equally rely on the outline of her own body to dissect histories of slavery, colonisation and sexual abuse. In her mixed-media collages, Howardena Pindell revisits Hammons's fear that '"[e]veryone is so quick to cover up history"' (in Reid, 1995: 30).

Howardena Pindell (b.1943)

'I wanted to get to the guts of my own past'

'"We must evolve a new language which empowers us and does not cause us to participate in our own disenfranchisement"', Howardena Pindell advises other black artists (in Sims, 1997: 16). Pindell's determination to create a 'new language' resonates with Hammons's search for a new 'vocabulary' to confront the grotesque, uncensored and taboo realities

of black suffering within a diasporic context. She pushes the boundaries of aesthetic experimentation in her large-scale, full-colour, mixed-media collages, videos and installations to visualise powerful histories of black female subjugation, exploitation and sexual abuse. Pindell fights for the right of the black female artist to aesthetic and political freedom by examining issues surrounding autobiography, identity, feminism, politics and history. As she explains, '"I wanted to do autobiographical painting because I wanted to get to the guts of my own past"' (in Sims, 1992: 8–9). Unafraid of provoking hostility from black audiences and artists, she is intent on liberating African American artists from the 'resistance' they encounter 'within the power structure in their communities of color' as well as the 'silence' they face from 'Eurocentric peers in the so-called mainstream' (in Sims, 1997: 39). '"Being black in this country, you have to cover up your identity",' Pindell argues. '"You have to whitewash everything in order to make it palatable"' (in Lippard, 1990: 232). In her works to date, she opposes 'racism in the artworld and the white feminists' which has led to her feeling 'very isolated as a token artist' (in Sims, 1997: 65). Pindell's collages and installations reject what she identifies as a white 'domination and erasure of experience' by 'cancelling and rewriting history that made one group feel safe and not threatened' (Ibid.).

In 1980, Pindell reached a personal breakthrough by producing an 'autobiographical' video installation titled *Free, White, and 21* (Ibid.: 66). Previously, she had created only large-scale, abstract works characterised by miniscule, individually glued and frequently numbered dots. She concedes, during this early period, '[M]y work as an artist was usually devoid of personal, narrative, or autobiographical reference' because 'I considered myself fairly voiceless in those days' (Ibid.: 65). Pindell's satirically titled *Free, White, and 21* more than makes up for this sense of 'voicelessness' by not only playing herself but also 'white-ing up' to ventriloquise the prejudices of a white woman and further examine her experience of 'de facto censorship issues throughout [her] life as part of the system of apartheid in the United States' (Ibid.). This video was initially distributed on the underground circuit due to the controversies it ignited within the black community and the art world more generally. As she comments, in one museum, 'black security guards refused to turn on the video because they felt it was offensive to people of color' (Ibid.: 67). Pindell's videos, installations and collages can be situated within a tradition of works by recent female artists who similarly rely on their own bodies and autobiographies to communicate personal experiences

of race, class and gender discrimination. They share Pindell's realisation that 'the desire to keep me silent, and to be pleased that I might be by fault forced into silence, was an extension of the legacy of slavery and racism' (Ibid.: 65–6).

In this final chapter, I examine Howardena Pindell's mixed-media collage, *Water/Ancestors/Middle Passage/Family Ghosts* (1988, see Plate 15), which explores the enforced silences buried within a 'legacy of slavery'. This work is part of her 1980s *Autobiography Series* in which she admits, 'I wanted to reflect the horror of some of my experiences and my struggle to overcome their effects by traditional, spiritual, as well as non-traditional means' (in Sims, 1992: 34). There are clear continuities between these works and her earlier video which, she argues, 'officially begins my autobiography series' (in Sims, 1997: 67). This 'selection of works on paper and canvas' examines what Pindell describes as the 'multifaceted aspects of my being and experience' (in Sims, 1992: 34). She goes further than Richard Powell's earlier analysis of David Hammons's practice to represent her sense of self not in art but as art itself. Pindell describes how she was careful in canvases such as *Water/Ancestors/Middle Passage/Family Ghosts* 'not to focus solely on that which has brought me distress, such as my personal experience with issues of abuse', but to 'include my inner spiritual as well as outer journey' (Ibid.). Controversially, in another work in the series which she titled, *Air/CS560* (1988), Pindell explains how '[she] put [her] own blood on the canvas' to 'symbolize [her] feelings about universal struggles for dignity, civil and human rights, as well as some of [her] personal agonies' (Ibid.). While *Autobiography: Water/Ancestors/Middle Passage/Family Ghosts* may not be suffused in Pindell's own blood, this dramatic collage maps her 'personal agonies' on to a worldwide struggle 'for dignity, civil and human rights'.

Autobiography: *Water/Ancestors/Middle Passage/Family Ghosts* (1988, Plate 15)

'My ancestral background is a vast stew,' Howardena Pindell admits. 'The painting symbolises this mixture and the fact that Africans kidnapped and held hostage in this country were massively tortured and sexually abused by their captors, who drew up laws to prevent those they had enslaved from protecting themselves' (Ibid.: 66). In *Water/Ancestors/ Middle Passage/Family Ghosts* (see Plate 15), Pindell relies on acrylic, tempera, cattle markers, oil stick, paper and polymer photo transfer to

dramatise themes of suffering, loss and memorialisation. This large-scale, multicoloured and layered collage resonates with works by David Hammons and Kara Walker by including the silhouetted outline of her own body which provoked outrage among black viewers. As Lowery Stokes Sims argues, '[B]ecause of that outline people were furious with her. The outline went back to our associations of the body as a crime scene' (in Freeman and Irving, 1998: n.p.). In this work, Pindell provides an aerial view of a black woman, one whose face and physical contours resemble her own, floating in a deep-blue sea. At the same time, however, she surrounds this figure with miscellaneous body parts, fragments of photographs, masks, eyes and faces, a historical diagram of a slave ship and pieces of racist legal texts and slogans to expose the ellipses and paradoxes of hidden black female histories. For Pindell as for Walker and Hammons, new narratives and art forms emerge by working within the silences and gaps produced by missing records and distorted legacies.

In this mixed-media collage, Pindell's body operates as a signifier of suffering black womanhood during the Middle Passage. The torn apart limbs and fragmented eyes and faces resonate with the '60 million and more' of Toni Morrison's novel, *Beloved*, in which the autobiographical experiences of black women were 'not a story to pass on' (Morrison, 1987: 274). By experimenting with fragments and layers, Pindell creates an ambiguous collage which retains authority over her personal narrative and the stories of unknown enslaved women by insisting that theirs was 'not a story to pass on'. Furthermore, Pindell's submersion of this canvas in swathes of dark and light blues resonates with Aaron Douglas's much earlier canvas, *Into Bondage* (1936, see Plate 1), while her representation of broken up bodies and partially erased text recalls Jean-Michel Basquiat's more recent collage, *Slave Auction* (1982). Pindell's work also testifies to Romare Bearden's influence by including assortments of eyes cut out from black and white faces to 'represent witnesses, even if silence was the only testimony permitted' (in Sims, 1992: 66). Attempts to situate Pindell's work within an African American art tradition also proves her greater commitment to a visual poetics of silence in an aesthetic practice of telling and untelling.

Speaking of her aesthetic process, Pindell explains that, in works such as *Water/Ancestors/Middle Passage/Family Ghosts*, she would 'split and sew the canvases so the threads show', at the same time that she relied on 'acrylic' and 'photo transfer images' in 'a collage process' (in Freeman

and Irving, 1998: n.p.). By displaying the 'threads' of her canvas and interweaving photographic fragments and painted layers, she insists on the importance of rough surfaces and textures to replicate the horrors of ravaged and cut-up skin as well as torn-apart body parts. This is no surprise given that this work was partly inspired by the experiences of one of her slave ancestors who 'had been blinded by the lash of one of the enslaver's whips' (in Sims, 1997: 67). 'The thick paint strokes' of the collages in her *Autobiography Series*, Pindell argues, 'represent both notes and sounds of a mantra as well as scarring, echoing both a rupture and a healing' (in Sims, 1992: 34). The textured incisions of juxtaposed rows of meticulously rendered brushstrokes in *Water/Ancestors/Middle Passage/Family Ghosts* resonate with the numbered dots of her earlier abstract paintings which Corinne Jennings interprets as symbols of the anonymous victims of the 'the Slave Trade and the Middle Passage' (in Freeman and Irving, 1998: n.p.). Whether this is or is not the case, this collage commemorates the slave women whose stories were not told because their bodies lie in unmarked graves at the bottom of the Atlantic Ocean. A close inspection of this collage soon reveals other bodies and body parts shadowed beneath her own silhouette. While Pindell's own body lies with outstretched arms as if to evoke the crucifixion, the raised fists of the partially visible body immediately beneath suggests a 1960s Black Power salute. These additional limbs viscerally evoke the multiplicity of perspectives within buried histories of slavery by emphasising mixed messages of black female passivity and agency.

Regarding her *Autobiography* paintings, Pindell argues that her brushstrokes are 'symbolic of African ritual scarification for beauty, knitting together keloids, fusing into a whole fabric, skin, or canvas' (in Sims, 1992: 34). By suggesting an inextricable relationship between 'skin' and 'canvas' in *Water/Ancestors/Middle Passage/Family Ghosts*, Pindell makes the links between the black body and art much more visceral. She invites comparison with nineteenth-century slave narrators such as Frederick Douglass who described the violence endured by slaves as leaving a 'living parchment on most of their backs' (Douglass, 1855: 177). In the same way that slaves carried scars stamped on their back, in this work Pindell wears the wounds of slavery and segregation within the contours of her own skin as body outline as well as the 'skin' of the 'canvas' itself. Echoing Hammons's approach to the body, Pindell explores representations of the body as text and as art in works such as *Water/Ancestors/Middle Passage/ Family Ghosts* as she dissects,

splits and anatomises the black female figure. Both Hammons's body prints and Pindell's collages testify to the difficulties of representing the black body as art against a backdrop of objectification and spectacular display.

A key theme in Pindell's work concerns the ways in which psychological scarring maps on to bodily suffering. In this collage in particular, Pindell positions her own body between a small-scale reproduction of the slave ship *Brookes* and a North Carolina slave law which reads: "'if the master attempt the violation of the slave's wife and the husband resist his attempts ... the law does not merely permit but authorizes the master to murder the slave on the spot'" (in Sims, 1992: 66). Beneath this law, she inserts a partially legible sign, 'SEPARATE BUT EQUAL', in which she almost entirely obscures 'EQUAL' to indict twentieth-century systems of racial segregation. By situating her own body outline between a slave ship and legal texts, both of which reinforce white racism in the destruction of black families, identities and sexuality, Pindell argues that one way out is through the aesthetic process itself. Just as Douglass regained his humanity through written narratives, Pindell and other black artists engage in 'visual storytelling' to explore black female subjectivity and critique representations of the black body. Despite Pindell's self-identification as a radical outsider, in her experimental works she has much in common with earlier black artists as she argues for the necessity that 'we educate ourselves about our history' (in Sims, 1997: 29).

Pindell's collage, *Water/Ancestors/Middle Passage/Family Ghosts* deconstructs myths, recovers ancestral memories, revisits autobiographical narratives and splits apart dominant histories to contest racist fictions. She opposes myths according to which '[m]en of color have been presented as the perpetrators of rape' which she describes as an 'elaborate mythology' which has been 'developed to sanitize the history of the country' (in Sims, 1992: 66). Pindell bridges works by David Hammons and Kara Walker in her collages by investigating the relationship between memory and history, presence and absence and invisibility and visibility in a radical negotiation of positive and negative space. As Lucy Lippard argues, her *Autobiography Series* suggests 'displacement, dismemberment and amnesia' by 'charting a vital but painful search, an absence that, in her art, becomes a strong presence' (Lippard, 1990: 40). As we saw in the introduction to this book, Pindell has recently undertaken an extensive study of 'artworld racism' in major United States galleries. In 1988 and again in 1997, her investigation has shown that the

'"mainstream" artworld continues to exclude people of color' (in Sims, 1997: 16). For Pindell, 'omission – de facto censoring of artists of color – is an act of violence, whether you erase our presence by physical violence or erase us by turning your backs on us' (Ibid.: 41). With Betye Saar, she is one of the first artists virulently to oppose works by contemporary black artists such as Kara Walker whom she argues 'encourage hyperactive, exotic, or demeaning images of sexuality (especially in combination with race)' by including 'racially stereotypical images that demean or distort their own people' (Ibid.: 23). She does not mince words when she describes artists such as Walker as 'focusing on racial stereotypes' to 'cater (or pander) to European tastes and a European market' in an act of 'selling out to sell out' (Ibid.). Howardena Pindell's critique of Kara Walker's '"visual terrorism"' paves the way for investigations in this chapter into the controversies and paradoxes of this artist's recent installations, drawings, and prints (in Reinhardt, 2003: 119).

Kara Walker (b.1969)

'I don't know how much I believe in redemptive stories'

Kara Walker writes:

> My issues with the proverbial Ancestors goes
> something like this:
> 'Thanks for the gestures, the songs and the secret
> tongues – Thanks for the performance – the great
> spectacle of Blackness is re-presente
> d so artfully by you (Y'all)
> but I sit, and try to paint, to use massa's
> visual language to carry on that Project. and
> you Don't give me Shit'
>
> (in Berry, 2003: n.p.)

Walker's anger at artistic forebears who '[d]on't give [her] shit' gets to the heart of the controversies surrounding not only her own installations and prints but also the paintings, performance pieces and sculptures of many recent artists. By producing uncensored and confrontational artworks, she and other contemporary artists critique mainstream practices within the African American art tradition. One of the most controversial and youngest artists I examine in this book, Kara Walker, has been vilified by older African Americans artists such as Howardena Pindell and Betye Saar who find her art offensive, insulting and demeaning. They

are shocked by Walker's graphic scenes of rape, sexual abuse, torture, murder and labour in her works. Her bathetic, satirical and pornographic treatment of colliding and overlapping black and white, adult and child, male and female bodies creates visual vignettes of explicit and perverse histories. If Archibald J. Motley, Jr remains the skeleton in the cupboard of the Harlem Renaissance then, for many black artists, Walker represents the 'mad woman in the attic' whose voice will not be repressed or silenced.

In her career so far, Walker has refused to produce artworks which fit into the heroic iconography popularised by the monumental, dignified and progressive works of other artists such as Elizabeth Catlett, Charles White, Horace Pippin, Charles Alston and Romare Bearden. Even David Hammons and Howardena Pindell play with stereotypes and push the boundaries of appropriate materials in the interests of recovering untold histories and narratives with dignity and respect. This is not the case for Walker whose gruesome, grotesque, pornographic and carnivalesque scenes of antebellum slave plantation life resist the cathartic narratives of black progress and racial uplift popularised by many black artists. In her works, she holds her ground in the fight for aesthetic freedom in the face of black censorship. Fearlessly debunking popular representations of black victimisation and heroism, she rejects the 'proud black history of struggle and achievement' celebrated by black artists on the grounds that it is steeped in the 'rhetoric of biological determinism' (Walker, 1998: 48). Walker makes no bones about her determination to 'send up this expectation that as a Black woman artist I would be "authentically Black"' (in Stewart, 2004: n.p.). Borrowing from white racist rhetoric, she has no qualms in describing herself as a 'Negress – this semi-artificial artist attempting to usurp power from everybody' (Walker, 1999: n.p.). By keeping racist images and language circulating, she shares David Hammons's concern with 'nothingness' and suggests that art is 'all artifice, just a ruse to tantalize the viewer' (Ibid.). Her art has come a long way from Charles White's images exposing black 'nonbeing' and invisibility.

'The whole problem with racism and its continuing legacy in this country,' Walker argues, 'is that we simply *love* it. Who would we be without it and without the "struggle"?' (in Reid-Pharr, 2002: 32, her emphasis). Her controversial assertion that African Americans 'love' the 'struggle' is anathema to the views of the majority of black artists in this book. Walker's works pull the rug from under the beliefs of earlier

black artists who depict scenes of violence and hardship in their photographs, murals, sculptures and paintings. She undermines their focus on heroic narratives by creating works which eulogise the strength, resilience, beauty and faith of African Americans who were able to survive and transcend their brutalised and impoverished surroundings. Black martyrs and heroes are nowhere to be found in Walker's installations, prints and text cards which focus upon themes of sadomasochism, perversion and complicity within master-slave relationships. Walker has gone even further by confessing, '"I don't know how much I believe in redemptive stories, even though people want them and strive for them. They're satisfied with stories of triumph over evil, but the triumph is a dead end. Triumph never sits still. Life goes on"' (in Raymond, 2007: 348). Walker's resistance to 'redemptive stories' reflects Hammons's determination not to let earlier artists 'wipe [her] out' at the same time as revealing her determination to deny audiences of her art any cathartic release or closure. '"Heroes are not completely pure, and villains aren't purely evil",' Walker explains '"I'm interested in the continuity of conflict, the creation of racist narratives people use to construct a group identity and keep themselves whole"' (Ibid.). By refusing to provide visual narratives of progress, she experiments with subject matter and materials in her mixed-media works to unsettle, agitate, disturb and provoke her viewers to further self-examination and analysis.

By mining the taboo debris of our imaginations to dramatise the 'continuity of conflict' and resurrect forbidden desires, Walker's art debates unresolved problems and issues as proof that '[l]ife goes on'. Her assertion that 'nothing ever comes' of the '"Color Purple" scenario' in which 'things resolve' and a 'heroine actualizes through a process of self-discovery and historical discovery' is an apt summary of her work (Walker, 'Projecting Fictions', n.d.: n.p.). She overturns one hundred years of African American art history by admitting that there is a 'failure of that kind of resolution' because the heroine is 'not evil, she's not a hero either, but then she sort of engages these oppositions constantly and keeps it open' (Ibid.). By engaging with 'oppositions' and 'conflicts', Walker creates multifaceted artworks which speak the unspeakable and see the unseen. As Michele Wallace claims, it is 'as if the visual imagination of her work was packed with our collective psychological refuse' (Wallace, 2003: 176).

Walker's tortured, incomplete and fragmented visual narratives of perverse desires, bodily fluids and excrement, cycles of abuse and

grotesque behaviour revive the eighteenth-century tradition of silhou-
ette portraiture. Her vast panoramas of scenes from antebellum southern
folklore are animated by stark silhouetted forms created from cut-black
paper pasted on to white museum walls. As Walker admits, this form
'spoke to me in the same way that the minstrel show does' because
'it's middle class white people rendering themselves black, making
themselves somewhat invisible' (Walker, 1999: n.p.). She remains drawn
to this form because of its freedom as '[y]ou can play out different roles
when you're rendered black, or halfway invisible' (Ibid.). For Walker,
the silhouette encapsulates paradoxes of presence and absence, visibility
and invisibility in a positive and negative negotiation of black-and-white
space. By experimenting with this technique, she explores the ways in
which African American women are not only missing from dominant
white histories but also how their bodies have operated as receptacles
for white penetration and violation. Walker suggests that the silhouette
operates in the same way as the black woman's body during slavery by
providing a 'blank space that you project your desires into. It can be
positive or negative. It's just a hole in a piece of paper, and it's the inside
of that hole' (in Shaw, 2004: 23). Walker is in no doubt that the silhouette
can contribute to the deferral of meaning as it 'lends itself to avoidance of
the subject' and can be compared to 'the stereotype' by communicating a
great deal 'with very little information' (Walker, 'PBS: The Melodrama',
n.d.: n.p.; in Halbreich, 2007: 1).

Scratch the surface of Walker's paper-thin black silhouettes and it
soon becomes clear that a great deal of research has gone into these
ambiguous, colliding and enigmatic works. 'I appropriate from many
sources,' Walker explains, 'frontispieces for slave narratives, authentic
documents, as well as a novel or a great source of artistic spectacle'
(in Golden, 2002: 47). 'I love historical paintings,' she admits, 'and I
love the language that goes with them' and yet, 'I'm not quite capable
of constructing the whole novel at once, the whole narrative' (Ibid.).
However, as Robert Reid-Pharr argues, the 'idea that historical memory
can be incredibly thin ... stands at the center of Walker's aesthetic'
(Reid-Pharr, 2002: 38). Similarly, Gwendolyn DuBois Shaw sheds light
on Walker's experimental approach to storytelling by suggesting that,
in her works, she is 're-membering an antinarrative that exists in a place
before memory and beyond it, always familiar, yet resoundingly alien'
(Shaw, 2004: 39). By revisiting historical documents and experimenting
with the silhouette form, Walker produces 'antinarratives' and 'antihis-

tories' which contest the authority of official records to open up alternative spaces within which to create new panoramas of never-before-seen experiences.

Nearly a decade ago, in 1998, Walker exhibited *Letter from a Black Girl*, addressed to 'you hypocritical fucking Twerp' by which she seems to suggest a white slave-holder/oppressor (in Dixon, 2002: 96). In this mural-size letter occupying the whole of a museum wall, she adopted the controversial persona of the artist as 'Negress' to state that 'now That I'm free of ... that peculiar institution we engaged in ... I am LOST ... I was a blank space defined in contrast to your POSITIVE, concrete avowal' (Ibid.). If Hammons's work is preoccupied with 'nothingness' and 'confusions' and Pindell's address trauma and amnesia, then Walker's installations investigate the absent-presence of 'blank spaces' to address themes of loss and cultural denial during and long after slavery. The closing sentence of this letter summarises the paradoxes of black and white relationships by stating, 'I am left here alone to recreate my WHOLE HISTORY without benefit of you, my compliment, my enemy, my oppressor, my Love' (Ibid.). This letter proves that one of the most controversial and recurring figures in Walker's art is the '"nigger wench"' whom she describes as a '"young and pretty black girl whose function is as a receptacle"' (in Shaw, 2004: 19). In these and other works, she provides radical representations of African American femininity which she sees as a 'black hole, a space defined by things sucked into her, a "nigger cunt", a scent, an ass, a complication' and as 'simultaneously sub-human and super-human' (Ibid.).

In this chapter, I examine Walker's work, *The Means to an End ... A Shadow Drama in Five Acts* (1995, see Plate 16) to explore her fascination with torn-apart, contorted and dislocated black and white bodies. One of the ways in which Walker challenges the conventions established by African American artists is by dramatising raw, immediate and shocking images of children in degraded, abusive and shocking situations. It is this tendency, in particular, which compounds the taboo nature of her works as she represents the grotesque suffering of children whose voices have rarely, if ever, been recovered in historical narratives. Michael Harris's view that she 'has locked herself into the racial discourse she is attempting to subvert' is typical of readings which overlook the self-consciousness of her aesthetic practice (Harris, 2003: 216). A close analysis of Walker's works shows how she voluntarily 'locks herself' and her viewers in only to prove the multifarious ways in which both artist and audience are

perpetually imprisoned in the 'dark alleys' of their imagination. For Kara Walker, the only possibility of escape is through a visual poetics of witnessing, confrontation and reconstruction as she creates vignettes of sexual violation, seditious rebellion and pornographic fantasy.

> *The Means to an End ... A Shadow Drama in Five Acts* (1995,
> Plate 16)

'Had positive imaging of the black body to date solved the problem of representing blackness and power,' Kara Walker explains, 'the "black" and "white" bodies in my work would be virtually silent' (Walker, 1998: 48). By presenting a vast panorama of stereotypical 'Nigger wenches', 'pickanninies', 'mammies' and 'bucks' in her five-part and theatrically titled installation, *The Means to an End ... A Shadow Drama in Five Acts* (1995, see Plate 16), Walker exposes the failures of revisionist, monumentalising narratives. For Walker, '[p]ositive absolutes have served to romanticise an essentialist African American body politic easily captured, negated, even ridiculed by a dominant (white) discourse' (Ibid). She commiserates in a text card:

> Our rebellion never really succeeded.
> I gathered my armies fromthe [sic] pages of
> Negro fiction, from the Pages of Historical
> fact. From the Bigger than Nigger images
> adorning the imagination of the day.
>
> (in Berry, 2003: 101)

Rather than providing a corrective iconography of dignified African American women, men and children characterised by heroic attributes and idealistic hopes, Walker argues that the only way to debunk and displace racist myths is by importing them into her work. '"Really it's about finding one's voice in the wrong end",' she explains (in Shaw, 2004: 52). In *The Means to an End ...*, Walker sets the viewer up for the expediency involved in African American strategies for survival by rupturing heroic paradigms of spiritual purification and uplift through suffering. Rather than 'selling out', Walker's horrifying and caricatured black bodies indict ongoing difficulties in constantly resurfacing racist stereotypes.

The Means to an End ... supports Walker's statement that, in many of her works, 'I was trying to make up my mythology and deconstruct it at the same time' (in Dixon, 2002: 14). This installation consists of

five 'Acts' which dramatise various graphic scenes in which an African American woman suckles a white boy, a white girl rides a slathering dog backwards, a vengeful mammy dances on skull debris, a black man is reduced to body parts and a white man wrings the neck of a black girl. If Pindell opposes the 'whitewashing' of history, then Walker's is a revisionist blackwashing. Given her groundbreaking subject matter and a tradition of silhouette portraiture which was a mechanical process by which all subjects, white and black, become visibly black, Walker relies on stereotypical markers to differentiate between women, men and children. In the first scene, she examines issues surrounding black maternity and white infantalisation by portraying the 'nigger wench' of plantation mythology suckling the white child suspended in mid-air. Black children are missing from this scene to protest against the denial of black mother and child relationships during slavery. While the white boy wears garters, shoes and a full suit of clothes, the black woman is bare-breasted and barefooted as she stands on unrecognisable matter which spills into the second image.

The second 'Act' signifies on the first by showing a white girl with hands upraised while she is spirited away on a large dog. Beneath her we find the excrement, debris and oozing liquid typical of the majority of Walker's works and which generates emotional responses by focusing audience attention on detritus and debris to expose the ways in which official histories have been sanitised. Walker offsets the angelic purity of this white girl, who could be Eva of Harriet Beecher Stowe's *Uncle Tom's Cabin* or Bonnie of Margaret Mitchell's *Gone with the Wind*, by nestling bestial ears among her ringlets to contrast with her stereotypi-cally 'white' profile. Walker's explicit reference to animalistic propensi-ties buried within representations of white girlhood subverts stereotypical associations of black identities with bestiality. By depicting a white girl raising her hand upwards towards the black female figure of the first work as if begging to be suckled, Walker's image counters myths of black dependency and exposes white parental abandonment. Given the symbolic slipperiness of Walker's images, the dog on which this white girl rides may offer a displaced metaphor for black resistance by evoking the infamous bloodhounds who tracked runaway slaves in the south.

In the third 'Act', Walker undermines her earlier representation of the black female by portraying an African American woman wearing the bandanna of the mammy stereotype but also in a pose parodying Betye Saar's gun-toting mammy in *The Liberation of Aunt Jemima* (1972).

Walker's image is far more hard-hitting, however, as the mammy's skirts billow outwards in her dance of the macabre; in particular, her jumping heel rests on one of three flattened and severed heads lying at her feet. Thus, the excrement and debris of the first and second scenes take human form by this third 'Act' which makes the interrelated themes of black female resistance and subjugation much more tangible. By showing 'ooze' and excrement, Walker exposes the horrors of slavery by testifying to the ways in which it physically and psychologically penetrates black bodies. Each of the three severed heads is different and tellingly they share distinct similarities with the profiles of specific characters in this installation. The head to the bottom left of the image, for example, resembles the profile of the mammy herself while the hairstyle on the head to the right resonates with that of the 'nigger wench' of the opening 'Act'. These severed black female heads which rest at the murderous mammy's feet suggest the ways in which African American women have been historically complicit in their own oppression, at the same time that they have rebelled in acts of resistance and mutilation. Even more controversially, however, it is likely that the profile of the head on which the mammy's foot rests is the severed head of the African American man in the fourth scene. By showing a black woman crushing the skull of a black man, Walker follows on from Pindell's emphasis by examining the abuses of power in black and black and black and white relationships. As Walker explains, her work investigates 'this body of a collective experience, a history' to the 'point of leaving nothing intact' so that there is 'just this pile of parts and goo' in a 'pre-dissected body of information' (Walker, 'PBS: Projection Fictions', n.d.: n.p.). In this installation, her split-apart, eradicated and dissected bodies are able to find only an illusion of wholeness in the racist imaginations of her viewers.

The fourth scene of *The Means to an End* ... is by far the most graphic and tragic 'Act'. In this image, Walker depicts an expanse of white space at the bottom of which rests the severed head of a man distinguished only by the stereotypical hair, nose and lips of racist caricature. By positioning his upturned head and dislocated hand with fingers pointing upwards next to oozing entrails, Walker signifies on Josiah Wedgwood's eighteenth-century representation of the pleading male slave in his antislavery medallion, *Am I Not a Man and a Brother?* (1787). By carving up Wedgwood's image, Walker shows how even antislavery images can swallow black bodies whole in paternalist discourses which perpetuate myths of black martyrdom, passivity and childishness, even

as they served the cause of abolition. This male slave's missing body highlights Walker's concern with lost histories by providing horrific visual narratives of decapitation and dismemberment. The black man looks upwards towards the fifth and final image which exists in a call and response relationship with the first work. This final image crystallises the horror of these five scenes by showing the corpulent figure of an aggressive and well-dressed white man strangling the emaciated, frail and semi-clothed figure of an innocent black female child. Her pigtails accentuate her youthful vulnerability while his large boots and top hat highlight his abuses of unearned privilege and power. However, this final image may not be as bleak as it first appears. The white man's foot is poised over an abyss of white nothingness as he is about to step off from the security of the black ground on which his other foot rests. Ever the satirist, Walker relies on bathos to undermine the crippling authority of white manhood and offer hope in black survival.

In works such as *The Means to an End ... A Shadow Drama in Five Acts*, Walker experiments with the series format to create installations which will haunt museum walls and devour her viewers whole. They cannot help but become implicated in the 'grotesque phantasmagoria' of Walker's 'carnivalesque' imagination (Shaw, 2004: 104). As she argues, the 'audience has to deal with their own prejudices or fear or distress when they look at these images' (Ibid.: 103). She intends a visceral effect to destabilise, disturb and physically implicate her viewers because the '"content doesn't reveal itself right away"' and yet '"[s]uddenly that leg and hand belonged to that viewer"' (Ibid.: 39). 'I had a visceral reaction which I don't really want to go away,' Walker admits, 'and the problem with making this kind of work [is that] ... [it] starts to feed on itself' (in Gilman, 2007: 33). Her experimental installations relish in an art of bodily appetites as her gorging, swallowing and penetrating black and white bodies provide a space within which her viewers can viscerally relive taboo and untold histories of slavery. Moreover, the sense that the body parts of Walker's protagonists can suddenly 'feed on one another' and 'belong' to her viewers encourages a far more visceral form of identification with slavery than had been created by any other African American artist either before or since.

'One of the themes in my work is the idea that a black subject in the present tense is a container for specific pathologies from the past and is continually growing and feeding off those maladies,' Walker urges. 'Racist pathology is the muck' (in Vergne, 2007: 8). In her instal-

lations, prints and drawings she experiments with racist iconography to signify on the problematic dynamics of white dominant histories and black revisionist responses. Walker exalts in fictions of identities and narratives to reinforce her sense that, 'I am too aware of the role of my overzealous imagination interfering in the basic fact of history' (in English, 2003: 144). She does not shy away from but empowers her dispossessed figures by adopting the view that in 'order to have a real connection with my history I had to be somebody's slave. But I was in control. That's the difference' (in Wagner, 2003: 99). For Walker, there is no indignity or shame in showing the ways in which black women, children and men were forced to live during slavery. Rather than substituting negative images for positive ones, she argues that empowerment is only made possible by inhabiting, owning and redefining racist fantasies. By describing many of her works as a visual '"slave narrative"', Walker tells only half the story (in Shaw, 2004: 19). If they are 'visual slave narratives' then they are those into which she has reinserted the dirt, debris and detritus of human lives to wrest control from white editors, patrons and audiences and access the uncut and unmediated emotional lives of her African American subjects.

Conclusion: 'Personal memory, ancestral knowledge and historic events'

'Often, the simple act of taking tea or the mere presence of a tea cup, a spoon, or a canning jar can become an important vehicle in the preservation and transmission of personal memory, ancestral knowledge and historic events,' explains contemporary artist, Debra Priestly, as the 'power of association and the storytelling tradition can be powerful tools' (Priestly, 2005-7: n.p.). In her recent mixed-media work, *Strange Fruit 2* (2002), Priestly inserts photographic images on to Mason jars to portray historical images from slavery. She represents a vast panorama of nineteenth-century images on each of these domestic objects by including historical drawings of: the fugitive slave 'Gordon' whose scarred back made him famous; heroic figures Sojourner Truth and Frederick Douglass; the 'Am I Not a Man and a Brother?' begging male slave; the head harnesses and instruments of torture worn by slaves; cross-sections of the slave ship *Brookes*; runaway slave advertisements; the escape of the fugitive slave Henry 'Box' Brown; and slaves on the deck of a slave ship. Priestly's installation borrows the titles from Billie Holliday's protest song, 'Strange Fruit', to accentuate the horror of her

imagery as well as a history of resistance through cultural strategies of subversion and survival.

In the early twenty-first century, Debra Priestly's decision to transfer nineteenth-century drawings, diagrams and advertisements on to Mason jars brings us full circle and back to Dave the Potter's technique of inscribing poetic texts on to epic-size pots. Both Priestly and Dave the Potter juxtapose text and image, artefacts and visual stories to create touchstones for political reform and a social critique out of everyday objects. By comparison, Hammons, Pindell and Walker rely not only on the cultural artefacts and historical images integral to Priestly's practice but also their own bodies, blood and hair to visualise their stories inspired by 'personal memory, ancestral knowledge and historic events'.

The installations, canvases and performance art of Debra Priestly, David Hammons, Howardena Pindell and Kara Walker prove that recent African American artists share far more similarities than differences with their forebears. David Hammons is the first to admit, '"I hate the system, every black man does, but too much work about racism is redundant",' and yet he cautions, '"You've got to take your anger and make it beautiful"' (in Rugoff, 1995: 20). Similarly, Howardena Pindell states that her works reflect an 'African concept that you bring in the spiritual through beauty' (in Freeman and Irving, 1998: n.p.). As she explains, '[E]ven with the most horrendous aspects that I will touch in these works the works are beautiful' (Ibid.). No views could resonate more clearly with Kara Walker's aesthetic practice for which she admits, '"if some of the actions are ugly or ambiguous or not in keeping with a progressive view of ourselves, then I try and at least make the gesture beautiful, and ultimately the form is beautiful"' (in Golden, 2002: 45). From the quilts, pots, sculptures and portraits of early slaves to works by Harlem Renaissance artists, on through to those working during segregation and against a backdrop of civil rights, African American artists engage in visual storytelling as they share Horace Pippin's determination that, 'I can never forget suffering, and I will never forget sunset'. African American artists of the nineteenth, twentieth and twenty-first centuries experiment with aesthetic forms and themes to create beauty out of pain as they conjure up forceful, experimental and often abstract art works born of suffering, horror and disfranchisement.

'"Everybody was just groveling and tomming, anything to be in the room with somebody with some money"', was how David Hammons saw the white mainstream art world in the 1980s. '"There were no bad

guys here: so I said, 'Let me be a bad guy'" (Hammons, 'Interview', n.d.: n.p.). David Hammons, Howardena Pindell and Kara Walker relish in being the 'bad guy' by refusing to serve up sanitised and acceptable representations of black bodies, cultures and lives. They dig deep into the ambivalences and contradictions of personal and public narratives and histories by creating canvases and sculptures from the blood, hair, grease and dirt of their own bodies. Theirs is a history with the dirt left on. In the hands of these artists, African American bodies which were previously the subjects of colour abstractions, realist portraits, nostalgic collages, heroic murals, dignified drawings, protest photographs and mythic sculptures are critiqued, split apart, silenced and only partially visible. Hammons, Pindell and Walker can be situated within a black visual arts tradition which relies on humour, irony, satire and impro-visation to fight racism in white mainstream arts and resist producing moralising and didactic works advocating racial uplift. As Walker tells Betye Saar, "'You look or you don't look. But I'll make it as long as I have to. The whole gamut of black people, whether by black people or not, are free rein in my mind'" (in Shaw, 2004: 117). She controversially states, "'You can't really survive without satire, can you?'" (in McEvilly, 2007: 56).

The collages, videos and installations of David Hammons, Howardena Pindell and Kara Walker are 'anti-art', 'anti-history', and 'anti-narrative' as they break up, tear apart, fragment and distort popular representa-tions of black bodies in African American art and white mainstream culture. Both Pindell and Walker reinforce Hammons's insistence to his white audiences that, 'I'm not letting you get away thinking that you're different than me. On that light-skin privilege trip' (in Rothschild, 1994: 43). For sheer playfulness and irreverence, Hammons's advice to white audiences, patrons and critics should be the rallying cry on which to conclude the final chapter of this book. "'You don't have to make it into some big mystery",' David Hammons warns. "'Damn, relax. Use your energy on something besides intellectual masturbation. You need to dance more"' (Ibid.: 22).

Epilogue:
'A solitary body wrapped in canvas'

'Using slave ships as a design image and a solitary body wrapped in canvas,' explains contemporary artist, Jefferson Pinder, 'I created an installation that dealt with the journey made by hundreds of thousands across the Atlantic' (Pinder, 2004: n.p.). For up-and-coming painters, sculptors, photographers and installation and performance artists such as Jefferson Pinder, Kerry James Marshall, Michael Ray Charles, Laylah Ali and Renée Cox, the history of the Middle Passage, the transatlantic slave trade and slavery continues to fire their aesthetic imagination. Appearing as recently as 2005, Pinder's installation takes us back to the beginning of this book by examining the horrors of slavery in an installation titled, *Middle Passage*, which he exhibited in New Orleans. In this mixed-media work, he dramatised the tragedies of lives lost to history by displaying 'solitary bodies' wrapped in white sheets and tied together with rough twine. Lying on the floor or on coffin-shaped plinths, they dominated the exhibition space to signify upon a history of black bodies buried in watery graves, for sale on auction blocks or forgotten in the wake of natural disasters. Abandoned at their feet or hanging on white walls, small-scale replicas of slave ships testified to absent histories, physical abjection and ongoing financial commodification. Pinder's decision to encase enslaved bodies in rolls of 'blank canvas' tackles the ways in which art itself can be complicit in burying or denying the 'solitary' lives of black women, men and children. Wrapping enslaved bodies in white shrouds, he critiqued mainstream tendencies to 'whitewash', erase and marginalise African American histories and narratives.

As Pinder insists, 'Access to history is equally as important as the record itself' (Ibid.). In this context, the anonymous bodies of Jefferson Pinder's *Middle Passage* can be situated alongside his earlier *Bound History* series created in 2003 and consisting of a number of collaged photographic images, split apart into small square newspaper bundles tied together with string. Borrowing from the aesthetic practices of Betye

Saar, Romare Bearden and Howardena Pindell, he inserted photographic fragments on to newsprint to juxtapose close-ups of black women, children and men with scenes of racist brutality in these works. 'In my *Bound History* series I am presenting disposable, bound documents,' he asserts. 'The knowledge is inaccessible and remote, ready to be eliminated or thrown to the curb. How many stories are within? No one will ever know. Bound together with twine, they are either ready to be unravelled or waiting to be discarded' (Pinder, 2004: n.p.). Pinder's discussion of unknown and hidden stories which are 'either ready to be unravelled or waiting to be discarded' is an apt summary of the aesthetic approach of the majority of African American artists examined in this book. For many nineteenth-, twentieth- and twenty-first-century artists, the act of excavating and unravelling innumerable stories to gain insights into a contested and off-limits knowledge lies at the heart of their experimental aesthetic practices. 'Excavating and probing into the essence of black imagery,' Pinder admits, 'I'm searching for the heart of black identity' (Pinder, 2003). While recent artists have fought to establish new priorities for African American art, they remain as preoccupied as their forebears with unearthing buried stories to communicate an 'essence of black imagery'.

Just over a year ago, abstract sculptor Melvin Edwards lashed out at white art world attempts to dictate the forms and subject matter in his works. '"You think I'm going to listen to some idiot who tells me my stuff is not relevant",' he asked, '"when they don't know their ass from a hole in the ground as far as art goes?"' (in Golden, 2006: 113). Edwards's frustration with critics who question the cultural 'relevance' of his metal sculptures revisits Greg Tate's belief discussed in the introduction to this book that, '[i]t is easier for a rich white man to enter the kingdom of heaven than for a Black abstract and/or Conceptual artist to get a one-man shown in lower Manhattan' (Tate, 1992: 234). As a result, experimental works by contemporary artists prove that the African American artist's fight for aesthetic freedom is still ongoing. In 2005, Kerry James Marshall opposed what he saw as a '"white" power elite' who possess the 'capital resources to build institutions, codify definitions and create markets' and which 'sets the parameters' by defining 'what is good and who is best' (in Smith, 2005: 17). Similarly, recent artists subvert the racist expectations of white art establishments by 'mining' what Marshall describes as 'the widest possible formal terrain in the hope of accumulating enough raw material to synthesise new forms' (Ibid.: 18).

Up-and-coming artists signify upon the experimental practices of their forebears in their sculptures, paintings, installations and photography. However much African American artists differ in terms of form and technique, continuities remain concerning their ongoing exploration of issues related to caricature, abstraction, gender and class tensions, labour, sexual politics, identity and the slippery relationship between text and image. Given a history of racist imagery in white mainstream culture, in their mixed-media works, recent artists are committed to exposing the difficulties of language or art ever to recover African American public and private histories and narratives.

Moreover, many contemporary painters, sculptors and installation artists experiment with the ambiguities of irony, satire, bathos and stereotyping to signify on representations of the black body as missing, disfigured, dispossessed and anti-heroic. For example, paintings such as Kerry James Marshall's *Two Invisible Men Naked* (1985) debate issues surrounding African American 'nonbeing' by supporting his 'impression that representing black figures had something to do with their absence' (Ibid.: 19). By portraying only the eyes of his 'invisible men' as the missing bodies of a black and a white man confront the viewer from their respective white and black backgrounds in this work, Marshall critiques representations of black physicality as refracted through racist caricatures. Borrowing from images within popular advertising and blackface minstrelsy, Michael Ray Charles adopts an alternative approach. Controversially, he creates his own stereotypes of black identities in his mixed-media works. 'I developed a fictitious product, "Forever Free",' he asserts, with the aim of presenting a 'loose definition of ideas about freedom' and countering problematic histories of stereotyping and commodification (in Kern-Foxworth, 1997: 26). 'When it comes to interracial relationships, gender issues, stereotyping,' Charles argues, 'those are things that I think people need to deal with but really don't deal with' (Ibid.). His thought-provoking paintings 'deal with' issues people 'really don't deal with' by causing a stir within the white mainstream art world, at the same time that they address assumptions concerning African American art held within black communities. As he explains, '[M]ost blacks have a perception about art by black people. That art by an African-American artist should look a certain way' (Ibid.: 21). By fighting against prescriptive definitions of black art endorsed by black audiences, Charles is one of many contemporary artists determined to extend the repertoire of African American art by destabilising

the enduring power of racist iconography and by reclaiming autonomy as an artist. His insistence that, 'I'm choosing to speak about the African-American experience in a different way', by creating works which are 'talking about the invisible image, the invisible reality', is an apt summary for the multifarious and eclectic practices of many recent artists (Ibid.).

'I'm more in a witness position now,' Laylah Ali explains. 'Not a direct witness. A kind of removed witness' (Ali, n.d.). Works by painter Laylah Ali draw attention to the ways in which contemporary artists explore dislocated histories and dismembered lives with a detachment which suggests that they are a 'kind of removed witness'. In her comic book graphic novel-style works, Ali explores the psychological implications of brutal conflict to provoke emotional responses from her audiences. Full-colour, ghoulish and surreal images such as her comic book, *Untitled* (2002), provide an assortment of powerful vignettes. Refusing to accompany these images with either captions or titles, she gives us no insights into how to read her black silhouetted figures which are strung up, shackled or prostrate on the floor as they brandish belts, guns, ropes and other weapons to signal ongoing cycles of violence. As she explains, 'It's not like one thing happens and you say, "Wow! That was just so terrible," and it will never happen again' (Ibid.). Just as Kara Walker failed to believe in a 'Color Purple scenario' in which all tragedies are resolved, Ali does not flinch from portraying ongoing cycles of struggles and abuse.

Ali's experimental gouaches which depict unending patterns of violence could not be further from works by earlier artists which exalt in a cathartic teleology of racial uplift. By providing 'very little' emphasis on the 'moment when violence occurs', she proves her point that she is 'more interested in what happens before and after' as her figures blur the boundaries between the roles of 'perpetrator', 'victim' and 'negotiator' (Ibid.). Daring and unequivocal, her ambivalent and implicated figures have nothing in common with the iconic, monumental heroes of earlier artists but share a great deal with the subjects of Walker's installations. 'Sometimes, I like to choose situations that have multiple readings,' Ali insists as '[t]hings happen that I didn't anticipate in terms of potential narrative relationships, strands of stories, character motivations' (Ibid.). Laylah Ali's emphasis upon 'multiple readings' resonates with the aesthetic practices of Kara Walker, Michael Ray Charles, Jefferson Pinder and many other emerging artists who experiment with open-ended 'narrative relationships' to tackle taboo tensions in their works.

As Ali argues, she creates 'distilled narratives' not only 'to tell a story' but also to 'hint at something larger than the individual' (Ibid.).

I would like to end this book by turning to the recent works by contemporary performance artist and photographer, Renée Cox. She is as fascinated as Ali with creating artworks which will gesture at 'something larger than the individual'. In one of her earlier works, a startling black-and-white photograph titled, *Do or Die* (1992), Cox includes a nude image of herself standing in front of a brick wall in an abandoned urban environment. Given that her head is bowed and her hands obscure her face, Cox's self-representation seems at first to evoke the praying, begging slave popular in eighteenth- and nineteenth-century abolitionist iconography. The white chains which she wears on both her hands and feet do little to counter this interpretation by symbolising black powerlessness in the face of white brutality. However, on closer inspection, it soon becomes clear that Cox has shaped her hands into clenched fists to communicate the militant rebellion suggested by the Black Power style slogan, 'Do or Die', with which she titles this work.

Thus, in these and other photographs and performance pieces, Renée Cox continues in a tradition established by many other African American artists of inserting their own bodies into their works both as art and as incendiary symbols of political protest. She admits, the 'main inspiration for my work comes from my life experiences. I use myself as a conduit for my photographs because I think that working with the self is the most honest representation of being' (Cox, n.d.: n.p.). In the last few years, Cox has continued in this vein by creating photographs which counter representations of unknown, faceless and anonymous bodies provided in installations such as Jefferson Pinder's *Middle Passage* which opened this epilogue. For example, in her most recent series, *Queen Nanny of the Maroons* (2004), Cox performs as an eighteenth-century African Jamaican female slave warrior, 'Nanny', whom she describes as 'a military expert and symbol of unity and strength to her people' (Ibid.). One of the works in this series, a full-colour photograph titled *Redcoat*, includes a violent image of Cox wearing full military regalia while holding an upraised sword in her clenched fist and staring directly at the viewer. This work is a vivid indictment of Renée Cox's conviction that '[s]lavery stripped black men and women of their dignity and identity and that history continues to have an adverse affect on the African American psyche' (Ibid.). As this book shows, whether we are looking at Dave's poetic couplets delicately etched in clay, the mythic marble sculptures

of Edmonia Lewis, the modernist murals of Aaron Douglas, the 'found object' assemblages of Betye Saar, the body prints of David Hammons, the installations of Jefferson Pinder or even the photographs of Renée Cox, a defining feature of the African American visual arts tradition can be located in the act of remembering and revisualising the lost lives, histories and testimonies of enslaved women, men and children.

Finally, the lack of critical debate surrounding the installations, assemblages, paintings, sculptures, performance and digital art of up-and-coming as well as established African American artists supports James Smalls's conviction that, 'Knowledge and understanding of African American art by the mainstream culture is at an all-time low' (Smalls, 1994: 8). By emphasising the need to 'restore an urgency and viability to African American art scholarship – to at least give it a ghost of a chance', he encapsulates the motivations of black artists as well as the overall purpose of this study (Ibid.). As I argue, the only way in which to give 'African American art scholarship' the 'ghost of a chance' is by agreeing with bell hooks that, 'We must set our imaginations free' (hooks, 1995:4). In closing this book, I would like to give the last word to twentieth-century muralist and painter, John Biggers, grandson of a slave and slave-owner. Biggers's description of how he and fellow artist, Carroll Sims, had to fight the combined forces of ignorance and poverty to create art in the early twentieth century can be mapped on to contemporary struggles. African American artists working today continue to experiment with new art forms and push the boundaries of appropriate subject matter in the fight to 'cut through contrivances, to take off blinders, to rip down veils' and 'understand new truths' (Biggers, 1978: 16).

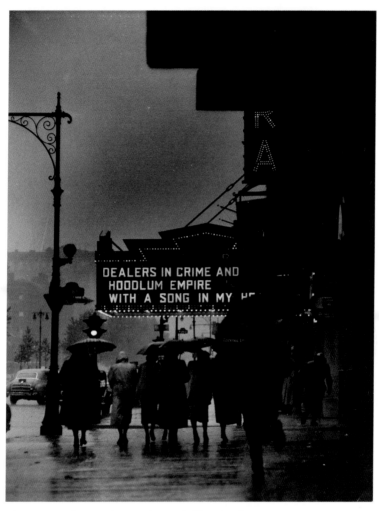

Plate 9 Gordon Parks, *Harlem Neighbourhood*, 1948

Plate 10 Hale Woodruff, *Ancestral Memory*, 1967

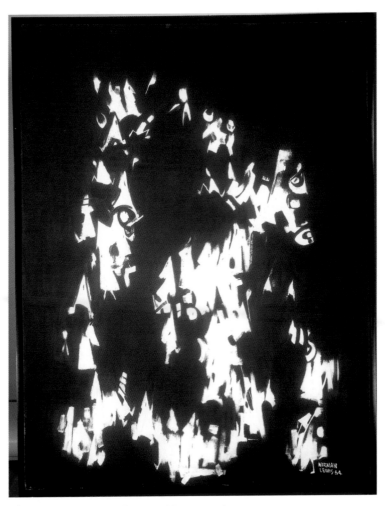

Plate 11 Norman Lewis, *Post Mortem*, 1964

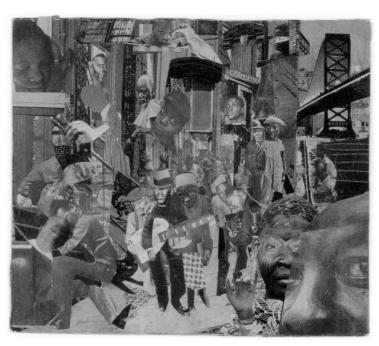

Plate 12 Romare Bearden, *The Street*, 1964

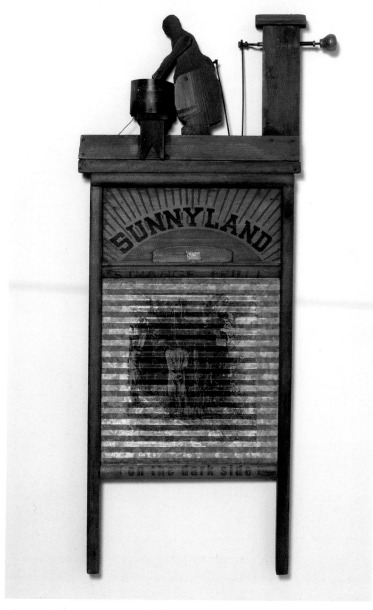

Plate 13 Betye Saar, *Sunnyland (On the Dark Side)*, 1998

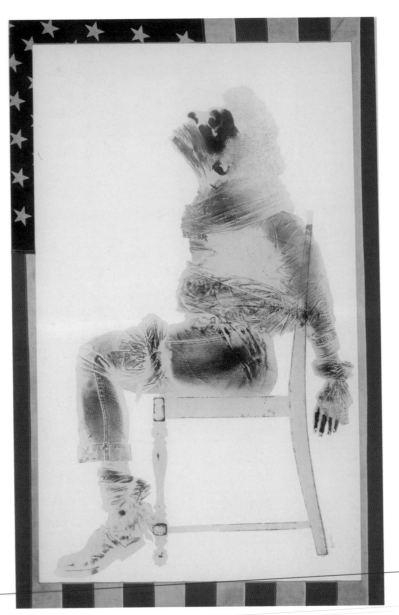

Plate 14 David Hammons, *Injustice Case*, 1970

Plate 15 Howardena Pindell, *Autobiography: Water/Ancestors/Middle Passage/Family Ghosts*, 1988

Plate 16 Kara Walker, *A Means to an End . . . A Shadow Drama in Five Acts*, 1995

Appendix A

Alphabetical list by chapter of additional African American artists for further study

Chapter 1

Edward Mitchell Bannister
Peter Bentzon
Grafton Tyler Brown
Thomas Day
Robert Scott Duncanson
Thomas Gross, Jr
Henry Gudgell
Joshua Johnston
Jules Lion
Scipio Moorhead
Patrick Reason
Philip Simmons
Eugene Warburg
Augustus Washington

Chapter 2

William Artis
Henry Bannarn
Richmond Barthé
Meta Warrick Fuller
Palmer Hayden
Malvin Gray Johnson
Sargent Johnson
William H. Johnson
Loïs Mailou Jones
Edna Manley
Philomene Obin
Nancy Elizabeth Prophet
Augusta Savage
Laura Wheeler Waring
James Lesesne Wells

Chapter 3

David Butler
Claude Clark
Thornton Dial, Sr
Minnie Evans
Henry Luke Faust
James Hampton
Bessie Harvey
Clementine Hunter
Gertrude Morgan
Linda Pettway
Elijah Pierce
Kevin Sampson
Lucy Witherspoon
Annie Mae Young

Chapter 4

Robert Blackburn
Margaret Burroughs
Eldzier Cortor
Renée Cox
Ernest Crichlow
Roy DeCarava
Lyle Ashton Harris

William E. Scott
Lorna Simpson
Hughie Lee-Smith
Dox Thrash
Christian Walker
Carrie Mae Weems
Pat Ward Williams
Deborah Willis
Hale Woodruff
James Van Der Zee

Chapter 5

Benny Andrews
Selma Burke
Barbara Chase-Riboud
Beauford Delaney
Joseph Delaney
Jeff Donaldson
Melvin Edwards
Sam Gilliam
Felrath Hines
Richard Hunt
Wadsworth Jarrell
Al Loving
Mary Lovelace O'Neal
John Outterbridge
Joe Overstreet
Rose Piper

Noah Purifoy
Faith Ringgold
Raymond Saunders
Thelma Johnson Street
Alma Thomas
Bob Thompson
Mildred Thompson

Chapter 6

Dawoud Bey
Camille Billops
Beverly Buchanan
Zoë Charlton
Robert Colescott
Ellen Gallagher
Deborah Grant
Renee Green
Trenton Doyle Hancock
Martha Jackson-Jarvis
Jean Lacy
Glenn Ligon
Valerie Maynard
Willie Robert Middlebrook
Adrian Piper
Carl Robert Pope, Jr
Sandra Rowe
Alison Saar
Renée Stout

Appendix B

Locations for artworks which have not been reproduced in this book

These artworks are listed in the order in which they appear in this book, rather than being in chronological or alphabetical order.

Introduction

Carrie Mae Weems *A Negroid Type / You Became a Scientific Profile / An Anthropological Debate / & A Photographic Subject* (1995–6): http://cuscasdasgajas.blogspot.com/2007_07_01_archive.html

Chapter 1

Dave the Potter, samples of his pots:
http://www.usca.edu/aasc/davepotter.htm

Afro-Carolinian Face Vessel (c.1860). Reproduced in Patton, Sharon F. (1998) *African-American Art*. Oxford: Oxford University Press.

James P. Ball (1896) *Portrait of William Biggerstaff, The Execution of William Biggerstaff, Hanging of William Biggerstaff* and *William Biggerstaff in Coffin*. Reproduced in Willis-Thomas, Deborah (ed.) (1993) *J. P. Ball, Daguerrean and Studio Photographer*. New York: Garland.

Harriet Powers (1886) *Bible Quilt*:
http://www.uwrf.edu/~rw66/minority/minam/afr/oxford/22.jpg

Harriet Powers (1898) *Bible Quilt*:
http://www.uwrf.edu/~rw66/minority/minam/afr/oxford/23.jpg

Edmonia Lewis (1867) *Forever Free*:
http://www.csupomona.edu/~plin/women/images/edmolewis4_big.jpg

Edmonia Lewis (1876) *Death of Cleopatra*:
http://z.about.com/d/womenshistory/1/7/0/J/death_of_cleopatra.jpg

Henry Ossawa Tanner (1893) *The Banjo Lesson*:
http://blogs.princeton.edu/wri152-3/s06/dooreyc/Images/the%20banjo%20olesson.jpg

Henry Ossawa Tanner (1894) *The Thankful Poor*:
http://daphne.palomar.edu/mhudelson/WorksofArt/23PostImp/3545.jpg

Joe Overstreet (1993) *The Door of No Return*. Reproduced in Piché, Jr, Thomas (ed.) (1996) *Joe Overstreet: (Re) call & Response*. New York: Eveson Museum of Art.

Chapter 2

Loïs Mailou Jones (1932) *Ascent of Ethiopia*:
http://negroartist.com/negro%20artist/Lois%20Mailou%20Jones/images/Lois%20Mailou%20Jones%20The%20Ascent%20of%20Ethiopia,%201932,%20oil%20on%20canvas_jpg.jpg

Aaron Douglas (1934) *Aspects of Negro Life*:
The Negro in an African Setting:
http://northbysouth.kenyon.edu/1999/food/neh/finalaspiration.jpg
An Idyll of the Deep South:
http://www.brown.edu/Courses/HA0293/images/Pereira_fig2.jpg
Slavery through Reconstruction:
http://www.ashp.cuny.edu/video/images/douglas.jpg
Song of the Towers:
http://www.artlex.com/ArtLex/a/images/africamer_douglas_song_lg.jpg

Archibald J. Motley, Jr (1963–72) *The First One Hundred Years: He Amongst You Who Is Without Sin Shall Cast the First Stone: Forgive Them Father For They Know Not What They Do*. Reproduced in Robinson, Jontyle T. and Wendy Greenhouse (1991) *The Art of Archibald J. Motley, Jr.* Chicago: Chicago Historical Society.

Charles Alston (1969) *Confrontation*. Reproduced in *African-American Art: 20th Century Masterworks, VII*. New York: Michael Rosenfeld Gallery, 2000: 18. Further reproductions of his works can be found in Wardlaw, Alvia J. (2007) *Charles Alston*. San Francisco: Pomegranate.

Palmer Hayden (c.1939–40) *The Janitor Who Paints*:
http://americanart.si.edu/images/1967/1967.57.28_1b.jpg

Chapter 3

Bill Traylor *Chicken Toter Being Chased* (1939/1942) and *Figures Chasing Bird on Construction* (1940/1942).Reproduced in Helfenstein, Josef and Roman Kurzmeyer (eds.) (1999) *Deep Blues: Bill Traylor 1854-1949*. New Haven: Yale University Press

Bill Traylor (c.1941) *Figure/Construction with Blue Border*:
http://www.news.uiuc.edu/WebsandThumbs/KAM_Traylor-Edmondson/Traylor_constr_B.jpg

William Edmondson (1934–41) *Jack Johnson*:
 http://www.csudh.edu/dearhabermas/karlins6-13-13s.jpg

Horace Pippin (1942) *John Brown Reading His Bible* and *The Trial of John Brown*. Reproduced in Stein, Judith E. (ed.) (1993) *I Tell My Heart: The Art of Horace Pippin*. Philadelphia: Universe Publishing.

Horace Pippin (c.1945) *The Barracks*. Reproduced in Stein, Judith E. (ed.) (1993) *I Tell My Heart: The Art of Horace Pippin*. Philadelphia: Universe Publishing.

Jacob Lawrence (1941) *The Migration of the Negro*. All sixty panels are reproduced in Turner, Elizabeth Hutton (ed.) (1993) *Jacob Lawrence: The Migration Series*. Washington, DC: Rappahannock Press.

William H. Johnson (1945) *Nat Turner*:
 http://americanart.si.edu/images/1967/1967.59.658_1b.jpg

Chapter 4

Charles White (1969–71) *Wanted Poster Series*. A selection of these works are reprinted in Barnwell, Andrea D. (2002) *Charles White*. San Francisco: Pomegranate; Bearden, Romare and Harry Henderson (1993) *A History of African-American Artists: from 1792 to the Present*. New York: Pantheon Books; and *Freedomways: [Special Issue on Charles White]*, 20, no. 3.

Elizabeth Catlett (1946–7) '*I have given the world my songs*':
 http://library.georgetown.edu/advancement/newsletter/68/images/blues68.jpg The complete series is reproduced in Herzog, Melanie (2005) *Elizabeth Catlett: In the Image of the People*. Chicago: Art Institute of Chicago.

Gordon Parks (1942) *American Gothic*:
 http://upload.wikimedia.org/wikipedia/commons/thumb/9/94/Gordon_Parks_-_American_Gothic.jpg/424px-Gordon_Parks_-_American_Gothic.jpg

Gordon Parks (1948) *Gang Warfare Series*. Reproduced in Parks, Gordon (1997) *Half Past Autumn: A Retrospective*. Boston, MA: Little, Brown and Co.

Gordon Parks (1956) *Willy Causey and Family Series*. Reproduced in Parks, Gordon (1997) *Half Past Autumn: A Retrospective*. Boston, MA: Little, Brown and Co.

Gordon Parks (1968) *Fontenelle Family Series*. Reproduced in Parks, Gordon (1997) *Half Past Autumn: A Retrospective*. Boston, MA: Little, Brown and Co.

Chapter 5

Norman Lewis (1946) *Fantasy*. Reproduced in Gibson, Ann E. (ed.) (1989) *Norman Lewis: From the Harlem Renaissance to Abstraction*. New York:

Kenkeleba Gallery: 34. The majority of Norman Lewis's 'Civil Rights Paintings' have been reproduced in Gibson, Ann (ed.) (1998) *Norman Lewis: Black Paintings 1946–1977*. Harlem: Studio Museum.

Romare Bearden (1978) *Mecklenburg County, Railroad Shack Sporting House*. Reproduced in Fine, Ruth (2003) *The Art of Romare Bearden*. Washington, DC: National Gallery of Art. Romare Bearden's 1960s photomontage projections have all been reproduced in Gelburd, Gail and Thelma Golden (1997) *Romare Bearden in Black-and-White: Photomontage Projections (1964)*. New York: Harry N. Abrams.

Betye Saar (1971–2) *Sambo's Banjo*:
http://www.umma.umich.edu/images/view/2005/saar_sambo.jpg
Reproductions of works from Betye Saar's series, *Workers and Warriors* can be found in Saar, Betye (1999) *Workers and Warriors, The Return of Aunt Jemima*. New York: Michael Rosenfeld Gallery.

Emma Amos (1995) *Measuring Measuring*. Reproduced as the front cover in Farrington, Lisa (2005) *Creating their Image: History of African-American Women Artists*. Oxford: Oxford University Press.

Chapter 6

Kara Walker (1997) *Middle Passage*. Reproduced in Dixon, Annette (ed.) (2002) *Kara Walker: Pictures from another Time*. Ann Arbor: University of Michigan Museum of Art.

David Hammons (1983) *Bliz-aard Ball Sale*:
http://www.schulden.ch/mm/hammons.gif

Howardena Pindell (1980) *Free, White, and 21*:
http://www.keith-miller.com/curatorial/theotherself/jesseimages/howardenaimage.jpg
The full text of this video is reprinted in Sims, Lowery Stokes (ed.) (1997) *The Heart of the Question: The Writings and Paintings of Howardena Pindell*. New York: Midmarch Arts Press.

Howardena Pindell (1980s) *Autobiography Series*. Reproduced in Sims, Lowery Stokes (ed.) (1992) *Howardena Pindell: Paintings and Drawings, A Retrospective Exhibition, 1972–1992*. New York: Roland Gibson Gallery.

Kara Walker (1998) *Letter from a Black Girl*. Reproduced in Dixon, Annette (ed.) (2002) *Kara Walker: Pictures from another Time*. Ann Arbor: University of Michigan Museum of Art: 96.

Debra Priestly (2002) *Strange Fruit 2*:
http://debrapriestly.net/page4/files/page4-1030-full.html

Epilogue

Jefferson Pinder (2005) *Middle Passage*:
 http://home.mindspring.com/~toughskins/mixed/mixedone/mixedone.
 html

Jefferson Pinder (2003) *Bound History*:
 http://home.mindspring.com/~toughskins/mixed/mixedtwo/mixedtwo.
 html

Kerry James Marshall (1985) *Two Invisible Men Naked*. Reproduced in Smith, Deborah (ed.) (2005) *Along the Way: Kerry James Marshall*. London: Camden Arts Centre.

Michael Ray Charles (1994) *Forever Free [Beware]*:
 http://www.albrightknox.org/Past_Exhibitions/1990s/MRCharles/
 BEWARE.JPG. Other works in this series are reproduced in Kern-Foxworth, Marilyn (1997) *1989–1997 Michael Ray Charles An American Artist's Work*. Texas: Texas Fine Arts Association.

Laylah Ali (2002) *Untitled*. Reproduced in Ali, Laylah (2002) *Projects 75: Laylah Ali*. New York: Museum of Modern Art.

Sources and Further Reading

Archives

The Papers of African American Art, Smithsonian Archives of American Art. (www.aaa.si.edu/guides/pastguides/afriamer/afamguid.htm/)
Special Collections, Fisk University (www.fisk.edu/)
Special Collections, Hampton University (www.hamptonu.edu/)
Schomburg Center for Research in Black Culture (www.nypl.org/research/sc/sc.html/)
Studio Museum in Harlem (www.studiomuseum.org/)

Galleries and Museums

Private

ACA Gallery (www.acagallery.com/)
Bill Hodges (www.billhodgesgallery.com/)
June Kelly (www.junekellygallery.com/)
Kenkeleba Gallery
Michael Rosenfeld (www.michaelrosenfeldart.com/)

Public

Ackland Art Museum (www.ackland.org/)
African American Museum in Philadelphia (http://www.aampmuseum.org/home/)
National Museum of African Art (www.nmafa.si.edu/)
American Folk Art Museum (www.folkartmuseum.org/)
Amistad Research Center (http://www.amistadresearchcenter.org/arc-art.htm)
Anacostia Community Museum (anacostia.si.edu/)
Art Institute of Chicago (www.artic.edu/)
California African American Museum (www.caamuseum.org/)
Carl Van Vechten and Aaron Douglas Galleries, Fisk University (www.fisk.edu/)
Clark Atlanta University Art Galleries (www.cau.edu/art_gallery/)

David C. Driskell Collection, University of Maryland (www.artgallery.umd. edu/driskell/)

Detroit Institute of the Arts (www.dia.org/)

Hampton University Museum (www.hamptonu.edu/museum/)

Howard University Art Collection (www.howard.edu/library/Art@Howard/ HUCollection/)

Los Angeles County Museum of Art (collectionsonline.lacma.org/)

Metropolitan Museum of Art (www.metmuseum.org/)

Museum of Modern Art (www.moma.org/)

North Carolina Central University Museum (www.nccu.edu/artmuseum/)

Savery Library, Talladega College (www.talladega.edu/prep_st/sav_lib.htm/)

Smithsonian American Art Museum (americanart.si.edu/index3.cfm/)

Studio Museum in Harlem (www.studiomuseum.org/)

Walker Art Center (collections.walkerart.org/index.html/)

Walter O. Evans Foundation (www.walteroevansfoundation.org/)

Bibliographies and Journals

Davis, Lenwood G. (1980) *Black Artists in the United States: An Annotated Bibliography*. Westport, CT: Greenwood Press.

Harris, Juliette (ed.) (1984–present) *International Review of African American Art [IRAAA]*. Hampton: Hampton University Museum. Formerly *Black Art* (1976–84).

Otfinoski, Steven (2003) *African Americans in the Visual Arts*. New York: Facts on File Inc.

Archival Collections at the Smithsonian Archives of American Art

Charles Alston Papers (CAP) – Reels N/70–23, 4222–23.

Romare Bearden Papers(RBP) – Reels N68–87 and Unmicrofilmed Materials (*URBP*) (Can be viewed online at: http://www.aaa.si.edu/collectionsonline/).

Elizabeth Catlett Papers (ECP) – Reel 2249.

Aaron Douglas Papers (ADP) – Reels 4520, 4521–4523.

William Johnson Papers (WJP) – Reels 2678, 3829.

Jacob Lawrence and Gwendolyn Knight Papers (JLP and GKP) – Unmicrofilmed Materials (*UJLP*), Reels D286, 4571–73.

Archibald J. Motley, Jr Papers (AMP) – Reel 3161.

Horace Pippin Papers (HPP) – Reel 4018, 138.

Henry Ossawa Tanner Papers (HTP) – Reels D306, D307, 107.

Charles Wilbur White Papers (CWP) – Unmicrofilmed Materials (*UCWP*) and Reels LA7, 2041, 3099, 3189–95.

Hale A. Woodruff Papers (HWP) – Reels N70–60, 4222.

Audio Visual Materials

Against the Odds: The Artists of the Harlem Renaissance. New Jersey Network: PBS Home Video, 1994.

The Art of Romare Bearden. Washington, DC: National Gallery of Art and Home Vision Entertainment, 2003.

Babcock, Grover and Elvin Whitesides (1993) *Jacob Lawrence: An Intimate Portrait*. Museum Associates: Los Angeles County Museum of Art.

Basquiat: An Interview. Art/New york-Inner-Tube Video, 1989.

Carey, Celia (2004) *The Quiltmakers of Gee's Bend*. Alabama: PBS Alabama Public Television.

Edwards, Amber (1994) *Against the Odds: The Artists of the Harlem Renaissance*. New Jersey Network: PBS Home Video.

Freeman, Linda and David Irving (1998) *Betye and Alison Saar: Conjure Women of the Arts*. New York: L & S Video.

Freeman Linda and David Irving (1998) *Horace Pippin: There Will Be Peace*. New York: L & S Video.

Freeman, Linda and David Irving (1998) *Howardena Pindell: Atomizing Art*. New York: L & S Video.

Freeman, Linda and David Irving (1988) *Jacob Lawrence: the Glory of Expression*. New York: L & S Video.

Freeman, Linda and David Irving (1998) *Romare Bearden: Visual Jazz*. New York: L & S Video.

Moore, Carroll (2003) *The Art of Romare Bearden*. HRH Foundation: National Gallery of Art.

Rice, Craig and Lou Potter (2000) *Half-Past Autumn: The Life and Works of Gordon Parks*. HBO Video.

Sollins, Susan and Susan Dowling (2003) *Art 21: Art in the Twenty-First Century*. Seasons 1 and 2. PBS Home Video.

Sollins, Susan and Susan Dowling (2005) *Art 21: Art in the Twenty-First Century*. Season 3. PBS Home Video.

History and Criticism

Adams, Marie Jeanne (1983) 'The Harriet Powers Pictorial Quilts', in Ferris, William (ed.) *Afro-American Folk Art and Crafts*. Boston, MA: G. K. Hall: 67–76.

Ahearn, Charlie (1991) '"Tragic Magic" Sparks Hammons Retrospective at P.S.1'. *The City Sun*, January 16–22: 25.

Alexander, Elizabeth (2003) 'The Genius of Romare Bearden' in Hill, Grant (ed.) *Something All Our Own: The Grant Hill Collection of African American Art*. Durham, NC: Duke University Press: 56–77.

Ali, Laylah (2001–7) 'Portraiture, Performance and Violence': http://www.pbs.org/art21/artists/ali/clip1.html

Ali, Laylah (2002) *Projects 75: Laylah Ali*. New York: Museum of Modern Art.

Amaki, Amalia K. and Andrea Barnwell Brownlee (eds) (2007) *Hale Woodruff, Nancy Elizabeth Prophet and the Academy*. Seattle: University of Washington Press.

Ames, Winslow (1940) 'Contemporary American Artists: Richmond Barthé'. *Parnassus*, 12, no. 3: 10–17.

Araeen, Rasheed (2004) 'The Success and the Failure of Black Art'. *Third Text*, 18, no. 2: 135–52.

Arnett Paul and William Arnett (eds) (1999–2001) *Souls Grown Deep: African American Vernacular Art of the South*. Atlanta: Tinwood Books. 2 vols.

Arnett, Paul and William Arnett et al. (eds) (2006) *Gee's Bend: The Architecture of the Quilt*. Atlanta: Tinwood Books.

Arnould-Taylor, William E. and Harriet G. Warkel (eds) (1996) *A Shared Heritage: Art by Four African Americans*. Indiana: Indiana University Press.

Ater, Renée (2007) 'Creating a "Usable Past" and a "Future Perfect Society": Aaron Douglas's Murals for the 1936 Texas Centennial Exposition' in Earle, Susan (ed.) *Aaron Douglas: African American Modernist*. New Haven: Yale University Press: 95–113.

Atkinson, Edward J. (ed.) (1971) *Black Dimensions in Contemporary Art*. New York: New American Library.

Barnwell, Andrea D. (1996) 'Been to Africa and Back: Contextualising Howardena Pindell's Abstract Art'. *IRAAA*, 13, no. 3: 43–9.

Barnwell, Andrea D. (2000) *The Walter O. Evans Collection of African American Art*. Seattle: University of Washington Press.

Barnwell, Andrea D. (2002) *Charles White*. San Francisco: Pomegranate.

Barrett-White, Frances with Anne Scott (1994) *Reaches of the Heart*. New York: Barricade Books.

Barrie, Dennis (23 January 1978) 'Archibald J. Motley, Jr.', transcript, Archives of American Art, Smithsonian Institution: http://www.aaa.si.edu/collections/oralhistories/transcripts/motley78.htm

Bearden, Romare (1969) 'The Black Artist in America: A Symposium'. *Metropolitan Museum of Art Bulletin*, 27, no. 5 (January): 245–60.

Bearden, Romare and Harry Henderson (1993) *A History of African-American Artists: from 1792 to the Present*. New York: Pantheon Books.

Beardsley, John and William Arnett et al. (eds) (2002) *The Quilts of Gee's Bend*. Atlanta: Tinwood Books.

Berger, Maurice, Brian Wallis and Simon Watson (eds) (1996) *Constructing Masculinity*. New York: Routledge.

Berger, Maurice (1993) *How Art Becomes History*. Colorado: Westview Press.

Berger, Maurice (ed.) (1994) *Modern Art and Society: An Anthology of Social and Multicultural Readings*. Colorado: Westview Press.

Berman, Avis (31 July 1980) 'Interview with Romare Bearden', transcript, Archives of American Art, Smithsonian Institution.

Berman, Avis (20 July 1982) 'Interview with Jacob Lawrence', transcript, Archives of American Art, Smithsonian Institution.

Bernier, Celeste-Marie (2007) '"My Art Speaks for Both My Peoples": Transnationalism, African American Visual Culture and the New American Studies' in Izzo Donatella, Giorgio Mariani and Paola Zaccaria (eds) *American Solitudes: Individual, National, Transnational*. Roma: Carocci Editore.

Berry, Ian (ed.) (2003) *Kara Walker: Narratives of a Negress*. Cambridge, MA: MIT Press.

Biggers, John and Carroll Sims with John Edward Weems and Donald Weismann (1978) *Black Art in Houston: The Texas Southern University Experience*. London: Texas A & M University Press.

Biggers, John and Alvia Short (1979) 'Contribution of the Negro Woman To American Life and Education: A Mural'. *Callaloo*, 5: 127–34.

Blodgett, Geoffrey (1968) 'John Mercer Langston and the Case of Edmonia Lewis: Oberlin, 1862'. *The Journal of Negro History*, 53, no. 3 (July): 201–18.

Boime, Albert (1993) 'Henry Ossawa Tanner's Subversion of Genre'. *Art Bulletin*, 75, no. 3: 415–42.

'The Booklist Interview: Jacob Lawrence'. (1994) *Booklist*, 90, no. 12. (15 February): 1048–9.

Boyden, Martha, (1994) 'David Hammons and Martha Boyden: A Conversation' in Rothschild, Deborah Menaker (ed.) *Yardbird Suite*. Williamstown: Williams College Museum of Art: 60–8.

Brawley, Benjamin (1934) *The Negro in Literature and Art in the United States*. New York: Dodd Mead and Co.

Brenson, Michael et al. (1993) *Melvin Edwards Sculpture: A Thirty-Year Retrospective 1963–1993*. New York: Neuberger Museum of Art.

Brenson, Michael (2003) 'Form that Achieves Sympathy: A Conversation with Elizabeth Catlett'. *Sculpture*, 22, no. 3 (April): http://www.sculpture.org/documents/scmag03/apr03/catlett/cat.shtml

Brown, Timothy (2002) 'The Black Male: Ritual Violence and Redemption'. *Third Text*, 16, no. 2: 183–93.

Brown, William Wells (1853) *Clotel: or, the President's Daughter* in Farrison, William E. (ed.) (1969). New York: Carol Publishing.

Browne, Vivian (1974) 'Interview with Norman Lewis'. Rpt. (1999) *Artist and Influence*, XVIII: 71–91.

Bruce, Marcus (2002) *Henry Ossawa Tanner: A Spiritual Biography*. New York: Crossroad Publishing.

Buick, Kirsten P. (1995) 'The Ideal Works of Edmonia Lewis: Invoking and Inverting Autobiography'. *American Art*, 9, no. 2: 4–19.

Burke, Daniel (1988) 'Henry Ossawa Tanner's "La Sainte-Marie"'. *Smithsonian*

Studies in American Art, 2, no. 2: 64–73.

Burrison, John A. (1983) 'Afro-American Folk Pottery in the South' in Ferris, William (ed.) *Afro-American Folk Art and Crafts*. Boston, MA: G. K. Hall.

Butcher, Margaret (1969) *The Negro in American Culture*. New York: Alfred A. Knopf.

Cahan, Susan and Pamela R. Metzger (2005) *Carrie Mae Weems: The Louisiana Project*. Seattle: University of Washington Press.

Campbell, Mary Schmidt (ed.) (1979) *Hale Woodruff: Fifty Years of his Art*. New York: Studio Museum in Harlem.

Campbell, Mary Schmidt and Sharon Patton (1991) *Memory and Metaphor: Art of Romare Bearden, 1940–87*. New York: Oxford University Press.

Campbell Mary Schmidt (ed.) (1994) *Harlem Renaissance: Art of Black America*. New York: Harry N. Abrams.

Canon, Steve (ed.) (1991) *David Hammons: Rousing the Rubble*. Cambridge, MA: MIT Press.

Carpenter, Jane H. (2003) *Betye Saar*. San Francisco: Pomegranate.

Cash, Floris (1995) 'Kinship and Quilting: An Examination of an African-American Tradition'. *Journal of Negro History*, 80, no. 1: 30–41.

Cash, Floris (2004) 'Charles Alston – An Appreciation'. *IRAAA*, 19, no. 4: 28–41.

Chase, Judith W. (1971) *Afro-American Art and Craft*. New York: Van Nostrand Reinhold.

Cheim, John (ed.) (1990) *Basquiat Drawings*. New York: Robert Miller Gallery.

Cliff, Michelle (1987) 'Object into Subject: Some Thoughts on the Work of Black Women Artists' in Robinson, Hilary (ed.) *Visibly Female: Feminism and Art*. London: Camden Press: 140–57.

Clothier, Peter (1980) 'The Story of White's Art is the Story of a Struggle'. *Freedomways: [Special Issue on Charles White]*, 20, no. 3: 138–44.

Coker, Garvin (1990) 'Charles Alston: The Legacy' in Henderson, Harry et al. (1990) *Charles Alston, Artist and Teacher*. New York: Kenkeleba House.

Coleman, Floyd (1994) 'Black Colleges and the Development of an African American Visual Arts Tradition'. *IRAAA*, 2. no. 3: 31–8.

Coleman, Floyd (2003) 'African American Art Then and Now: Some Personal Reflections'. *American Art*, 17, no. 1: 23–5.

Collins, Lisa Gail (2002) *The Art of History: African American Women Artists Engage the Past*. New Brunswick, NJ: Rutgers University Press.

Collins, L. M. (16 July 1971) 'Interview with Aaron Douglas', 16 July 1971, transcript, Fisk University, Franklin Library Special Collections.

Conwill, Kinshasha H. (1991) 'In Search of an "Authentic" Vision: Decoding the Appeal of the Self-Taught African-American Artist'. *American Art*, 5, no. 4: 2–9.

Conwill, Kinshasha H. (1991) *Memory and Metaphor: The Art of Romare Bearden 1940–1987*. Oxford: Oxford University Press.

Conwill, Kinshasa H. (1998) 'Introduction: The Importance of Being Norman' in Gibson, Ann (ed.) *Norman Lewis: Black Paintings 1946–1977*. Harlem: Studio Museum: 9–10.

Conwill, Kinshasa H. and Arthur C. Danto et al. (2002) *Testimony: Vernacular Art of the African-American South*. New York: Harry N. Abrams.

Cousins, Harold et al. (1974) 'Is there a Black Aesthetic?' *Leonardo*, 7, no. 2: 188–9.

Cox, Camilla (2006) 'Unearthing Resistance: African American Cultural Artefacts in the Antebellum Period' *U.S. Studies Online*, 8 (Spring): http://www.baas.ac.uk/resources/usstudiesonline/article.asp?us=8&id=6

Cox, Renée (n.d.) 'Feminist Art Statement': http://www.brooklynmuseum.org/eascfa/feminist_art_base/gallery/renee_cox.php

Craven, David (1998) 'Norman Lewis as Political Activist and Post-Colonial Artist' in Gibson, Ann (ed.) *Norman Lewis: Black Paintings 1946–1977*. Harlem: Studio Museum: 51–60.

Dallow Jessica and Barbara C. Matilsky (eds) (2005) *Family Legacies: The Art of Betye, Lezley, and Alison Saar*. Seattle: University of Washington Press.

D'Arcy, David (2006). 'The Eyes of the Storm: Kara Walker on Hurricanes, Heroes and Villains'. *Modern Painters: International Arts and Culture* (April): 54–61.

Davis, Donald F. (1984) 'Aaron Douglas of Fisk: Molder of Black Artists'. *Journal of Negro History*, 69, no. 2: 95–9.

Davis, Donald F. (1984) 'Hale Woodruff of Atlanta: Molder of Black Artists'. *Journal of Negro History*, 69, no. 3/4: 147–54.

DeCarava, Roy and Langston Hughes (1955) *The Sweet Flypaper of Life*. New York: Simon and Schuster.

Dent, Gina (ed.) (2000) *Black Popular Culture: A Project by Michele Wallace*. New York: New Press.

Dixon, Annette (ed.) (2002) *Kara Walker: Pictures from Another Time*. Ann Arbor: University of Michigan Museum of Art.

Donaldson, Jeff (1970) '10 in Search of a Nation'. *Black World* (October): 80–9.

Donaldson, Jeff (1980) 'TransAfrican Art'. *Black Collegian*, 11 (October/November): 90–101.

Doud, Richard (1964) 'Interview with Gordon Parks'. Smithsonian Archives of American Art: Oral History Project.

Douglass, Frederick (1985) 'Pictures and Progress: An Address Delivered in Boston, Massachusetts, on 3 December 1861' in Blassingame, John W. (ed.) *The Frederick Douglass Papers*. New Haven: Yale University Press, vol. 3: 452–73.

Douglass, Frederick (1849) 'A Tribute for the Negro' in Foner, Philip (ed.) (Rpt. 1975) *Life and Writings of Frederick Douglass*. New York: International Publisher, vol. 1: 379–84.

Dover, Cedric (1960) *American Negro Art*. London: Studio Books.

Doy, Gen (2000) *Black Visual Culture: Modernity and Post-Modernity*. London: I. B. Tauris.

Driskell, David C. (1976) *Two Centuries of Black American Art: 1750–1950*. New York: Alfred A. Knopf.

Driskell, David C. (1994) 'The Flowering of the Harlem Renaissance: the Art of Aaron Douglas, Meta Warrick Fuller, Palmer Hayden and William H. Johnson' in Campbell, Mary S. *Harlem Renaissance: Art of Black America*. New York: Harry N. Abrams: 105–54.

Driskell, David C. (ed.) (1995) *African American Visual Artists: A Postmodernist View*. Washington, DC: Smithsonian Institution Press.

Driskell, David C. (2001) *The Other Side of Color*. San Francisco: Pomegranate.

Driskell, David C. (2007) 'Some Observations on Aaron Douglas as Taste-maker in the Renaissance Movement' in Earle, Susan (ed.) *Aaron Douglas: African American Modernist*. New Haven: Yale University Press: 87–93.

Du Bois, W. E. B. (1926) 'Criteria of Negro Art'. *Crisis*, 32, no. 6 (October): 290–7.

Du Bois, W. E. B. (1941) 'The Saga of L'Amistad'. *Phylon* 2, no. 1: 1–4.

Dunbar, Paul Laurence (1913) 'We Wear the Mask' in *The Collected Poetry of Paul Laurence Dunbar*. Rpt. (ed.). Braxton, Joanne (1993). Virginia: University of Virginia Press: 71.

Earle, Susan (ed.) (2007) *Aaron Douglas: African American Modernist*. New Haven: Yale University Press.

Ellison, Ralph (2003) 'The Art of Romare Bearden'. Rpt. in Callahan, John (ed.) *The Collected Essays of Ralph Ellison*. New York: Modern Library.

English, Darby, (2003) 'This is not about the Past: Silhouettes in the Work of Kara Walker' in Berry, Ian (ed.) *Kara Walker: Narratives of a Negress*. Cambridge, MA: MIT Press: 141–67.

Everett, Gwen (2003) *African American Masters: Highlights from the Smithsonian American Art Museum*. New York: Harry N. Abrams.

Farrington, Lisa (2004) 'Reinventing Herself: The Black Female Nude'. *Woman's Art Journal*, 24, no. 2 (2003–4): 15–23.

Farrington, Lisa (2005) *Creating their Image: History of African-American Women Artists*. Oxford: Oxford University Press.

Farris, John and Ulnich Loock (1997) *David Hammons, Blues and the Abstract Truth*. Bern: Die Kunsthalle.

Fax, Elton (1971) *Seventeen Black Artists*. New York: Dodd and Mead.

Fax, Elton (1977) *Black Artists of the New Generation*. New York: Dodd and Mead.

Ferguson, Leland (1992) *Uncommon Ground: Archaeology and Early African America 1650–1800*. Washington, DC: Smithsonian Books.

Ferris, William (ed.) (1983) *Afro-American Folk Art and Crafts*. Boston, MA: G. K. Hall.

Fine, Elsa Honig (1969) 'The Afro-American Artist: A Search for Identity'. *Art Journal*, 29, no. 1: 32–5.

Fine, Elsa Honig (1971) 'Mainstream, Blackstream and the Black Art Movement'. *Art Journal*, 30, no. 4: 374–5.

Fine, Elsa Honig (1973) *Afro-American Artist*. Dallas: Brown Book Co.

Fine, Ruth (2003) *The Art of Romare Bearden*. Washington, DC: National Gallery of Art.

Fine, Ruth and David C. Driskell (2004) *Romare Bearden*. San Francisco: Pomegranate.

Finkelpearl, Tom (1991) 'On the Ideology of Dirt' in Canon, Steve (ed.) *David Hammons: Rousing the Rubble*. Cambridge, MA: MIT Press: 61–91.

Firstenberg, Lauri Firstenberg (2001) 'Neo-Archival and Textual Modes of Production: An Interview with Glenn Ligon'. *Art Journal*, 60, no. 1 (Spring): 42–7.

Fitzgerald, Sharon G. (1980) 'Charles White in Person'. *Freedomways [Special Issue on Charles White]*, 20, no. 3: 158–62.

Freeman, Roland L. (1996) *A Communion of the Spirits: African-American Quilters, Preservers and their Stories*. Tennessee: Rutledge Hill Press.

Freeman, Rusty (2000) 'Community Heroes in the Sculpture of William Edmondson' in Thompson, Robert Farris, Bobby L. Lovett and Rusty Freeman et al. *The Art of William Edmondson*. Jackson: University Press of Mississippi: 38–44.

Fry, Gladys-Marie (2001) *Stitched from the Soul: Slave Quilts from the Ante-Bellum South*. Durham, NC: University of North Carolina Press.

Fuller, Edmund L. (1973) *Visions in Stone: The Sculpture of William Edmondson*. Pittsburgh: University of Pittsburgh Press.

Gaither, Edmund B. (1996) 'The Mural Tradition' in Arnould-Taylor, William E. and Harriet G. Warkel (eds) *A Shared Heritage: Art by Four African Americans*. Indiana: Indiana University Press, 1996: 124–42.

Gallo, Ruben and Lucia Fiol-Matta (2003) *New Tendencies in Mexican Art*. Hampshire: Palgrave Macmillan.

Gates, Jr, Henry Louis (1994) 'The Face and Voice of Blackness in Berger, Maurice (ed.) *Modern Art and Society: An Anthology of Social and Multicultural Readings*. Colorado: Westview Press: 51–72.

Gelburd, Gail and Thelma Golden (1997) *Romare Bearden in Black-and-White: Photomontage Projections (1964)*. New York: Harry N. Abrams.

Ghent, Henri (14 July 1968a) 'Interview with Norman Lewis', transcript, Archives of American Art, Smithsonian Institution: http://www.aaa.si.edu/collections/oralhistories/transcripts/lewisn68.htm

Ghent, Henri (29 June 1968b) 'Interview with Romare Bearden', transcript,

Archives of American Art, Smithsonian Institution: http://www.aaa.
si.edu/collections/oralhistories/transcripts/bearde68.htm

Gibson, Ann E. (ed.) (1989) *Norman Lewis: From the Harlem Renaissance to
Abstraction*. New York: Kenkeleba Gallery.

Gibson Ann E. (1990) *Issues in Abstract Expressionism*. Ann Arbor: UMI
Research Press.

Gibson, Ann (ed.) (1998) *Norman Lewis: Black Paintings 1946–1977*. Harlem:
Studio Museum.

Gibson, Ann E. (1998–9) 'Diaspora and Ritual: Norman Lewis's Civil Rights
Paintings'. *Third Text*, 45: 29–44.

Gibson, Ann E. (1999) *Abstract Expressionism: Other Politics*. New Haven: Yale
University Press.

Gilman, Sander L. (2007) 'Confessions of an Academic Pornographer' in
Gilman, Sander L. et al. *Kara Walker: My Complement, My Enemy, My
Oppressor, My Love*. Ostfildern: Hatje Cantz Verlag: 27–35.

Gilman, Sander L. et al. (2007) *Kara Walker: My Complement, My Enemy, My
Oppressor, My Love*. Ostfildern: Hatje Cantz Verlag.

Glazer, Lee Stephens (1994) 'Signifying Identity: Art and Race in Romare
Bearden's Projections'. *The Art Bulletin*, 76, no. 3: 411–26.

Golden, Thelma (ed.) (1998) *Bob Thompson*. New York: Whitney Museum of
American Art.

Golden, Thelma (2002) 'Thelma Golden/Kara Walker: A Dialogue' in Dixon,
Annette (ed.) *Kara Walker: Pictures From Another Time*. Michigan: Univer-
sity of Michigan Museum of Art: 43–9.

Golden, Thelma and Kellie Jones et al. (eds) (2002) *Lorna Simpson*. New York:
Phaidon Press.

Golden, Thelma et al. (ed.) (2006) *Energy/Experimentation: Black Artists and
Abstraction 1964–1980*. New York: Studio Museum, 2006.

Gouma-Peterson, Thalia (1983) 'Elizabeth Catlett: The Power of Human
Feeling and of Art'. *Women's Art Journal*, 4, no. 1 (Spring/Summer): 48–56.

Grant, Nathan (1989) 'Image and Text in Jacob Lawrence'. *Black American
Literature Forum*, 23, no. 3: 523–37.

Graulich, Melodie and Mara Witzling (2001) 'The Freedom to Say What She
Wants: A Conversation with Faith Ringgold' in Bobo, Jacqueline (ed.) *Black
Feminist Cultural Criticism*. Oxford: Blackwell Publishers, 2001: 184–209.

Green, Jr, Carroll (26 October 1968) 'Interview with Jacob Lawrence',
transcript, Archives of American Art, Smithsonian Institution: http://www.
aaa.si.edu/collections/oralhistories/transcripts/lewisn68.htm

Greene, Jr, Carroll (1987) *American Visions: Afro-American Art – 1986*.
Washington, DC: Visions Foundation.

Greenhouse, Wendy (1998) 'An Early Portrait by Archibald Motley, Jr.'.
American Art Journal, 29, no. 1/2: 97–102.

De Groft, Aaron (1998) 'Eloquent Vessels/Poetics of Power: The Heroic Stoneware of "Dave the Potter". *Winterthur Portfolio*, 33, no. 4: 249–60.

Gruber, Richard J. (ed.) (1997) *American Icons: From Madison to Manhattan, the Art of Benny Andrews, 1948–1997*. Georgia: Morris Museum of Art.

Gundaker Grey (2000) 'William Edmondson's Yard' in Thompson, Robert Farris, Bobby L. Lovett and Rusty Freeman et al. *The Art of William Edmondson*. Jackson: University Press of Mississippi: 61–70.

Halbreich, Kathy (2007) 'Foreword' in Gilman, Sander L. et al. *Kara Walker: My Complement, My Enemy, My Oppressor, My Love*. Ostfildern: Hatje Cantz Verlag: 1–3.

Hall, James (2001) *Mercy, Mercy Me: African American Culture and the American Sixties*. Oxford: Oxford University Press.

Hammons, David (1986) 'Artviews: David Hammons: In His Own Words': http://www.heyokamagazine.com/HEYOKA.2.ARTVIEWS.HAMMONS.htm

Hammons, David (n.d.) 'Interview': http://www.brown.edu/Departments/MCM/people/cokes/Hammons.html

Hammons, David (1991) 'A Dream Walking' in Stein, Jean (1995) *Grand Street: New York*. New York: Distributed Art Publishers.

Hanks, Eric (2002) 'Journey From The Crossroads: Palmer Hayden's Right Turn'. *IRAAA*, 16, no. 1: 30–42.

Hannaham, James (1998) 'Pea, ball, bounce – artist Kara Walker – Interview': http://findarticles.com/p/articles/mi_m1285/is_n11_v28/ai_21248654

Hansen, Joyce and Gary McGowan (1998) *Breaking Ground, Breaking Silence: The Story of New York's African Burial Ground*. New York: Henry Holt and Co.

Harper, Jennifer J. (1992) 'The Early Religious Paintings of Henry Ossawa Tanner: A Study of the Influences of Church, Family, and Era', *American Art*, 6, no. 4: 68–85.

Harris, Michael D. (1990) 'Ritual Bodies – Sexual Bodies: The Role and Presentation of the body in African-American Art'. *Third Text*, 12: 81–95.

Harris, Michael D. (2003) *Colored Pictures*. Chapel Hill: University of North Carolina Press.

Hartigan, Lynda Roscoe (2000) 'Going Urban: American Folk Art and the Great Migration'. *American Art*, 14, no. 2: 26–51.

Hayden, Palmer C. (1969) *The Legend of John Henry*. Pittsburgh: University of Pittsburgh.

Hayden, Palmer C. (1974) *Southern Scenes and City Streets*. New York: Studio Museum.

Heath, Barbara J. (1999) 'Buttons, Beads and Buckles: Contextualising Adornment Within the Bounds of Slavery' in Franklin, Maria and Garrett Fesler (eds) *Historical Archaeology, Identity Formation and the Interpretation of*

Ethnicity. Virginia: Dietz Press.

Helfenstein, Josef and Roman Kurzmeyer (eds) (1999) *Deep Blues: Bill Traylor 1854–1949*. New Haven: Yale University Press.

Helfenstein, Josef and Roxanne Stanulis (eds) (2004) *Bill Traylor, William Edmondson and the Modernist Impulse*. Urbana-Champaign: University of Illinois Press.

Hemenway, Robert E. (2007) 'Foreword' in Earle, Susan (ed.) *Aaron Douglas: African American Modernist*. New Haven: Yale University Press: vii–viii.

Henderson, Harry et al. (1990) *Charles Alston: Artist and Teacher*. New York: Kenkeleba Gallery.

Henderson, Harry (1996) 'Norman Lewis: the Making of a Black Abstract Expressionist'. *IRAAA*, 13, no. 3: 59–64.

Herzog, Melanie (2000) *Elizabeth Catlett: An American Artist in Mexico*. Seattle: University of Washington Press.

Herzog, Melanie (2005) *Elizabeth Catlett: In the Image of the People*. Chicago: Art Institute of Chicago.

Hess, Elizabeth (1989) 'Train of Thought'. *Village Voice*, 34.22 (30 May): n.p.

Hewitt, M. J. (1980) 'A Tribute to Charles White'. *Black Art: An International Quarterly*, 4: 32.

Hewitt, M. J. (1992) 'Betye Saar: An Interview'. *IRAAA*, 10, no. 2: 7–23.

Hill, Grant (2004) *Something All Our Own: the Grant Hill Collection of African American Art*. Durham, NC: Duke University Press.

Hills, Patricia (1993) 'Jacob Lawrence as Pictorial Griot: The "Harriet Tubman" Series'. *American Art*, 7, no. 1: 40–59.

Hoag, Betty (9 March 1965) 'Interview with Charles White', transcript, Archives of American Art, Smithsonian Institution: http://www.aaa.si.edu/collections/oralhistories/transcripts/white65.htm

Holland, Juanita Marie (1992) 'Reaching Through the Veil: African-American Artist Edward Mitchell Bannister' in Jennings, Corinne *Edward Mitchell Bannister, 1828–1901*. New York: Harry N. Abrams.

Holloway, Joseph (ed.) (1990) *Africanisms in American Culture*. Bloomington: Indiana University Press.

hooks, bell (1992) *Black Looks: Race and Representation*. Boston, MA: South End Press.

hooks, bell (1994) *Outlaw Culture: Resisting Representations*. London: Routledge.

hooks, bell (1995) *Art on My Mind: Visual Politics*. New York: New Press.

Hughes, Langston (1951) 'Montage of a Dream Deferred' in Rampersad, Arnold and David Roessel (eds) (1995) *Collected Poems of Langston Hughes*. New York: Vintage.

Hurston, Zora Neale (1936) 'Characteristics of Negro Expression' in Gates, Jr, Henry Louis and Nellie Y. McKay (eds) (Rpt. 1997) *The Norton Anthology of African American Literature*. New York: W. W. Norton and Co.:1020–32.

Jacobs, Harriet A. (1861) *Incidents in the Life of a Slave Girl: Written by Herself*, Yellin, Jean Fagan (ed.) (1987). Cambridge, MA: Harvard University Press.

Jacobs, Harriet A. 'Runaway Slave advertisement': http://content.answers. com/main/content/wp/en/thumb/1/1c/160px-Harrietjacobsreward.jpg

Jacques, Geoffrey (2002) 'Mood Swing: David Hammons'. *Artforum* (Summer): 152–7.

Jennings, Corrine and Ann Gibson et al. (1989) *Norman Lewis: From the Harlem Renaissance to Abstraction*. New York: Kenkeleba Gallery.

Jennings, Corrine (1996) 'Hale Woodruff: African-American Metaphor, Myth and Allegory' in Arnould-Taylor, William E. and Harriet G. Warkel (eds) *A Shared Heritage: Art by Four African Americans*. Indiana: Indiana University Press: 78–97.

Jones, Anne Hudson (1987) 'The Centennial of Clementine Hunter'. *Woman's Art Journal*, 8, no. 1: 23–7.

Jones, Kellie (2005a) 'Brothers and Sisters' in Powell, Richard J. (ed.) *Back to Black: Art, Cinema and the Racial Imaginary*. London: Whitechapel Gallery: 142–7.

Jones, Kellie (2005b) 'To/From Los Angeles with Betye Saar' in Steward, John C. and Deborah Willis et al. *Betye Saar: Extending the Frozen Moment*. California: University of California Press: 28–37.

Jones, Steven Loring (1995) 'A Keen Sense of the Artistic: African American Material Culture in Nineteenth Century Philadelphia'. *IRAAA*, 12, no. 2: 4–29.

Kennel, Sarah (2003) 'Bearden's Musée Imaginaire' in Fine, Ruth *The Art of Romare Bearden*. Washington, DC: National Gallery of Art: 138–55.

Kern-Foxworth, Marilyn (1997) *1989–1997 Michael Ray Charles An American Artist's Work*. Texas: Texas Fine Arts Association.

Kirschke, Amy Helene (1995) *Aaron Douglas: Art, Race, and The Harlem Renaissance*. Jackson: University Press of Mississippi.

Kirschke, Amy Helene (2007a) *Art in Crisis: W. E. B. Du Bois and the Struggle for African American Identity and Memory*. Indiana: Indiana University Press.

Kirschke, Amy Helene (2007b) 'The Fisk Murals Revealed: Memories of Africa, Hope for the Future' in Earle, Susan (ed.) *Aaron Douglas: African American Modernist*. New Haven: Yale University Press: 115–35.

Kramer, Hilton (1974) 'Chronicles of Black History'. *The New York Times*, 26 no. 17 May: 17.

Lamm, Kimberly (2003) 'Visuality and Black Masculinity in Ralph Ellison's *Invisible Man* and Romare Bearden's Photomontages'. *Callaloo*, 26, no. 3: 813–35.

Landsmark, Theodore C. (1998) 'Comments on African American Contributions to American Material Life'. *Winterthur Portfolio*, 33, no. 4: 261–82.

Langa, Helen (1999) 'Two Antilynching Art Exhibitions: Politicized Viewpoints, Racial Perspectives, Gendered Constraints'. *American Art*, 13, no. 1: 10–39.

Lawrence, Jacob (1970) 'The Artist Responds'. *Crisis*, 77, no. 7: 266–7.

Leeming, David (1998) *Amazing Grace: A Life of Beauford Delaney*. Oxford: Oxford University Press.

LeFalle-Collins, Lizzetta (1995) 'Contribution of the American Negro to Democracy: A History Painting by Charles White'. *IRAAA*, 12, no. 4: 39–41.

LeFalle-Collins, Lizzetta (1996) *In the Spirit of Resistance: African American Modernists and the Mexican Muralist School*. New York: American Federation of Arts.

Leininger-Miller, Theresa (2000) *New Negro Artists in Paris: African American Painters and Sculptors in the City of Light, 1922–1934*. New Brunswick, NJ: Rutgers University Press.

Lennon, Mary Ellen (2006) 'A Question of Relevancy: New York Museums and the Black Arts Movement, 1968–71' in Collins, Lisa Gail and Margo Natalie Crawford (eds) *New Thoughts on the Black Arts Movement*. New Brunswick, NJ: Rutgers University Press: 92–114.

Lewis, David Levering (1997) *When Harlem Was in Vogue*. London: Penguin Books.

Lewis, Norman (1946) 'Thesis' in Gibson, Ann E. (ed.) (1989) *Norman Lewis: From the Harlem Renaissance to Abstraction*. New York: Kenkeleba Gallery: 63.

Lewis, Norman (1949) 'Application for Guggenheim Fellowship' in Gibson, Ann E. (ed.) (1989) *Norman Lewis: From the Harlem Renaissance to Abstraction*. New York: Kenkeleba Gallery: 65.

Lewis, Norman (1951) 'Plan for Work' Gibson, Ann E. (ed.) (1989) *Norman Lewis: From the Harlem Renaissance to Abstraction*. New York: Kenkeleba Gallery: 65–6.

Lewis, Norman (1999) *Intuitive Markings: Works on Paper 1945–1975*. New York: Michael Rosenfeld Gallery.

Lewis, Samella S. and Ruth G. Waddy (1971 & 1976) *Black Artists on Art* (2 vols). Los Angeles: Contemporary Crafts.

Lewis, Samella S. (1978) *Art: African American*. New York: Harcourt Brace.

Lewis, Samella S. (1984) *The Art of Elizabeth Catlett*. Los Angeles: Hancraft Studios.

Lewis, Samella S. (1998) *Elizabeth Catlett; Sculpture: A Fifty-Year Retrospective*. Seattle: University of Washington Press.

Lewis, Samella S. (2003) *African American Art and Artists*. California: University of California Press.

Ligon, Glenn (2004) 'Black Light: David Hammons and the Poetics of Emptiness'. *Artforum*: http://findarticles.com/p/articles/mi_mo268/is_1_43/ai_n7069057

Ligon, Glenn (2001) *New Work*. Minneapolis: Walker Art Center.

Lippard, Lucy R. (1990) *Mixed Blessings: New Art in a Multicultural America*. New York: Pantheon Books.

Lippard, Lucy R. (1994) 'Sapphire and Ruby in the Indigo Gardens' in Shepherd, Elizabeth *Secrets, Dialogues, Revelations: Art of Betye and Alison Saar*. Seattle: University of Washington Press: 10–20.

Locke, Alain (1936) *Negro Art: Past and Present*. Washington, DC: Associates in Negro Folk Education.

Locke, Alain (1947) *Horace Pippin Memorial Exhibition*. Philadelphia: Art Alliance.

Locke, Alain (ed.) (1968) *The New Negro*. New York: Atheneum.

Lovett, Bobby (2000) 'From Plantation to the City: William Edmondson and the African-American Community' in Thompson, Robert Farris, Bobby L. Lovett and Rusty Freeman et al. *The Art of William Edmondson*. Jackson: University Press of Mississippi: 15–32.

Lucie-Smith, Edward (1994) *Race, Sex and Gender in Contemporary Art: The Rise of Minority Culture*. London: Art Books International.

Lyons, Mary E. (ed.) (1998) *Talking with Tebé: Clementine Hunter, Memory Artist*. Boston, MA: Houghton Mifflin.

Maguire, R. (ed.) (1997) *Conversations with Albert Murray*. Mississippi: University of Mississippi Press.

Major, Clarence (1977) 'Jacob Lawrence, The Expressionist'. *The Black Scholar*, 9, no. 3: 23–34.

Maresca, Frank and Roger Ricco (1991) *Bill Traylor: His Art, His Life*. New York: Alfred A. Knopf.

Marshall, Kerry James (2005) 'Sticks and Stones…, but Names…' in Helfenstein, Josef and Roxanne Stanulis (eds) *Bill Traylor, William Edmondson and the Modernist Impulse*. Urbana-Champaign: University of Illinois Press: 119–46.

Mason, Karen Ann (1996) 'Betye Saar', *African-American Artists of Los Angeles Oral History Transcript, 1990–1991*. Department of Special Collections, Young Research Library, University of California, Los Angeles c.1996.

Matthews, Marcia M. (1969) *Henry Ossawa Tanner*. Chicago: Chicago University Press.

McCausland, Elizabeth (1945) 'Jacob Lawrence'. *Magazine of Art*, XXXVIII (November): 251–4.

McElroy, Guy C. (1990) *Facing History, The Black Image in American Art, 1710–1940*. San Francisco: Bedford Arts Publishers.

McEvilly, Thomas (2007) 'Primitivism in the Works of an Emancipated Negress' in Gilman, Sander L. et al. *Kara Walker: My Complement, My Enemy, My Oppressor, My Love*. Ostfildern: Hatje Cantz Verlag: 53–61.

McWillie Judith (1999) 'William Edmondson with Edward Weston and Louise

Dahl-Wolfe' in Thompson, Robert Farris, Bobby L. Lovett and Rusty Freeman et al. *The Art of William Edmondson*. Jackson: University Press of Mississippi: 45–60.

Mercer, Kobena (1994) *Welcome to the Jungle*. New York: Routledge.

Messenger, Lisa M. (ed.) (2003) *African-American Artists, 1929–1945*. Metropolitan Museum of Art: Yale University Press.

Metcalf, Eugene W. (1983) 'Black Art, Folk Art, and Social Control'. *Winterhur Porfolio*, 18, no. 4: 271–89.

Meyer, Richard 'Borrowed Voices: Glenn Ligon and the Force of Language': http://www.queerculturalcenter.org/Pages/Ligon/LigonEssay.html

Miller, Ivor (1990) '"If It Hasn't Been One of Color": An Interview with Roy DeCarava'. *Callaloo*, 13, no. 4: 847–57.

Mooney, Amy (1999) 'Representing Race: Disjunctures in the Work of Archibald J. Motley, Jr'. *Museum Studies*, 24, no. 2: 162–79, 262–5.

Mooney, Amy (2004) *Archibald J. Motley Jr*. San Francisco: Pomegranate.

Morgan, Stacy I. (2004) *Rethinking Social Realism: African American Art and Literature, 1930–1953*. Athens: University of Georgia Press.

Morrison, Toni (1987) *Beloved*. London: Chatto and Windus.

Moutoussamy-Ashe, Jeanne (1993) *Viewfinders: of Black Women Photographers 1839–1985*. New York: Dodd, Mead and Co.

Murray, Albert (19 October 1968) 'Interview with Charles Alston', transcript, Archives of American Art, Smithsonian Institution: http://www.aaa.si.edu/collections/oralhistories/transcripts/alston68.htm

Murray, Albert (18 November 1968) 'Interview with Hale Woodruff', transcript, Archives of American Art, Smithsonian Institution: http://www.aaa.si.edu/collections/oralhistories/transcripts/woodru68.htm

Murray, Albert, (1979) 'An Interview with Hale Woodruff' in Campbell, Mary Schmidt (ed.) *Hale Woodruff: Fifty Years of his Art*. New York: Studio Museum in Harlem.

Murray, Albert (1997) *The Blue Devils of Nada*. New York: Vintage.

Murray, Freeman Henry Morris (1916) *Emancipation and the Freed in American Sculpture*. Washington, DC: Black Folk in Art Series.

Nadell, Martha Jane (2004) *Enter the New Negroes: Images of Race in American Culture*. Cambridge, MA: Harvard University Press.

Neri, Louise (1994) 'No Wonder: David Hammons and Louise Neri' in Rothschild, Deborah Menaker (ed.) *Yardbird Suite*. Williamstown: Williams College Museum of Art: 63–9.

Nesbett, Peter T. and Michelle Du Bois (eds) (2000) *The Complete Jacob Lawrence*. Seattle: University of Washington Press. 2 vols.

O'Keefe, Tricia (2005) 'Strategy or Spectacle?: Postmodernism, African-American Artists and Art Scholarship'. *Third Text*, 19, no. 6: 617–23.

Parks, Gordon (1963) *The Learning Tree*. New York: Harper and Row.

Parks, Gordon (1968) *A Poet and His Camera*. New York: Viking Press.

Parks, Gordon (1971) *Born Black*. New York: Lippincott.

Parks, Gordon (1979) *To Smile in Autumn: A Memoir*. New York: W. W. Norton and Co.

Parks, Gordon (1986) *A Choice of Weapons*. Minnesota: Minnesota Historical Press.

Parks, Gordon (1992) *Voices in the Mirror: An Autobiography*. New York: Doubleday.

Parks, Gordon (1997) *Half Past Autumn: A Retrospective*. Boston, MA: Little, Brown and Co.

Parks, Gordon (2005) *A Hungry Heart: A Memoir*. New York: Atria Books.

Parks, Gordon and Maren Strange (2007) *Gordon Parks: Bare Witness*. Italy: Skira Editore.

Patterson, Vivian (ed.). (2000) *Carrie Mae Weems: The Hampton Project*. Massachusetts: Aperture.

Patton, Sharon F. (1998) *African-American Art*. Oxford: Oxford University Press.

Perry, Regenia (1989) 'African Art and African-American Folk Art: A Stylistic and Spiritual Kinship' in Wardlaw, Alvia J. and Robert V. Rozelle (eds) *Black Art: Ancestral Legacy: The African Impulse in American Art*. Dallas: Dallas Museum of Art: 35–52.

Perry, Regenia (1992) *Free Within Ourselves: African-American Artists in the Collection of the National Museum of American Art*. Washington, DC: National Museum of American Art.

Perry, Regenia (1994) *Harriet Powers's Bible Quilts*. New York: Rizzoli.

Phillips, Harlan (28 September 1965) 'Interview with Charles Alston' transcript, Archives of American Art, Smithsonian Institution: http://www.aaa.si.edu/collections/oralhistories/transcripts/alston65.htm

Piché, Jr, Thomas (ed.) (1996) *Joe Overstreet: (Re) call & Response*. New York: Eveson Museum of Art.

Piché, Jr, Thomas and Thelma Golden (2003) *Carrie Mae Weems: Recent Work*. New York: George Braziller.

Pierce, Lemoine (2004) 'Charles Alston – An Appreciation: Special Issue'. *IRAAA*, 19, no. 4.

Pieterse, Jan Nederveen (1992) *White on Black: Images of Africa and Blacks in Western Popular Culture*. New Haven: Yale University Press.

Pindell, Howardena (1997) 'Art World Racism: A Documentation' in Sims, Lowery Stokes (ed.) *The Heart of the Question: The Writings and Paintings of Howardena Pindell*. New York: Midmarch Arts Press.

Pinder, Jefferson (2003) 'Jefferson Pinder: About': http://home.mindspring.com/~toughskins/about.html

Pinder, Jefferson (2004) 'Jefferson Pinder: Installations': http://home.mindspring.com/~toughskins/mixed/mixedone/mixedone.html

Pinder, Kimberly N. (1997) '"Our Father, God: our Brother, Christ; or are We Bastard Kin?": Images of Christ in African American Painting'. *African American Review*, 31, no. 2: 223–33.

Porter, James (1942) 'Four Problems in the History of Negro Art'. *Journal of Negro History*, 27, no. 1: 9–36.

Porter, James (1967) *Ten Afro-American Artists of the Nineteenth Century*. Washington, DC: Howard University Gallery of Art.

Porter, James (1943) *Modern Negro Art*. Rpt. in Driskell, David C. (ed.) (1992) Washington, DC: Howard University Press.

Powell, Richard J. (ed.) (1989) *The Blues Aesthetic: Black Culture and Modernism*. Washington, DC: Washington Project for the Arts.

Powell, Richard J. (1991) *Homecoming: the Art and Life of William H. Johnson*. New York: W. W. Norton and Co.

Powell, Richard J. (1993) 'Re-Creating American History' in Stein, Judith E. (ed.) *I Tell My Heart: The Art of Horace Pippin*. Philadelphia: Universe Publishing: 70–81.

Powell, Richard J. (1994) 'Art History and Black Memory: Toward a "Blues Aesthetic" in Fabre, Geneviève and Robert O'Meally *History and Memory in African-American Culture*. Oxford: Oxford University Press, 1994.

Powell, Richard J. (1995) 'African American Postmodernism and David Hammons: Body and Soul' in Driskell, David C. (ed.) *African American Visual Artists: A Postmodernist View*. Washington, DC: Smithsonian Institution Press: 121–38.

Powell, Richard J. and David Bailey (eds) (1997) *Rhapsodies in Black*. London: Hayward Gallery.

Powell, Richard J. (1999) *To Conserve a Legacy: American Art from Historically Black Colleges and Universities*. New York: Studio Museum in Harlem.

Powell, Richard J. (2002) *Black Art: A Cultural History*. London: Thames and Hudson.

Powell, Richard J. (ed.) (2005) *Back to Black: Art, Cinema and the Racial Imaginary*. London: Whitechapel Gallery.

Powell, Richard J. (ed.) (2006) *Conjuring Bearden*. Durham, NC: Duke University Press.

Priestly, Debra (2005–7) 'Statement': http://www.debrapriestly.net/page1/page1.html

Prown, Jonathan (1998) 'The Furniture of Thomas Day: A Re-evaluation', *Winterthur Portfolio*, 33, no. 4, 261–82.

Pruitt, Sharon (2004) 'Collage and Photomontage: Bearden's Spiralist Reflections of American and Africa' in Amaki, Amalia K. (ed.) *A Century of African American Art: The Paul R. Jones Collection*. New Brunswick, NJ: Rutgers University Press.

Rager, Cheryl R. (2007) 'Aaron Douglas: Influences and Impacts of the Early

Years' in Earle, Susan (ed.) *Aaron Douglas: African American Modernist*. New Haven: Yale University Press: 75–85.

Raverty, Dennis (2002) 'The Self as Other: A Search for Identity in the Painting of Archibald J. Motley, Jr'. *IRAAA*, 18, no. 2 (2002): 25–36.

Raymond, Yasmil (2007) 'Maladies of Power: A Kara Walker Lexicon' in Gilman, Sander L. et al. *Kara Walker: My Complement, My Enemy, My Oppressor, My Love*. Ostfildern: Hatje Cantz Verlag: 347–69.

Reid, Calvin, (1995) 'Mr. Hammons' Neighbourhood' in Snodgrass, Susan (ed.) *David Hammons in the Hood*. Illinois: Illinois State Museum: 30–49.

Reid-Pharr, Robert F. (2002) 'Black Girl Lost' in Dixon, Annette (ed.) *Kara Walker: Pictures from Another Time*. Ann Arbor: University of Michigan Museum of Art: 27–41.

Reinhardt, Mark (2003) 'The Art of Racial Profiling' in Berry, Ian (ed.) *Kara Walker: Narratives of a Negress*. Cambridge, MA: MIT Press: 109–29.

Reynolds, Gary (1989) *Against the Odds: African American Artists and the Harmon Foundation*. Newark: Newark Museum.

Roberts, John W. (1999) 'Horace Pippin and the African American Vernacular'. *Cultural Critique*, 41: 5–36.

Robinson, Hilary (ed.) (1987) *Visibly Female – Feminism and Art Today: An Anthology*. London: Camden Press.

Robinson, Jontyle T. and Wendy Greenhouse (1991) *The Art of Archibald J. Motley, Jr*. Chicago: Chicago Historical Society.

Robinson, Jontyle T. (ed.) (1996) *Bearing Witness: Contemporary Works by African American Women Artists*. New York: Rizzoli International Publications.

Rodgers, Kenneth G. (2006) *William H. Johnson: Revisiting an African American Modernist*. Durham, NC: North Carolina Central University Art Museum.

Rodman, Selden (1947) *Horace Pippin: A Negro Painter in America*. New York: Quadrangle Press.

Rogers, Paul (1994) 'Ralph Ellison, the Collage of Romare Bearden and Race: Some Speculations'. *IRAAA*, 11, no. 3: 7–10.

Rothschild, Deborah Menaker (ed.) (1994) *Yardbird Suite*. Williamstown: Williams College Museum of Art.

Rowell, Charles H. (1988) '"Inscription at The City of Brass": An Interview with Romare Bearden'. *Callaloo*, 36: 428–46.

Rowell, Charles H. (1990) '"I Have Never Looked Back Since": An Interview with Roy DeCarava'. *Callaloo*, 13, no. 4: 859–71.

Rugoff, Ralph (1995) 'David Hammons: Public Nuisance, Rubble Rouser, Hometown Artist' in Snodgrass, Susan (ed.) *David Hammons in the Hood*. Illinois: Illinois State Museum: 10–21.

Saar, Betye (1999) *Workers and Warriors, The Return of Aunt Jemima*. New York: Michael Rosenfeld Gallery.

Saar, Betye (2000) *In Service: A Version of Survival*. New York: Michael Rosenfeld Gallery.

Saarinen, Aline B. (1960) *Jacob Lawrence*. New York: American Federation of Arts.

Samford Patricia M. (1999) '"Strong is the Bond of Kinship": West-African Style Ancestor Shrines and Subfloor Pits on African-American Slave Quarters' in Franklin, Maria and Garrett Fesler (eds) *Historical Archaeology, Identity Formation and the Interpretation of Ethnicity*. Virginia: Dietz Press.

Schwartzman, Myron (1990) *Romare Bearden: His Life & Art*. New York: Harry N. Abrams.

Seifert, Charles S. (1986) *The Negro's or Ethiopian's Contribution to Art*. New York: Black Classic Press. First pub. 1938.

Sewell, Darrel (1991) *Henry Ossawa Tanner*. New York: Rizzoli International Publications.

Shaw, Gwendolyn DuBois (2004) *Seeing the Unspeakable: The Art of Kara Walker*. Durham, NC: Duke University Press.

Shepherd, Elizabeth (1994) *Secrets, Dialogues, Revelations: Art of Betye and Alison Saar*. Seattle: University of Washington Press.

Shockley, Ann Allen (19 November 1973) 'Aaron Douglas', interview conducted by Ann Allen Shockley, transcript, Fisk University, Franklin Library Special Collections.

Siegel, Jeanne (1966) 'Why Spiral?' *Art News*, 65, no. 5 (September): 50–1, 67.

Sill, Robert (1995) 'The Travelling Medicine Show' in Snodgrass, Susan (ed.) *David Hammons in the Hood*. Illinois: Illinois State Museum: 22–9.

Sims, Lowery Stokes (ed.) (1992) *Howardena Pindell: Paintings and Drawings, A Retrospective Exhibition, 1972–1992*. New York: Roland Gibson Gallery.

Sims, Lowery Stokes (ed.) (1997) *The Heart of the Question: The Writings and Paintings of Howardena Pindell*. New York: Midmarch Arts Press.

Sims, Lowery Stokes (2000) 'The Self-Taught Among Us: William Edmondson and the Vanguardist Dilemma' in Thompson, Robert Farris et al. *The Art of William Edmondson*. Jackson: University Press of Mississippi: 71–8.

Sims, Lowery Stokes (2003) *Challenge of the Modern: African-American Artists 1925–1945*. New York: Studio Museum.

Smalls, James (1994) 'A Ghost of a Chance: Invisibility and Elision in African American Art Historical Practice'. *Art Documentation*, 13, no. 1: 3–8.

Smalls, James (2001) 'African-American Self-Portraiture: Repair, Reclamation, Redemption'. *Third Text*, 54: 47–62.

Smith, Deborah (ed.) (2005) *Along the Way: Kerry James Marshall*. London: Camden Arts Centre.

Smith, Shawn Michelle (2004) *Photography on the Color Line: W. E. B. Du Bois, Race, and Visual Culture*. Durham, NC: Duke University Press.

Snodgrass, Susan (ed.) (1995) *David Hammons in the Hood*. Illinois: Illinois State Museum.

Stanulis, Roxanne and Josef Helfenstein (eds) (2005) *Bill Traylor, William Edmondson and the Modernist Impulse*. Seattle: University of Washington Press.

Stauffer, John (2002) *The Black Hearts of Men: Radical Abolitionists and the Transformation of Race*. Cambridge, MA: Harvard University Press.

Stauffer, John (2004) 'Creating an Image in Black: The Power of Abolition Pictures' in Stauffer, John and Timothy Patrick McCarthy (eds) *Prophets of Protest: Reconsidering the History of American Abolitionism*. New York: New Press: 256–67.

Stein, Judith E. (ed.) (1993) *I Tell My Heart: The Art of Horace Pippin*. Philadelphia: Universe Publishing.

Steward, John C. and Deborah Willis et al. (2005) *Betye Saar: Extending the Frozen Moment*. California: University of California Press.

Stewart, Jeffrey C. (1994) 'Black Modernism and White Patronage'. *IRAAA*, II, no. 3: 43–6.

Stewart, Rhonda (2004) 'Still Here: Artist Kara Walker in Black and White'. *The Crisis* January/February 2004: http://findarticles.com/p/articles/mi_qa4081/is_200401/ai_n9382167

Storr, Robert (1994) 'You have to be Prepared: A Conversation Between David Hammons and Robert Storr' in Rothschild, Deborah Menaker (ed.) *Yardbird Suite*. Williamstown: Williams College Museum of Art: 53–9.

Sullivan, George (1996) *Black Artists in Photography, 1840–1940*. New York: Cobblehill Books.

Tancons, Claire (2005) 'An Elective Affinity: David Hammons's *Hidden from View* and *Made in the People's Republic of Harlem*'. *Third Text*, 19, no. 2: 169–75.

Tate, Greg (1992) *Flyboy in the Buttermilk: Essays on Contemporary America*. New York: Simon and Schuster.

Tesfagiorgis, Freida High W. (2001) 'In Search of a Discourse and Critique/s that Center the Art of Black Women Artists' in Bobo, Jacqueline (ed.) *Black Feminist Cultural Criticism* Oxford: Blackwell Publishers, 2001: 146–72.

Thomas, Brian W. (1998) 'Power and Community: The Archaeology of Slavery at the Hermitage Plantation'. *American Antiquity*, 63, no. 4: 531–51.

Thomas, Lorenzo (1978) 'The Shadow World: New York's Umbra Workshop and Origins of the Black Arts Movement'. *Calalloo*, 4: 53–72.

Thompson, Robert Farris (1983) 'African Influence in the Art of the U.S.' in Ferris, William (ed.) *Afro-American Folk Art and Crafts*. Boston, MA: G. K. Hall: 27–63.

Thompson, Robert Farris (1984) *Flash of the Spirit: African and Afro-American Art and Philosophy*. New York: Vintage Books.

Thompson, Robert Farris (1989) 'The Song that Named the Land: the Visionary

Presence of African-American Art' in Wardlaw, Alvia J. and Robert V. Rozelle (eds) *Black Art: Ancestral Legacy: The African Impulse in American Art*. Dallas: Dallas Museum of Art: 97–141.

Thompson, Robert Farris (1992) 'Royalty, Heroism, and the Streets: The Art of Jean-Michel Basquiat' in Marshall, Richard (ed.) *Jean-Michel Basquiat*. New York: Whitney Museum of Art: 28–42.

Thompson, Robert Farris, Bobby L. Lovett and Rusty Freeman et al. (2000) *The Art of William Edmondson*. Jackson: University Press of Mississippi.

Tobin, Jacqueline L. and Raymond G. Dobard (2000) *Hidden in Plain View: A Secret Story of Quilts and the Underground Railroad*. New York: Anchor Books.

Turner, Elizabeth Hutton (ed.) (1993) *Jacob Lawrence: The Migration Series*. Washington, DC: Rappahannock Press.

Veneciano, Jorge Daniel (1998) 'The Quality of Absence in the Black Paintings of Norman Lewis' in Gibson, Ann (ed.) *Norman Lewis: Black Paintings 1946–1977*. Harlem: Studio Museum: 31–41.

Vergne, Philippe (2007) 'The Black Saint is the Sinner Lady' in Gilman, Sander L. et al. *Kara Walker: My Complement, My Enemy, My Oppressor, My Love*. Ostfildern: Hatje Cantz Verlag: 7–25.

Vlach, John M. and Simon Bronner (eds) (1988) *Folk Art and Art Worlds*. Ann Arbor: UMI Research Press.

Vlach, John M. (1991) *By the Work of their Hands: Studies in Afro-American Folklife*. Charlottesville: University Press of Virginia.

Vlach, John M. (1992) *Charleston Blacksmith: The Work of Philip Simmons*. Columbia: University of South Carolina Press.

Vlach, John M. (1993) *Back of the Big House: the Architecture of Plantation Slavery*. Chapel Hill: University of North Carolina Press.

Wagner, Anne M. (2003) 'Kara Walker: "The Black-White Relation"' in Berry, Ian (ed.) *Kara Walker: Narratives of a Negress*. Cambridge, MA: MIT Press: 89–101.

Wahlman, Maude Southwell and John Scully (1983) 'Aesthetic Principles in Afro-American Quilts' in Ferris, William (ed.) *Afro-American Folk Art and Crafts*. Boston, MA: G. K. Hall: 79–97.

Walker, Kara (1998) 'Kara Walker's Response'. *IRAAA*, 15, no. 2: 48–9.

Walker, Kara (1999) 'MOMA, Conversations with Contemporary Artists: Kara Walker': http://www.moma.org/onlineprojects/conversations/kw_f.html

Walker, Kara 'Projecting Fictions: "Insurrection! Our Tools were Rudimentary, Yet We Pressed On!"'
http://www.pbs.org/art21/artists/walker/clip2.html

Walker, Kara 'The Melodrama of "Gone with the Wind"': http://www.pbs.org/art21/artists/walker/clip2.html

Walker, Kara (2002) 'Letter from a Black Girl' in Dixon, Annette (ed.) *Kara*

Walker: Pictures from Another Time. Ann Arbor: University of Michigan Museum of Art: 96.

Wallace, Michele (1990) *Invisibility Blues: From Pop to Theory*. New York: Verso Books.

Wallace, Michele (2003) 'The Enigma of the Negress Kara Walker' in Berry, Ian (ed.) *Kara Walker: Narratives of a Negress*. Cambridge, MA: MIT Press: 175–9.

Wallace, Michele (2004) *Dark Designs and Visual Culture*. Durham, NC: Duke University Press.

Wallis, Brian (1995) 'Black Bodies, White Science: Louis Agassiz's Slave Daguerreotypes'. *American Art*, 9, no. 2: 38–61.

Wallis, Stephen (1996) 'Jacob Lawrence: Portrait of a Serial Painter'. *Art and Antiques*, 19, no. 11: 58–64.

Wardlaw, Alvia J. and Robert V. Rozelle (eds) (1989) *Black Art: Ancestral Legacy: The African Impulse in African American Art*. Dallas: Dallas Museum of Art.

Wardlaw, Alvia J. (2007) *Charles Alston*. San Francisco: Pomegranate.

Washington, Mary Parks (2007) 'Hale Woodruff: Artist, Teacher and Mentor' in Amaki, Amalia K. and Andrea Barnwell Brownlee (eds) *Hale Woodruff, Nancy Elizabeth Prophet and the Academy*. Seattle: University of Washington Press: 87–93.

West, Cornel (1993) 'Horace Pippin's Challenge to Art Criticism' in Stein, Judith E. (ed.) *I Tell My Heart: The Art of Horace Pippin*. Philadelphia: Universe Publishing: 44–52.

West, Cornel (1994) 'The New Cultural Politics of Difference' in Berger, Maurice (ed.) *Modern Art and Society: An Anthology of Social and Multi-cultural Readings*. Colorado: Westview Press.

Wheat, Ellen Harkins (1986) *Jacob Lawrence: American Painter*. London: University of Washington Press.

Wheat, Ellen Harkins (ed.) (1991) *The Frederick Douglass and Harriet Tubman Series of 1938–40*. Seattle: Washington University Press.

White, Michelle-Lee (1995) 'Common Directions, Epic Dimensions: Jacob Lawrence's Murals at Howard University'. *IRAAA*, 12, no. 4: 30–7.

White, Shane and Graham White (1995) 'Slave Clothing and African-American Culture in the Eighteenth and Nineteenth Centuries'. *Past and Present*, 148: 148–86.

White, Shane and Graham White (1999) *Stylin': African American Expressive Culture, from its Beginnings to the Zoot Suit*. Ithaca: Cornell University Press.

Wilkin, Karen (1995) 'The Naïve and the Modern: Horace Pippin and Jacob Lawrence'. *New Criterion*, 13: 33–8.

Willis, Deborah and Andy Grundberg (1992) *Lorna Simpson: Untitled; 54*. New York: Distributed Art Publishers.

Willis, Deborah (ed.) (1995) *Picturing Us: African American Identity in Photography*. New York: The New Press.

Willis, Deborah and Carla Williams (2002) *The Black Female Body: A Photographic History*. Philadelphia: Temple University Press.

Willis, Deborah (2005) 'Looks and Gazes: Photographic Fragmentation and the Found Object' in Steward, John C. and Deborah Willis et al. *Betye Saar: Extending the Frozen Moment*. California: University of California Press: 20–7.

Willis-Thomas, Deborah (1992) *Early Black Photographers, 1840–1940*. New York: New Press.

Willis-Thomas, Deborah (ed.) (1993) *J. P. Ball, Daguerrean and Studio Photographer*. New York: Garland.

Willis-Thomas, Deborah (2000) *Reflections in Black: a History of Black Photographers, 1840 to the Present*. New York: W.W. Norton and Co.

Wilson, Judith (1990) 'The Myth of the Black Aesthetic' in Adkins, Terry and Adrian Piper et al. *Next Generation: Southern Black Aesthetic*. Durham, NC: University of North Carolina Press.

Wilson, Judith (1991) 'Optical Illusions: Images of Miscegenation in Nineteenth- and Twentieth-Century American Art'. *American Art*, 5, no. 3: 88–107.

Wilson, Judith (1992) 'Getting Down to Get Over: Romare Bearden's Use of Pornography and the Problem of the Black Female Body in Afro U.S. Art' in Dent, Gina and Michele Wallace (eds) *Black Popular Culture*. Seattle: Bay Press: 112–22.

Withers, Josephine (1980) 'Betye Saar: Art'. *Feminist Studies*, 6, no. 2: 336–41.

Witkovsky, Matthew S. (1989) 'Experience vs. Theory: Romare Bearden and Abstract Expressionism'. *Black American Literature Forum*, 23, no. 2: 257–82.

Wolfe, Rinna Evelyn (1998) *Edmonia Lewis: Wildfire in Marble*. Englewood Cliffs: Silver Burdett Press.

Wood, Sara (2007) *Shadow and Act: Race and Representation in African American Art, 1945–1970*. Ph.D. Diss.: University of Birmingham, 2007.

Woodruff, Hale (1966) *Ten Negro Artists from the United States*. New York: National Collection of the Fine Arts.

Wright, Beryl (ed.) (1992) *Lorna Simpson: For the Sake of the Viewer*. New York: Universe Publishing.

Wright, Richard (1941) *Twelve Million Black Voices*. Rpt. Ignatiev, Noel and David Bradley (eds) (2001) New York: Thunder's Mouth Press.

Wyatt, MacGaffey, Michael D. Harris, Sylvia H. Williams and David C. Driskell (eds) (1993) *Astonishment and Power*. Washington, DC: Smithsonian Institution Press.

Zabunyan Elvan (2005) *Black is a Color: A History of African American Art*. Paris: Éditions Dis Voir.

Index